Documenta11_Plattform5: Ausstellung | Exhibition
Kurzführer I Short Guide

Hatje Cantz

INHALT | CONTENTS

VORWORT | PREFACE

Fast fünfzig Jahre nach ihrer Gründung sieht die Documenta sich erneut mit den Gespenstern einer unruhigen Zeit fortwährender kultureller, gesellschaftlicher und politischer Konflikte, Veränderungen, Übergänge, Umbrüche und globaler Konsolidierungen konfrontiert. Wenn wir diese Ereignisse in ihrer weitreichenden historischen Bedeutung bedenken und ebenso die Kräfte, die gegenwärtig die Wertvorstellungen und Anschauungen unserer Welt gestalten, wird uns gewahr, wie schwierig und heikel die Aussichten der aktuellen Kunst und ihre Position bei der Erarbeitung und Entwicklung von Interpretationsmodellen für die verschiedenen Aspekte heutiger Vorstellungswelten sind.

Wie können wir diese rapiden Veränderungen verstehen, die nach neuen Ideen und Modellen für ein transdisziplinäres Handeln im globalen öffentlichen Raum unserer Zeit verlangen? Die brisante Aufgabe einer sinnvollen Artikulierung der Möglichkeiten, die der Kunst in einem solchen Klima offen stehen, und der disziplinäre, räumliche, zeitliche und historische Druck, dem sie ausgesetzt ist, bilden den Rahmen der diagnostischen Prozesse und Debatten, in dem die Documenta11 ansetzt. Das Grundkonzept der Documenta11 beruht auf der Formulierung einer Abfolge von fünf Plattformen in Form von öffentlichen Diskussionen, Konferenzen, Workshops, Büchern, Film- und Videoprogrammen, die versuchen, den gegenwärtigen Ort der Kultur und ihre Schnittstellen mit anderen komplexen globalen Wissenssystemen zu beschreiben. Die fünf Plattformen greifen eine Reihe von Fragen auf, die für das intellektuelle Projekt der Documenta11 von zentraler Bedeutung sind. Von der *Plattform1. Demokratie als unvollendeter Prozess* über die *Plattform2. Experimente mit der Wahrheit: Rechtssysteme im Wandel und die Prozesse der Wahrheitsfindung und Versöhnung* sowie die *Plattform3. Créolité und Kreolisierung* und die *Plattform4. Unter Belagerung: Vier afrikanische Städte – Freetown, Johannesburg, Kinshasa, Lagos* bis hin zur *Plattform5*, der Ausstellung selbst, verfolgt die Documenta11 ihre grundlegende Intention, den Horizont der kritischen Diskussionen im gegenwärtigen Kunstdiskurs zu erweitern.

In einem gewissen Sinn beginnen die fünf Plattformen der Documenta11 in einer paradoxen, aber notwendigen kritischen Geste mit einer Serie von Deterritorialisierungen, die nicht nur die historische Lokalisierung der Documenta in Kassel betreffen, sondern auch die Mechanismen veranschaulichen, die den Raum der aktuellen Kunst mit vielfachen Brüchen durchziehen. Vom Beginn in Wien am 15. März 2001 über Neu-Delhi, Berlin, Santa Lucia und Lagos bis zum Abschluss in Kassel am 15. September 2002 entfalten die Plattformen sich über achtzehn Monate hinweg in verschiedenen Kontinenten, Städten und Disziplinen. Sie oszillieren zwischen verschiedenen Prozeduren, geprägt von Diskussionen, die aus der tief greifenden historischen Erfahrung von gesellschaftlicher Veränderung und Erneuerung hervorgehen. Es wäre eine katastrophale intellektuelle Anmaßung, die Fragen, die aus diesen historischen Erfahrungen entstanden sind, nicht ernst zu nehmen und sie nicht aufzugreifen, um an ihnen zu ermessen, wie die aktuelle Kunst in all ihren verschiedenen Ausprägungen sich in einer dialektischen Beziehung zur gesamten globalen Kultur weiterentwickeln kann.

Almost fifty years after its founding, Documenta finds itself confronted once again with the specters of yet another turbulent time of unceasing cultural, social, and political frictions, transitions, transformations, fissures, and global institutional consolidations. If we take on board these events in all their historical significance, along with the forces that are today reshaping the values and views of our world, the prospects for contemporary art and its position in producing and explicating critical models of interpreting the features of the contemporary imagination could not be more demanding and daunting.

How do we make sense of these rapid changes and transformations, which call upon all practitioners for new, inventive models of enabling trans-disciplinary action within the contemporary global public sphere? The challenge of making a meaningful articulation of the possibilities of contemporary art in such a climate, as well as the disciplinary, spatial, temporal, and historical pressures to which it has been subjected, represent the diagnostic, deliberative process out of which the full measure of Documenta11 has been engaged. The constitutive conceptual dimension of Documenta11 is grounded in the formulation of a series of five Platforms of public discussions, conferences, workshops, books, and film and video programs that seek to mark the location of culture today and the spaces in which culture intersects with the domains of complex global knowledge circuits. The five Platforms take up a number of questions which we deem of critical relevance to the intellectual project of Documenta11. From *Platform1, Democracy Unrealized; Platform2, Experiments with Truth: Transitional Justice and the Processes of Truth and Reconciliation; Platform3, Créolité and Creolization; Platform4, Under Siege: Four African Cities—Freetown, Johannesburg, Kinshasa, Lagos;* to *Platform5, Exhibition,* Documenta11 has tried to spell out its statement of intent, which is to enlarge the space of the critical debates of contemporary artistic discourse today.

In a sense, then, Documenta11's five Platforms, in a paradoxical but necessary critical move, begin with a series of deterritorializations which not only intervene in the very historical location of Documenta in Kassel but also emblematize the mechanisms that make the space of contemporary art one of multiple ruptures. Beginning in Vienna on March 15, 2001, then to New Delhi, Berlin, St. Lucia, Lagos, and ending in Kassel on September 15, 2002, the Platforms unfold over the course of eighteen months across continents, cities, and disciplines; they oscillate between procedures marked by debates that come out of the deep historical experience of societies undergoing change and renewal. It would have been a catastrophic intellectual presumption to make light of the questions that have emerged from these historical experiences, and not to take them on board as a challenge in terms of how contemporary art and its various enterprises can move forward in a dialectical relationship with global culture at large.

Throughout Documenta11's preparation I have had the exceeding good fortune of working with a team of six brilliant and committed colleagues in shaping every single facet of this project. That I have learned more from this project working with Carlos Basualdo, Ute Meta Bauer, Susanne

Während der Vorbereitung der Documenta11 hatte ich das außerordentliche Glück, mit einem Team von sechs hervorragenden und engagierten Kolleginnen und Kollegen zusammenzuarbeiten, die bei der Gestaltung dieses Projekts in allen seinen Facetten mitgewirkt haben. Was ich bei der gemeinsamen Arbeit mit Carlos Basualdo, Ute Meta Bauer, Susanne Ghez, Sarat Maharaj, Mark Nash und Octavio Zaya hinzugelernt habe, ist von unschätzbarem Wert. Mit ihnen erfuhr ich die lebhafteste und reichhaltigste kritische, forschende und produktive intellektuelle Zusammenarbeit, die man sich wünschen kann. Die Documenta11 ist auch ein Resultat ihrer gründlichen Analyse der schwierigen Aufgabe, etwas Bedeutungsvolles und Dauerhaftes zu erstellen. Bei einem Projekt dieser Größenordnung ist es schlechterdings unmöglich, eine einzige Person als Urheber zu bezeichnen, dennoch wird diese Rolle dem Künstlerischen Leiter zugewiesen. Ich danke der Stadt Kassel, insbesondere ihrem Oberbürgermeister, Herrn Georg Lewandowski, und dem Documenta-Aufsichtsrat für die Ehre, als Künstlerischer Leiter dieser legendären Institution dienen zu dürfen. Ebenso danke ich Bernd Leifeld, dem Geschäftsführer der documenta GmbH, für die unentwegte gute Zusammenarbeit und seine uneingeschränkte Unterstützung für sämtliche Projekte im Rahmen der Documenta11.

Desgleichen danke ich allen Mitgliedern des Teams der Documenta11, die während dieser Zeit unermüdlich und mit außerordentlichem Engagement, Professionalismus, Generosität, Enthusiasmus und Kollegialität gearbeitet haben. Während für alle Fehler ich allein einstehe, ist der Erfolg des Projekts eine Bekundung ihrer hervorragenden Arbeit. Namentlich gilt mein Dank Angelika Nollert (Projektleiterin), Markus Müller (Leiter der Kommunikation), Gerti Fietzek (Redaktionsleiterin), Wilfried Waldeyer (Technischer Leiter) sowie Andreas Seiler, der sich in vielfältigster Weise um die reibungslose Arbeit des Documenta-Projektbüros verdient gemacht hat.

Besonders möchte ich meiner Tochter Uchenna danken sowie meiner Frau und Partnerin Muna El Fituri, die mich von vielem entlastet hat, das sich nur schwerlich mit den Anforderungen dieser Aufgabe hätte vereinbaren lassen. Mein Dank gilt weiterhin allen Förderern, Leihgebern und Sponsoren sowie dem Publikum der Plattformen. Schließlich möchte ich allen KünstlerInnen und TeilnehmerInnen der Plattformen danken, die uns ihre künstlerische und intellektuelle Arbeit zum Geschenk gemacht haben.

Okwui Enwezor
Künstlerischer Leiter der Documenta11

Ghez, Sarat Maharaj, Mark Nash, and Octavio Zaya is surely to be taken as the supreme understatement. Ours have been the most lively, generous, critical, inquisitive, and enabling intellectual environment that any professional can ever hope for. Documenta11 is a tribute to their steadfast, careful analysis of the difficult task of making something meaningful and durable. A project of this magnitude easily disqualifies the notion of one singular author, yet that has been the role the Artistic Director has been given. I am immensely grateful to the city of Kassel, especially to his honor Georg Lewandowski, the Mayor of Kassel, and to the Supervisory Board, for the opportunity to serve as the Artistic Director in what is a legendary institution. My gratitude also goes to Bernd Leifeld, the Managing Director of Documenta, who has worked closely and tirelessly with me and has been steadfast in his unwavering support for the full scope of Documenta11.

I am deeply indebted to the entire team of Documenta11, all of whom have worked without stop and with incredible commitment, professionalism, generosity, enthusiasm, and colleagueship. While the failures are mine indeed, the success of this project is a testament to their hard work. In particular I would like to express my gratitude to Angelika Nollert (Project Manager), Markus Müller (Director of Communication), Gerti Fietzek (Managing Editor), Winfried Waldeyer (Technical Director), and to Andreas Seiler for his exacting diligence in keeping all affairs of the exhibition project office working seamlessly.

I would like to register my deepest thanks to my daughter Uchenna and to my wife and partner Muna El Fituri for covering many other duties which would have been difficult to juggle with the challenges of this task. My thanks also to all the supporting institutions, lenders, and sponsors, and to the audiences of the various Platforms. Finally, I wish to thank all the artists and speakers for making us a gift of their artistic and intellectual labor.

Okwui Enwezor
Artistic Director, Documenta11

GEORGES ADÉAGBO

***1942 in Cotonou, Benin. Lebt/Lives in Cotonou, Benin.**

Georges Adéagbo studierte Recht und Wirtschaft in Frankreich, als ihn 1971 der Tod seines Vaters zwang, nach Benin zurückzukehren. Damals entstanden seine ersten Installationen im Hof seines Hauses in Cotonou. Zwanzig Jahre lang arbeitete er extrem isoliert, bis die zufällige Begegnung mit einem französischen Kurator und Sammler ihn in die Kunstwelt katapultierte.

Adéagbos Werdegang wäre weniger wichtig, würde er ihn nicht immer wieder in seinen untrennbar mit den Installationen verbundenen Texten thematisieren. Er betont, man könne seine Arbeit schwerlich Kunst nennen, und da es ihm widerstrebt, sich Künstler nennen zu lassen, könnte man hieraus eine radikale Infragestellung beider Begriffe lesen. Man muss sich auf jeden Fall vor Augen halten, dass die komplexe Logik seiner Arbeit sich parallel zur wechselvollen Entwicklung der jüngsten Kunstgeschichte und nicht aus ihr heraus entwickelt hat. Aufgrund ihrer recht weit vom gängigen Begriff der zeitgenössischen Kunst entfernten Position hinterfragt Adéagbos Arbeit radikal die Annahmen, die diesem Begriff zugrunde liegen.

Strukturell ähneln sich seine Installationen in der Regel: In der Raummitte befindet sich der thematische Hauptgegenstand, umgeben von einer Serie von Informationsschichten an den Wänden. Die Arbeiten leiten sich fast ausnahmslos von einer zentralen Anekdote ab, die Adéagbo mit dem Grund für die Ausführung der Arbeit verbindet. Geschichte bzw. die zahllosen voneinander unabhängigen Arten, wie sich persönliche Geschichten mit Kunstgeschichte und Geschichte im weiteren Sinne verbinden, sind ein wiederkehrendes Thema. Seine Installationen enthalten stets ein narratives Element, wobei die Geschichte allerdings nicht linear und folglich endlos ist. Das narrative Element nutzt Adéagbo eher als einen Vorwand, um eine Struktur für seine Untersuchungen herauszuarbeiten, die sich im Ausstellungsraum in Form eines fast immer symmetrischen Arrangements von visuellen und textuellen Referenzen manifestiert. Die Referenzen fungieren als erläuternde Anhänge der in den Begleittexten umrissenen Erzählung und haben sehr unterschiedliche Formen: Zeitungen, Zeitschriften, vor Ort vorgefundene Bücher, Bilder und Plastiken, die auf Materialien aus dem Untersuchungsprozess basieren und von Adéagbo selbst in Cotonou in Auftrag gegeben werden, sowie vor allem Adéagbos eigene räumlich gestreute Texte, die die Gesamtinstallation immer wieder unterbrechen. Dank seiner Position als Außenseiter kann Adéagbo gegenüber den von ihm untersuchten Gegenständen – kulturellen Entwicklungen, afrikanischer und europäischer Geschichte, Kunstgeschichte und Ereignissen aus seiner eigenen Biografie – eine aufmerksame, kritische Haltung einnehmen, ohne dabei jemals in ideologische Konditionierungen oder Simplifikationen zu verfallen.

Georges Adéagbo was studying law and business in France when his father's death in 1971 obliged him to return to Benin. This is when Adéagbo began making his first installations in the courtyard of his house in Cotonou. Over the next two decades he continued to work in extreme isolation, until a chance meeting with a French curator and collector catapulted him into the art world.

Adéagbo's biography would not be relevant if he did not mention it, time and again, in the texts that inevitably accompany his installations. Adéagbo insists that it is difficult to consider his work "art," and his resistance to being labeled an "artist" can be interpreted as a profound questioning of both categories. However, it is extremely important not to forget that the complex logic of Adéagbo's work developed in parallel to and not out of the vicissitudes of the recent history of art. This relative "outsideness" with respect to the canonical notion of "contemporary art" lends Adéagbo's work its character of radically challenging the assumptions the label embodies.

In general, Adéagbo's installations all have a similar structure: a central body placed horizontally in the middle of the space and a series of strata of information on the walls. Nearly all of Adéagbo's works derive from a central anecdote that the artist connects to the reason behind the execution of the work. History, or the myriad disconnected ways that personal stories are mixed and jumbled with the history of art and history in general, is the recurrent theme of Adéagbo's work. His installations always contain a narrative element, but the narration is not linear and is therefore endless. The narrative is more like a pretext, allowing Adéagbo to devise a research procedure that manifests itself in the exhibition space as the nearly always symmetrical and orderly distribution of a series of visual and textual references. These references function as exegetic appendices to the narrative sketched in the accompanying texts. Adéagbo's references are of the most diverse kinds: newspapers, books found on location, magazines, paintings, and sculptures that Adéagbo himself commissions in Cotonou, based on the material that emerges from the very process of research, and, especially, his own texts dispersed in space, punctuating the installation in its totality. Adéagbo is able to contemplate cultural processes, the histories of Africa and Europe, the history of art and the events of his own life from a certain perspective of exteriority allowing him to assume an alert and critical position with respect to the subjects he deals with, without ever succumbing to ideological conditioning or simplification. C. B.

Le socialisme Afrique | African Socialism | Afrikanischer Sozialismus, 2001/02
Installation view | Installationsansicht, Museum Villa Stuck, Munich | München, 2001

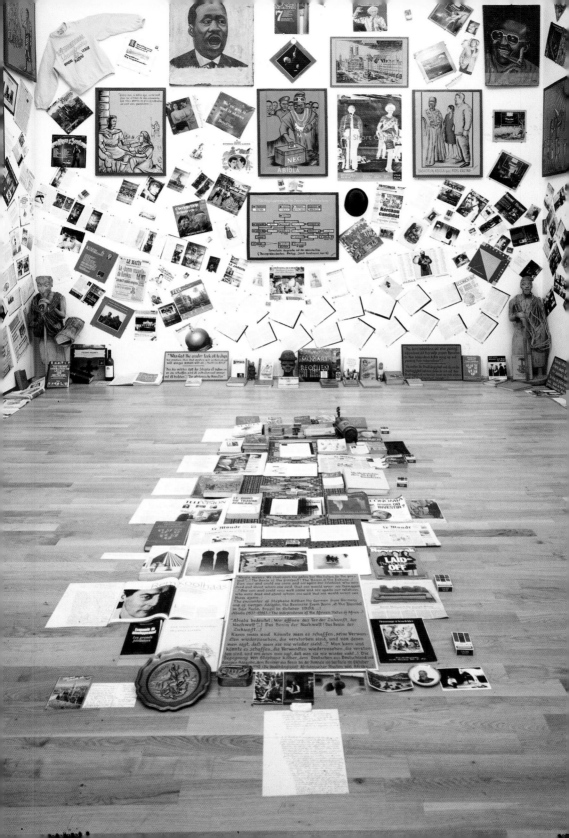

RAVI AGARWAL

*1958 in Neu-Delhi/New Delhi. Lebt/Lives in
Neu-Delhi/New Delhi.

Ravi Agarwals fotojournalistische Reise führt uns mitten in den Alltag der Arbeiter im indischen Süd-Gujarat, die über keinerlei oder lediglich unrentablen Grundbesitz verfügen. Durch den einzigartigen sezierenden Charakter seiner Fotografien werden wir mit einem extrem heterogenen, informellen Dasein dieser „vorindustriellen" Arbeiter konfrontiert, die in beengten Manufakturen, in Privathaushalten, in Slums, unter freiem Himmel, auf der Straße, im Feld, im Steinbruch, im Flussbett und als Wanderarbeiter mühevoll ihrem Tagewerk nachgehen. Agarwals Serie sinnlicher Fotografien (in Auszügen veröffentlicht in *Down and Out: Labouring under Global Capitalism,* 2000) widmet sich dem entmenschlichenden Aspekt der Arbeit dieser mittellosen Schicht, ohne in die Dichotomie vom heroisierten oder zum Opfer stilisierten proletarischen Arbeiter zu verfallen.

Süd-Gujarat, ein Gebiet entlang der indischen Westküste – die Hauptstadt Surat verzeichnet das größte Bevölkerungswachstum seit der Unabhängigkeit Indiens 1947 –, ist zum Übungsplatz für Maßnahmen geworden, die einen Strukturwandel herbeiführen sollen und durch Weltbank- und IMF-Kredite finanziert werden. Am Rande der Gesellschaft verdingt sich eine rechtlich ungeschützte Bevölkerungsschicht aus städtischen und vorstädtischen Agrar-Industriearbeitern als Hausangestellte, Steinhauer und Rohrschneider, als Lumpensammler, Ziegelbrenner, Erd- und Bauarbeiter, Prostituierte, Händler, Flickschuster, Handwerker, in der Gastronomie und in der größtenteils in Privathaushalten angesiedelten Jari-Industrie (Kunstseide). Von Bürgerrechten und Kapitalmobilität ausgeschlossen, durch Jobvielfalt und zyklische Konjunkturveränderungen geschwächt, bilden diese Arbeiter zwar den Grundstock und die Eckpfeiler der Wirtschaft, doch der Zugang zum angesammelten Reichtum bleibt ihnen verwehrt. Unter dem alles beherrschenden Eindruck einer fehlgeschlagenen Industrialisierung im Stil westlicher Länder, der korrupten Bodennutzungspolitik – illegales Geld (kalu be) macht zwei Drittel des „cashflow" der Wirtschaft aus – und der globalisierungsbedingten Trennung in Güter für die nationale Produktion und Güter für den Export, porträtiert Agarwal die auf wenige Orte beschränkten und zergliederten Manufakturen ohne jegliches Pathos und mit einem Engagement, das auch die großen Fotografen der „Farm Security Administration"-Ära (Walker Evans, Dorothea Lange, Arthur Rothstein) in den USA der zwanziger und dreißiger Jahre auszeichnete.

1996 gründete Agarwal seine eigene Organisation, Toxics Link, ein von der Gemeinde betriebenes Informationsnetzwerk, das sich speziell mit dem Sammeln und Verbreiten wissenschaftlicher Daten zu Fragen des städtischen Müllmanagements befasst. Indem Agarwals Fotografien seine fotojournalistische Praxis in den erweiterten Kontext seiner Tätigkeit als Umweltschutzaktivist rücken, wenden sie sich an ein Publikum außerhalb Indiens – vor dem Hintergrund zunehmender ökologischer Probleme durch die Verflechtungen des international boomenden Giftmüllhandels und seiner Gewinnerzielungsstrategien.

Ravi Agarwal's pivotal photojournalistic enterprise takes us deep down into the daily routine of India's landpoor and landless workers of South Gujarat. Through his unique photographic dissection we are confronted with an extremely heterogeneous informal sector of "pre-industrial" workers laboring in cramped manufactors, within households, slums, under open sky, on streets, in fields, quarries, riverbeds, and on the move. Agarwal's sensual series of untitled photographs (published in excerpts in *Down and Out: Labouring under Global Capitalism,* 2000) addresses the dehumanizing aspect of the laboring poor without falling into the dichotomy of the heroized and the victimized proletarian worker.

South Gujarat, a zone along the West coast of India— with its capital city Surat experiencing the highest population growth rates since independence in 1947—has become a training ground for World Bank and IMF loans and diverse structural adjustment policies. The region hosts a legally unprotected stratum of low-wage urban and suburban agroindustrial workers as domestic servants, stone and cane cutters, ragpickers, brickmakers, diggers and builders, sex workers, tradesmen, cobblers, craftsmen, and food vendors in the service sector, and in the mostly home-based jari (artificial silk) industry. These workers, excluded from citizenship and the hypermobility of capital, debilitated by occupational multiplicity and cyclical mobility, build and support the economy but are not granted access to the accumulated wealth. Under the pervasive impact of a failed industrialization in the style of Western countries, the corrupt politics and policies of land use—money which has no legal standing (kalu be) accounts for two thirds of the economy's cash flow —and globalization's segregation between goods for national production and those for exported consumption, Agarwal portrays the localized and fragmented manufactories without pathos and with the same strong sense of agency that the great photographers of the Farm Security Administration era (Walker Evans, Dorothea Lange, Arthur Rothstein) had shown in the U.S. in the 1920s and 1930s.

In 1996, Agarwal founded his own organization Toxics Link, a community-driven information exchange network specializing in collecting and disseminating scientific information on issues of urban waste management. Situating his photojournalistic practice within the larger context of his profession as an activist for environmental justice, Agarwal uses his work to address a non-Indian audience, setting out from the premise of an increasing interconnectedness of ecological problems, such as is shown in the case of the unequal profit-making strategies of India's internationally booming toxic waste trade. N. R.

Slum Dwellers in Front of Skyscraper, Gujarat, India | Bewohner eines Elendsviertels mit Hochhäusern im Hintergrund, Gujarat, Indien, 1999
Color-print on archival paper | Farbfotografie auf Archivpapier, 40 x 60 cm

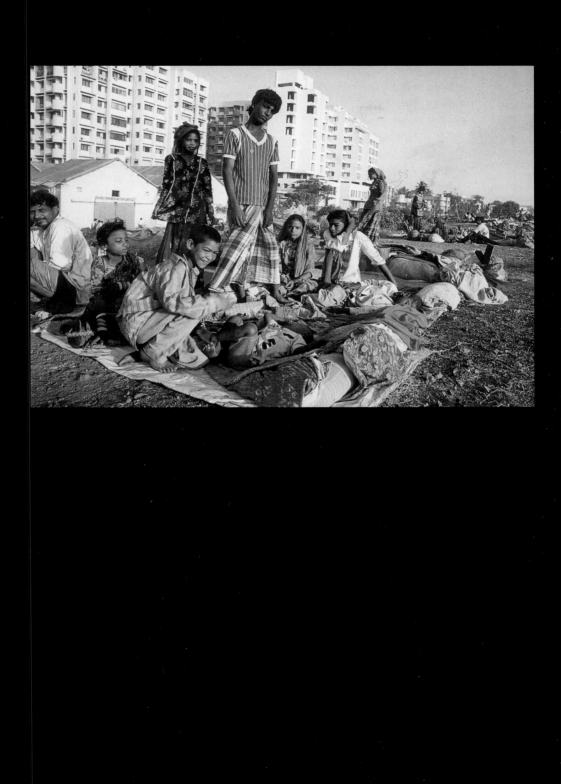

EIJA-LIISA AHTILA

*1959 in Hämeenlinna, Finnland/Finland. Lebt/Lives in Helsinki.

Die Filme und Videoinstallationen Eija-Liisa Ahtilas spielen mit Genres wie Spiel- und Dokumentarfilm, Musikvideo und Werbespot. Bei der Präsentation ihrer audiovisuellen Erzählungen legt sich die Künstlerin nicht auf eine Form fest, sondern zeigt ihre Arbeiten sowohl als Mehrfachprojektionen im Kunstkontext als auch als autonome Filme im Kino oder Fernsehen. Fern der Ironie formalistischer Medienreflexivität untersucht sie die Möglichkeiten, Wahrnehmung und Abbildbarkeit von Wirklichkeit erzählerisch zu durchdringen.

Ahtilas Geschichten handeln vielfach von Grenzsituationen. Immer ein wenig rätselhaft, mit Witz und sensibel beobachtet, werden Erlebnisse und Erfahrungen des Übergangs geschildert: Mädchen auf der Schwelle zum Erwachsenwerden, die ihre körperliche Selbstwahrnehmung beschreiben (*If 6 Was 9*, 1995), ein junges Paar im Prozess seiner Trennung (*Consolation Service*, 1999), Wissenschaftlerinnen, die die Ausmaße einer nuklearen Katastrophe zu begreifen versuchen (*Gray*, 1993).

Ahtilas Figuren werden in ihrem sozialen Umfeld – im Basketball-Team, in der Clique oder der Familie – gezeigt. Sie stellen sich Fragen der Selbst- und Identitätsfindung, äußern in kurzen, deskriptiven Sätzen ihre Ängste, Wünsche und Vorstellungen von Erfüllung, Nähe und Distanz. Um Eindrücke subjektiver Wahrnehmung entstehen zu lassen, greift die Künstlerin, die seit Ende der achtziger Jahre mit zeitbasierten visuellen Medien arbeitet, auf diskontinuierliche Erzählstrategien zurück. Manchmal gliedern Wiederholungen den Sprachrhythmus, es entstehen Überlagerungen, und am Ende der performativen Monologe haben die Protagonisten scheinbar unbemerkt Zeit und Raum gewechselt.

Die Grundlage für Ahtilas Erzählungen bilden Dokumentationen und Recherchen. So basiert etwa die szenische Videoinstallation *Anne, Aki & God* (1998) auf Aufzeichnungen von Gesprächen des schizophrenen Aki mit seinem Therapeuten, und den Drehbucharbeiten für *If 6 Was 9* gingen Interviews und Diskussionen mit Jugendlichen voraus. Doch selbst wenn die Umsetzung des Stoffes einer quasidokumentarischen Form folgt, dienen die empirischen Daten immer nur als konzeptuelle Ausgangsbasis und Dialogmaterial für Ahtilas Fiktionen.

The House (2002) ist die Geschichte einer Frau, die Stimmen zu hören beginnt, welche immer stärker ihre Wahrnehmung beeinträchtigen und die Zeit und den Raum um sie herum durchdringen. Um den Stimmen näher zu kommen, begibt sich die Protagonistin in einen Zustand der Isolation. *The House* basiert auf Gesprächen mit Frauen, die eine Psychose überwunden haben. Berichte vom Verlust kohärenter Raum- und Zeiterfahrung bis zum Zusammenbruch der Logik der Wahrnehmung finden in Ahtilas diskontinuierlichem Erzählmodus ihre formale Entsprechung.

Jenseits der Klischees von vermeintlich nordischen Themen wie Licht, Melancholie und Wahnsinn relativiert Ahtila bestehende Konzepte von Normalität und Abweichung und beschreibt einfühlsam die „Wahrheit" vergangener Gefühle.

Eija-Liisa Ahtila's films and video installations play with genres such as feature and documentary films, music videos, and commercials. In staging her audiovisual narrations, the artist does not limit herself to one form of presentation, but shows her works both as multiple projections within an art context and as autonomous films in the theater and on television. Far from the irony of formalistic reflexivity toward the media, she examines the possibilities of penetrating perception and the reproducibility of reality through narrative.

Ahtila's stories often deal with borderline situations, observing them with humor and sensitivity. Her work is always slightly enigmatic. She frequently describes experiences of transition: girls on the threshold of adulthood recount their physical self-awareness (*If 6 Was 9*, 1995); a young couple is followed through the process of separation (*Consolation Service*, 1999); and scientists attempt to comprehend the extent of a nuclear catastrophe (*Gray*, 1993). Ahtila's figures are characterized within their social surroundings—on the basketball team, in the clique, or in the family—and confront questions about self-discovery and identity. In short descriptive sentences they express their fears, desires, and ideas about fulfillment, closeness, and distance. The artist, who has worked with time-based visual media since the end of the 1980s, draws upon discontinuous narrative strategies to give the impression of subjective perception. Repetitions sometimes subdivide the rhythm of speech, overlapping occurs and, at the end of the monologue, the protagonists have apparently moved unnoticed into another time and place.

Documentations and research form the basis for Ahtila's narratives. For instance, the multi-sequence video installation *Anne, Aki & God* (1998) is based on recordings of conversations between schizophrenic Aki and his therapist, and the script work for *If 6 Was 9* followed interviews and discussions with youths. But even if the translation of the material follows a quasi-documentary format, the empirical data only serve as a conceptual starting point and dialogue material for Ahtila's fiction.

The House (2002) is the story of a woman who begins to hear voices. They increasingly interfere with her perception, pervading the time and space she lives in. In order to get closer to the voices, the protagonist isolates herself more and more. *The House* (2002) is based on conversations with women who have overcome a psychosis. Accounts of experiences ranging from losing a coherent sense of space and time to a breakdown of perceptive logic find their formal equivalent in Ahtila's discontinuous narrative style.

Moving beyond long-established clichés of supposedly Nordic themes like light, melancholy, and insanity, Ahtila qualifies prevailing concepts of normality and divergence and sensitively tells the "truth" about past feelings. T. M.

The House | *Das Haus*, 2002
Production still: three-screen DVD projection, color, sound, 14 min. | Produktionsfoto: DVD-Projektion auf drei Leinwände, Farbe, Ton, 14 Min.

CHANTAL AKERMAN

*1950 in Brüssel/Brussels, Belgien/Belgium. Lebt/Lives in Paris.

Chantal Akermans Filme aus den siebziger und achtziger Jahren leisteten einen bedeutenden Beitrag zu einem „neuen Frauenkino" und zur feministischen Filmtheorie. Unter dem Einfluss der Arbeit von Michael Snow konzentrierte sich Akerman auf die Entwicklung einer strengen, prozessorientierten Avantgarde-Ästhetik. Sie selbst beschreibt Snows Filme als Werke „ohne Handlung und Emotionen", die sich „ausschließlich mit der Filmsprache [beschäftigen] ... Sie sind Sprache in ihrer Reinform, ohne die Möglichkeiten der Identifizierung." In ihren eigenen Filmen kombiniert Akerman einen radikal feministischen narrativen Inhalt mit der Hinterfragung verschiedener Vortragsformen.

Einige von Akermans frühen Arbeiten sind in New York entstanden, wo die Regisseurin eine minimalistische Ästhetik entwickelte, um den architektonischen (*Hotel Monterey,* 1972) und urbanen (*News From Home,* 1976) Raum zu erkunden. Der Raum außerhalb der Leinwand wurde durch einen atmosphärischen, quasi autobiografischen Kommentar verstärkt. In ihrem ersten abendfüllenden Film *Je tu il elle* (Ich Du Er Sie, 1974) untersuchte Akerman die ungewisse Beschaffenheit sexueller Identität und Begierde und knüpfte damit an eine Arbeit aus ihrer Studienzeit an, den Kurzfilm *Saute ma ville* (Sprenge meine Stadt, 1968), der die Anomie und den Suizid eines jungen Mädchens zum Thema hat.

In einigen ihrer jüngeren Installationsprojekte greift die Filmemacherin einzelne Elemente aus ihren Spielfilmen wieder auf. Für die Arbeit *D'Est: au bord de la fiction* (Vom Osten: An Fiktion grenzend, 1995) nimmt sie Szenen aus ihrem Dokumentarepos über eine Winterreise durch die frühere Sowjetunion (*D'Est,* Vom Osten, 1993) und lässt sie gleichzeitig ablaufen – sie syntagmatisiert gewissermaßen das Paradigma.

In *Woman Sitting After Killing* (2001), ihrem Projekt für die Biennale in Venedig 2001, verwendet Akerman die Schluss-Szene ihres radikal-feministischen Kunstfilms *Jeanne Dielman, 23, quai du commerce, 1080 Bruxelles* (1975). Zentrum der Installation ist eine Szene, in der die Protagonistin – eine Frau aus bürgerlichen Verhältnissen (gespielt von Delphine Seyrig), die sich nebenbei als Prostituierte verdingt – am Küchentisch sitzt und tief Luft holt, kurz nachdem sie einen ihrer Freier umgebracht hat. Ein Fragment einer Einstellung wird wiederholt – eine einzelne Geste, die metonymisch die Kernaussage des Films hervorruft.

Formal gesehen versucht Akerman in ihren Installationen, Elemente aus früheren filmischen Arbeiten zu übertragen und neu zu artikulieren, wobei sie den Schwerpunkt ihrer Untersuchung von feministischen Themen auf die Bedingungen des Betrachtens verlagert.

From the Other Side, Akermans Projekt für die Documenta11, spielt in der Grenzregion zwischen Mexiko und den USA und beschäftigt sich mit dem Elend der unzähligen Menschen, die dort versuchen, nach Nordamerika zu immigrieren. Sogar nachts spüren die Grenzpatrouillen die Flüchtlinge mit Infrarotgeräten auf, viele werden von ortsansässigen Ranchern in improvisierte Konzentrationslager gepfercht. Akerman plant, den Film zeitgleich in New Mexico und in Kassel vorzuführen und damit eine technische Direktverbindung zu einem politischen Brennpunkt herzustellen.

Chantal Akerman's films in the 1970s and 1980s made a major contribution to a "new women's cinema" and feminist film theory. In her insistence on developing a rigorous avantgarde procedural aesthetic, Akerman was particularly influenced by the work of Michael Snow. She has described his films as working "exclusively on the language of cinema without any story or sentiment.... It is language itself without the possibilities of identification." Her films combine a radical feminist narrative content with the questioning of modes of address.

Some of Akerman's early films were made in New York, where she developed a minimalist aesthetic exploring architectural (*Hotel Monterey,* 1972) and urban space (*News From Home,* 1976), with an evocative quasi-autobiographical voice-over, which amplifies the off-screen space. Her first feature-length film, *Je tu il elle* (I You He She, 1974), continues her exploration of the uncertain constitution of sexual identity and desire, which she began with her student short *Saute ma ville* (Blow Up My City, 1968), about the anomie and suicide of a teenage girl.

Recent installation projects have involved a reworking of elements of her feature films. Her installation *D'Est: au bord de la fiction* (From the East: Bordering on Fiction, 1995), extracted sequences from her epic film documentary of a road journey eastward through the former Soviet Union in dead of winter (*D'Est,* From the East, 1993), and presented them simultaneously on multiple screens—syntagmatizing the paradigm.

Her recent project for the 2001 Venice Biennale, *Woman Sitting After Killing* (2001), utilizes the final scene of her radical feminist art feature *Jeanne Dielman, 23, quai du commerce, 1080 Bruxelles* (1975). The installation focuses on a scene in which the protagonist—a bourgeois woman who is also a prostitute played by Delphine Seyrig—sits at the kitchen table, taking a deep breath after murdering a client. A fragment of a single shot is repeated—a single gesture metonymically evoking the whole of the film.

At a formal level, Akerman's installations grapple with the need to translate and rearticulate some elements of a pre-existing cinematic work, shifting the focus of her inquiry from feminist issues to the conditions of spectatorship.

From the Other Side, her project for Documenta11, is shot in the US-Mexican border region and concerns the plight of the many thousands who attempt to migrate northwards, and who, even at night, are hunted down by the Border Patrol with infrared sensing devices or are incarcerated by local ranchers in improvised concentration camps. Akerman plans to present the film simultaneously in New Mexico and Kassel, providing a technological direct link to a pressing political issue. M. N.

From the Other Side I *Von der anderen Seite,* 2002
Video installation for eighteen monitors and two screens, real time video broadcast, super16 and video transferred to DVD I Video-Installation (Super16 und Video auf DVD) für 18 Monitore und 2 Leinwände, Echtzeit-Videoübertragung

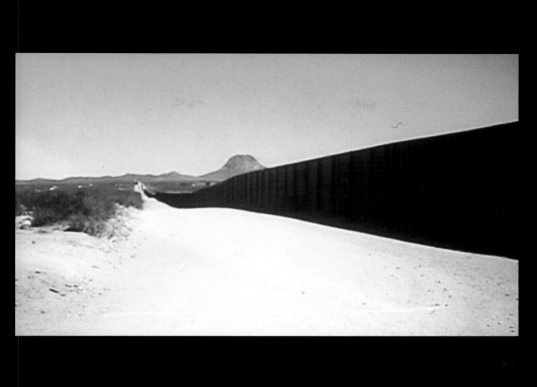

GASTON A. ANCELOVICI
(COLECTIVO CINE OJO)

*1945 in Santiago de Chile. Lebt/Lives in Santiago de Chile.

Gaston Ancelovici gehört zu einer Generation von Dokumentarfilmern in Chile, die nach dem Sturz von Salvador Allende durch General Augusto Pinochet 1973 das Land verließen. Als Mitglied der Gruppe Colectivo Cine Ojo war er im Exil unter anderem an deren erster gemeinsamer Dokumentation beteiligt. *Chile, no te invoco tu nombre en vano* (Chile, ich rufe deinen Namen nicht vergeblich, 1983) zeigte die Situation in Chile zehn Jahre nach dem Putsch, als es für kurze Zeit die Hoffnung auf ein „Tauwetter" gab. Öffentliche Demonstrationen in der Stadt ließen auf die Möglichkeit eines organisierten politischen Protests hoffen. „Es war das erste Mal in zehn Jahren, dass man hunderttausend Menschen die Straße hinuntermarschieren sah … Die Reaktion der chilenischen Regierung war sehr brutal. Tausende von Menschen wurden verhaftet und gefoltert." (Cine Ojo)

Drei Jahre später kehrte Ancelovici für *Memorias de Una Guerra Cotidiana* (Memoiren eines alltäglichen Krieges, 1986) nach Chile zurück, um die veränderte Situation aufzuzeichnen. Der Film beschreibt den täglichen Kampf der Zivilbevölkerung gegen die Maßnahmen der Polizei und des Militärs, die mit Inhaftierungen, Folter und Exekutionen auf den demokratischen Protest reagierten. Er verdeutlicht anhand individueller Geschichten, dass dieser Terror nicht gegen bestimmte politische Gegner, sondern die ganze Bevölkerung gerichtet war. Es werden ganz normale Menschen gezeigt – wie der Schauspieler Victor, dessen Sohn Jose Manuel Parada ermordet wurde, oder der Pfarrer Pierre, der in der Armensiedlung La Victoria Gemeindearbeit verrichtet und dessen Vorgänger in der Stube beim Bibelstudium erschossen wurde.

Auch die jüngeren Filme Ancelovicis bezeugen die Auseinandersetzung mit der Geschichte und der sozialen und politischen Situation in Chile, wohin der Filmemacher nach dem Sturz Pinochets zurückkehrte. Dazu gehören *Avante, Soldados de Cristo* (Vorwärts, Soldaten Christi, 1989), ein Film über die Auswirkungen der aggressiven evangelisch-protestantischen Missionierung im traditionell katholischen Lateinamerika, *Neruda en el Corazón* (Neruda im Herzen, 1997), ein Porträt des Nobelpreisträgers Pablo Neruda, sowie *Chacabuco, Memoria del Silencio* (Chacabuco, Erinnerungen des Schweigens, 2001). Ancelovici begleitet hier eine Gruppe früherer Häftlinge nach Chacabuco – ein Lager, in dem Tausende von Allendes Anhängern viele Monate gefangen gehalten worden waren und das sie 25 Jahre später in Begleitung ihrer Familien besuchen.

Gaston Ancelovici belongs to a generation of documentary filmmakers in Chile who left the country after General Augusto Pinochet's overthrow of Salvador Allende in 1973. He was a member of the Group Colectivo Cine Ojo, a collective working both in Chile and in exile on developing the documentary tradition. Their first documentary, *Chile, no te invoco tu nombre en vano* (Chile, I Don't Take Your Name in Vain, 1983), shows the situation in Chile ten years after the coup, when there was a brief prospect of a political thaw. The video shows demonstrations in the city that indicate the renewed hopes for organized political protest. "It was the first time in ten years that you saw a hundred thousand people marching down the street…. The reaction of the Chilean government was very violent. Thousands of people were arrested and tortured" (Cine Ojo).

Three years later, Ancelovici was able to return to Chile to make *Memorias de Una Guerra Cotidiana* (Memoirs of an Everyday War, 1986), again documenting a new situation. The film describes the daily struggle of the civilian population against the police and the military, who reacted to the democratic protests with imprisonment, torture, and executions. By telling the stories of individuals, Ancelovici makes it clear that this struggle is not directed at particular political opponents, but at the entire population. He portrays ordinary people—such as Victor, an actor whose son, Jose Manuel Parada, was murdered, or the priest Pierre who performs community work in the poor district La Victoria and whose predecessor was shot in the reading room while studying the Bible.

Ancelovici's more recent films also examine the history and social and political conditions of Chile, where the filmmaker returned after Pinochet was deposed. Among these are *Avante, Soldados de Cristo* (Onward, Christian Soldiers, 1989), a film about the effects of aggressive Protestant missionary work in traditionally Catholic Latin America; *Neruda en el Corazón* (Neruda in the Heart, 1997), a moving portrait of the Noble Prize winner Pablo Neruda based partly on archive material; and *Chacabuco, Memoria del Silencio* (Chacabuco, Memories of Silence, 2001), in which Ancelovici accompanies a group of former detainees and their families on a visit to Chacabuco—a camp where thousands of Allende's followers were held prisoner for many months 25 years before. C. R.

Memorias de Una Guerra Cotidiana | Memoirs of an Everyday War |
Memoiren eines alltäglichen Krieges, 1986
Film: 16mm, color, sound, 30 min. | 16-mm-Film, Farbe, Ton,
30 Min.

FAREED ARMALY

*1957 in Iowa, USA. Lebt/Lives in Stuttgart, Deutschland/Germany.

Seit Ende der achtziger Jahre arbeitet Fareed Armaly an komplexen Installationen, die sich auf den jeweiligen Ausstellungsort und seine Geschichte beziehen, oder einzelne Momente aus diesen Verflechtungen als Ausgangspunkt für neue Netzwerke der Erkenntnis verwenden. Sie sind das Resultat intensiver Forschung und beginnen oft mit einer Frage, die aus den architektonischen Gegebenheiten entstand.

Für seine Ausstellung BREA-KD-OWN (1993) im Palais für Schöne Künste in Brüssel sind zwei Räume des Hauses Ausgangspunkt von Armalys Arbeit. Zum einen ist das die zentrale Rotunde des 1928 gebauten Museums, die in ihrer Symmetrie und Ordnung den Idealraum der klassizistischen Ideen beruhte, darstellt. Zum anderen ist es der zentrale Ausstellungssaal, der 1972 mit Hilfe moderner, frei tragender „Space-Frame"-Konstruktionen – als eine Übersetzung von Ideen der 68er-Bewegung – zu einem öffentlichen Vortrags- und Versammlungsraum umgestaltet wurde. Die Begriffe von „öffentlichem Raum" und „offener", erweiterbarer, frei kombinierbarer Architektur, wie sie die Space-Frame-Technik impliziert, stellt Armaly der klassizistischen Idee der ursprünglichen Museumsarchitektur gegenüber, die sich auch von der damals zeitgemäßen Moderne des internationalen Stils und des Bauhauses absetzte. Eine ebensolche Vorgehensweise markiert auch die Arbeit PARTS (1997) im Kunstverein München: Eine aus Pappe nachgebaute barocke Arkade der Münchener Residenz, in der der Kunstverein untergebracht ist, kontrastiert mit der Architektur des Kunstvereins – die nach dem Krieg eingebaut und in den achtziger Jahren umgebaut wurde – und wird um Elemente vom Dach des 1972 entstandenen Münchner Olympiastadions erweitert. Für Armaly geht es darum, die jeweiligen Architekturstile in Korrespondenz zu den Gesellschaftsentwürfen ihrer Zeit zu zeigen.

In der Arbeit From/To (1999), die erstmals in Rotterdam präsentiert wurde und in neuer Form auf der Documenta11 zu sehen ist, thematisiert Armaly – Amerikaner libanesischpalästinensischer Abstammung – die Geschichte Palästinas. Er digitalisiert die Oberfläche eines Steines – den er als Sinnbild für die Welt an sich, aber auch für Architektur und für Waffen versteht – und projiziert dessen Konstruktionsraster als schematische Landkarte der palästinensischen Gebiete auf den Fussboden. In Zusammenarbeit mit Rashid Masharawi – einem palästinensischen Filmemacher, der 1962 im Flüchtlingslager Shati geboren und dort aufgewachsen ist und heute in Ramallah lebt – und seinem Cinema Production Center zeichnet Armaly darüber hinaus ein materialreiches Porträt des Landes und seiner Gegenwart. War der Charakter der Arbeit 1999 noch vom Friedensprozess geprägt, stellt der Kontext der aktuellen Krise die Arbeit unter neue Vorzeichen.

Since the end of the 1980s, Fareed Armaly has been working on complex installations that refer to exhibition sites and their histories, or use one aspect of these as a starting point for new networks of knowledge. His works are the result of intensive research and often begin with a question that arose from the architectural setting.

For his exhibition BREA-KD-OWN (1993) in the Palace of Fine Arts in Brussels, Armaly makes two rooms the starting point of his work. The first is the central rotunda of the museum, which was built in 1928 and whose symmetry and order constitute ideal space in the sense of classical architecture. The other is the central exhibition hall, which was remodeled in 1972 into a public lecture and assembly room with the help of modern, freely supporting "space-frame" constructions—implementing ideas from the 1960s. Armaly confronts the terms "public space" and "open," expandable, freely combinable architecture—as implied by the space-frame technique—with the classical idea at the root of the original museum architecture, which itself had represented a conscious distance from Bauhaus and the International Style that was modern in the 1920s. The work PARTS (1997) in the Munich Kunstverein is characterized by the same procedure. A cardboard replica of a Baroque arcade taken from the Munich Residence, which houses the Kunstverein, is contrasted with the architecture of the Kunstverein, which was installed after the war and renovated in the 1980s. This is in turn augmented by elements from the roof of Munich's Olympic stadium, which was built in 1972. Armaly is interested in showing these various architectural styles in relation to the social conditions of their time.

An American of Lebanese-Palestinian descent, Armaly takes the history of Palestine as the subject for his work From/To (1999), first presented in Rotterdam and currently being shown in its new form at Documenta11. He digitalizes the surface of a stone, which he sees as a symbol for the world, for architecture, and for weapons, and then projects the pattern created as a schematic map of Palestinian territories onto the floor. In collaboration with Rashid Masharawi —a Palestinian filmmaker born and raised in the refugee camp Shati in 1962 and presently living in Ramallah—and his Cinema Production Center, Armaly draws from a wealth of material to create a portrait of the country and its present situation. In 1999 the work's character was influenced by the peace process. Within the context of the current crisis, however, this work takes on a new significance. C.R.

From/To I Von/Nach, 2002
Detail: Digitized stone, model for installation at documenta exhibition hall/Documenta11 I Detail: digitalisierter Stein, Modell für die Installation in der documenta-Halle/Documenta11

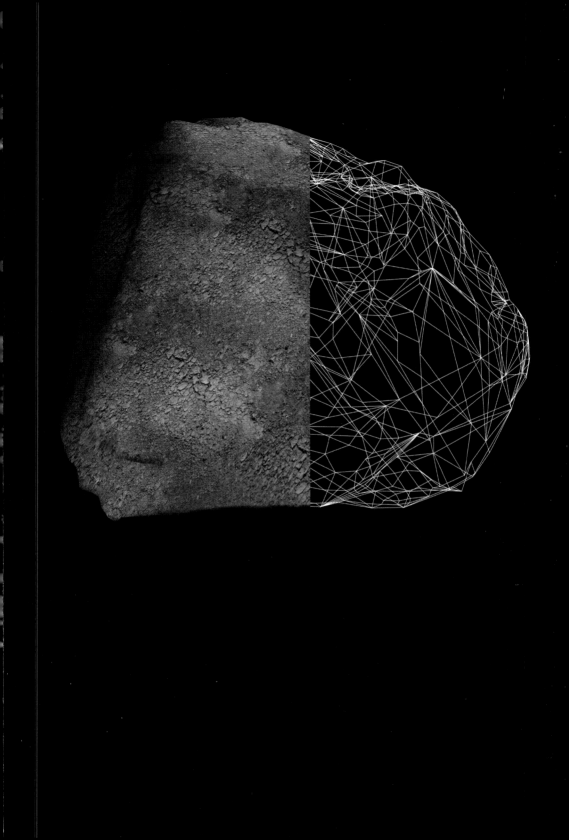

MICHAEL ASHKIN

*1955 in Morristown, NJ, USA. Lebt/Lives in New York.

Michael Ashkin ist – wie andere Fotografen und Videofilmer Mitte der neunziger Jahre auch – fasziniert von transnationalen „Nicht-Orten": von Flughäfen und Highways, die die eigentlichen Schauplätze einer globalisierten Wirtschaft sind, bar jeder lokalen Besonderheit oder sozialen Organizität. Die Arbeit *Untitled (New Jersey Meadowlands Project)* (2001/ 02) vermisst den „Gartenstaat" New Jersey auf mehr als 100 kleinen rechteckigen Schwarz-Weiß-Fotografien – nicht als Heimstatt von Gemeinwesen und Alltagsleben, sondern als Raum einer solitären „Schrumpfung". Verlassene, grasbewachsene Parkplätze, abgezäunte Hinterhöfe längst geschlossener Fabriken und stillgelegte Bahngleise – unweit des Flughafens, entlang der Autobahn gelegen – kurz, die Ruinen einer zerfallenen Industrielandschaft stehen im Kontrast zum weiten Horizont und zu den zurückerobernden Kräften der Natur. Ashkin arrangiert seine atmosphärisch weichen, grauen Fotografien in dichten, relationalen Gitterstrukturen von periodisch wiederkehrenden Bildern, welche den einzigen Blickwinkel moderner bürgerlicher Vorstellung in eine Vielzahl von Wahrnehmungen auflösen. Der Künstler spielt mit geläufigen perzeptiven Erwartungshaltungen, die auf einem Foto stets nur einen semiotisch kodierten Ort suchen. Narrative und ikonografische Lesarten bleiben virulent, obwohl ihn vor allem die Transformationen des Raumes durch den Kapitalismus beschäftigen.

Ashkins Fotografien vom industriellen Amerika sind erfüllt von der Unzugänglichkeit und seltsamen Anziehungskraft banaler Alltagssituationen jenseits von Bedeutung und Ereignis. In *Proof Range,* einem „ereignislosen", meditativen Farbvideo, das 1999 in Sandy Hook, New Jersey, entstanden ist, fährt Ashkin mit der Handkamera langsam durch eine trostlose, verlassene Steinlandschaft. Nach und nach zieht diese Arbeit alle Sinne des Betrachters durch das Gefühl in Bann, die Zeit verwandele dieses verlassene Industriegelände in einen uralten mythischen, sagenumwobenen Ort.

Der entropische Charakter des fotografischen Werkes – zwischen pittoresker Naturbeschwörung und Darstellung der Natur als eine Kultur und Industrie allmählich vernichtende Kraft – steht dem ökologischen Interesse kreativ gegenüber, das seine Bilder skulpturaler Einöden aus den neunziger Jahren prägte. In *No. 49* (1997), eines von zahlreichen weitläufigen Miniatur-Tischdioramen, markieren zwei Masten, verbunden mit garnähnlichen Stromkabeln, die entlang einer alten Eisenbahnlinie verlaufen, einen von melancholischem postindustriellen Pessimismus geprägten „Nicht-Ort". Auf den Spuren der Earthworks und Robert Smithsons re-definiert Ashkin Landschaft als soziale und allegorische Bühne für ein Schauspiel, das noch stattzufinden hat oder das sich bereits vor langer Zeit ereignete.

Michael Ashkin belongs to a generation of photographers and videomakers from the mid 1990s fascinated by transnational non-places such as airports and highways that portray actual sites of a global economy detached from any local particularity or social organicity. The Garden State of New Jersey serves as the protagonist in *Untitled (New Jersey Meadowlands Project)* (2001/02), featured in over 100 small rectangular black and white photographs not as a site of community and daily life, but as a space of solitary contractuality. Close by the airport, just off the New Jersey Turnpike, deserted and overgrown parking lots, fenced-off backyards of long since evacuated factory buildings, obsolete railroad tracks, and the ruins of industrial wasteland are set against the invisible horizon and the recuperative forces of nature. Ashkin arranges his soft, grayish photographs in a dense relational grid-structure of recurring images that, repeating each other in a flow of endless recurrence, relegate modern, bourgeois visions of a unison viewpoint into a multiplicity of perceptions. Playing with perceptual habits of always expecting a semiotically encoded place in a photograph, narrative and iconographic readings remain resilient in favor of a general concern with capitalism's large-scale spatial transformations.

In his photographs of industrial America, Ashkin indulges in the utter inaccessibility and the odd attraction of commonplaces, programmatically refuting the contemporary excess of meaning and events. In *Proof Range,* a silent, meditational videowork in color, shot in 1999 in Sandy Hook, New Jersey, a hand held camera zooms slowly into a desolate and abandoned area of accumulated stones. The viewer's attention is gradually captivated by an overabundant sensory perception of time transforming an obsolescent industrial site into an ancient place of myth and legend.

Pulsating between a picturesque evocation of nature and its gradual annihilation of culture and industry, the entropic character of the photographic work is set as a creative force against the ecological interest of his earlier sculptural wastelands from the mid 1990s. In *No. 49* (1997), one of a series of many strikingly vast miniature tabletop dioramas, two poles with thread-like power lines running parallel to an old railroad create a non-site of melancholic postindustrial pessimism. In the wake of Earthworks and Robert Smithson, Ashkin redefines landscape as a social and allegorical space ready for a spectacle that is still to come or one that has already occurred long ago. N. R.

Untitled (New Jersey Meadowlands Project) | *Ohne Titel (New Jersey Meadowlands Projekt),* 2001/02
Detail: 112 Gelatin silver prints | Detail: 112 Silbergelatine Abzüge, each | je 10 x 25,5 cm

ASYMPTOTE
LISE-ANNE COUTURE, HANI RASHID

Die Wechselwirkung zwischen virtuellem und realem Raum, die Frage nach der Flexibilität der Parameter, welche die Grenze zwischen beiden Bereichen markieren, die Bewegung des Körpers durch die von Datenflüssen geprägten Räume sowie das Experimentieren mit und Ausweiten von traditionellen Arbeitsgebieten der Architektur bilden den Hintergrund für die Arbeit des Architekturbüros Asymptote. Die Projekte umfassen sowohl konkrete Bauaufträge als auch experimentelle Installationen (*FluxSpace 3.0*, 2002), computergenerierte virtuelle Environments (*Virtual New York Stock Exchange*, 1998) oder Internet- und Designprojekte (*A3*, eine mobile Büroeinheit für Knoll International, 2002). Asymptotes Architektur ist vielmehr Studie als Manifest, ein „aktiver" Part in einer permanenten Interaktion zwischen virtuellem und realem Raum. Sie formt sich kontinuierlich verändernde Räume und erhält ihre Impulse maßgeblich durch die Bewegung und Aktionen seiner BenutzerInnen.

International Aufsehen erregten Asymptote bereits 1989 mit dem Vorschlag für das *Los Angeles West Coast Gateway*, einem nationalen Denkmal für Immigration. Die „stählerne Wolke" (*Steel Cloud*), mit der sie den Wettbewerb gewannen, bildet eine über einer Autobahn schwebende langgestreckte Konstruktion, die einerseits auf Yona Friedmans *La ville spatiale* (Die Raumstadt) und seiner Idee der in den Himmel wachsenden Stadt zurückgreift und andererseits auf Constants situationistischen Stadtentwurf, das mäandernde *New Babylon*, verweist. Das Bild der Wolke – die sich als solche durch ein permanentes Wechselspiel ihrer Konsistenz auszeichnet – ist sicherlich auch für die jüngsten Projekte von Asymptote paradigmatisch.

Ihr Projekt für die Documenta11, *FluxSpace 3.0/-Mscapes*, bildet den dritten Teil in einer Folge, die im Jahr 2000 am California College of Arts and Crafts in San Francisco begonnen wurde. *FluxSpace 1.0* ist eine interaktive Architektur, ein Objekt im ständigen Oszillieren zwischen virtuellem und realem Dasein, das auf Körper und Berührung in Form morphologischer, aber auch akustischer Veränderungen reagiert. *FluxSpace 2.0* hingegen, das 2000 anlässlich der Architektur-Biennale in Venedig entstand, formt eine nomadische Struktur, die mit der Dialektik ihrer äußeren physischen Präsenz auf der einen Seite und ihrer inneren, virtuellen Gegenwart auf der anderen Seite spielt. Von außen ist *FluxSpace 2.0* eine Zeltdachkonstruktion, im Inneren befindet sich ein fast intimer Bereich mit zwei rotierenden Spiegeln; sie sind mit Webkameras ausgestattet, die jede Veränderung im Raum aufzeichnen und diese Bilder in regelmäßigen Intervallen ins Internet stellen. Die Spiegel sind auf eine Weise beschichtet, die es ermöglicht, dass der Blick abwechselnd zurückgeworfen oder nach außen durchgelassen wird. Diese gegenseitige Durchdringung von Raum- und Blickperspektiven wird auch in dem auf der Documenta11 gezeigten Projekt *FluxSpace 3.0/Mscapes* sichtbar. Ein architektonisches Objekt reproduziert sich in einer verspiegelten Umgebung, geformt durch Datenstrom-Projektionen. *M(otion)scapes* (Bewegungsstudien) positionieren das Subjekt in einem mutierten Durchgangsraum, der Falten, Räume und Bereiche schafft, die ihm ein Hin- und Herpendeln zwischen körperlichem Ich und virtuellem Dasein erlauben.

The New York-based architectural office Asymptote is interested in the interplay between virtual and real space. In questioning the flexibility of the parameters between the two, and examining the different ways in which the human body moves through spaces molded by the flow of data, Asymptote experiments with and expands traditional fields of architecture. Recent projects include both actual buildings and experimental installations (*FluxSpace 3.0*, 2002), computer-generated virtual environments (*Virtual New York Stock Exchange*, 1998), or Internet and design projects (*A3*, a mobile office unit for Knoll International, 2002). Theirs is a kind of architecture that is more study than manifesto, an "active" part of a permanent interaction between virtual and real space. Spaces change continually and receive substantial impulses from the movement and action of their users.

Asymptote guined international public interest in 1989 with their proposal for the Los Angeles West Coast Gateway, a national monument to immigration. Their *Steel Cloud*, which won the competition, forms a long structure that floats over a freeway. The structure recalls Yona Friedman's *La ville spatiale* and his idea of a city that expands upward into the sky. Another reference is Constant's Situationist urban plan, the meandering *New Babylon*. The image of clouds that are characterized by a permanent interplay of form, is most certainly paradigmatic for the most recent Asymptote projects.

Asymptote's project for Documenta11, *FluxSpace 3.0/ Mscapes*, is the third in a series begun in 2000 at the California College of Arts and Crafts, in the San Francisco Bay Area. *FluxSpace 1.0* is interactive architecture, an object constantly oscillating between virtual and real existence, which reacts to bodies and touch with morphological as well as acoustic changes. *FluxSpace 2.0*, created in 2000 for the architecture Biennial in Venice, is a nomadic structure that plays with the dialectic between its external, physical presence and its internal, virtual one. Resembling a tent construction on the outside, the inside of *FluxSpace 2.0* is an almost intimate area with two rotating mirrors equipped with web cameras, so that each change in the space is recorded. Photos are shown on the Internet at regular intervals. The mirror coating allows the gaze to be alternately reflected and pass through to the outside. This reciprocal penetration of space and gaze is visible in *FluxSpace 3.0/Mscapes*, the project presented at Documenta11. An architectural object is reproduced in mirrored surroundings, which are shaped by projections of data streams. *M(otion)scapes* present the subject in a mutated hallway, which creates folds, spaces, and areas that make it possible to commute back and forth between the physical self and virtual existence. H.A.

FluxSpace 2.0, 2000
Installation view I Installationsansicht, 7ᵃ Mostra Internazionale d'Architettura, La Biennale di Venezia, Venice I Venedig, 2000

KUTLUG ATAMAN

***1962 in Istanbul, Türkei/Turkey. Lebt/Lives in London.**

Kutlug Ataman ist Künstler, Dokumentar- und Spielfilmregisseur. Sein Spielfilm *Lola + Billyddikid* (1998) war der erste unabhängige türkische Film, der offen Homosexualität thematisierte. Der Film, der in Berlin mit dort lebenden türkischen und deutschen Schauspielern gedreht wurde, untersucht, auf welche unterschiedlichen Arten sich Außenseitertum in der gegenwärtigen Gesellschaft manifestiert, und präsentiert Charaktere, deren bewusst gewählte gesellschaftliche Außenseiterrolle eine auch problematische Freiheit bedeuten kann.

Atamans künstlerische Videos untergraben das Dokumentarformat nicht nur durch die Form der Installation, die wahlweise als Kinovorführung auf nur einer Leinwand oder als Mehrkanal-Videoinstallation realisierbar ist, sondern auch durch die Themenwahl und Länge. Sein fast achtstündiges Interview mit der 87-jährigen türkischen Diva Semiha Berksoy, *Semiha B Unplugged* (1997), ist ein „sturzbachartiger Monolog", in dem Berksoy die Höhepunkte ihrer Karriere von der Opernheroine bis zum befohlenen Auftritt vor dem damaligen Staatspräsidenten Kemal Atatürk, dem so genannten Modernisierer der Türkei, nachspielt. Während sie ihr Leben, ihre Liebschaften und ihre Karriere Revue passieren lässt, verwischen sich Realität und Fantasie sowohl für sie selbst wie auch für den Betrachter.

In anderen Videoarbeiten dokumentiert Ataman in offen und engagiert geführten Interviews, weshalb vier im heutigen Istanbul lebende Frauen Perücken tragen (*Women Who Wear Wigs*, 1999), oder fängt die persönliche Geschichte einer transsexuellen türkischen Prostituierten ein, die ihre turbulente Biografie als erotischen Fantasy-Film nachspielt (*Never My Soul*, 2001).

Seine Installation für die Documenta11, *The Four Seasons of Veronica Read* (2002), verzeichnet in ähnlicher, geradezu hysterischer Obsessivität chronologisch die vier Jahreszeiten des Rittersterns (Hippeastrum), einer Pflanze, die Ataman ebenso heiß verehrt wie Veronica Read selbst. Read kultiviert Großbritanniens umfassendste Sammlung dieser Zwiebelpflanzen, die in tropischen Wäldern genauso heimisch sind wie in Blumenregalen von Supermärkten. Ataman besucht den Mikrokosmos von Veronica Reads botanischem Garten in ihrem Westlondoner Vorstadtdomizil und verzeichnet hingerissen selbst das winzigste Detail, das für die Liebhaber dieser Pflanze bedeutend sein könnte.

Atamans formale Subversion liegt in der Art, wie er seine Interviewpartner dazu verführt, die intimsten Fantasien ihres Innenlebens zu verraten und zu inszenieren, die dann in fast unerträglicher Offenheit gezeigt werden. Die stundenlangen Interviews sind so zusammengeschnitten, dass das narrative Moment beinahe ständig von der unterbewusst mitspielenden Fantasie verdrängt wird. Brillant beweist Ataman in seiner Arbeit, dass Anderssein nicht nur in griffigen Bildern sexueller und rassenbedingter Differenzen zu finden ist, sondern auch in der Struktur menschlicher Sehnsüchte und Bedürfnisse.

Kutlug Ataman is an artist and filmmaker who works in documentary and fiction. His feature film *Lola + Billyddikid* (1998) was the first independent Turkish film to deal openly with homosexuality. Shot in Berlin with local Turkish and German actors, the film explores the multiple ways in which marginalization is rendered in contemporary society, through characters whose self-conscious societal marginalization begins to represent a kind of problematic freedom.

His art videos represent a subversion of the video documentary format, not only through the mode of installation, which can be shown both in single-channel theater screenings and multichannel installations, but also through choice of subject matter and length. His almost 8 hour interview of 87-year-old Turkish diva Semiha Berksoy, *Semiha B Unplugged* (1997), is a "torrential monologue" in which Berksoy acts out her major career triumphs from opera heroine to a command performance for President Atatürk, the modernizer of Turkey. As she goes through her life, her career, and her lovers, fantasy and reality are confused both for Berksoy and for the viewer.

In other video works, Ataman has documented in frank and engaging interviews the various reasons why four contemporary Istanbul women wear wigs (*Women Who Wear Wigs*, 1999), and has captured the personal story of a transsexual Turkish prostitute, who has chosen to act out her turbulent life as a kind of erotic fantasy movie (*Never My Soul*, 2001).

The Four Seasons of Veronica Read (2002), Ataman's installation for Documenta11, is similar in its hysterical obsessiveness, chronicling the four seasons of the Hippeastrum bulb of which both Ataman and Read are devotees. Read is the owner of the British national collection of the bulbs of this denizen of tropical forests and supermarket flower stands. Ataman visits the miniature botanical facility she has established in her West London suburban apartment and devotedly chronicles the smallest obsessive detail that is of interest to these plant lovers.

Ataman's formal subversion lies in the way he seduces his subjects into revealing and staging the innermost fantasies of their personal lives, which are then laid bare in almost unbearable frankness. The many hours of interview are assembled in such a way that their narrative drive is always on the verge of being submerged by the subconscious fantasy at play. In his work, Ataman brilliantly reveals that it is not only in the tropes of sexual and racial difference that otherness is to be found, but in the psychoanalytic structure of desire itself. M. N.

The Four Seasons of Veronica Read | *Die vier Jahreszeiten der Veronica Read*, 2002
Four screen video projection | Videoprojektion auf vier Leinwänden

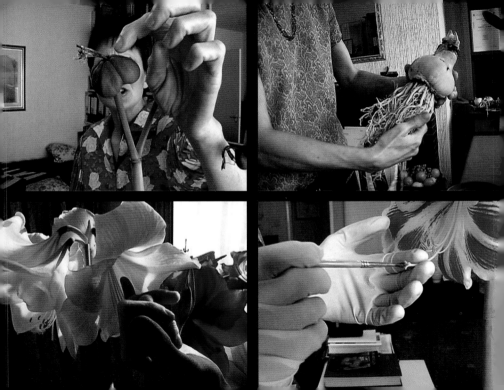

THE ATLAS GROUP

Gegründet/Founded 1999 von/by Walid Ra'ad (*1967 in Chbanieh, Libanon/Lebanon. Lebt/Lives in New York.)

Walid Ra'ad gründete die Atlas Group, eine imaginäre Stiftung, die libanesische Gegenwartsgeschichte erforscht und dokumentiert. Die Atlas Group tritt vor allem mit Vorlesungen, Filmen, Fotoausstellungen, Videos und unterschiedlichsten Dokumenten aus den gruppeneigenen Archiven an die Öffentlichkeit. In jüngerer Zeit wurden bestimmte Abteilungen der Archive verschiedentlich als Installationen im musealen Raum ausgestellt. Die Archive umfassen ein weites Spektrum von Materialien, darunter Notizbücher des libanesischen Historikers Fadl Fakhouri, Videos mit der Ex-Geisel Souheil Bachar und mit Zainab Hilwé, dem Opfer einer Autobombe, sowie eine Reihe anonymer Dokumente, wie die Fotoserie *Secrets in the Open Sea*. Die literarische Sorgfalt von Ra'ads Projekt wirkt präzise und klar, stellt man sie Jorge Luis Borges' imaginären Enzyklopädien und Fernando Pessoas Heteronymen gegenüber. Sein Ziel ist es, ein Archiv aufzubauen, dessen fiktionale Beschaffenheit die vermeintliche Objektivität historischer Diskurse in Frage stellt und gleichzeitig die angebliche Autonomie künstlerischer Arbeit demontiert. Dank der genauen, flüchtigen und einprägsamen Bilder, der eingestreuten Notizen und der knappen, aber dichten fragmentarischen Zeugnisse des Archivs erzeugen die Charaktere der Atlas Group einen emotional ergreifenden Raum, der auch die instrumentelle Logik in den historischen Diskurs einbezieht. Es geht hier eindeutig um das Evozieren der Substrate intimster Gefühle und Erfahrungen, das letztendlich das wahre Fundament jedes Archivs bildet. Die Schrecken der Bürgerkriege im Libanon – die sich über fast zwei Jahrzehnte, von 1975 bis 1991 hinzogen – hallen dumpf und allgegenwärtig in allen Diskursen und Bildern wider. Die Schrecken manifestieren sich zwar niemals sichtbar in einzelnen Archivmaterialien, artikulieren sich aber beharrlich im Projekt als Ganzem.

Die Documenta11 präsentiert einen Großteil der Atlas-Group-Archive so detailliert wie nur möglich. In diesem Gesamtzusammenhang wird Ra'ads Werk vielleicht in seiner ganzen Größe und Komplexität sichtbar – als Zeugnis der subjektiven Dimension historischer Erfahrung ebenso wie als Beleg des ethischen Anliegens, welches das Rückgrat allen künstlerischen Schaffens ist.

Walid Ra'ad founded the Atlas Group, an imaginary foundation whose objective is to research and document Lebanon's contemporary history. Ra'ad presents the Atlas Group primarily through lectures that include films, photography exhibitions, videos, and a variety of documents from the group's archives. More recently, certain sections of the archive have been the object of a number of installations in museum spaces. The Atlas Group's archives include a variety of different materials, among them notebooks belonging to the Lebanese historian Fadl Fakhouri, videos of the former hostage Souheil Bachar and of Zainab Hilwé, the victim of a car bombing, as well as a number of anonymous documents that include, for example, a series of photos entitled *Secrets in the Open Sea*. Alongside Jorge Luis Borges's imaginary encyclopedias and Fernando Pessoa's heteronyms, the careful literary dimension of Ra'ad's project is at once precise and evident. The aim is to compose an archive of a fictional nature that both criticizes the feigned objectivity of historical discourse and dismantles the supposed autonomy of artistic work. With their scattered notes, their precise, furtive, and pregnant images, with the succinct density of their fragmentary testimonies, the characters of the Atlas Group evoke a purely affective space that instrumental logic keeps sweeping into the discourse of history. Surely this is about evoking the substrata of intimate emotions and experiences that ultimately makes up the inexorable foundation of every archive. The horrors of the civil wars in Lebanon—prolonged over nearly two decades from 1975 to 1991—throb dully, omnipresent in each of the discourses and images, yet are never manifested as such in any of the various materials of the archive. Nevertheless they insistently articulate the project as a whole.

Documenta11 presents a large part of the archives of the Atlas Group in the greatest possible detail. Within this context, Ra'ad's work appears perhaps in all of its magnitude and complexity, a testimony to the subjective dimension of the historical experience and proof of the ethical concerns that are the backbone of all artistic work. C.B.

Notebook Volume 38. Already Been in a Lake of Fire | *Notizbuch Band 38. Schon in einem See aus Feuer gewesen,* 1999
Notebook, original pages 145, available pages 17 | Notizbuch, im Original 145 Seiten, 17 Seiten zugänglich, each | je 20,5 x 14 cm

JULIE BARGMANN (D.I.R.T. STUDIO)
STACY LEVY (SERE LTD.)

Julie Bargmann: *1958. Lebt/Lives in Charlottesville, VA, USA. Stacy Levy: *1960 in Philadelphia, PA, USA. Lebt/Lives in Spring Mills, PA.

In *Testing the Waters*, einem Gemeinschaftsprojekt der Landschaftsarchitektin Julie Bargmann und der Künstlerin Stacy Levy, geht es um die Regeneration eines Landschaftsgebiets, das mit sauren Minenwässern aus dem ehemaligen Kohlebergwerk Nr. 6 in Vintondale, Pennsylvania, verseucht ist. In Zusammenarbeit mit Wissenschaftlern, Historikern, Architekten und den örtlichen Behörden haben Bargmann und Levy verseuchtes Brachland, dem bis dahin sowohl ein ökologischer Status als auch eine historische Identität abgesprochen wurden, neu belebt. Als das Kohlebergwerk von Vintondale in den frühen sechziger Jahren stillgelegt wurde, ließ man die Koksöfen einfach in dem überschwemmten Gebiet stehen, wo sie allmählich zerfielen und dabei die Umwelt mit Abraum und Minenwässern belasteten, die in den nahe gelegenen Blacklick Creek flossen.

Im Jahr 1995 wurde *Testing the Waters* mit dem Ziel ins Leben gerufen, das Land nicht länger ungenutzt zu lassen, sondern es in einen 160.000 m² großen „Park" zu verwandeln, der aus drei Teilen bestehen sollte: einem „Aufbereitungsgarten" mit pH-Becken – um das fluoreszierende Abwasser, das aus dem alten Bergwerk sickerte, aufzubereiten –, dem „Feuchtgebiet für wiederkehrende Geschichte" und dem „Gemeinschaftshochland" mit Erholungsstätten. Anlagen zur Gewinnung von Kali, sechs Klärbecken und Abflusskanäle aus Kalkstein verwandeln die giftige Flüssigkeit nach und nach wieder in klares Wasser, das grelle Orange in Hellgrün und schließlich in ein neutrales Türkisblau. Dieses Wasser wird anschließend in das Feuchtgebiet geleitet, wo es ein letztes Mal gereinigt wird, bevor man es wieder dem Blacklick Creek zuführt.

Zwischen den Aufbereitungsanlagen liegen die „Lackmus-Gärten", eine sorgsam gestaltete Landschaft, die den begonnenen Umwandlungsprozess spiegeln und zum Ausdruck bringen soll. So wurden die hier angepflanzten einheimischen Bäume und Gewächse passend zur jeweiligen Farbe des Wassers ausgewählt. An den Garten schließt sich eine große Fläche mit ausgehobenem Erdreich an. Abraumhalden mit eingelassenen schwarzen Scheiben erinnern an die 152 Koksöfen, die sich einst auf dem Gelände des Bergwerks von Vintondale befanden. Der auf diese Weise entstandene Park vermittelt ein eindrucksvolles Bild, das aus der Synthese von giftigen Abfällen und natürlichen Materialien entstanden ist. Er ist gleichsam ein Denkmal, das eng mit seiner wirtschaftlichen und politischen Geschichte verbunden und von ihr beeinflusst ist.

Testing the Waters führt künstlerische Konzepte fort, die postindustrielle Landschaften zu Denkmälern erheben – wie beispielsweise Robert Smithsons *The Monuments of Passaic*. Die auf der Documenta11 gezeigten giftigen Substanzen aus Vintondale, von sandgestrahlten Glasplatten abgedeckt, verweisen auf dieses umfassende Problem der Landschaftsrückgewinnung in der heutigen Gesellschaft. Programme wie *Testing the Waters* oder auch der Landschaftspark Duisburg-Nord, ein Projekt der *Internationalen Bauausstellung Emscher Park* im Ruhrgebiet, machen deutlich, dass man endlich bereit ist, sich mit einer als wertlos und unbedeutend erachteten Vergangenheit auseinander zu setzen und sie zurückzuerobern.

Landscape architect Julie Bargmann and artist Stacy Levy's collaborative project *Testing the Waters* regenerates an area affected by acid mine drainage (AMD) from the former coal-mine No. Six in Vintondale, Pennsylvania. They have collaborated with scientists, historians, architects, and the local community to revitalize a toxic wasteland formerly denied both its ecological condition and historical identity. When Vintondale coal mines were abandoned in the early 1960s, coke ovens were left to decay on flood plains, polluting the environment with mounds of mine refuse and acidic streams running into the nearby Blacklick Creek.

In 1995, *Testing the Waters* was launched to confront the postindustrial wasteland and transform it into a 40 acre Park made up of three parts: a Treatment Garden with pH ponds, Emergent History Wetlands, and Community Uplands with recreation sites to treat fluorescent deposit leaking out of the old mine. Sequential alkaline producing systems, six settling basins and limestone spillways gradually turn the poisonous liquid into clear water, from biting orange to pea green to neutral turquoise blue. Subsequently it is diverted into the Emergent History Wetlands where it gets a final rinse before being returned to the Blacklick Creek.

Amongst the treatment systems the Litmus Gardens appear as a carefully constructed landscape, which aims to echo and enhance the transformative processes employed. Rows of native trees and plants are carefully chosen to match the color of the water. Adjacent to the garden, a long plinth of excavated soil and coal refuse inscribed with black discs is reminiscent of 152 coke ovens that stretched across the Vinton mines. The overall resulting park appears as a powerful image that has paradoxically emerged from a synthesis of toxic and natural materials. It is a monument paying tribute to an area deeply connected to and influenced by its economic and political history.

Testing the Waters expands artistic concepts of elevating post-industrial sites to the status of monuments, like Robert Smithson's *The Monuments of Passaic*. The sandblasted glass plates covering acidic substances from Vintondale in Documenta11 thus disclose a more universal problem of postindustrial societies. Recovery programs such as *Testing the Waters* and others like the Landschaftspark Duisburg-Nord, a project of the *Internationale Bauausstellung Emscher Park* in the German Ruhrgebiet, show that they have already confronted and reclaimed a past formerly considered worthless and insignificant. S.M.

Testing the Waters | Wasserproben, since | seit 1995
AMD & Art Pilot Project for Vintondale, PA, to create a public park and water treatment facility | AMD & Art-Pilotprojekt für Vintondale, Pennsylvania, Errichtung eines öffentlichen Parks und einer Anlage zur Wasseraufbereitung

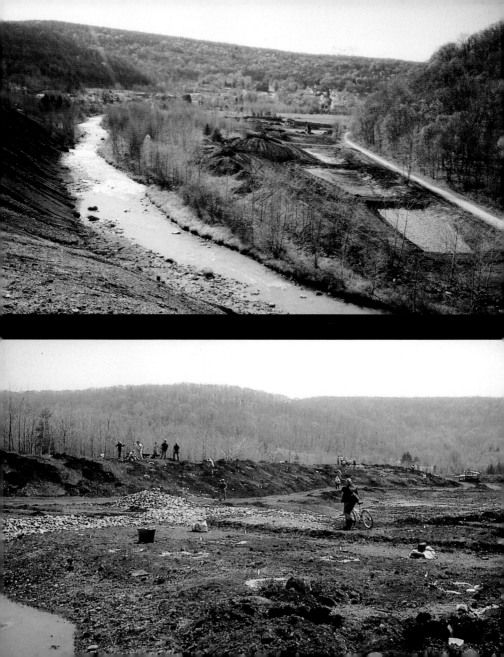

ARTUR BARRIO

*1945 in Porto, Portugal. Lebt/Lives in Rio de Janeiro.

Einige der radikalsten Infragestellungen des Begriffs „Kunst" gingen in den vergangenen 30 Jahren von geografisch, politisch und sozioökonomisch marginalen Orten aus. Artur Barrios Arbeit ist beispielhaft für dieses Phänomen. Zusammen mit Cildo Meireles, Waltercio Caldas und José Resende gehört Barrio einer talentierten Generation brasilianischer Künstler an, die gegen Ende der sechziger Jahre – in der repressivsten Phase der Militärdiktatur in Brasilien nach dem Regierungssturz von 1964 – an die Öffentlichkeit trat. Das Vermächtnis von Künstlern wie Hélio Oiticica und Lygia Clark, der Wille, die eigene Arbeit im Dialog mit den progressivsten europäischen und nordamerikanischen Kunstströmungen weiterzuentwickeln, und die Erfahrung der Militärherrschaft prägten die Richtung, die Barrio mit seinem Werk einschlug.

Barrio geht von einer ökonomischen Analyse des Kunstobjekts in zweierlei Hinsicht aus. In seinen Texten beschreibt er das herkömmliche Kunstobjekt als Ware und macht für die Kapitalisierung des Werks den Kunstbetrieb verantwortlich, welcher allein den Wert von Kunst vermerkt und sie in eine gegen Geld eintauschbare Ware verwandelt. In einem brillanten, 1969 verfassten Essay mit dem Titel *Manifesto* (Manifest) wendet Barrio sich gegen alle Institutionen, eingeschlossen die Kunstkritik, die den Kunstbetrieb als Zyklus von Kreativität und Kapitalakkumulation begreifen. Dabei bleibt er jedoch nicht, sondern er sucht auch die libidinöse Ökonomie des Kunstwerks zu erhellen. 1970 schreibt er: „Mein Werk hängt mit einer subjektiv/objektiven Körper-/Geist-Situation zusammen; ich betrachte diese Beziehung als ein Ding an sich, da sie einen energetischen Prozess anstößt, der psycho-organische Situationen verstärkt, die den Betrachter involvieren, und somit zu einer stärkeren Partizipation am gezeigten Werk führt." Barrio verfolgte von Anfang an eine Doppelstrategie: Zum einen geißelt er den falschen Materialismus, der das Kunstwerk zum kapitalistischen Objekt macht. Zum anderen versucht er am Kunstwerk das wieder zu beleben, was – konträr zum kumulativen Prozess – verlor: die Emotionalität, die von einem Pol (dem Künstler) zum anderen (dem Betrachter) wandert und beide irritiert.

Die zur Documenta11 gezeigte Arbeit beruht auf zwei verschiedenen Werkgruppen: Bei *Situações* (Situationen) handelt es sich um mehr oder minder kurze Aktionen, die Barrio zu Anfang der siebziger Jahre durchführte, und die in ihrer Gesamtheit den Begriff der öffentlichen Kunst radikal in Frage stellen. In den Ende der achtziger Jahre entstandenen *Experiências* (Erfahrungen) nutzt Barrio das Museum bzw. die Galerie als Ausgangspunkt, um das Verhältnis zwischen Institutionen und zeitgenössischer Kunstproduktion zu hinterfragen. In *Ideia/Situação* (Idee/Situation) verschmelzen die Erfahrungen aus beiden Werkgruppen in einer poetischen Synthese, welche die Spannung zwischen der künstlerischen Arbeit und den dem museologischen Raum inhärenten Konditionierungen unterstreichen sucht.

Some of the most radical questioning of the category "art" over the past three decades has taken place on geographical, political, and socioeconomic margins. The work of Artur Barrio is an excellent example. Barrio belongs to a talented generation of Brazilian artists including Cildo Meireles, Waltercio Caldas, and José Resende. These artists began working at the end of the 1960s, the most repressive period of the military dictatorship in Brazil after the coup of 1964. The heritage of the previous generation with artists like Hélio Oiticica and Lygia Clark, the will to develop his work through dialogue with the most progressive European and North American artistic movements, and the experience of the military dictatorship determined the direction Barrio's work would take.

Barrio starts with an economic analysis of the artistic object, with two meanings of the term. In his texts, Barrio describes the traditional art object as merchandise, and blames the artistic circuit for the capitalization of the work, which it endorses as art according to the value it places on it, turning it into goods to be exchanged for money. In a brilliant essay written in 1969 entitled *Manifesto*, Barrio opposes all institutions, including art criticism, which enable an art system as a cycle of creativity and accumulation of capital. Barrio's analysis does not stop at this point, but further aims to elucidate the libidinal economy of the work of art. In 1970 he wrote: "My work is connected to a subjective/objective mind/body situation; I consider this relationship a thing in itself, since it initiates an energetic process that will combust psycho-organic situations involving the viewer, leading to greater participation in the work presented." Barrio's program has been split since its inception: on one hand, he criticizes the false materialism that converts the work of art into a capitalistic object. On the other, he tries to recover in the work of art that which, contrary to a cumulative process, he identifies as pure loss, emotional discharge that passes from one pole (the artist) to another (the viewer), confusing them.

The work shown at Documenta11 derives from two different series. *Situações* (Situations) are more or less ephemeral actions Barrio carried out at the beginning of the 1970s and that, as a whole, constitute a radical questioning of the notion of public art. With *Experiências* (Experiences), from the late 1980s, Barrio uses the museum or gallery space as the starting point to question the relationship between institutions and contemporary artistic production. His *Ideia/Situação* (Idea/Situation) fuses the experience of both groups of work in a poetic synthesis that attempts to underscore the tension between artistic work and the conditionings inherent in the museological space. C. B.

Situação...cidade...y...campo | *Situation...City...and...Country* | *Situation...Stadt...und...Land,* 1970
Intervention, photographic record, five 35mm color slides and two 35mm black-and-white slides I fotografische Aufzeichnung, fünf 35-mm-Farb-Diapositive und zwei 35-mm-Schwarz-Weiß-Diapositive

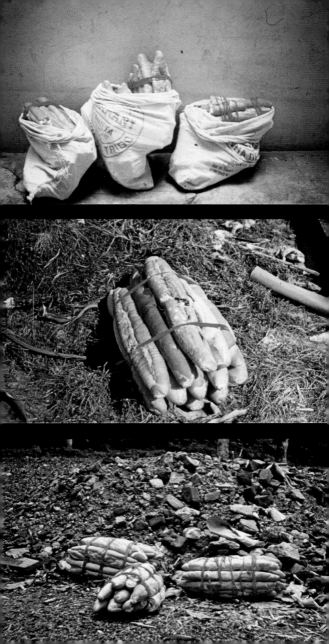

BERND & HILLA BECHER

Bernhard Becher: *1931 in Siegen, Deutschland/
Germany. Hilla Becher: *1934 in Potsdam, Deutschland/
Germany. Leben/Live in Düsseldorf,
Deutschland/Germany.

Seit 1959 arbeiten Bernd und Hilla Becher an der systematischen Erfassung von Industriebauten des 19. und 20. Jahrhunderts, die sie nach strengen formalen Kriterien fotografieren und als Tableaus zu vergleichenden Typologien zusammenstellen. Dazu gehören Förder- und Wassertürme, Hochöfen, Fabrikhallen, Zechenanlagen, Zement- und Kalkwerke sowie industriell vorgefertigte Fachwerkhäuser. Neben den Typologien existieren vielteilige Beschreibungen von Werkkomplexen, „Abwicklungen" (zu Tableaus geordnete Folgen unterschiedlicher Ansichten derselben Architektur) sowie Einzelarbeiten. Die Bechers dokumentieren Zeugnisse der Industriekultur aus dem Ruhrgebiet, dem Siegerland, dem europäischen Ausland und den USA.

Die Objektivität ihrer Fotografien erreichen die Künstler durch definierte Kriterien: Alle Aufnahmen sind schwarzweiße Mittelformate, von einem erhöhten Standpunkt aus fotografiert. Dieses Verfahren bewirkt, dass der Vordergrund ausgeschlossen wird und die Objekte isoliert werden. Diffuses Tageslicht erzeugt gleichmäßiges Streulicht und lässt die Details des Gegenstandes genau hervortreten. Nebensächliche Details werden durch den engen Bildausschnitt eliminiert. Der Verzicht auf Personen erhöht die Konzentration auf die Architektur, die deshalb überzeitlich erscheint.

Das Einzelbild innerhalb einer Serie wird zu einem pars pro toto. Die Typologien implizieren eine morphologische Bestandsaufnahme, die theoretisch unendlich fortsetzbar wäre. Trotz aller individuellen Charakterzüge – die Arbeiten sind präzise betitelt, Ort und Zeit jeder Aufnahme genau dokumentiert – zeigt die Zusammenstellung, wie gleichartig die Formen eines Architekturtyps sind. Die Fotografien stehen in der Tradition naturwissenschaftlicher Bildatlanten des 19. Jahrhunderts, der typologischen Bildserien August Sanders und der Industriefotografie der Neuen Sachlichkeit Albert Renger-Patzschs. Den Bechers jedoch dient die fotografische Dokumentation vielmehr zur Darstellung einer konzeptuellen künstlerischen Auffassung. Ein Wirklichkeitszitat wird ohne Veränderung zum Element einer seriellen Struktur und so einem Abstraktionsprozess unterworfen. Die objektive Darstellung ermöglicht darüber hinaus eine stete Neuordnung der Tableaus und die Einbeziehung weiterer Aufnahmen. Die Bechers selbst nennen ihre Arbeiten „Anonyme Skulpturen". Damit meinen sie nicht, dass die Namen der Architekten unbekannt sind oder die abgebildeten Architekturen skulpturale Formen besitzen. Vielmehr deutet die Bezeichnung auf die Inszenierung ihrer Fotografien zu objekthaften Fotoinstallationen.

Mit der Serie *Fachwerkhäuser des Siegener Industriegebietes*, die überwiegend in den Jahren 1958–1962 und 1968–1973 entstanden ist, zeigt die Documenta11 eines der frühen Projekte der Bechers. Über 200 zu Gruppen geordnete Fotografien stehen für die Konzeption und Bildgrammatik des Gesamtwerks.

Bernd and Hilla Becher have been working since 1959 on systematically classifying industrial buildings of the 19th and 20th centuries. They photograph them according to very strict, formal criteria, and then present them as tableaux of comparable types, which include mining and water towers, blast furnaces, factories, collieries, cement and lime works, and industrially prefabricated half-timbered buildings. Apart from the typological pictures, the Bechers' work also consists of multi-part depictions of different industrial complexes, as well as "Abwicklungen" (tableaux featuring a series of different views of the same architecture), and individual photographs. The Bechers document evidence of industrial culture in the Ruhr area, the Siegerland area east of Cologne, Europe, and the USA.

By defining set criteria the artists are able to ensure that their photographs are objectively comparable. All the photographs are in medium format, and black and white. Diffuse daylight produces an evenly distributed light, so that each object appears in clear detail. The elevated perspective disregards the foreground and isolates the object. Unimportant details are eliminated by the picture's narrow focus, and the absence of people results in a heightened concentration on the architecture, making it appear timeless.

Each individual picture within a series becomes a totality unto itself. The various types seem to be a morphological inventory, which could, theoretically, be continued forever. Each work has a title, and the location and time of each photograph are documented precisely, but despite all these individual characteristics the arrangements in these photographs show how much certain architectural types resemble each other. The works follow the tradition of 19th-century scientific picture atlases, August Sanders's typological photo series, and Albert Renger-Paetzsch's Neue Sachlichkeit industrial photography. Unlike these, though, the Bechers' photographic documentation is concerned with a conceptual artistic approach. Without being altered, a citation of reality becomes an element in a serialized structure and is thus subjected to a process of abstraction. Moreover, the objective, timeless presentation makes it possible to constantly change the order of the tableaus by adding further pictures. The Bechers themselves call their works "anonymous sculptures." Their term refers less to the anonymity of the architects or to the sculptural forms of the architecture than to their way of staging photographs as installations graced with objecthood.

Documenta11 is showing one of the Bechers' earliest works, the series *Fachwerkhäuser des Siegener Industriegebietes* (Half-timbered Houses of the Siegen Industrial Zone), most of which was created between 1958–1962 and 1968–1973. Here, groups of over two hundred photographs exemplify the concept and pictorial grammar of their entire œuvre. A. N.

Fassaden Fachwerk I Half-timbered Facades, 1971–1973
Black-and-white photographs, framed I Schwarz-Weiß-Fotografien, gerahmt

ZARINA BHIMJI

*1963 in Mbarara, Uganda. Lebt/Lives in London.

Formal präzise, scharfsinnig, skeptisch gegenüber großen Worten und dennoch schön, aussagekräftig und oft unergründlich – wie eine Archäologie des Wissens führen uns Zarina Bhimjis Arbeiten heran an den Unterschied „zwischen dem, von dem wir wissen, dass es wahr ist, und dem, von dem wir glauben, dass es wahr ist", wie es die Künstlerin selbst formuliert. Im Grenzbereich zwischen Fakt und Fiktion, Macht und Möglichkeit, Vernunft und Verlangen veranschaulicht sie die komplexen Wechselbeziehungen, Mühen und Enttäuschungen des Körpers in der Welt – des Körpers als naturgegebener Quelle von Identität und Neigungen, Fragment und Spur, Verlust und Projektion. Selbst wenn manche Arbeiten die etwas muffige Atmosphäre alter Bibliotheken und Archive verströmen, so als habe man sie aus vergessenen Kellern ausgegraben, insistieren sie doch vor allem auf die Lebendigkeit der Vergangenheit. Bhimjis Arbeiten drehen sich um Gefühle und Erinnerungen ebenso wie um deren Überdauern: Sie stehen für die Geschichte der jüngsten Vergangenheit, überleben sie gleichzeitig und schaffen neue Vergleiche, noch während sie alte Beziehungen heraufbeschwören.

Mit Installationen, großformatigen Farbfotos und Leuchtkästen lässt Bhimji ein Netz von Darstellungen entstehen, das Zeit und Raum für unser Bewusstsein rekonstruiert. Verschiedene Erfahrungsformen, multiple Bedeutungssysteme, kulturelle Metaphern werden vergegenwärtigt, ebenso reale und imaginäre persönliche Streifzüge – emotional von ihren ursprünglichen Bezügen durchdrungen und durch sie komplexer geworden. All diese Darstellungen sind Fragmente, Versatzstücke eines Labyrinths der Entwurzelung. Bhimji kam in Mbarara, Uganda als Tochter einer indischen Einwandererfamilie zur Welt und lebt seit 1974 – zwei Jahre nach der Vertreibung der asiatischen Bevölkerung durch Idi Amin – in London. Sie lebt also in doppeltem Sinn im Exil – eine Erfahrung, die unweigerlich ihr Werk beeinflusst, das von Verlustgefühlen geprägt ist, von der zweiten Ankunft und von Erinnerung. Diese Motive bestimmen auch den Film und die Farbfotografien, die für die Documenta11 entstanden sind.

Bhimji kehrte hierfür nach Uganda zurück, um sich selbst mit der Unmöglichkeit zu konfrontieren, das, „was geschehen ist", in Worte zu fassen. Die Künstlerin weiß, dass die Bedeutung des Gesagten sich ständig verschiebt und erschüttert wird – zum einen, weil der Akt des Ausschaltens, Vernichtens und Auslöschens die Widerstandskraft der Erinnerung gegen die Zeit schwächt, zum anderen, weil sich das individuelle Gedächtnis nicht vom kollektiven trennen lässt. Nachdem sie alle Möglichkeiten der Erzählung ausgeschöpft hat, entfernt Bhimji sich vom Uganda ihrer Kindheit, von seiner Architektur, seinen Flughäfen und Friedhöfen, den Militärbaracken, Arrestzellen und Gefängnissen der Zeit von Idi Amins Terrorregime. Erst durch die Metapher des Feuers – das in ihrem Werk für Gewalt und Zerstörung, aber auch für das veränderliche Wesen der Erfahrung steht – gibt sie dieser Landschaft das Potenzial zur Erneuerung zurück.

Formally exact, observant, skeptical of grand statements and yet always beautiful, eloquent and often inscrutable, Zarina Bhimji's work entails, much as an archaeology of knowledge, a progressive excavation between "what we know to be true and what we believe to be true," as the artist remarks. Within this border between fact and fiction, power and access, reason and desire, she exposes and untangles the intricacies and exchanges, labor and disappointments of the body in the world: the body as repository of the nature of identity and liability, the body as fragment and trace, as loss and projection. And although her works sometimes have that old library flavor, archival and somewhat musty, as if dug out of a forgotten cellar, they are primarily motivated by an attempt to claim the past as alive. For Bhimji's works are as much about feeling and memory as about survival. While standing for the history of the recent past, they also outlive it, conjuring old relations as they produce new juxtapositions.

In her installations, large-format color photographs and light boxes, Bhimji has created a web of representations that reconstructs time and space for our consciousness, conjuring up different modes of experience, multiple systems of meaning, cultural metaphors and personal expeditions, both real and imaginary, emotionally saturated with and complicated by their original reference. These representations are always fragments, pieces of a labyrinth of displacement. Born in Mbarara, Uganda, to a family of Indian immigrants, and living in England since 1974, two years after Idi Amin expelled Asians from Uganda, Bhimji has inscribed this double diaspora onto her work, immersing it in ineludible traits of loss, second arrival, awareness, and remembrance. These are precisely the inscriptions that permeate the film and color photographs that Bhimji has created for Documenta11.

Returning to Uganda, Bhimji confronts the impossibility of coming to terms with "what has happened." Elimination, extermination, and erasure make memory susceptible to change and time, as the fact that you cannot separate individual from collective memory constantly shifts and shatters meaning. Bhimji walks away from the landscape of the Uganda of her childhood, its architecture, airports, and graveyards, from the military barracks, police cells, and prisons of Amin's regime of terror. She has failed to unravel any possibility of narration. And yet, through the metaphor of burning, which recurs throughout her works to convey violence and destruction, but also the fluctuating nature of experience, she brings back to this landscape the possibility of renewal. O.Z.

The Wall Brooded | *Wand der Schwermut*, 2002
Cibachrome on aluminum | Cibachrom auf Aluminium,
122 x 198 cm

BLACK AUDIO FILM COLLECTIVE

Aktiv/Active 1983–1998 in London.

JOHN AKOMFRAH, REECE AUGUISTE, EDDIE GEORGE, LINA GOPAUL, AVRIL JOHNSON, TREVOR MATHISON, DAVID LAWSON

Black Audio Film Collective ist eine der Film- und Video-workshop-Gruppen, die in den achtziger Jahren nach den Protesten gegen den institutionellen britischen Rassismus entstanden. Als Teil einer Bewegung für die Vertretung der Schwarzen in Großbritanniens Politik und Kultur ist das Kollektiv gleichsam Element eines anhaltenden Prozesses in der Geschichte des englischen Postkolonialismus. Zusammen mit dem Sankofa Film/Video Collective bestand Black Audio darauf, den Schwerpunkt avantgardistischer Filmtheorie und -praxis zu verlagern und sie um eine kontinuierliche Auseinandersetzung mit den „politics of race" zu ergänzen. Montageästhetik mit Elementen persönlicher Reflexion kombinierend, schuf Black Audio faktisch ein neues Genre, das den Realismus der britischen Dokumentarfilmbewegung und den des Spielfilms gleichermaßen anficht. Damit setzte sich Black Audio von anderen britischen Workshop-Gruppen ab, auch weil die Gruppe – sich Foucaults Kritik an namentlicher und seine Favorisierung kollektiver „Autorschaft" zu Eigen machend – bestrebt war, sich kollektivere Methoden der kulturellen Produktion anzueignen.

Black Audio wandte sich vom fotografischen Realismus ab und erörterte stattdessen die diskursiven Bedingungen der „black experience" in palimpsestähnlich sich überlagernden Bildern, Texten und Sounds. Durch kritische Gegenüberstellung von Nachrichtenausschnitten, Interviews, polemischer Geschichtsdarstellung, politischer Analyse und Dramatisierung suchte das Kollektiv, die traditionelle Geschichtsschreibung über die Schwarzen in Großbritannien zu hinterfragen und den „Geist anderer Geschichten" zu enthüllen.

Black Audios kontroversestes Werk *Handsworth Songs* (1986, Regie John Akomfrah) entstand in der Zeit nach den Demonstrationen gegen Diskriminierung und Arbeitslosigkeit in Handsworth bei Birmingham – nur eine von vielen im „Thatcher-England" der achtziger Jahre. *Handsworth Songs* fasst die dokumentarische Form neu, um die Geschichte moderner „black experience" in Großbritannien zur Debatte zu stellen. Videoaufnahmen von den Unruhen (brennende Autos, Zusammenstöße mit der Polizei etc.) sind zwischen Interviews mit Anwohnern aus Handsworth geschnitten, unterlegt von inneren Monologen und atmosphärischer Musik. Kontrapunktisch werden diesen Bildern Sequenzen aus Archivfilmen über frühere Immigrationsbewegungen nach England und die – ironisch eingesetzte – Mainstream-Berichterstattung von den Aufständen gegenübergestellt. *Handsworth Songs* fordert sowohl das weiße wie auch das schwarze kritische und politische Establishment heraus. Das Kontroverse des Films besteht darin, dass er die Diskussion über die Ursachen der Aufstände nicht in soziologischen Begriffen führt, sondern analysiert, wer in heutigen Großbritannien das Sagen hat. Die ins Detail gehenden und selbstreflexiven ästhetischen Strategien von Black Audio waren der Beginn einer Repräsentationspolitik, die sowohl auf den Independent Film, als auch auf das Filmschaffen in der Diaspora immensen Einfluss ausgeübt hat und die für die neu entstehende Disziplin der Kulturwissenschaften elementar war.

Black Audio Film Collective was one of the film and video workshop collectives set up in the 1980s in the aftermath of innercity protests against British institutional racism. As part of a movement for greater cultural and political representation for and by black people in Britain, it can be seen as part of the ongoing process of Britain's postcolonial history. Together with Sankofa Film/Video Collective, Black Audio insisted on shifting the terms of avant-garde film theory and practice to include an ongoing engagement with the politics of race, combining a montage aesthetic with elements of personal reflection. They effectively created a new genre, contesting the realism of both the British documentary movement and of fictional feature films, thus setting themselves apart from other British workshops. This movement was concerned to effect a shift to more collective modes of cultural production fully embracing Foucault's critique of the author name in favor of collective 'authorship.'

Refuting photographic realism, they sought instead to explore the discursive conditions of the black experience through a palimpsest of overlapping images, texts, and sounds. By critically juxtaposing news footage, interviews, polemical narration, political analysis and dramatization, they sought to question the received history of blacks in Britain and to reveal the "ghosts of other stories."

Handsworth Songs (1986, directed by John Akomfrah) was their most controversial work. Shot in the aftermath of the riots against discrimination and unemployment in Handsworth, Birmingham, one of many riots that shook Thatcherite England in the 1980s, *Handsworth Songs* reworks the documentary form to consider the history of contemporary black experience in Britain. Video images of the riots (burning cars, street confrontations with police etc.), are intercut with interviews with Handsworth residents, interior monologue, and evocative music. These images are counterpointed with archival footage of earlier immigration into Britain, as well as ironically used mainstream media coverage of the riots. *Handsworth Songs* confronted the black and the white critical and political establishments alike. The film was controversial because it reopened discussion of the causes of riots not in terms of sociology, but by analyzing who has the power to speak in contemporary Britain. Their fragmented and self-reflexive aesthetic strategies opened up a politics of representation which has been immensely influential both in independent and diaspora film making and foundational for the emerging discipline of cultural studies itself. M. N.

Handsworth Songs I *Handsworth Lieder*, 1986
Film: 16mm, color, 58 min. I 16-mm-Film, Farbe, 58 Min., director I Regie: John Akomfrah

JOHN BOCK

*1965 in Gribbohm, Deutschland/Germany. Lebt/Lives in Berlin.

Wissenschaftliche Denk- und Visualisierungsmodelle sind ebenso Grundlagen von John Bocks Aktionen, die er „Vorträge" nennt, wie verschiedenste Aufführungstraditionen des Theaters und der Performance. Im Laufe der Zeit entwickelten sich Bocks Arbeiten zu raumfüllenden Installationen, die der Künstler als Bühne für Performances nutzt, und für die er höhlenartige, oftmals in unterschiedliche Ebenen geteilte Architekturen konstruiert. Dabei verwendet er eine breite Palette von Materialien, unter anderem selbstgefertigte Kleidungsstücke, Alufolie, Küchengeräte, Klebstoff, Rasierschaum und Gemüse. Objekte und Architektur werden von Bock zu Beginn jeder Ausstellung durch einen Vortrag eingeführt, der trotz vorher festgelegten Skripts stark improvisatorische Züge trägt. Oft mehrere Sprachen verwendend verknüpft Bock assoziativ und nicht logisch wissenschaftliche und literarische Fragmente mit sprachlichen Neuschöpfungen zu einem absurden Text, der das Scheitern des eigenen Versuchs, „das theoretisch Kleine ins praktisch Große umzusetzen" (Bock), immer wieder vorführt und thematisiert. Bock zeichnet seine Vorträge auf Video auf, das dann die Objekte in die Ausstellung eingliedert.

Für *LiquiditätsAuraAromaPortfolio* (1998) teilte Bock den Ausstellungsraum horizontal in zwei Ebenen, von denen die obere für das Publikum über eine kleine Holztreppe zugänglich war. Dort deuteten einzelne Einbauten und Objekte aus Holz und Stoff, diverse Abfallmaterialien, Küchengeräte sowie ein Monitor auf die Aktivitäten, die sich in der unteren Ebene zutrugen. Das Prinzip der räumlichen Interaktion, bei dem die Besucher allerdings nicht eigentlich zu handelnden Personen werden, hat Bock beispielhaft in einer Serie von vier Vorträgen – *Multiple Quasi-Maybe-Me-Be uptown; Intro-Inside-Cashflow-Box; MEECHfeverlump schmears the artwellfareelasticity; Gribbohm meets Mini-Max-Society* (alle 2000) – variiert und durchgespielt. Eine öffentliche Modenschau, ein Vortrag in einer durch ein Sichtfenster einsehbaren Kiste, ein dritter Vortrag, bei dem Bock erst per Video und später persönlich auftritt, und ein letzter Vortrag, bei dem Bock in einer nicht einsehbaren mobilen Dunkelkammer agiert und nur durch kontinuierlich während des Vortrags entwickelter Fotografien mit den Betrachtern kommuniziert, deuten den Spielraum seiner Aktionsformen an.

Für die Documenta11 setzt Bock seine Arbeit zwischen Theater und Performance, medialer Aufzeichnung und direktem Kontakt, prozessualer Handlung und Herstellung von benutzbaren Objekt fort. In einer großen Installation im Außenraum wird Bock über den gesamten Zeitraum der Ausstellung ein selbst geschriebenes Theaterstück inszenieren, das sich auf eine Vielzahl von anderen Konstruktionen und Aktionen bezieht.

Scientific models of thought and visualization are just as much a fundamental part of John Bock's actions—which he calls "lectures"—as are different theater and performance traditions. Over the course of time, his works have become installations that fill entire rooms, used as stages for performances. The installations are cave-like architectural constructions, often divided into different levels and made of a wide palette of materials, including self-made clothing, aluminum foil, kitchen equipment, glue, shaving cream, and vegetables. At the beginning of every exhibit, Bock's lecture introduces the objects and structures. Despite having a pre-written script, the lectures often have a strong improvisational character. In what is frequently a multilingual, associative, nonlogical form, Bock combines scientific nomenclature, literary fragments, and newly coined phrases into an absurd text, which always exposes and examines the failure of his own attempt "to turn theoretical minutia into practical greatness" (Bock). Bock always records his lectures on video, which integrates the objects into the narrative of the lecture during the course of the exhibition.

For *LiquiditätsAuraAromaPortfolio* (LiquidityAuraAromaPortfolio, 1998), Bock divided the space horizontally into two levels. The upper level was accessible to the public via a small wooden staircase. There, various structures and objects made of wood and fabric, diverse garbage, kitchen equipment, and a monitor alluded to the activities taking place on the lower level. Bock varied and played with this principle of spatial interaction—in which visitors come very close to the artist without actually becoming actors—in an exemplary manner in a series of four lectures: *Multiple Quasi-Maybe-Me-Be uptown; Intro-Inside-Cashflow-Box; MEECHfeverlump schmears the artwelfareelasticity; Gribbohm meets Mini-Max-Society* (all 2000). These show the spectrum of his direct and media-mediated events: one was a public fashion show; the second, a lecture in a box, which was fenced off and only visually accessible through a window; a third lecture featured Bock only on video at first and then later in person; and in the fourth lecture, the artist was in a mobile darkroom, blocked off from the audience, only communicating with them via photographs, which he continuously developed during the lecture.

For Documenta11, Bock continues his work in combining theater, performance, recording, direct contact, procedural action, and practical objects. In a large-size installation outdoors, Bock will stage a self-written play linked to numerous other structures and actions, spanning the entire period of the exhibition. C. R.

MEECHfeverlump schmears the artwelfareelasticity, 2000
One hour lecture, exhibition I Einstündiger Vortrag, Ausstellung
Installation view I Installationsansicht, The Museum of Modern Art,
New York, 2000

ECKE BONK

*1953 in Berlin. Lebt/Lives in Karlsruhe, Deutschland/
Germany und/and Fontainebleau, Frankreich/France.

Ecke Bonk beschäftigt sich mit Zeichensystemen als inter-disziplinärem Ausdruck von Kunst, Naturwissenschaft, Typografie und Philosophie, um damit die Bedingungen und Zusammenhänge kultureller Leistungen zu reflektieren. Er selbst bezeichnet sich als „Typosoph", der sich um die modellhafte Darstellung dieser Systeme bemüht.

Alle Zeichensysteme sind grundsätzlich frei kombinierbar. Jedoch nur in einer bestimmten Ordnung – „in Formation" – können sie Informationen transportieren und als Kommunikationsmittel und Erklärungsmodelle dienen. Bonks „Typosophie" stellt die ästhetisch-visuelle Umsetzung von „Informationszeichen" dar und strebt nach poetischer Versöhnung der Bereiche Kunst und Wissenschaft. 1994 gründete er The Typosophic Society (seit 2001 Typosophes sans Frontières), die sich mit den Grundlagen der Zeichen-bildung und der Ästhetik der „in Formation" befasst und dabei sowohl auf künstlerische Praktiken als auch auf Mathematik, Biologie und Physik zurückgreift.

Der Tractatus logico-philosophicus Wittgensteins als Miniaturdruck auf vier DIN-A5-Karten (1989) oder das Periodensystem in Gestalt einer Scheckkarte (1999) dienen Bonk als Möglichkeit, Welterklärungsmodelle in ein handhabbares Format zu bringen. Die Herausgabe und Gestaltung der Atomenlehre von Fechner (1995) und der Erkenntnistheorie von Helmholtz (1998) sind als eine Hommage an diese Wissenschaftler zu verstehen – dabei geht es um eine ganzheitliche Sicht auf ihre Forschungsgegenstände.

Bonk war für die NASA-Spaceshuttle-Mission als Berater für typografische Fragen tätig (1988) und entwickelte für die Industrie Informationssysteme – so genannte Maschinenzeichen (1996). Er arbeitete über Duchamp und veröffentlichte u. a. Marcel Duchamp: Die große Schachtel (1989). Mit Richard Hamilton entwarf er für die documenta X den Typosophic Pavilion (1996/97), in dem die Thesen und Verfahrensweisen der Typosophic Society vorgestellt wurden. Bonk liebt Wortschöpfungen und die Entwicklung von Palindromen und Anagrammen: Die Wortmarke Documenta11 – bestehend aus 11 Zeichen – ist auf seine Idee zurückzuführen.

Für die Documenta11 hat Bonk das Projekt BOOK OF WORDS – RANDOM READING erarbeitet. Grundlage ist das Deutsche Wörterbuch der Brüder Grimm. Dieses 1838 von Jacob und Wilhelm Grimm begonnene, 1960 vollendete und 32 Bände umfassende Wörterbuch gilt als Standardwerk zur deutschen Sprach- und Wortforschung. Die Installation von Bonk reflektiert die etymologisch-historische Untersuchung des deutschen Wortschatzes; sie zeigt potenziell alle 350.000 Einträge des Grimmschen Wörterbuches, indem sie einzelne Wörter, durch ein Zufallsprogramm ermittelt, projiziert. Bonk ermöglicht dem Betrachter damit eine neuartige, nicht vorherbestimmbare Einsicht in dieses einflussreiche Wortzeichensystem, das repräsentativ für ein zentrales Wahrnehmungsmodell von Wirklichkeit steht.

In order to reflect the conditions and contexts of cultural production, Ecke Bonk works with sign systems representing an interdisciplinary expression of art, science, typography, and philosophy. He describes himself as a "typosopher," someone interested in models that depict these systems.

Basically, all sign systems can be freely combined. However, they can only transport information and serve as means of communication and explanatory models when they are in a certain order, "in formation." Bonk's "typosophy" can be defined as the aesthetic, visual realization of informational signs, which strives to attain a new, poetic reconciliation between art and science. In 1994, Bonk founded The Typosophic Society (renamed Typosophes sans Frontières in 2001). It is strongly concerned with the fundamentals of making signs and the aesthetics of "in formation," which makes use of artistic practices as well as mathematics, biology, and physics.

For instance, a miniature print of Ludwig Wittgenstein's Tractatus Logico-Philosophicus on four A5 cards (1989), or the ATM card-size Periodic Table (1999) are some of Bonk's ways of transforming explanatory models of the world into handy formats. Bonk's work on designing and publishing an atomic theory ("Atomenlehre") by Gustav Fechner in 1995 and a theory of knowledge ("Erkenntnistheorie") by Hermann von Helmholtz in 1998 is a homage to these 19th-century scientists who maintained an integral, interdisciplinary view of their research.

Bonk served as a typographical consultant for the 1988 NASA space shuttle mission. He worked on Duchamp, publishing, among other things, Marcel Duchamp: The Box in a Valise (1989). He and Richard Hamilton developed the Typosophic Pavilion (1996/97) for the documenta X, where they presented the Typosophic Society's theses and procedures. Bonk loves the creation of new words, anagrams, and palindromes, and he designed the Documenta11 non-logo as a "Wordmark" consisting of eleven characters.

For the exhibition itself, he has developed a project called BOOK OF WORDS—RANDOM READING, which is concerned with the German dictionary by the brothers Grimm. Begun by Jacob and Wilhelm Grimm in 1838, the dictionary was finished in 1960, encompasses 32 volumes, and is the major standard work on the German language. Bonk's installation reflects on this etymological, historical investigation of German vocabulary; using projectors and a program that randomly selects individual words, the installation potentially shows all 350,000 entries in Grimms' dictionary. Bonk allows the visitor to experience a new, unpredictable way of viewing this influential system of word signs—a system that represents an important model for perceiving reality. A.N.

Notes for the Non-Logo. The Non-Logo was developed specifically for Documenta11 as a "chilled logotype" (Bonk) consisting of eleven letters in Frutiger Condensed without spacing. | Notizen zum Non-Logo. Das Non-Logo wurde von Ecke Bonk speziell für die Documenta11 entwickelt, als eine „unterkühlte Wortmarke" (Bonk), die aus elf Buchstaben in Frutiger Condensed ohne Zwischenabstand besteht.

de - determine
randomize

voiced
dental
slop

relentless
hedonism
of the ABC
(polymorph
polyvalent)

D = global
pf(parole) ?
phoneme

san. baletti - tentdoor

FRÉDÉRIC BRULY BOUABRÉ

***1921 in Zéprégühé, Elfenbeinküste/Côte d'Ivoire.**
Lebt/Lives in Abidjan, Elfenbeinküste/Côte d'Ivoire.

Zur Kunst kam Frédéric Bruly Bouabré über Umwege. Seit den vierziger Jahren formuliert er an seiner Vorstellung von der Welt als einem großen, in allen Bereichen miteinander verbundenen Text. Seine Arbeit verschreibt sich der Lektüre dieses Textes, der Entschlüsselung und Niederschrift in immer größeren, umfassenderen Zyklen und Serien. Fast allen grafischen Serien gehen Manuskripte voraus, in denen Bruly Bouabré unterschiedliche Themenbereiche – zum Beispiel Naturerscheinungen und Lebensweisen in Afrika – untersucht sowie Thesen über die Zusammenhänge von Sprache, Zeichen und Symbolen aufstellt. In über 100 Manuskripten formuliert er eine offene „Wissenschaft" von der Welt, in der Aberglauben, Lebensweisheiten, eine eigene Farbsymbolik und die Deutung der Wolken und der Muster in Orangenschalen und Kolanüssen ihren Platz haben. Sein Verständnis der Dinge, von denen seine Kunst berichtet, ist mit den Instrumenten bloßer Ethnografie nicht zu erschließen. Bruly versucht, Geschichten und Mythen, Religiosität und Linguistik mit seiner weit gespannten Neugier an der visuellen Vielfalt der Welt in einer umfassenden Erkenntnisarbeit zu vereinen.

Bruly Bouabrés Bilderserien bestehen aus unzähligen kleinen einfachen Zeichnungen, die mit Kugelschreiber, Filzstift, Tinte und Bleistift auf kleinen Kartons ausgeführt sind. Fast immer bilden sie ein zentrales bildliches Motiv ab, das von einer erläuternden Textzeile umgeben ist, welche die Bedeutung des Motivs erklärt. In den fünfziger Jahren erkannte Bruly Bouabré, dass zur Erkenntnis der eigenen (afrikanischen) Identität eine eigene Schrift gehört, die sich von jener der Kolonialmächte unterscheidet. Er entwickelte also eine Schreibweise des Alphabets seiner Muttersprache Bété, die er in immer neuen grafischen Serien erklärt und differenziert (*Alphabet Bété*, 1980–1991/92). In *Skarifikations* (1982–1992) untersucht Bruly Bouabré die Tätowierungen und Hauteinritzungen, die – traditionellerweise in Afrika zu finden – für ihn piktografischer Ausdruck von Redensarten und Sprichwörtern und von mythischen Botschaften über die Zusammensetzung des Himmels, über Städte und Bewohner sind. In seinem Zyklus *Poids d'or* (Goldgewichte, 1989) finden die im Museum der Elfenbeinküste ausgestellten alten Gewichte zur Goldwägung eine symbolische Ausdeutung: Bruly Boubaré erkennt in ihnen Beschreibungen von Natur und Gesellschaft, Tugenden und Sprichwörtern.

Tätowierungen und Steinspuren, meteorologische Erscheinungen und moderne Plakate, ethnologische Forschungen und volkstümliche Geschichten werden in Bruly Bouabrés Kunst als umfassende Bildsprache gedeutet, welche die Möglichkeiten, die Welt zu lesen, eindrucksvoll erweitert.

Frédéric Bruly Bouabré took many detours on the way to art. Since the 1940s, he has been working on his idea of the world as a large text connecting everything. His work consists of reading this text, deciphering it, and rewriting it in increasingly large, ever more comprehensive cycles and series covering a continually expanding number of themes. Before almost every graphic series, Bruly Bouabré produces a manuscript in which he investigates the meaning of the various themes, developing theses on the connections between language, signs, and symbols, and between natural phenomena and African ways of life. In over one hundred manuscripts, he formulates an open science of the world, incorporating such diverse subjects as maxims, superstitions, and his own system of color symbols, and the interpretation of clouds and patterns in orange peels and cola nuts. His art relays his understanding of things, exceeding the sphere of ethnography and attempting to unite histories, myths, religion, linguistics, and an extravagant curiosity in the visual diversity of the world in one comprehensive epistemological work.

Bruly Bouabré's series of pictures consist of countless small, simple drawings, made with ball-point and felt pen, ink, and pencil on small pieces of cardboard; they almost always depict one central visual motif surrounded by explanatory lines of text. In the 1950s, Bruly Bouabré realized that African self-understanding needed its own writing, different from that of the colonial powers. He then developed a method for writing the alphabet of his native tongue, Bété, which he continued to explain and subtly diversify in new graphic series (*Alphabet Bété*, 1980–1991/92). *Scarifications* (1982–1992) focuses on the tattoos and scarifications traditionally found in Africa. For him, these are ancient pictographic messages about the formation of the heavens, or cities and their populations, or which depict idioms and proverbs. His cycle *Poids d'or* (Gold Weights, 1989), featuring old weights used to measure gold—now on exhibit at the Côte d'Ivoire Museum—reinterprets the weights as symbols. Bruly Boubaré takes them as expressions of descriptions of nature, social life, virtues, and proverbs.

Tattoos, fossil markings, meteorological phenomena, modern posters, ethnological research, and folk legends are flexibly connected in Bruly Bouabré's art; his broad curiosity reinterprets objects so that they become part of an endlessly expanding visual language that impressively renews our chances of being able to read the world. C. R.

Poids akan à peser l'or | Weight of the Akan for Weighing Gold |
Gewicht der Akan zum Wiegen von Gold, 1989–1990
Drawing | Zeichnung, 15 x 9,5 cm

DU « DECÈS » D'UNE
FEMME ADULTE : « VUE LA « ROTONDITÉ »
DES FORMES COURTES »
« C'EST L'ANTIQUE FIGURATION »

LOUISE BOURGEOIS

*1911 in Paris. Lebt/Lives in New York.

Louise Bourgeois kann sicher als eine der wichtigsten Bildhauerinnen des 20. Jahrhunderts bezeichnet werden. Ihr Werk widersetzt sich in seiner Vielfalt von Medien und Ausdrucksformen der kunsthistorischen Einordnung in eine lineare Abfolge von Stilen. Sie studierte in den dreißiger Jahren in Paris, bevor sie 1938, ihrem amerikanischen Ehemann folgend, in die USA auswanderte. Bourgeois' frühe Zeichnungen und Skulpturen, metaphorische Mutationen von Häusern und Frauendarstellungen sowie totemähnliche Stelen mit bezugsreichen Titeln (*Portrait of C.Y.*, 1947–1949; *The Blind leading the Blind*, 1947–1949; *Depression Woman*, 1949–1950) griffen Erfahrungen aus einer „häuslichen" Welt auf – das Sein als Hausfrau und Mutter, aber auch Verlust- und Existenzängste und das Gefühl alltäglicher Isolation. Gleichzeitig können ihre Arbeiten in einem Zusammenhang mit der damals in New York ausgestellten präkolumbianischen und ozeanischen Kunst und mit dem Werk der Surrealisten gesehen werden. Von Breton und Duchamp setzte Bourgeois sich freilich ab: „Sie waren mir zu nahe und ich lehnte ... ihre Rolle als Hohepriester strikt ab. Da ich weggelaufen war, gingen mir Vaterfiguren an diesen Küsten gegen den Strich."

Ihre provokativen Experimente mit verschiedenen Materialien und Darstellungsformen, mit Latex, Gips und Performances (*A Banquet/Fashion Show of Body Parts*, 1978), und der Bruch mit Darstellungskonventionen von Sexualität lassen Bourgeois in den siebziger Jahren zu einem der wichtigsten Vorbilder für eine neue Künstlergeneration und einer Identifikationsfigur für die feministische Bewegung werden. Aber erst im Alter von siebzig Jahren gelang ihr der künstlerische Durchbruch mit ihrer ersten großen Einzelausstellung im Museum of Modern Art in New York.

In Bourgeois' Arbeit kehren autobiografische Bezüge immer wieder. Dennoch wäre es ein Missverständnis, ihre Arbeit illustrativ-narrativ in Bezug auf die Vergangenheit zu lesen: „Man kann die Gegenwart nicht aufhalten. Man muss jeden Tag der Vergangenheit entsagen ... Und wenn man sie nicht gewähren lassen kann, dann muss man sie wiedererschaffen. Genau dies ist mein Vorhaben."

Das Spektrum im Werk von Bourgeois reicht von abstrakten bis zu gegenständlichen Arbeiten, von präzisen Zeichnungen bis zu großen Installationen. Es bringt einen eigenständigen, radikal subjektiven Kosmos hervor, obwohl sich Bezüge von Rodin bis zu Brancusi und Bruce Nauman herstellen lassen. Ihre seit 1985 entstandenen *Cells* stellen eine radikale Erweiterung dieses Werks in den Raum dar. Die Innenräume sind begehbare Enzyklopädien der Erinnerung, Bühne und Schutzraum des Subjekts. Wie die früheren Arbeiten und auch die in schlaflosen Nächten entstandenen *Insomnia Drawings* (1994/95) sind die Erinnerungsfragmente und Metaphern der *Cells* in der eigenen Existenz verankert, reichen jedoch in ihrer Aussagekraft über sie hinaus.

Louise Bourgeois is certainly one of the most important sculptors of the 20th century. Her work is a phenomenon unto itself, and the variety of media and forms of expression defies any art-historical classification into a linear succession of styles. She studied in Paris during the 1930s, before emigrating with her husband to the USA in 1938. Bourgeois's early drawings and sculptures, metaphorical mutations of houses and portraits of women as well as totem-like steles with titles rich in references (*Portrait of C.Y.,* 1947–1949; *The Blind Leading the Blind,* 1947–1949; Depression Woman, 1949–1950) drew upon experiences of a "domestic" world of a housewife and mother, but also of fears of loss, anxiety, and everyday isolation. These early works can also be seen in connection with pre-Colombian and Oceanic art, then on exhibit in New York, and also with the work of the Surrealists. Yet Bourgeois distanced herself from the Surrealists, and in particular from Breton and Duchamp: "They were too close to me and I objected ... violently to their pontification. Since I was a runaway, father figures on these shores rubbed me the wrong way."

During the 1970s, her provocative experiments with diverse materials and forms of expression—with latex, plaster, and performances (*A Banquet/Fashion Show of Body Parts,* 1978)—and the break with convention in the portrayal of sexuality made Bourgeois one of the most important figures for a new generation of artists and also a role model for the feminist movement.

Like in the chorus of a song, autobiographical motifs recur throughout Bourgeois's work: memories of childhood and youth, family relations, the loss of intimacy, birth, pain, and the fragility of human existence. It would be wrong, however, to read her work as illustrative-narrative in reference to the past: "You cannot stop the present. Every day you have to renounce the past.... And if you cannot stop it, you have to recreate it. Exactly this is my intention."

The spectrum of Bourgeois's work ranges from abstract to representational, from precise drawings to large installations. There may be references to artists ranging from Rodin to Brancusi and Bruce Nauman, and yet Bourgeois produces an original and radically subjective cosmos. Following her artistic breakthrough at the age of seventy, with her first, significant one-person show at the Museum of Modern Art in New York, Bourgeois has been working since 1985 on *Cells,* a radical expansion of her work into space. The inner rooms of these works are accessible encyclopaedias of memories—the subject's stage and shelter. As with the *Insomnia Drawings* (1994/95), done during sleepless nights, the fragments of memory and metaphors in *Cells* are anchored in their own existence, yet their power of expression stretches beyond it. C.M.

Cell XVIII (Portrait) | *Zelle XVIII (Porträt),* 2000
Steel, fabric, wood, glass | Stahl, Stoff, Holz, Glas,
208 x 122 x 129,5 cm

PAVEL BRĂILA

*1971 in Chisinau, Moldawien/Moldavia. Lebt/Lives in Maastricht, Niederlande/Netherlands.

Pavel Brăila, der bevorzugt mit Video und Performance arbeitet, hat ein subjektives Vokabular entwickelt, in dem das Durchqueren von Raum viele kulturell und ökonomisch kodierte Bedeutungen annimmt. In seinem Video *Road* (2001) begibt sich Brăila als Lkw-Beifahrer auf eine holprige Nachtreise vom Land in die Stadt, durchmisst den Westen bis hinein in den Osten, von Maastricht bis nach Chisinau, und überbrückt beim Nachziehen von Verkehrswegen symbolisch klassenbedingte, geografische und politische Grenzen. In *Pioneer* (1997) wälzen der Künstler und ein Mithelfer eine gigantische weiße Rolle Druckpapier bergab in einen nahen Wald. Das Ephemere und Natürliche des Papiers wird in *Work* (2000) noch weitergesponnen: Ein barfüßiger Brăila deckt matschiges Ackerland mit weißem Papier ab, bohrt Pflanzlöcher hinein und gräbt sein „Papierfeld" um.

Brăilas zweites Filmprojekt *Shoes for Europe* (2002) untersucht die politisch bedingte Ost-West-Differenzierung vor dem Hintergrund geschichtlicher Übergangsprozesse, die sich körperlich in Alltagserfahrungen wie Reisen einschreiben. Auf dem kleinen Grenzbahnhof Ungheni an der moldawisch-rumänischen Grenze müssen die Züge von der in Moldawien gebräuchlichen russischen Spurweite auf die in Rumänien und Westeuropa übliche Normalspur umgestellt werden. Die langwierige Passage des Zuges von Ost nach West und den mühsamen, arbeitsintensiven Prozess der Anpassung – jeder Zug hält drei Stunden und wird für die Spurumstellung zwei Meter angehoben, während die Fahrgäste den Zoll passieren – dokumentiert der Künstler inner- und außerhalb der Waggons illegal, da Filmen im moldawischen Grenzgebiet offiziell nicht erlaubt ist. *Shoes for Europe* ist durch zwei parallele Fantasien strukturiert: einerseits durch den stetig wachsenden Wunsch nach Zugang zu Westeuropa als einer fragilen Insel von Wohlstand, Frieden, Demokratie, Kultur, Wissenschaft, Wohlfahrt und Bürgerrechten; andererseits durch die mit dem einsetzenden Zerfall des kommunistischen Ostens Anfang der neunziger Jahre sich durchsetzende Vorstellung von Westeuropa als einer totalen Ordnung, die eine Gleichschaltung aller kommunikativen und technologischen Mittel erfordert, um Entfernung und Ort aufzuheben. Der Film verzeichnet diese Entwicklung und reflektiert dabei Fragen zyklischer Migrationen und kultureller Identität sowie Macht und Scheitern staatlicher Kulturpolitik im Kontext einer omnipräsenten kapitalistischen Weltwirtschaftsordnung.

In unterschiedlicher Höhe auf einander gegenüberliegende Wände im Ausstellungsraum projiziert, spiegeln zwei digital gefilmte, weich gezeichnete Videobilder, auf 16-mm-Film überspielt, nicht nur das doppelte Kraftfeld von Ost und West, von Innen und Außen wider, sondern thematisieren auch die unvermeidliche Frage, wie Subjektivität in einer Zeit der Fragmentierung, der Entwurzelung und des neuen Mythos von der transnationalen Identität verortet und vermittelt werden kann.

Working preferably with video and performances, Pavel Brăila has developed a subjective vocabulary in which the traversal of space has taken on a broad range of culturally and economically coded significance. In his video *Road* (2001), Brăila undertakes a jittery night-time trip as a truck driver's mate from the countryside to the city, traversing the West into the East, from Maastricht to Chisinau, symbolically bridging class, geographical, and political divides by retracing routes of transport. In *Pioneer* (1997), the artist rolls, hand in hand with a coperformer, a giant industrial spool of white paper down the hill into the nearby forest. The ephemerality and naturalness of paper is even taken further in *Work* (2000), where barefooted Brăila covers mushy farm ground with white paper drilling holes for plants and digging over his "paperfield."

Brăila's second film project, *Shoes for Europe* (2002), probes a politically enforced East-West differentiation against the background of processes of historical transition as they are corporeally inscribed into the everyday experience of traveling and commuting. In the small frontier train station of Ungheni, at the Moldovan-Romanian border, the train's wheels need to be changed from Russian gauge used in Moldova to standard gauge used in Romania and Western Europe. The train's laborious passage between East and West and the painstaking and labor-intensive process of adaptation—every train stops for three hours and is lifted two meters in the air to change wheels, while passengers go through customs—is recorded by the artist from inside and outside the wagon illegally, since no shooting is officially allowed in the Moldavian border area. *Shoes for Europe* presents a double fantasy structure of an ever growing desire to gain access to Western Europe, the fragile island of prosperity, peace, democracy, culture, science, welfare, and civil rights. Simultaneously, with the beginning of the disintegration of the communist East in the early 1990s, the notion of Western Europe has come to signify total order, demanding the homogenization of all communicative and technological tools to neutralize distance and place. In documenting this procedure, the film meditates on questions of cyclical migration, cultural identity, and the power and the failure of cultural state policies within the context of an ever imposing capitalist economic world order.

Shot in digital video and transferred onto 16mm film, two soft-edged images are projected on opposite walls and at different heights in the exhibition space mirroring not only the dual force field of East and West and inside and outside, but the ever present subject of how to locate and mediate subjectivity in times of fragmentation, dislocation, and a new myth of transnational identity. N. R.

Shoes for Europe | Schuhe für Europa, 2001/02
Film: 16mm transferred to DVD, color, sound, c. 40 min. | 16-mm-Film übertragen auf DVD, Farbe, Ton, ca. 40 Min.

STANLEY BROUWN

Auf Wunsch des Künstlers wird in Publikationen auf biografische Angaben und auf Erläuterungen zu seinen künstlerischen Arbeiten verzichtet.

In accordance with the wishes of the artist, no details of his life and work shall be published.

stanley brouwn befindet sich im moment x fuß entfernt von diesem punkt

at this moment stanley brouwn is at a distance of x feet from this point

en ce moment stanley brouwn se trouve à x pieds de ce point

TANIA BRUGUERA

*1968 in Havanna/Havana, Kuba/Cuba. Lebt/Lives in Havanna/Havana.

Schweigen und Selbstzensur als Mittel der Machtausübung, aber auch des Widerstands sind Tania Brugueras zentrale Themen. In ihren Performances und Installationen setzt sie Schweigen als Akt der Unterwerfung und zugleich als Form des Widerstands ein.

Ihre Arbeit *El peso de la culpa* (Die Bürde der Schuld, 1997–1999) baut auf der Legende von Kubas indianischen Ureinwohnern auf, die bei ihrem verzweifelten Widerstand gegen die spanischen Eroberer beschlossen, solange Erde zu essen, bis sie starben. In der Performance trägt Bruguera einen Schutzschild, bestehend aus einem geschlachteten Lamm, und formt Bälle aus Erde und Salzwasser, um sie dann zu verzehren. In diesem Ritual des Ertragens opfert sie ihren eigenen Körper bis zur Ekstase, bis an die Grenzen physischer Erschöpfung. Einerseits lastet auf ihr die Schuld der Unterwürfigkeit und des Schweigens. Andererseits ist das Schweigen ein politisches Instrument, mit dessen Hilfe man widersteht, überlebt und sich seine eigene Identität bewahrt, um so deren Unveräußerlichkeit zu demonstrieren.

Brugueras kubanische Herkunft ist daher das Fundament ihrer Arbeit. Sie wuchs in einem Land auf, das fortwährend anderen Herrschaftsverhältnissen unterworfen war. Durch stillen Widerstand haben die Kubaner aber die eigene Identität bewahren können. Bruguera – die sich entschied, in Kuba zu bleiben, während viele andere Künstler die Insel in den späten achtziger und den frühen neunziger Jahren verließen – stellt thematische Bezüge zur sozialen, politischen und wirtschaftlichen Geschichte des Landes her, in dem die Emigration zu einem wachsenden Problem geworden ist. Die daraus resultierenden physischen und geistigen Erfahrungen der Entfremdung und Desorientierung drückt sie durch körperliche Aktionen aus.

In einer Arbeit aus dem Jahre 2000 verwandelte Bruguera ein früheres Gefängnis in Havanna in einen völlig abgedunkelten Raum. Sie bedeckte den Boden mit gärendem Zuckerrohr und störte damit nicht nur den Gesichtssinn, sondern auch den Gleichgewichts- und den Geruchssinn. Die einzige Lichtquelle im Raum war ein Fernsehbildschirm, auf dem Szenen aus dem Leben Fidel Castros zu sehen waren. Hatte sich das Auge allerdings erst einmal an das Dunkel gewöhnt, sah man Männer nackt im Raum stehen, die sich wiederholende rituelle Gesten ausführten.

In ihrer Arbeit *Untitled* (*Kassel*) für die Documenta11 kehrt Bruguera nun diese Erfahrung der Orientierungslosigkeit um. Beim Eintreten in den Raum wird man von einem starken Licht geblendet, das verschiedene live erzeugte Geräusche sinnlich noch beeindruckender macht: Jemand geht über einen Laufsteg, ein anderer zerlegt ein Gewehr und setzt es wieder zusammen, eine weitere Person spielt mit Patronenhülsen. Die Installation stellt Kassels Geschichte als Rüstungsindustriestandort des Zweiten Weltkriegs und als grenznaher Ort im Kalten Krieg in den Zusammenhang von Brugueras allgemeinerer Auseinandersetzung mit der Geschichte eines Ortes. Die performative Geste läßt die Arbeit zur sinnlichen Erfahrung werden, die sich in die Erinnerung einschreibt und so dem Vergessen widersteht.

Silence and self-censorship as a means to impose and resist power are the central issues taken up by Tania Bruguera. In her performances and installations she uses silence as an act of submission, yet simultaneously transforms it into a mode of resistance.

In *El peso de la culpa* (The Burden of Guilt, 1997–1999), Bruguera has incorporated the legend of Cuba's indigenous Indians who, in their desperate resistance against the Spanish conquerors, decided to eat dirt until they died. In the performance, the artist wears a shield made from a raw lamb carcass, and forms balls of earth and salt water to then consume them. In this abiding ritualistic act, Bruguera sacrifices her own body to a point of physical exhaustion and ecstasy. The burden of guilt lies on her for being submissive and silent. But this is also a political tool of resistance and survival, ingesting one's own identity to demonstrate its inalienability.

Bruguera grew up in a country that was always subjugated to diverse powers, and her Cuban origin is fundamental to her work. In silently resisting, Cuba has indeed preserved its distinct identity. Many artists left Cuba during the late 1980s and early 1990s, but Bruguera decided to stay, and to take up issues embedded in Cuba's social, political and economic history—in which emigration has become an increasing problem. She expresses the resulting experiences of alienation and disorientation through the body in action, physically and spiritually.

In *Untitled* (2000), Bruguera turned a former jail in Havana into a pitch-dark space. She covered the floor with sugarcane, to immediately disrupt the senses of sight, balance, and smell (through fermentation). The only source of light available was a TV screen showing scenes from the life of Fidel Castro. Once the eye adapted to the darkness, one would suddenly notice male nudes standing in the space making ritualistic repetitive gestures.

In *Untitled (Kassel),* her work for Documenta11, Bruguera has inverted this experience of disorientation. Upon entering the space, the viewer is blinded by a powerful light that permits a more sensual experience of sounds that are performed live: a person walking on a catwalk, another assembling and disassembling a rifle, yet another playing with empty bullets. In the installation, Bruguera has woven Kassel's history as an arms manufacturing center during World War II and its proximity to the border during the Cold War into her overall concerns with the history of a place. Through the performed gesture the work becomes a sensual experience that inscribes itself into memory and thus resists oblivion. S.M.

El peso de la culpa | The Burden of Guilt | Die Bürde der Schuld, 1997–1999
Performance, 45 min., Tejadillo 214, Havana | Havanna, 1997

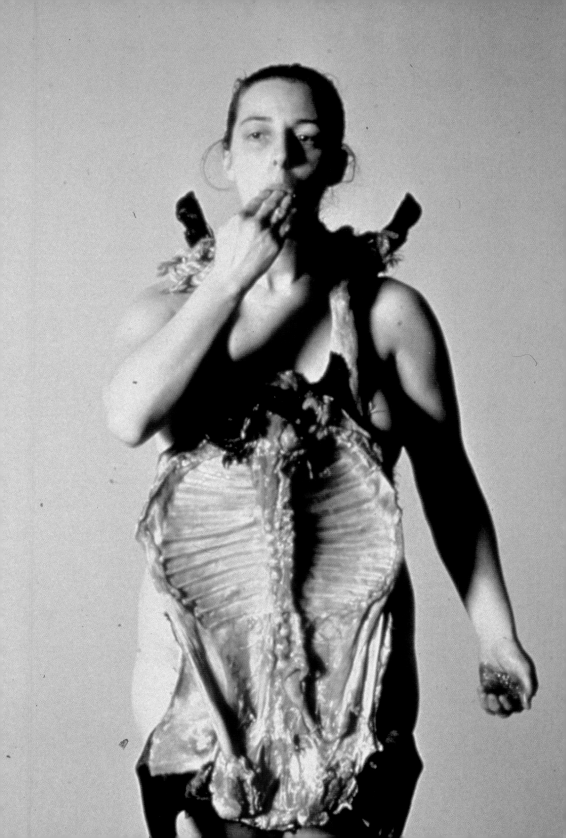

LUIS CAMNITZER

*1937 in Lübeck, Deutschland/Germany. Lebt/Lives in Great Neck, NY, USA.

Luis Camnitzer, dessen Familie 1939 nach Uruguay emigrierte, und der 1964 in die USA übersiedelte, vereinigt in seinem Werk seit den sechziger Jahren Tendenzen sowohl der amerikanischen als auch der lateinamerikanischen Konzeptkunst. Nach Ausbildung und Tätigkeit als Druckgrafiker – das Medium wurde von Camnitzer wegen seiner demokratischen Möglichkeiten geschätzt – wandte sich der Künstler seit den sechziger Jahren Arbeitsweisen zu, die mit Sprache operierten. Camnitzer untersuchte die tautologischen Kapazitäten von Sprache, ihre strukturelle Beschaffenheit als arbiträres Zeichensystem und ihr Verhältnis zu Bildern und Objekten.

Die Arbeit *Leftovers* (1970), ein Stapel identischer Pappkartons, die mit „Leftover" bedruckt und mit blutig gefärbter Gaze umhüllt waren, wurde bereits deutlich um politische Referenzen erweitert. Camnitzers Maxime ist, dass Kunst ein System der Aufbereitung und Darstellung gesellschaftlich und politisch relevanter Auffassungen zu sein hat, das dank seiner Offenheit und Vorläufigkeit hegemonialer und ideologischer Bevormundung entgehen kann. Dabei verfährt Camnitzer niemals propagandistisch, sondern ist vielmehr daran interessiert, wie sich die subjektiven Vorstellungen und Erfahrungen, Vorurteile und Vorlieben in so scheinbar objektive Diskurse wie beispielsweise die Geschichtsschreibung eintragen. Er entwickelt seine Werke wie ein Forscher, schreibt Geschichte neu und reflektiert die eigenen Verflechtungen in diesen Prozess. Mehrdeutigkeit ist somit nicht nur Teil der Erscheinungsform, sondern auch Inhalt seiner Arbeiten.

In *From the Uruguayan Torture Series* (1983/84), einer Gruppe von 35 Fotogravuren, die auf der Documenta11 gezeigt werden, finden konzeptuelle Darstellung und politischer Inhalt auf eindrucksvolle Weise zusammen. Einzelne Bilder sind mit knappen handschriftlichen Bildunterschriften versehen – eine Hand, aus deren Fingernägeln Nadeln hervorstehen, mit „He practised every day", oder ein Finger, der mit elektrisch geladenem Draht umwickelt ist, mit „Her fragrance lingered on". Die präzise Ökonomie der Form lässt die Diskrepanz zwischen brutalem Bildinhalt, den tagebuchartigen Zeilen und dem altmodischen, kunstvollen Medium so kenntlicher hervortreten. Obwohl alle Bilder auf Recherche und Berichte von tatsächlichen Folterungen zurückgehen, unterstreichen Camnitzers Arbeiten nicht den empirischen Aussagegehalt der Fotografien, sondern verdeutlichen, dass Folter bereits dann beginnt, wenn sie in die „Struktur des Empfindens" übergegangen ist.

In jüngerer Zeit sind oft raumgroße Installationen entstanden. Camnitzers Arbeit *Los San Patricios* (Das Bataillon des Heiligen Patrick, 1992) handelt von einer Gruppe vornehmlich irisch-amerikanischer Soldaten, die im amerikanisch-mexikanischen Krieg (1846–1948) auf der Seite Mexikos kämpften. *The Waiting Room* (1999) erschafft mit sparsamen Mitteln – Zeitungen, einem zerbrochenen Spiegel und einigen Kreidemarkierungen – das „Bild" einer Gefängniszelle.

Luis Camnitzer's family emigrated to Uruguay in 1939, and the artist moved to the USA in 1964, where he began to combine aspects of North American and Latin American Conceptual Art. Camnitzer trained and worked as a printmaker—a medium he favored for its democratic possibilities—and then he turned to methods that operated with language. Camnitzer examined the tautological potential of language, its structural composition as an arbitrary system of symbols, and its relationship to images and objects.

Leftovers (1970), a pile of identical cardboard boxes wrapped in blood-colored gauze with "Leftover" printed on them, was replete with political references. Camnitzer's maxim is that art should be an open and provisional system of processing and portraying socially and politically relevant views, and that it is able to avoid hegemonic and ideological control. Camnitzer never works as a propagandist, but is much more interested in how subjective ideas and experiences, prejudices, and preferences enter seemingly objective discourses, such as historiography. He develops his works like a researcher, rewrites history, and reflects on his own involvement in this process. This means that ambiguity is not just part of the appearance but also of the content of his works.

In *From the Uruguayan Torture Series* (1983/84), a group of 35 photographic engravings on exhibit at the Documenta11, conceptual form meets political content in an impressive manner. Individual photographs are given pithy, handwritten captions, such as "He practiced every day" for a hand with needles sticking out of the fingernails, and "Her fragrance lingered on" for a finger wrapped in electrically charged wire. The precise economy of the form of these photographs further highlights the contrasts between visual content, the diaristic captions, and the old-fashioned, elaborate medium. Although all of the photographs are based on research and reports of actual tortures, Camnitzer's works do not emphasize the images' empirical content, but show clearly that torture begins as soon as it turns into a "structure of feeling."

More recently, Camnitzer has created room-sized installations. His work *Los San Patricios* (The Saint Patrick Battalion, 1992) deals with a group of predominantly Irish-American soldiers who fought for Mexico in the Mexican-American War. *The Waiting Room* (1999) creates the "image" of a prison cell with scant means—newspapers, a broken mirror, and a few chalk markings. C.R.

The Waiting Room | *Der Warteraum,* 1999
Mixed media, dimensions variable | Verschiedene Materialien, Maße variabel
Installation view | Installationsansicht, Liverpool Biennial of Contemporary Art, Liverpool, 1999

JAMES COLEMAN

*1941 in Ballaghaderreen, County Roscommon, Irland/Ireland. Lebt/Lives in Dublin.

James Colemans komplexe audiovisuelle Montagen – Diaprojektionen, Videos und Performances – behandeln Themen wie das Wachrufen von Erinnerungen beim Darstellen und Erzählen und die Rolle, die dieses Erinnern bei der Wahrnehmung und Subjektbildung spielt. Coleman führt Theatralisches und Literarisches wieder in die Domäne des Visuellen ein. Er verknüpft die zeitliche Bindung ästhetischer Erfahrung in der elektronischen Bildsprache mit den mnemonischen Prozessen, die beim Sehen ablaufen. Sein Lieblingsszenario ist das projizierte Bild, das sich bewegende Dia, begleitet vom Klicken des Rundmagazins und einer kommentierenden Stimme, die diskontinuierlich Versatzstücke aus Gedichten, sentimentalen Groschenromanen und italienischen „fotoromanzi" zitiert. Für Coleman ist Subjektivität ein Phantom, das in den Erzählungen der Massenkultur spukt – collagenhaft zusammengesetzt zur Beschreibung von Erfahrungen, die durch den Akt der Erinnerung vermittelt und transformiert werden.

In *Slide Piece* (1972) lauscht der Betrachter verschiedenen assoziativen Beschreibungen einer banalen Gegend in einer Stadt und sieht gleichzeitig die sich wiederholende Projektion eines Dias von diesem Ort. Colemans Repräsentationsformat der Diaprojektion ist ein ideales Mittel, um eine „Archäologie des Narrativen" (Benjamin Buchloh) zu verfolgen und gleichzeitig Fotografie, Film und Video auf ihre bildlichen, narrativen und dramaturgischen Fähigkeiten zu testen. In *Box (ahhareturnabout)* (1977) lässt Coleman gefundenes Filmmaterial von einem Boxkampf als Loop abspielen und unterlegt den Soundtrack mit seinem eigenen inneren Monolog. Die Heterogenität von Bildlichem und Fotografischem, von Narrativität und Stillstand bleibt dabei bestehen: Der optische Rhythmus zeichnet die Boxhiebe in schnell wechselnden Folgen von Blackouts und Ton-Bild-Blenden nach und potenziert so visuell die physische Erfahrung des Boxers.

In Colemans krypto-narrativer Produktion seit den frühen achtziger Jahren steht jedes Bild zunächst unbewegt auf der Projektionsfläche, bevor es dem Schwarz weicht und – in der Art eines animierten „tableau vivant" – in ein neues Bild übergeht, so in Dia-Arbeiten wie *Background* (1991–1994), *Lapsus Exposure* (1992–1994), *I.N.I.T.I.A.L.S.* (1993/94) und *Photograph* (1998/99). Choreografierte Bewegung und bildlichen Stillstand, innehaltende Zeitlichkeit und präsente Unmittelbarkeit miteinander verschmelzend, demonstrieren diese Arbeiten foto-theatralisch die mnemonischen und performativen Dimensionen von Kultur.

I.N.I.T.I.A.L.S., angesiedelt in einem leer stehenden Krankenhaus der fünfziger Jahre, verweist auf die amphitheaterähnlichen Operationssäle des 17. und 18. Jahrhunderts, in denen der Körper öffentlich zur Untersuchung aufgebahrt und seziert wurde. Colemans Botschaft an uns als Betrachter scheint zu sein, dass unser Zugang zur Welt nicht primär durch das Sehen gewährt wird und dass Repräsentation letztendlich nicht zu meistern ist.

James Coleman's complex audiovisual montage work—slide projections, videos, and performances—addresses issues such as the recollection of memory in storytelling and representation, its role in perception, and the formation of the subject. Reintroducing the theatrical and the literary into the domain of the visual, Coleman links the temporalization of aesthetic experience in electronic imagery with mnemonic processes in the act of seeing. His preferred scenario is the projected image, the moving still of the photographic slide, accompanied by the click of the carousel and a discontinuous, embodied voice-over, citing a broad range of elements from poetry, romantic pulp fiction, and Italian photoromanza. For Coleman, subjectivity is a phantom that can be found in mass cultural narratives, collaged together to portray experiences that are mediated and transformed by acts of memorization.

In *Slide Piece* (1972) the viewer listens to different associative oral accounts of a banal urban site, while simultaneously witnessing the repeated projection of the same slide showing the site. Coleman's presentational format of slide projection is an ideal device for pursuing "an archeology of narrative" (Benjamin Buchloh), stripping photography, film, and video down to their pictorial, narrative, and dramaturgical viabilities. Sustaining the heterogeneity of the pictorial and the photographic, of narrativity and stasis, *Box (ahhareturnabout)* (1977) features found footage of a boxing match, looped and furnished with a sound track scripted by the artist's internal monologue. Rhythmically following the punches in rapidly alternating sequences of blackouts and image-sound flashes, the optical beat doubles the physical experience of the boxer.

In Coleman's cypto-narrational work since the early 1980s, in slide-pieces such as *Background* (1991–1994), *Lapsus Exposure* (1992–1994), *I.N.I.T.I.A.L.S.* (1993/94), and *Photograph* (1998/99), each image is held stable on a screen before going black and yielding into another in a form of tableau vivant. Fusing choreographed movement and pictorial stasis, arrested temporality and present immediacy, Coleman's works set up photo-theatrical displays of the mnemonic and performative dimensions of culture.

I.N.I.T.I.A.L.S., set in a disused hospital from the 1950s, refers back to a 17th and 18th-century "theatre of operations," where the body is laid out and dissected for public scrutiny. Coleman's ultimate message to us, the viewer, is that it is not primarily vision that grants us privileged access to the world, and that representation cannot be mastered. N.R.

Lapsus Exposure I *Lapsus-Preisgabe*, 1992–1994
Projected images with synchronized audio narration I Projizierte Bilder mit synchronisierter Tonspur

CONSTANT
CONSTANT A. NIEUWENHUYS

*1920 in Amsterdam. Lebt/Lives in Amsterdam.

Constant gründete 1948 mit Karel Appel und Corneille die Niederländische Experimentelle Gruppe. Ausschlaggebend war die Idee, dass „Improvisation eine wesentliche Vorbedingung für eine lebendige Kunst" ist. Noch im gleichen Jahr gründete er u. a. mit Asger Jorn und Christian Dotremont die Künstlergruppe CoBrA. Ihr Konzept richtete sich gegen eine rational geprägte, akademische Kunst und forderte eine ursprüngliche und phantasievolle, farbige und wilde Bildsprache. 1951 verließ Constant die Gruppe. Seine Malerei wurde zunehmend monochromer und abstrakter; später nahm sie geometrische Elemente auf, die sich auch dreidimensional entwickelten. Arbeiten mit sowohl malerischen als auch skulpturalen Elementen folgten konstruktivistische Skulpturen aus Metall, Plexiglas, Draht und Holz, die schließlich zu seinen Modellen von *New Babylon* führten. 1957 wurde Constant Mitbegründer der Situationistischen Internationale. Gesellschaftlicher Emanzipation verpflichtet setzte sich die Gruppe vor allem mit der spezifischen Struktur von Städten auseinander.

„*New Babylon* ist kein Projekt der Stadtplanung, sondern eine Art des Denkens, des Imaginierens, eine Blickweise auf die Dinge und das Leben." Von 1956 bis 1974 arbeitete Constant an diesem Projekt und entwickelte hierfür unzählige Modelle, Zeichnungen, Grafiken, Collagen und Gemälde. *New Babylon* setzt voraus, dass die menschliche Arbeitskraft durch Automatisierung überflüssig wird. Die frei werdende Energie des Menschen verwandelt sich in Kreativität und gestaltet die Welt nach Wunsch. In absoluter Freiheit verfügt der Mensch als Homo ludens über Zeit und Raum, nicht mehr ortsgebunden führt er ein nomadenhaftes Leben. Mit seiner unbestimmten, flexiblen und mobilen Struktur bildet *New Babylon* die adäquate Umgebung für diesen neuen Menschentypus. Verkehrs- und Lebensräume sind voneinander getrennt, ebenso die künstlich konstruierten Lebensräume von der unberührten Natur. Die urbanen Strukturen bestehen aus einem hoch gelagerten netzwerkartigen Gefüge geschützter Einheiten, so genannter Sektoren. Dieses System ist unbegrenzt und kann theoretisch die gesamte Erdoberfläche einnehmen. Die mobilen Konstruktionen und die technische Ausstattung zur Manipulation von Klima und Licht werden von den Bewohnern auf spielerische Weise genutzt. Für den Künstler ist *New Babylon* die Antwort auf eine stete Zunahme von Bevölkerung und Verkehr.

Die Arbeiten Constants wurden im Laufe der Entwicklung dieses Projekts zunehmend abstrakter. Zeichnungen und Lithografien lösten die vielen sehr detaillierten Stadtpläne und Sektorenmodelle ab, später entstanden vereinzelt Gemälde. 1974 wendete sich Constant wieder der Malerei zu, bis heute ist sie sein ausschließliches Metier.

Constant founded the Dutch Experimental Group in 1948, along with Karel Appel and Corneille. The idea behind this was that "improvisation should be an essential requirement for living art." In the same year, Constant started the artists' group CoBrA with Asger Jorn, Christian Dotremont, and others. Their concept was directed against rational, academic art, and demanded an original, imaginative, colorful, and wild language of images. In 1951, Constant left the group. His painting became quieter, more monochrome, and increasingly abstract, and then began to use geometric elements that also developed three-dimensionally. He began working with a combination of painting and sculpture, and in the following years he started making Constructivist sculptures of metal, Plexiglas, wire, and wood, which ultimately became the models for his *New Babylon*. In 1957, Constant co-founded the Situationist International, whose aim was the emancipation of life and society, and whose themes therefore included the specific structures of cities.

From 1956 to 1974, Constant worked on his project *New Babylon,* developing countless models, drawings, prints, collages, and paintings. "*New Babylon* is not an urban planning project, but a way of thinking, of imagining, of looking at things and life." *New Babylon* is based on the idea of future mechanization, which would make it possible to dispense with human workers. People could use their energy to be creative, in order to shape the world according to their desires. The human, as Homo ludens, would be able to freely determine time and space. No longer bound to a location, he would lead a nomadic life. With its indefinite, flexible, mobile structure, *New Babylon* would then be a suitable environment for this new type of human, and at the same time provide a solution for increasing population and traffic.

In *New Babylon,* transportation and living space are kept apart from each other, and the artificially constructed living space is also separate from pure nature. Urban structures consist of an elevated network of protected units, called sectors. This system has no limitations and can theoretically cover the entire surface of the Earth. The inhabitants playfully make use of the mobile structures and technical equipment for manipulating climate and light.

While developing *New Babylon,* Constant's works became increasingly abstract, eventually seeming to almost dissolve. Toward the end of the project, drawings and lithographs replaced the many detailed city plans and sector models. In 1969, he began once again to paint occasionally, and in 1974 Constant turned exclusively to painting, which he continues to pursue to this day. A. N.

Aerial view of *New Babylon* | Luftaufnahme von *New Babylon,* 1970/71

HANNE DARBOVEN

*1941 in München, Deutschland/Germany. Lebt/Lives in Hamburg, Deutschland/Germany.

Hanne Darboven studierte Malerei, nachdem sie kurze Zeit als Pianistin aufgetreten war. Als sie 1966–1968 in New York lebte, kam sie in Kontakt mit Künstlern der Minimal Art, unter anderen mit Sol LeWitt und Carl Andre. Es entstanden geometrische, konstruktionsartige Zeichnungen auf Millimeterpapier. Danach stellte Darboven mathematische Rechnungen auf, so ermittelte sie die Quersummen von Kalenderdaten. Einem spezifischen System folgend, entwickelte sie überdies Zahlenreihen in Hand- und Maschinenschrift, die sich wiederholten und aneinander reihten. Darboven verwendete in ihren Arbeiten – die sie seit 1971 als Raum füllende Installationen präsentiert – Kalendarien, schrieb literarische und wissenschaftliche Texte ab oder kombinierte Bilder, Ansichtskarten und Fotografien mit Zahlenkolonnen und Schriftzeilen.

Auch die Tätigkeit des Schreibens, die Dauer der Niederschrift und des rezipierenden Lesens wurden zum Gegenstand ihrer Untersuchungen. In Linien, die keine Buchstaben mehr erkennen lassen, thematisierte sie die stete Bewegung des Schreibens selbst: „Ich schreibe, aber ich schreibe nichts" ist eine wesentliche Aussage der Künstlerin.

Ein weiteres Thema, das Darboven an Beispielen zeitgeschichtlicher Ereignisse entwickelt, ist die Zeit (*Schreibzeit*, 1975–1981; *Kulturgeschichte 1880–1983*, 1980–1983). Vielfach bezieht sie sich dabei auf die deutsche Geschichte und Politik (*Ein Jahrhundert – Johann Wolfgang von Goethe gewidmet*, 1971–1982; *Bismarckzeit*, 1978; *Evolution Leibniz*, 1986).

Analog zu ihrer „mathematischen Literatur" hat Darboven eine „mathematische Musik" geschaffen. Durch das Überführen von Zahlen in Noten entstanden seit Ende der siebziger Jahre Partituren (*Wende »80«*, 1980/81): Jeder Ziffer ordnete die Künstlerin eine bestimmte Tonhöhe zu, während sie zusammengesetzte Zahlen in ein Intervall übertrug. Die exakte Transkription der Zahlenkonstruktionen erzeugte die Musik. Von Darboven existieren u.a. Symphonien, Streichquartette und ein Requiem.

Die Regelhaftigkeit und Logik der Musik Darbovens haben einen barocken Charakter, und so erscheint es nur folgerichtig, dass die Künstlerin ihre eigenen Orgelwerke mit Werken von Johann Sebastian Bach (so im Konzert zu ihrem 60. Geburtstag in Hamburg 2001) und Georg Friedrich Händel (so im Film *Der Mond ist aufgegangen*, 1983) kombiniert.

Nachdem Hanne Darboven auf der *documenta 5, 6,* und *7* mit Einzelarbeiten vertreten war, wird die Documenta11 die gesamte Bandbreite ihres Schaffens exemplarisch präsentieren: ihre Bücher (*Wunschkonzert*, 1984), ihre Filme (u.a. *Film 1–6*, 1968), ihre Rauminstallation (*Kontrabaßsolo, opus 45*, 1998–2000) und, als konzertante Aufführung, ihre Musik (*Sextett für Streicher, opus 44*, 1998/99).

After a short period as a performing pianist, Hanne Darboven began studying painting. While living in New York from 1966–1968, she came into contact with Minimal Art artists such as Sol LeWitt and Carl Andre. She began creating geometric, blueprint-like drawings on graph paper, and later, mathematic calculations, in which she ascertained the sum of particular calendar dates; she also developed numerical series, both hand and machine-written, which followed a specific system of succession and repetition. Darboven uses calendars, copies literature and scientific texts, combines images, postcards, and photography with columns of numbers or lines of writing—and has been presenting these works in large installations since 1971.

She also emphasizes the act of writing, the time spent writing, and the reader's reception of writing. Using lines that are no longer recognizable as series of letters, she investigates the motion of writing itself. "I write, but I don't write anything," is one of the artist's key statements.

A further subject is the progression of time, which Darboven has addressed by citing historical events, as in *Schreibzeit* (Writing Time, 1975–1981), and *Kulturgeschichte 1880–1983* (Cultural History 1880–1983), which was created from 1980–1983. She often refers to German history and politics, as in *Ein Jahrhundert – Johann Wolfgang von Goethe gewidmet* (One Century—Dedicated to Johann Wolfgang von Goethe, 1971–1982); *Bismarckzeit* (Bismarck Time, 1978); *Evolution Leibniz* (1986).

In analogy to her "mathematical literature," Darboven created "mathematical music." Since the end of the 1970s, Darboven wrote musical scores by translating numbers into notes. In *Wende »80«* (1980/81) each digit is assigned a certain pitch; and combinations of numbers are translated into intervals. Thus, the music is based on the exact transcription of the numerical structures. Darboven has composed symphonies, string quartets, and a requiem.

Darboven's music has a Baroque regularity and logic, and so it seems only right that the artist would combine her own organ works with works by Johann Sebastian Bach (as played at a concert for her 60th birthday, in Hamburg, 2001) and Georg Friedrich Handel (as played in the film *Der Mond ist aufgegangen,* The Moon has Risen, 1983).

After *documenta 5, 6,* and *7* presented individual works by Hanne Darboven, Documenta11 will now show examples from all stages of her œuvre: her books (*Wunschkonzert,* Fantasy Concert, 1984), films (*Film 1–6,* 1968), installations (*Kontrabaßsolo, opus 45*; Solo for Double Bass, opus 45, 1998–2000), and her music in concert (*Sextett für Streicher, opus 44*; Sextet for Strings, opus 44, 1998/99). A. N.

Leben, leben I *Life, Living,* 1997/98
2,782 works on paper, 30 x 20 cm each, 32 photographs, 30 x 20 cm each, 2 dollhouses, dimensions variable I 2.782 Arbeiten auf Papier, je 30 x 20 cm, 32 Fotografien, je 30 x 20 cm, 2 Puppenhäuser, Maße variabel
Installation view I Installationsansicht, Carnegie International 1999–2000, Carnegie Museum of Art, Pittsburgh, PA.

DESTINY DEACON

*1957 in Maryborough, Queensland, Australien/
Australia. Lebt/Lives in Melbourne, Australien/Australia.

Mit einem Augenzwinkern dekonstruiert Destiny Deacon die rassenspezifischen Gegensätze, die einst die künstlerische Produktion der Ureinwohner Australiens bestimmten und begrenzten. Ihre Bilder vereinen gewöhnliche Indigenität mit einfallsreicher „Verrückung" des Gewöhnlichen, sodass ihre Objekte und Motive, dem alltäglichen Kontext entzogen, ein unabhängiges semiotisches Leben annehmen. Deacon gehört zur Generation der „urban aboriginal"-Künstler, die ihre Arbeit als Blak Art bezeichnen und die sich in den neunziger Jahren gegen das in der nationalen Vorstellung verbreitete Klischee wandten, einheimische australische Kunst sei zwangsläufig eine Darstellung kultureller Wahrheit. Blak Art hingegen macht sich koloniale Stereotypen von Indigenität zu Eigen und spielt sie als Pastiches zurück: Alltagskitsch aus den fünfziger Jahren und Gartenzwerge, verziert mit „folkloristischem Design", werden zu höhnischen Readymades – es sind ironische Marksteine der interkulturellen Distanz, die diese Künstler haben.

Deacons Fotografien, Videoarbeiten und Performances zeugen von Scharfsinn und Humor. Sie drehen sich intelligent um Fragen der Identitätspolitik und generieren eine ästhetische Spannung zwischen Entropischem und Geordnetem. Da die Künstlerin in der Regel Freunde und Bekannte als Sujet wählt und überwiegend im eigenen Wohnzimmer oder in den Wohnungen ihrer Modelle arbeitet, wirken ihre Fotografien und Videos zufällig und episodisch. Arbeiten wie *Last Laugh* (1995) lassen an naive Schnappschüsse denken, während das Motiv „junges Supergirl" und die Palette von Primärfarben aus *Someday I'll Fly Away* (1999) eben diese Naivität als offene Art begreifen, die Welt zu betrachten. Das Nebeneinanderstellen deutet auf einen künstlerischen Ansatz, der das köstlich Nichtauthentische (ein Supergirl-Kostüm) mit der Authentizität des Readymade (Virginias Puppe) verschmilzt.

Das Video in Deacons Installation *Forced into Images* (2001) setzt dieses Thema von kindlichem Wunschbild und spielerischer Selbstdarstellung fort: Subjektivität und Identität werden „entwesentlicht" und eine problematische kulturelle Einstellung zu Differenz wird entlarvt. Wenn „das Selbst ein Bild ist", wie Jacques Lacan es ausdrückt, dann macht bereits die simple prä-technische Aufführung „Kinder tragen Gesichtsmasken anderer Familienmitglieder" das Selbst noch anfälliger dafür, aus dem Kontext zu fallen, als es sich Lacan vorgestellt haben mag. Das unterstreichen auch andere Werke der Künstlerin mit ihrer Verwendung von Bildern der „zweiten und dritten Generation" – Bubblejet-Drucken von Polaroids oder digital bearbeitetem Material. In den scheinbar darstellenden Bildern von *Postcards from Mummy* (1999) sind die Objekte von phantasmatischer Theatralik. Der Einsatz von Text durchbricht die reine Darstellung und schafft eine Art piktografischer Assemblage, in der die Wörter Bestandteil des Bildes werden, auf das sie sich beziehen. Die Arbeit kommentiert selbstironisch das Bild und vervielfacht die Perspektiven auf eben dieses, als wenn es bedeuten wollte, dass Identität nicht Schicksal ist, sondern vielmehr ein Readymade.

Destiny Deacon gleefully deconstructs the race-based oppositions that once defined and delimited the visual production of aboriginal Australia. Her images combine an ordinary indigeneity with an ingenious displacement of the ordinary, so that, removed from a quotidian context, her objects and subjects take on an independent semiotic life. Deacon's work is associated with the 1990s generation of "urban aboriginal" artists that call their work "Blak Art," operating against the compulsory performance of cultural truth assigned to Australian indigenous artists in the popular national imagination. Instead, Blak Art appropriates colonial stereotypes of indigeneity and plays them back as pastiche: "native designs" adorning 1950s everyday kitsch and garden gnomes become barbed readymades, ironic markers of the intercultural distance these artists have traveled.

Deacon's works in photography, video, and performance manifest an astute wit and humor, a sophisticated spin on identity politics and an aesthetic tension between the entropic and the ordered. Her subjects are often friends and acquaintances, and her photographs and videos are made in her own living room or in the homes of her subjects, giving the work a certain aleatory appearance. Works such as *Last Laugh* (1995) evoke the naiveté of the snapshot, whereas *Someday I'll Fly Away* (1999), with its young supergirl subject and its palette of primary colors, frames this naiveté as an open way of seeing the world. This juxtaposition suggests an approach which merges the deliciously inauthentic (a supergirl costume) with the authenticity of the readymade (Virginia's doll).

The video in her installation *Forced into Images* (2001) continues this theme of childish vision and playful self-imaging, de-essentializing subjectivity and identity while unmasking a problematic cultural attitude to difference. If "the self is a picture," as Jacques Lacan once said, then even the simple pretechnical performance of "children wearing masks with features of other family members" renders the self more prone to contextual slippage than Lacan may have imagined. A point underscored elsewhere in Deacon's work with its use of second and third generation images, such as bubblejet prints from polaroids and digital imaging. Even in the seemingly representational images of *Postcards from Mummy* (1998) there is a phantasmic theatricality to the objects. The use of text further disrupts representation, creating a kind of pictographic assemblage in which the words form part of the image to which they refer. The work provides its own ironic commentary on the image and multiplies the perspectives of the image as if to suggest that identity isn't destiny. It's a readymade. E.S.

From the series *Postcards from Mummy: Postcard from Innisfail* I Aus der Serie *Postkarten von Mama: Postkarte aus Innisfail,* 1998 Two black-and-white laser prints, framed I Zwei Schwarz-Weiß-Laserprints, gerahmt, 54,5 x 38,2 cm

Postcard from Innisfail (6) 1998. Davis

Postcard from Innisfail (5) 1998. Davis

STAN DOUGLAS

*1960 in Vancouver, Kanada/Canada. Lebt/Lives in Vancouver.

Stan Douglas' Arbeit *Le Détroit* (2000) enthält viele für sein Gesamtwerk charakteristische Elemente. In *Le Détroit* nimmt eine große Projektionsfläche die Mitte des Ausstellungsraums ein. Ein auf beide Seiten der Projektionsfläche geworfener 35-mm-Film – positiv auf der einen und negativ auf der anderen Seite – zeigt eine junge Schwarze, die aus einem Chevrolet Caprice (ein in den USA als Streifenwagen sehr beliebtes Modell) aussteigt und in ein offensichtlich verlassenes Haus geht. Begleitet vom hin- und herschwingenden Licht einer Taschenlampe führt sie im Hausinnern gedankenverloren eine Reihe scheinbar bedeutungsloser Handlungen aus – sie hebt ein Stück Papier vom Boden auf und schließt eine halb offene Schranktür. Plötzlich sieht sie durch ein Fenster im ersten Stock, wie die Parklichter ihres Wagens ausgehen. Sie geht denselben Weg zum Auto zurück und macht dabei alle Eingriffe rückgängig. Als die Frau schließlich wieder im Auto sitzt und den Zündschlüssel umdreht, ist es, als sei zwischen ihrer Ankunft und ihrer Abfahrt nichts geschehen. An diesem Punkt beginnt ein neuer Loop. Die Erzählung wiederholt sich und hebt damit die Zeit auf, ohne eine Spur auf dem Schirm zu hinterlassen. Es ist eine fatale Parallele, dass auch keine Erinnerung mehr an die tragischen Proteste zu existieren scheint, die Detroit gegen Ende der sechziger Jahre erschütterten und dazu führten, dass die weißen Einwohner das Zentrum verließen und die Stadt halb verlassen zurückblieb. Soziale Ungerechtigkeit, Rassentrennung und völliges Desinteresse an der Zukunft sozial schwacher Bürger gehören offenbar zur Geschichte von Wiederholung und Vergessen – in Detroit wie in den Vereinigten Staaten im Allgemeinen – bis heute. Durch und durch konsequent in ihrem Aufbau reflektiert Douglas' Arbeit den Zustand der Dinge in der sorgsamen Analyse der eigenen Struktur und der filmischen Sprache.

Suspiria, Douglas' Arbeit zur Documenta11, ist ebenso wie *Le Détroit* darauf angelegt, Gedanken durch die Struktur des Werkes zu formulieren. Douglas analysiert hier die Struktur des Fernsehbildes unter überwachungstechnologischen Aspekten und geht dabei von Dario Argentos Horrorklassiker *Suspiria* und von Märchen der Brüder Grimm aus. Der gemeinsame Nenner dieser scheinbar völlig disparaten Bezugspunkte ist der Begriff des „Geistes", wie er im psychoanalytischen Diskurs, aber auch für die Erscheinungen aus Argentos Film und in den Grimmschen Märchen verwendet wird. Douglas erinnert an die phantasmagorische Natur des Fernsehbildes und sucht die Position des zeitgenössischen Subjekts im Angesicht dieses machtvollsten Überwachungsinstruments des Spätkapitalismus zu klären – das nämlich imstande ist, Subjektivität so weit zu instrumentalisieren, dass sie, zum bloßen Gespenst ihrer selbst geworden, sogar der eigenen Zeitlosigkeit beraubt ist.

Stan Douglas's work *Le Détroit* (2000) displays many of the elements that characterize his work. In *Le Détroit,* a large screen occupies the center of the exhibition space. A 35mm film image projected onto both sides of this screen, positive on one side and negative on the other, shows a young black woman getting out of a Chevrolet Caprice (a car favored for police patrol cars in the United States) and entering what appears to be an abandoned house, guided by the swinging light of a flashlight. Inside the house, the woman distractedly carries out a series of apparently insignificant actions, like picking a piece of paper up off the floor or closing a half open wardrobe door. At one point the woman looks out of one of the upstairs windows to see her car's parking lights go out unexpectedly. She retraces her steps towards the car, undoing on the way her previous actions. When the woman gets back into her car and turns the key in the ignition it is as if nothing had happened between her arrival and her departure from the house. At this point the loop starts over. The narrative repeats itself, annulling the passage of time; no trace is preserved on the screen. In a fatal parallel, no memory seems to persist of the tragic protests that shook Detroit towards the end of the 1960s, causing the exodus of its white citizens from the city center and leaving the city half abandoned. Social injustice, racial segregation, and total disinterest in the future of its underprivileged citizens seem to be the components of a history of repetition and forgetting in Detroit and in the United States in general that continues still today. Douglas's work does what it says and says what it does, reflecting the state of things in a careful analysis of its own structure and of cinematographic language.

Suspiria, Douglas's work for Documenta11, shares with *Le Détroit* a concern for thinking through the very structure of the work. In this case the structure of the televised image as it relates to surveillance techniques is analyzed. In his work, Douglas uses Darío Argento's classic horror film, *Suspiria,* and fairy tales by the brothers Grimm as points of departure. The common denominator of these apparently disparate references is the idea of the "ghost" as employed in psychoanalytic discourse, but also in relation to the spectral figures who inhabit Argento's film and Grimms' tales. Douglas reminds us that the nature of the televised image is phantasmagorical. His aim is to analyze the position of the contemporary subject in the face of the powerful control tool of late capitalism, capable of instrumentalizing subjectivity to the point of rendering it ghostly, severing it even from its own timelessness. C.B.

Le Détroit I *Detroit,* 2000
Synchronized two-track 16mm film, black and white, sound, projected with two 16mm projectors on to one screen, looping device, anamorphic lens I Synchron geschalteter zweipuriger 16-mm-Film, schwarz-weiß, Ton, mit zwei 16-mm-Projektoren auf eine Leinwand projiziert, Loopsystem, anamorphotische Linse

CECILIA EDEFALK

*1954 in Norrköping, Schweden/Sweden. Lebt/Lives in Stockholm.

Cecilia Edefalks Medium ist die Malerei. Ihre Gemälde zeigen sich wiederholende Motive und sind meist zu Gruppen zusammengestellt. Immer sind es Personendarstellungen vor einem unbestimmten, meist monochromen Hintergrund. Die Farbigkeit der Bilder erscheint insgesamt sehr reduziert, vermittelt aber durch die Technik der Lasurmalerei einen zarten, durchscheinenden Eindruck.

Obwohl sie die Motive rekapituliert, variiert Edefalk jedes Werk einer Gruppe individuell in Ausdruck und Farbe. Drehung und Spiegelung der Figuren sowie die Veränderung ihrer Größe dienen als kompositorische Mittel. Die Entwicklung eines Bildmotivs ist für Edefalk ein langsamer, mitunter jahrelanger Prozess, denn erst über den Malvorgang tastet sie sich an das Sujet heran. Die Motive selbst basieren auf Fotografien. Die abgebildeten Figuren befinden sich immer in der vordersten Bildebene. Trotz ihrer starken Präsenz wirken diese irreal, festgefroren in der Momentaufnahme; sie füllen den Raum und lassen ihn gleichzeitig zeitlos und leer anmuten. Die Farbe gibt Auskunft über den Seelenzustand der Figuren.

Die Serie der Selbstporträts (1992–1994) zeigt die Künstlerin als Taillenbild im Dreiviertelprofil. Immer in der gleichen Haltung ändert sich doch auf subtile Weise die Erscheinung der Figur. Kein Bild entspricht ihrer Lebensgröße. Auch die graue Farbe des Inkarnats ist ein Hinweis auf die Unwirklichkeit des Porträts. Die verschiedenen Konstellationen werden durch die Titel – Mirror, Echo, Replique und Two Copies – genauer bezeichnet. Die Hängung der Gemälde im Raum und ihre Distanz zueinander gehören zur künstlerischen Aussage und ergänzen die Platzierung der Figuren im Bild. Another Movement (1990) lautet eine Serie von sieben Gemälden mit der Darstellung eines Paares in Rücken- und Seitenansicht. Der Titel könnte auf die Berührung des Mannes anspielen, aber auch auf das optische „Vor- und Zurückspringen" der Gemälde durch ihre sehr unterschiedlichen Formate. Das immer gleiche Motiv eines kopulierenden Paares der vierteiligen Serie In the Painting the Painting (1995/96) ist diagonal in das jeweilige Bildquadrat eingefügt, in den vier Gemälden aber jeweils um 90° gedreht. Im erschrockenen Gesicht des Mannes scheint sich Schwindel zu spiegeln.

Häufig wirken die Gemälde von Edefalk in hohem Grade symbolistisch, so die träumerisch-entrückte Gestalt von Baby (1986/87) oder die feierlich-mystische Figur The Be-Girl (1988–1999). Die Bilder der Elevator-Serie (1998) zeigen eine engelsgleiche somnambulische Figur mit erhobenen Armen und starrem Gesicht, die durch ihr strahlend helles Gewand zu einer Lichtgestalt wird.

Für die Documenta11 entstand die Serie To View the Painting From Within (2000–2002) mit der Abbildung eines antiken marmornen Halbreliefs in unterschiedlichen Ansichten. Der Titel verweist auf die Innensicht dieser unbestimmbaren Figur und die mögliche Identifikation des Betrachters mit ihr.

Painting is Cecilia Edefalk's chosen medium. Many of her paintings contain repeated themes and are combined into groups; they all depict people in front of unspecific, usually monochromatic backgrounds. In general, the colors are quite subdued, but Edefalk's technique of painting in layers lends them a soft translucence.

Despite the repetition of motifs, each work in a group is individually varied in expression and color. Other compositional means include rotating, mirroring, and changing size of the figures. For Edefalk, developing a motif is a long process, which sometimes lasts for years, since she employs a step-by-step procedure of painting to feel her way toward the subject. Motifs are taken from photographs, and the figures are always in the foreground. In spite of their strong presence, they appear unreal, frozen in the moment of the snapshot; they fill the space and yet simultaneously make it seem timeless, empty. Colors provide information about the mental or psychological state of the figures.

The 1992–1994 series of self-portraits shows the artist from the waist up in three-quarters profile. Although always in the same position, the figure's appearance changes in subtle ways. No portrait is life-size, and the gray color used for the image of the artist emphasizes the unreality of the portrait. The use of titles (Mirror, Echo, Replique and Two Copies) more exactly defines the various groups of paintings. In addition to the position of the figures within the painting, the way the works are hung in the room and their distance to each other are also part of the artist's statement. Another Movement (1990) is the title of a series of seven paintings of a couple shown from the back and side. The title might allude to the man's touch, as well as to the way the eye is forced to jump back and forth between the paintings as a result of their very different formats. The four paintings In the Painting the Painting (1995/96) shows a copulating couple, in each case in one quadrant of the picture, but each time turned into a different quadrant around the painting's central point. The face of the man seems to show a fear of dizziness.

Edefalk's paintings, such as the dreamy, withdrawn Baby (1986/87) and the celebratory, mystical figure of The Be-Girl (1988–1999), often appear to be highly symbolic. The paintings in the Elevator series (1998) show an angelic, somnambulant figure with raised arms and a still face, whose glowing, bright gown turns her into a silhouette of light.

Documenta11 is showing To View the Painting From Within (2000–2002), a new series featuring various perspectives of a classical marble half-relief. The title refers to the indefinite character's view from within and the viewer's possibel identification with it. A. N.

To View the Painting From Within | Das Bild von innen heraus sehen, 2000–2002
Oil on canvas | Öl auf Leinwand, 10 x 7cm

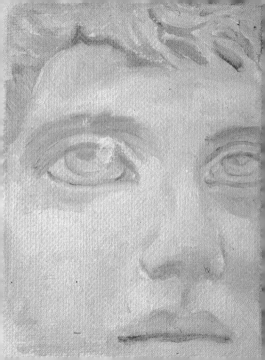

WILLIAM EGGLESTON

***1939 in Memphis, TN, USA. Lebt/Lives in Memphis.**

William Eggleston, ein Pionier der Farbfotografie der ausgehenden sechziger und frühen siebziger Jahre, ist inzwischen international bekannt für die klaren, überzeugenden Farben seiner Dye-Transfer-Abzüge von Motiven aus den amerikanischen Südstaaten. Talentiert im Aufspüren des Erhabenen im Gewöhnlichen, Trivialen und Alltäglichen, findet Eggleston faszinierende Harmonie an den unerwartetsten Orten. Beifall findet seine Arbeit vor allem, weil sie die Augen für die uns unmittelbar umgebende Alltagswelt öffnet und den Blick dafür sensibilisiert, Vorhandenes, so merkwürdig es auch sein mag, vorurteilslos zu erkennen. In dieser Hinsicht könnte man ihn in die Nähe von Walker Evans, Garry Winogrand und Robert Frank rücken, doch ist Eggleston, wie Walter Hopps einmal gesagt hat, der einzige, „dessen fotografischer Anspruch darüber hinausgeht, ein einziges perfektes Bild zu machen, und dessen Arbeit sich stets mit dem eigenen Umfeld befasst, so als sei das Mississippi-Delta das Zentrum des Kosmos".

Als John Szarkowski ihm 1976 als erstem Fotografen eine Einzelausstellung mit Farbfotos im New Yorker Museum of Modern Art ermöglichte, erregte er fast überall Verwunderung oder Ärger – nicht etwa wegen der Sujets, die den Kritikern alltäglich und simpel und deshalb fragwürdig vorkamen, sondern weil Egglestons Fotos farbig waren. Schließlich verwendete man solch intensive Farben, die mit dem inzwischen überholten Dye-Transfer-Verfahren erzielt wurden, damals fast nur für Zeitschriftenwerbung und andere kommerzielle Zwecke. Seriöse Fotografen dagegen meißelten ihre zeitlosen Inspirationen in Schwarz-Weiß, getreu Evans' Diktum: „Farbfotografie ist ordinär."

Wie die meisten Kritiker inzwischen wissen, beschloss Eggleston damals, mit Farbfotografie zu experimentieren, weil er Wege suchte, Erfahrung genauer und sinnlicher als mit der herkömmlichen Schwarz-Weiß-Fotografie festzuhalten. Für die Documenta11 wurden Iris-Prints aus einer Fotoserie ausgewählt, die im und um den Südwesten der USA aufgenommen wurden. Die unergründlichen Landschaften sind als befremdliche und exzentrische Environments mit Werbetafeln, Flaggen, religiösen Motiven, Parkplätzen, umgekippten Autos und anderen Alltagsobjekten aufgenommen. Sie beweisen nicht nur Egglestons Blick für Lokaltypisches und Ephemeres, sondern vergegenwärtigen auch den langsamen Rhythmus einer oft gespenstischen, immer aber lyrisch reinen Vision, die durchaus auch beiläufig und schmucklos erscheint. Dennoch ist sie stets durchorganisiert; Farben, Aufnahmewinkel und Kameraperspektive sind sorgfältig kalkuliert und die Aussagen so versteckt und bedeutungsgeladen wie in einem brillanten Gedicht, welches auf einen tieferen Sinn und einen Kosmos verweist, der den Bruch der Geschichte überdauert.

A pioneer in color photography in the late 1960s and early 1970s, William Eggleston is today internationally acclaimed for the hard-edged and persuasive colors of his dye-transfer prints of the American South. Having the talent to see splendor in the ordinary, the trivial and the quotidian, and finding compelling harmonies in the most unlikely places, his work is praised for opening our eyes to the world outside our door and to the world we live in, for clarifying our vision, for seeing what is there, however strange, without prejudice. In this he might be close in sensibility to Walker Evans, Garry Winogrand, and Robert Frank, but Eggleston is, in the words of Walter Hopps, the only one "with ambitions for photography that go beyond the making of a single perfect picture, who keeps his work centered on turf, as though the center of the cosmos were the Mississippi Delta."

However, when John Szarkowski distinguished him as the first photographer to have a solo show of color prints at the New York Museum of Modern Art in 1976, he mystified or infuriated almost everyone. Not so much for his subject matter, which the critics thought so mundane and simple to the point of being questionable and impenetrable, but because Eggleston's photographs were in color. After all, the intensity of color achieved by the now-defunct dye-transfer method of printing had until then been primarily used for magazine advertising and other commercial purposes. And, up to that time, serious photographers had preserved their enduring ideas in black and white, following Evans's dictum: "Color photography is vulgar."

Since then, most critics have caught up with Eggleston and his resolve to experiment with color photography as a means to record experience in more accurate and sensual terms than traditional black and white. The groups of Iris prints selected for Documenta11, from a collection taken in and around the southwestern United States, equally demonstrate that the inscrutable landscape he construes as an alienating and eccentric environment, with commercial signage, banners, religious images, parking lots, overturned cars, and other humble subjects, is not just the evidence of an eye for the vernacular and the ephemeral, but also presents the slow rhythms of an often lurid, always lyrical and unadulterated vision. For even when most offhand and bare, this vision is always highly organized, with color, camera angles, and perspectives carefully thought out, with meanings as oblique and loaded as a great poem invoking deeper concerns and a cosmos that perseveres on the fracture of history. O. Z.

Untitled (Open Door Into Trailer, Arizona) | *Ohne Titel (offene Tür in einen Wohnwagen, Arizona)*, 1999–2000
Iris print, 76 x 61 cm

MARIA EICHHORN

*1962 in Bamberg, Deutschland/Germany. Lebt/Lives in Berlin.

„Gegenstände sind keine statischen Objekte, sie repräsentieren soziale und institutionelle Prozesse und unterliegen einer permanenten Veränderung, auch definitorisch. Ich sehe Gegenstände immer im Zusammenhang mit Vorgängen. Und Vorgänge immer im Zusammenhang mit Menschen, die diese Vorgänge auslösen oder darin involviert sind. Die Verwendung von Gegenständen und Texten in meiner Arbeit ist meist an eine konkrete Handlung, ein Ereignis oder einen Vorgang gebunden."

Das „Ereignis" der Arbeit Maria Eichhorns für die Documenta11 ist die Gründung einer Aktiengesellschaft, die keinen Kapitalzuwachs duldet. Sie pervertiert damit das eigentliche Prinzip dieser gewinnorientierten Gesellschaftsform. Das Gründungskapital wird gemeinsam mit dem Dokumentationsmaterial des Gründungsvorgangs und den notariellen Urkunden im Ausstellungsraum präsentiert. Was geschieht mit dem realen Kapital als Teil der künstlerischen Arbeit? Wie bestimmt sich deren Verkaufswert? Was passiert bei Auflösung der Aktiengesellschaft nach frühestens fünf Jahren? Neben diesen Überlegungen finden in Eichhorns Arbeit auch Fragen zu den Prinzipien einer kapitalistisch orientierten Gesellschaft Eingang.

In ihren Projekte, die grundsätzlich über einen längeren Zeitraum angelegt sind, thematisiert Eichhorn gesellschaftsrelevante und politische Inhalte sowie Fragen zur Autonomie eines Kunstwerks und zu seiner Autorenschaft. Um ihre Arbeiten realisieren zu können, sucht sie die Mitarbeit von Personen aus anderen Disziplinen.

1989 begann Eichhorn ihre Arbeit *Vorhang,* welche die Herstellung von insgesamt zehn verschiedenfarbigen Vorhängen umfasst und 2001 abgeschlossen wurde. Auf unterschiedliche Weise definieren die Vorhänge jeweils den sie umgebenden Raum als Ort eines spezifischen Geschehens. Ihre Arbeit für *Skulptur. Projekte in Münster 1997* bestand darin, ein Grundstück zu erwerben und alle Vorgänge um diesen Erwerb zu dokumentieren. Die Arbeit spiegelte die Bedingungen von Besitzstand, Immobiliensituation sowie die sozialen und politischen Zustände in Münster, ohne dass der Besitz zu Eigentum wurde. Eichhorns Projekt 1. *Mai, Film, Medien, Stadt* verwandelte 1999 den Portikus in Frankfurt in eine „Redaktionsstätte". Im Laufe der Ausstellung fanden verschiedene Projekte, Workshops und Vorträge statt, es wurden Videos und Filme produziert, ein Architekturführer und ein Alphabet entwickelt. Die benötigten Materialien und die entstandenen Produkte verblieben im Ausstellungsraum und füllten ihn nach und nach. Zu Eichhorns jüngsten Arbeiten gehört das Projekt *Das Geld der Kunsthalle Bern* (2001), das sich mit den ökonomischen Verhältnissen der Kunsthalle Bern befasst. Die bereits einmal zur Finanzierung und zum Betrieb der Kunsthalle Bern edierten Anteilscheine wurden symbolisch neu herausgeben und das Geld für dringend erforderliche Unterhalts- und Renovierungsarbeiten verwendet.

"Objects are not static things. They represent social and institutional processes and are subject to permanent changes, also in terms of their definition. I always see objects in connection with events—and events are always connected with people, who instigate these events or are involved in them. The objects and texts in my work are mostly linked to a concrete act, an event, or an occurrence."

For Documenta11, Maria Eichhorn has created an "event": the founding of a public company that does not tolerate any capital gains and thus perverts the actual principle behind this kind of profit-oriented company. The venture capital, the documents on the foundation of the company, and the notarized deeds will be presented in the exhibition space. What happens to the real capital, which is a part of the artist's work? How can its sale value be determined? What will happen after the company is dissolved—something that will occur in five years, at the earliest? Apart from contemplating the existence and value of an artwork, Eichhorn's work also raises questions about the principles of a capitalist society.

Eichhorn's projects are generally meant to run over longer periods of time. She creates the conditions for complex events, to address socially and politically relevant issues, but also to question the autonomy of an artwork and its authorship. In order to produce her works, she cooperates with people from other disciplines. In 1989, Eichhorn began work on *Vorhang* (Curtain), for which ten curtains of various colors were manufactured; the work was finished in 2001. In different ways, the curtains define the space around them as the location of specific events. Her work for *Sculpture. Projects in Münster 1997* consisted of buying a piece of property and documenting the procedure involved. This work exposed the preconditions of becoming an owner of property, the real estate situation, and the social and political conditions in Münster, without allowing the real estate to actually become private property. Her 1999 project *May 1, Film, Media, City* turned the Portikus exhibition hall in Frankfurt into an "editing workshop." During the course of the exhibition, various projects, workshops, and lectures took place. Videos and films were produced; an architectural guide and an alphabet were developed. All the products and the materials needed to make them remained in the exhibition space, gradually filling it up. Among Eichhorn's most recent works is the project *Das Geld der Kunsthalle Bern* (The Money of the Kunsthalle Bern, 2001), which analyses the economic condition of the Kunsthalle Bern. Part of the exhibition included undertaking urgently required maintenance and renovation work and reissuing share certificates that were once used to finance and operate the Kunsthalle Bern. A.N.

Maria Eichhorn Aktiengesellschaft | Maria Eichhorn Public Limited Company, 2002
Foundation hearing and establishing proceedings of the supervisory board of the Maria Eichhorn Public Limited Company in Berlin on March 22, 2002 | Gründungsverhandlung und konstituierende Aufsichtsratssitzung der Maria Eichhorn Aktiengesellschaft am 22. März 2002 in Berlin, from left to right |

von links nach rechts: Klaus Mock (notary | Notar), Dr. Tilman Bezzenberger (vice-chairman of the supervisory board | stellvertretender Vorsitzender des Aufsichtsrats), Okwuchukwu Emmanuel Enwezor (chairman of the supervisory board | Vorsitzender des Aufsichtsrats), Denise Terry Williams (member of the supervisory board | Mitglied des Aufsichtsrats), Maria Eichhorn (founder, executive board | Gründerin, Vorstand).

TOUHAMI ENNADRE

*1953 in Casablanca, Marokko/Morocco. Lebt/Lives in Paris.

Touhami Ennadre sucht nach Wegen, sich seinen Sujets ohne Konventionen, Vorurteile oder gefälschte Szenarien zu nähern – gewissermaßen kontrapunktisch zu den fotografischen Verfahren des Fixierens, Rahmens, Konstruierens und Kategorisierens. Am Beginn seiner künstlerischen Betätigung, bei der Beerdigung seiner Mutter 1975, setzte sich Ennadre erstmals mit der Fähigkeit der Kamera auseinander, Körper in kritischen Situationen abzubilden. Darauf bedacht, die Tendenz zur Sensation in der Fotografie zu vermeiden, stellte Ennadre keine trauernden Personen dar, sondern zeigte sie in Spannung und Transformation; dabei verzichtete er auf das Gesicht oder den Körper als Ganzes. Es gelang ihm, Emotion in der Abbildung einer Hand zu kommunizieren.

Diese Art der Porträtfotografie – oder Anti-Porträtfotografie – ersetzt gleichsam die bloße Aufzeichnung des menschlichen Gesichts. Das zeigt sich am deutlichsten in seiner bemerkenswerten Serie geradezu meditativer Aufnahmen von nackten Rücken, Füßen und Händen – skulpturalen Studien von Haut und Struktur, die 1978 in Indonesien und Indien entstanden. Spontan, ohne Stativ oder kalkulierte Arrangements fotografiert, wirken die aus nächster Nähe aufgenommenen Sujets gleichwohl hochgradig erprobt und konstruiert.

Ennadre distorsiert Orte von Erinnerung, Identität, Tod und Katastrophe durch die Repräsentation unbestimmter Symbole dieses Ortes und des Traumas, das sich dort abspielte. Oft wird dem Betrachter die Bedeutung erst klar, wenn er die historische Stätte des Traumas identifizieren kann. Ennadres *Sarajevo-Mahnmal* (1996) erinnert an eine tote Taube, sein *Gedenken an Auschwitz* (1992) hat die Form von Koffern und Töpfen. Beharrlich verschleiert der Künstler immer wieder kulturell aufgeladene Zeichen mit dem Ziel, Ethnizität, Geschichte und Territorium zu entkörperlichen und mit seinen Objekten Kulturen und Völker zu ersetzen. Ennadre lokalisiert lediglich Symbole, die Ort und Identität in Erinnerung rufen, gleichzeitig jedoch nicht kulturspezifisch, sondern universell sind – wie Haut, Sterne, Hände oder Schuhe. Den Betrachtern eröffnen sich Lesarten voller Anspielungen und spielerischer Momente, die sich kurzzeitig verlagern können – Stein erscheint wie Haut, Haut wie Fels.

Angesichts der Nähe zu den tragischen Geschehnissen des 11. September kam Ennadre nicht umhin zu fotografieren – obwohl er sich dem dokumentarischen Stil stets verweigert hatte. Auf der Documenta11 wird seine Serie *September 11* erstmals ausgestellt. Der widersprüchliche Charakter des Ereignisses – die durch hartnäckige Rauch- und Staubwolken dringende Sonne, ihn umarmende und sich ihm wieder entfremdende Menschen, seine Angst und Konfrontation mit der Tragödie – brachen seinen langen Widerstand gegen die Reportage. Er verbrachte viel Zeit mit Blutspendern, Familien, Trauernden und Helfern, dokumentierte fotografisch den Prozess von Hilfe und Heilung – eine betende, weiß gekleidete Kniende vor einem kerzengeschmückten Mahnmal im Union Square Park, einen mit der US-Flagge vermummten Mann am World Trade Center. Die Bilder verdeutlichen Ennadres ungebrochenes Bestreben nach Transfiguration seiner Sujets und nach Dokumentation des Traumas als Mahnmal.

Touhami Ennadre endeavors to discover how to work without conventions or prejudices in approaching a subject, without fabricating a false scenario, making his a project that is contrary to the operations of the photographic—to fix, frame, construct, and categorize. At his mother's funeral in 1975 at the onset of his career, Ennadre initiated his negotiation of the camera's capacity to document the body in problematic ways. Negating the tendency of the camera to sensationalize, Ennadre did not represent subjects in mourning, but pictured them in tension and transformation. He avoided the face and the body as totalities and was able to communicate emotion in the image of a hand. His mode of portraiture, or anti-portraiture, serves to replace the recording of the human face. This tendency is most apparent in his notable series of meditations on nude backs, feet, and hands—sculptural studies in skin and texture from India and Indonesia in 1978. Spontaneous and unstaged, what appears to be highly rehearsed and constructed is actually the result of impromptu shooting with a hand-held camera, positioned in close proximity to his subjects.

Ennadre dislocates sites of memory, identity, death, and disaster through the representation of indistinct emblems of the place and its traumatic event. Often, meaning does not register for the viewer until the historical location of trauma is identified. Ennadre's *Memorial to Sarajevo* (1996) takes the form of a dead pigeon, and his *Commemoration of Auschwitz* (1992) remains in the form of suitcases and pots. He insistently and repetitively obscures charged cultural signs in an effort to decorporealize ethnicity, history, and territory, as objects become surrogates for cultures and peoples. He locates emblems that memorialize place and identity but also resonate a lack of cultural specificity and speak to the universal—skin, stars, hands, shoes. The viewer is confronted by allusive readings and moments of slippage—stone appears like skin, flesh like rock.

Resistant his entire career to taking pictures in the documentary style, Ennadre's proximity to the tragedy of September 11th nonetheless compelled him to begin shooting photographs. His series *September 11* is exhibited for the first time in Documenta11. Ennadre's incessant rejection of reportage was dispelled by the contradictions of this event—the sun piercing through the persistent smoke and dust, people embracing him and estranging him, his fear and confrontation of the tragedy. He spent time with blood donors, families, mourners, and rescue workers, photographing the process of relief and healing, a woman kneeling in white garb praying in Union Square park with a candle memorial, and a man with an American flag as a mask near the World Trade Center. These images signal a continuation of Ennadre's efforts towards the transfiguration of subjects and the documentation of trauma as memorial. L.F.

New York, September 11 | New York, 11. September, 2001
Black-and-white photographs | Schwarz-Weiß-Fotografien

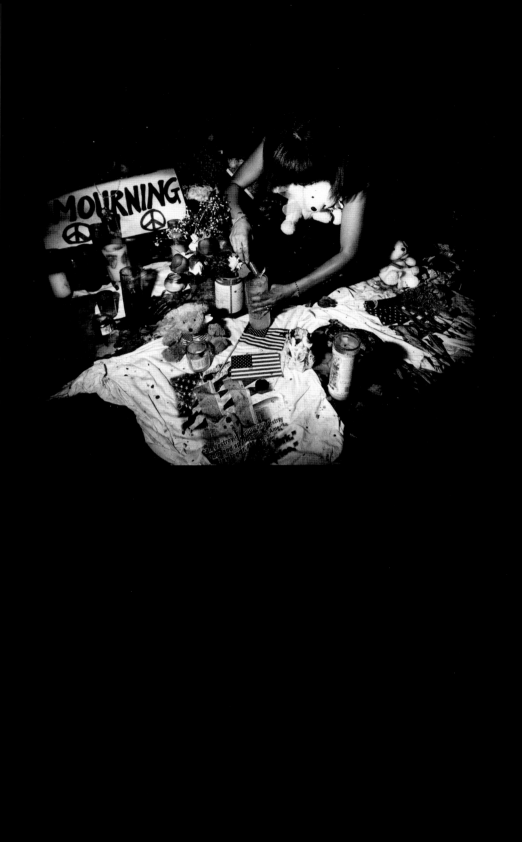

CERITH WYN EVANS

*1958 in Llanelli, Wales. Lebt/Lives in London.

Cerith Wyn Evans spielt auf die Nähe von Literatur und Film an, wenn er das kommunikative Potenzial von Skulptur untersucht, indem er chiffrierte Botschaften in ein Wahrnehmungslabyrinth zitatartiger Bezüge inskribiert. Getarnt durch die Dialektik zwischen Sichtbarem und Unsichtbarem pulsiert Information, intuitiv auf einen sichtbaren Rhythmus eingestellt. Evans' filmische Installationen und „Film-Skulpturen" erobern, angeregt von einer Psychologie der Wahrnehmung, den imaginären Raum von Traumlandschaften.

Inverse, Reverse, Perverse (1996), ein großer konkaver Spiegel in der Form der Linse des Auges und an die Brennweite von Le Corbusiers modernisierter Norm des Standards zu sehen angepasst, reflektiert spielerisch das Vergnügen des Sehens und Gesehenwerdens, indem es dem herantretenden Betrachter drei verschiedene surreale Spiegelbilder bietet: Inversion, Reduktion und groteske Verzerrung. Tatsächliche und mentale Projektion gehen Hand in Hand in Evans' wiederkehrenden Spiegelmotiven – zum Beispiel in seiner *Installation at Pino Casa Grande* (1996). Große konkave Spiegel, gefüllt mit Wasser und lebenden Goldfischen, sind um Lampen herum arrangiert, die Licht von oben abgeben und dabei die Projektion eines Films „weiß-aufweiß" auf die Wände der Galerie simulieren.

Cleave 00 (2000) besteht aus der Projektion von Myriaden wirbelnder weißer Glühbirnen und einer Diskokugel, die in Morsezeichen übersetzte Fragmente von Texten William Blakes übertragen. Sie ruft ein leichtes Gefühl der Übelkeit hervor, während sie Worte in Lichtsignale auflöst. Das Entropische sichtbar machend (das Geräusch, das während der Übertragung kodierter Bits und Fragmente von Informationen zwischen Sender und Empfänger entsteht), legt Evans filmische und fotografische Wahrnehmungstechnologien auf ihre phänomenologischen und viszeralen Formen des Genusses bloß. Durch Verwendung fluktuierender Wellen von Licht und Dunkel schreibt seine „naturalisierte" Metaphorik Botschaften in den Galerieraum, um den inneren Raum des geistigen Auges als Quelle von Vision und Traum auszuloten.

Evans Welt literarischer und filmhistorischer Zitate ist ein Portal zu einem anderen Universum, das durch eine Vielzahl von Referenzen und Chiffren geöffnet wird, und das nur emotional – in einem situationistischen „dérive" – durchschritten werden kann. Für *Take Your Desires for Reality* (1996) und *P.P.P. (Oedipus Rex)* (1998) wurden Zitate von Karl Marx („Ich nehme meine Wünsche für Realität, weil ich an die Realität meiner Wünsche glaube.") und dem italienischen Regisseur Pier Paolo Pasolini aus Feuerwerkskörpern auf ein Holzgerüst installiert. Entzündet bei Sonnenuntergang auf einem Dach unweit des Ortes, an dem Pasolini sein letztes Abendmahl verzehrte, und in der Bucht von Ostia, wo er noch in derselben Nacht ermordet wurde, verschmelzen in *P.P.P. (Oedipus Rex)* Gedankenimpressionen, lodernde Nostalgie und Flammen des Gedenkens.

Alluding to the threshold between the literary and the filmic, Cerith Wyn Evans explores the communicative potential of sculpture by inscribing encrypted messages into a perceptual maze of quotational references. Intuitively tuned into a visual beat, information is pulsed, hidden in a dialectic between the visible and the invisible. Evans's cinematic installations and "film-sculptures" occupy the imaginary space of dreamscapes, stimulated by a psychology of perception.

Inverse, Reverse, Perverse (1996), a large concave mirror in the shape of the lens of the eye and adapted to the focal point of Le Corbusier's modernized norm of standardized vision, playfully reflects on the pleasures of seeing and being seen by offering three different surreal reflections to the approaching spectator—inversion, reduction, and grotesque distortion. Actual and mental projection are simultaneously induced by Evans's recurrent mirror motifs, as in his *Installation at Pino Casa Grande* (1996). Large concave mirrors, filled with water and live goldfish, are arranged around lamps that emit light from above, simulating a "white on white" film on the surrounding gallery walls.

Cleave 00 (2000) consists of a projection of a myriad of spinning white light bulbs and a disco ball that transmit fragments of texts by William Blake transposed into Morse code, causing a sense of slight nausea while dispersing words into flashes of light. Visualizing the entropic (the noise that is created during the transmission of coded bits and pieces of information between sender and receiver), Evans strips filmic and photographic technologies of perception down to their phenomenological and visceral forms of pleasure. Using fluctuating waves of light and dark, his "naturalized" imagery writes messages into the gallery space to explore the inner space of the mind's eye as the source of imaging and dreaming.

Evans's world of literary and film historical quotations is a gateway to a different universe opened up by a multitude of references and ciphers that can only be traversed emotively in a Situationist "dérive." In *Take your Desires for Reality* (1996) and *P.P.P (Oedipus Rex)* (1998), quotes from Karl Marx ("I take my desires for reality because I believe in the reality of my desires") and Italian filmmaker Pier Paolo Pasolini are crafted from fireworks on a wooden scaffolding. Scenically lit at sundown on a rooftop around the corner from where Pasolini ate his last supper and in the bay in Ostia where he was murdered that very same night, *P.P.P (Oedipus Rex)* dissolves into impressions of thought, glimpses of nostalgia, and flames of commemoration. N. R.

Cleave 00 | *Brechung 00*, 2000
Mirror ball, lamp, shutter, computer, text by William Blake, plants, dimensions variable | Spiegelkugel, Lampe, Jalousie, Text von William Blake, Pflanzen, Maße variabel
Installation view | Installationsansicht, Tate Britain, London, 2000

FENG MENGBO

*1966 in Peking/Beijing. Lebt/Lives in Peking/Beijing.

Seit den frühen neunziger Jahren arbeitet Feng Mengbo an der Schnittstelle von Malerei und digitalen Medien (*Game Over*, 1993/94), mit CD-ROMs (*My Private Album*, 1997) und Videospielen (*Taking Mt. Doom by Strategy*, 1997). Travestien politischer Propaganda (*Game Over, My Private Album*) und verschiedene kulturelle Einflüsse – von Videospielen bis zu den Ikonen der chinesischen Kulturrevolution und dem Hongkong-Action-Kino – verknüpft er zu einer universellen Alltagsikonografie. Als Verfechter einer dadaistischen Psychologie des Humors und der Verfremdung bescheinigt Feng den kapitalistischen Technologien und Kommunikationsnetzwerken, dass ihnen die Destabilisierung raum-zeitlicher Sprachen immanent ist. Er konfrontiert einen immer vorhandenen Subjektbezug mit Computertechnologien, deren wesentlichster Zug ihre enträumlichte Körperlosigkeit ist.

In *Q4U* (2001/02), seiner Arbeit für die Documenta11, erkundet Feng die hoch individualisierten Strukturen kommerzieller Computerspiel-Software, indem er selbst eine Shareware des „Baller"-Spiels *Quake III Arena* zur Mehrspielerversion entwickelt; dieses in Fan-Kreisen als *Q3A* bekannte Actionspiel ohne Story wurde 1998 von id software herausgebracht. Für seine Internet-Performance *Q4U* schöpft Feng die Möglichkeiten der im offenen Quellcode geschriebenen Software des Spiels aus, in dem die Spieler die „skins" ihrer „Inkarnationen", auch „bots" genannt, aussuchen und neu konstruieren können. Einen Mini-DV-Camcorder in der linken und eine Waffe in der rechten Hand fügt Feng seinen eigenen „bot" – ein Selbstbildnis mit nacktem Oberkörper und US-Army-Hosen – in die Spielmatrix ein und fordert die Betrachter auf, als „Fengs" per Modem von zu Hause aus oder an den Terminals im Ausstellungsraum mitzuspielen. Bei allem Ballern und Metzeln bleiben die Spieler im Unklaren darüber, ob gerade der Künstler oder sie selbst am Zuge sind. In beschleunigter 3D-Grafik und realistischem Soundeffekt schießen die Fengs armeenweise aus allen möglichen Winkeln und Höhen aufeinander – und zersprengen damit den Mythos Identität.

Fengs radikal neuer Ansatz, männliche Subjektivität durch simulierte Gewalt und Fantasiespiele zu konzeptualisieren, bietet das Potenzial zur veränderten Wahrnehmung intersubjektiver Beziehungen. Er riskiert aber auch, Opfer vorgefasster Interpretationen von Realität und voreingenommener Meinungen zu werden. Der spielerische Umgang mit Formen hedonistischer Selbstdarstellung situiert *Q4U* an vorderster Front einer kulturpolitischen Herausforderung, die von Computerspielen ausgeht, denn die den Spielen zugrunde liegenden Gestaltungsprinzipien sind auch für Netzwerkanwendungen in der Wirtschaft und für die Lerntheorie von Bedeutung. Individuelle Wahl und Urteilsbildung formen neue gesamtgesellschaftliche Ergebnisse und fördern neue Möglichkeiten der Gemeinschaftsbildung, gegründet auf einer „gesunden" Wettbewerbsfähigkeit und der Potenz virtueller, internetbasierter Gruppierungen.

Since the early 1990s, Feng Mengbo has worked at the intersection between painting and digital media (*Game Over*, 1993/94), with CD-ROMs (*My Private Album*, 1997), and video game formats (*Taking Mt. Doom by Strategy*, 1997). Incorporating travesties of political propaganda (*Game Over, My Private Album*), Feng combines various cultural influences—from video games to icons from China's Cultural Revolution and Hong Kong action cinema—into a universal iconography of the everyday. Advocating a Dadaist psychology of humor and estrangement, he attests to the destabilization of spatiotemporal languages as intrinsic to the technologies of capitalism and communication networks. An ever present subject stands in contrast to a confrontation with a computerized technology whose essence is its deterritorialized disembodiedness.

In *Q4U* (2001/02), his work for Documenta11, Feng explores highly customizable structures of commercial videogame software by fabricating a shareware multiplayer version of the visceral shooter *Quake III Arena*, a storyless action game released by id software in 1998 (in fan circles referred to as *Q3A*). *Q4U* is an Internet performance where the artist prominently inserts his likeness with bare torso and US army pants, exploiting the possibilities of the game's software, written in open code, which allows players to select and construct new "skins" for their avatars, so called "bots." Holding a mini DV camcorder in his left hand and a weapon in his right, Feng inserts his own "bot" into the matrix of the game, inviting the audience to play as him via modem at home or at terminals in the exhibition space. The players in *Q4U* have no way of knowing who is playing, the artist or the audience, while the shooting and killing never stops. In silky smooth head-on attacks from any angle or altitude, an army of Fengs shoot each other in accelerated 3D graphics with realistic sound effects, blasting the myth of identity.

Running the risk of becoming hostages to prefabricated interpretations of reality and opinions, Feng's radically new way of conceptualizing male subjectivity by means of make-believe violence and fantasy games potentially alters perceptions of intersubjective relations. Playing with forms of hedonistic self-portrayal, *Q4U* is at the forefront of vast cultural policy challenges inspired by video games—principles of game designs play a role in network applications in the industry and in the theory of learning. Individual choice and judgment shape new aggregate social outcomes and promote vast new possibilities for community building, based on a "healthy" competitiveness and the possibilities of virtual, Internet-based groupings. N. R.

Q4U, 2001/02
Interactive Internet performance, computers, sound system, data projectors, Internet connection I Interaktive Internet-Performance, Computer, Tonanlage, Datenprojektoren, Internetverbindung

CHOHREH FEYZDJOU

***1955 in Teheran, Iran. †1996 in Paris.**

Chohreh Feyzdjous Œuvre besteht aus kraftvollen Objekten und Installationen, die eine eng mit ihrer Identität als Künstlerin verwobene Geschichte offenbaren – die Geschichte einer jüdischen Frau, die in eine moslemische Gesellschaft hineingeboren wurde und in Paris eine künstlerische Laufbahn einschlug. Im Bewusstsein ihrer Fremdheit beschrieb Feyzdjou in vielen ihrer Werke die Erfahrung der Vertreibung und des Unverstandenseins. Als Feyzdjous Vater mit seiner Familie in den Iran emigrierte, änderte er den Nachnamen Cohen in den gängigen persischen Nachnamen Feyzdjou; in Paris wiederum schlug man ihr vor, sie solle doch ihren Namen ändern, weil er zu schwierig auszusprechen und zu merken sei. Das blasslila Label „Products of Chohreh Feyzdjou", mit dem sie jedes ihrer Objekte kennzeichnet, bestätigt gewissermaßen die Identität der Künstlerin und klassifiziert die Arbeiten im Kontext ihrer Autobiografie. Schriftrollen – Gemälde und Zeichnungen in recycelter Form –, die auf Gestelle montiert, in Glasgefäßen konserviert oder in Plastik verpackt sind, erzählen von der Vergangenheit. Andere, oft biomorphe Arbeiten sind aus Wachs, Federn, Zwirn oder Stoff gefertigt. Die sorgfältig etikettierten und in Schachteln, Kisten und anderen Behältnissen arrangierten Objekte werden Teil eines persönlichen Erinnerungsarchivs. Feyzdjou selbst spricht von den so genannten *Boutiques* als den Aufbewahrungsorten für ihre gesammelten und katalogisierten Schätze – sie sind Ausdruck eines unstillbaren Verlangens aufzudecken und zu erkunden.

Das schwarze Pigment, das all ihre Objekte bedeckt, lässt freilich zuerst an den Tod denken: „Schwarz ist wie ins Innere von etwas vorzudringen, der Angst ins Gesicht zu blicken ... Wenn man an etwas arbeitet, hat man das Gefühl, lebendig zu sein; sobald der Schaffensprozess jedoch abgeschlossen ist, ist alles vorbei. Das hat etwas mit dem Tod zu tun ..., deshalb arbeitet man immer weiter ..." (Feyzdjou). Gleichzeitig ermöglicht der Prozess der Zerstörung einen neuen kreativen Akt. Bis zu ihrem eigenen Tod bearbeitete Feyzdjou unablässig ihre alten Werke. Diese Arbeitsweise hatte eine wichtige Funktion: Sie wurde zu einem Mittel, mit der eigenen Identität Frieden zu schließen.

Chohreh Feyzdjou's œuvre consists of powerful objects and installations that reveal a history deeply connected to the artist's identity—a Jewish woman born into a Muslim society who pursued an artistic career in Paris. Aware of her own otherness, Feyzdjou inscribes the experience of exile and alienation into her work. After immigrating with the family to Iran, Feyzdjou's father changed the family name Cohen to the common Persian name Feyzdjou, and later in Paris people suggested to Feyzdjou that she should change her name because it was too difficult to pronounce and remember. The pale lilac label "Products of Chohreh Feyzdjou," stuck onto each of her objects seems to confirm the identity of the artist, and to classify her works in the context of her autobiography. The scrolls, as recycled paintings and drawings, mounted on scaffolds, conserved in glass jars, or wrapped in plastic, recount their own past. Feyzdjou's other products in biomorphous shapes are made of wax, feathers, thread, and cloth. Meticulously labeling and arranging all these objects in boxes, crates, and other containers, Feyzdjou turns her works into an archive of her personal memory. The artist herself sees her *Boutiques* as places to preserve her collected, catalogued treasures, and the expression of an insatiable desire to discover and investigate.

The black pigment that covers all her objects is a signal of death: "Black is like a feeling of going inside something, like confronting fear.... When you are making something, it feels really alive; but when this process of making is finished, it's finished. It does have something to do with death ... that's why you keep making more work...." (Feyzdjou). At the same time, this artistic process makes a new creative act possible. Right up to her death, Feyzdjou never stopped reworking her old works. This method had a particular sense to it, as a means of finding peace with her own identity. S. M.

Products of Chohreh Feyzdjou | *Produkte von Chohreh Feyzdjou*
Installation view | Installationsansicht, Le monde de l'art, Paris, 1995

YONA FRIEDMAN

*1923 in Budapest, Ungarn/Hungary. Lebt/Lives in Paris.

Yona Friedman ist Architekt, bekannt geworden durch seine radikalen Entwürfe und seine Schriften. Er ist vor allem ein Theoretiker, denn die meisten seiner Projekte blieben Utopie. Die frühesten Entwürfe Friedmans datieren aus der Zeit nach dem Ende des Zweiten Weltkriegs, die von großer Wohnungsnot geprägt war. Mit *Panel Chains* (1945) und *Movable Boxes* (1949) entwarf er einfache, vorfabrizierte Paravent- und Kastenarchitekturen, die ihren Bewohnern eine Privatsphäre ermöglichen sollten. Sie waren leicht zu transportieren und zeichneten sich durch geringe Materialkosten, hohe Flexibilität sowie Variabilität aus. Friedman gab ein vielfältiges Spektrum möglicher Bauformen vor, das konkrete Ergebnis jedoch machte er von der Gestaltung durch die Bewohner und von ihren Bedürfnissen abhängig. Dieses offene Architekturprinzip liegt seinem Manifest *L'Architecture mobile* (Mobile Architektur) von 1956 (erweitert 1960) zugrunde, das er im gleichen Jahr beim Congrès Internationaux D'Architecture Moderne (CIAM) in Dubrovnik präsentierte. 1957 gründete er die Groupe d'Études d'Architecture Mobile (GEAM), um die weitere Bedeutung mobiler Architektur zu untersuchen.

Die architektonische Umsetzung des Manifestes entwickelte Friedman in seinen *Span-Over Blocks* (1957/58) und in seinem Projekt *La ville spatiale* (Die Raumstadt, 1958–1962), einer gleichsam schwebenden Stadtarchitektur. Ein mit vielen Ebenen gefülltes Raumnetz über dem Boden wird von Pfeilern in großen Abständen gehalten und kann mit mobilen Wänden und Unterteilungen nach individuellem Geschmack gefüllt werden. Diese Struktur lässt sich über existierende Städte legen, ohne diese zu beeinträchtigen. 1970 entstanden so genannte *Space-Chains*, Konstruktionen aus Kreiselementen, mit denen jede geometrische Form erstellt werden kann, um damit flexible Bau- und Oberflächenstrukturen zu bilden. Anfang der achtziger Jahre gründete er das Communication Centre of Scientific Knowledge for Self-Reliance, das Menschen aus benachteiligten Ländern zur selbständigen Erfüllung ihrer Grundbedürfnisse verhelfen soll.

Zur Verbreitung seiner Lehren veröffentlichte Friedman leicht verständliche Handbücher, die sich mit Fragen zu Architektur und Städteplanung beschäftigen oder Anleitungen für einfache Bauten enthalten (*Manuals for the Self-Planner,* 1973). Seine Raumauffassungen kommen auch in den Entwürfen für repräsentative Architekturen wie Museumsbauten (Centre Pompidou, Paris, 1970), Sakralgebäude (Hill of the Faiths, 1990), Parlamentsgebäude (Dar-es-Salaam, Tanzania, 1967) oder für städtische Bauaufgaben (Opernhaus, Paris, 1982) zum Ausdruck.

Mit Fragen räumlicher Erschließungstechniken befasste sich Friedman ebenfalls schon früh in seinem Projekt *Seven Bridge Towns to Link Four Continents* (1963). Die Verwirklichung dieses Entwurfs ist für ihn Europa als *Continent City* (1994): „Die Continent City ist weder ein Projekt noch eine Projektion in die Zukunft. Sie ist heute Wirklichkeit. Ist sie transitorisch oder definitiv? Das wissen wir noch nicht."

Yona Friedman is an architect whose radical designs and prolific writings have made him famous. However, since most of his projects remain in the utopian realm, he is primarily regarded as a theorist. His earliest designs date from the period after World War II—a period marked by an urgent need for housing. With *Panel Chains* (1945) and *Movable Boxes* (1949), he designed prefabricated architecture shaped like screens or boxes, whose simple construction allowed their inhabitants to maintain their privacy. Mobility, affordable materials, flexibility, and variability for the individual user are characteristics of Friedman's architecture. As an architect, he prescribes a varied spectrum of possible building shapes, but the concrete results of the design depend upon the inhabitants and their needs. This open architectural principle is the basis for his manifesto *L'Architecture mobile* (Mobile Architecture, 1956, expanded 1960), which he presented at the 1956 Congrès Internationaux d'Architecture Moderne (CIAM) in Dubrovnik. In 1957, he founded the Groupe d'Études d'Architecture Mobile (GEAM), created to investigate the importance of mobile architecture.

Friedman put his manifesto into practice in his *Span-Over Blocks* (1957/58), and continued this practical work in his project *La ville spatiale* (The Spatial City, 1958–1962), which features urban architecture that seems to hover in the air. Widely spaced columns support a network of multi-leveled rooms, while mobile walls and partitions can be used to arrange the rooms according to the taste of the inhabitants. This new structure could be placed over existing cities without impairing them. In 1970, Friedman developed *Space Chains,* constructions of circular elements that can be combined into any geometric shape to build flexible space and surface structures. In the early 1980s, Friedman founded the Communication Centre of Scientific Knowledge for Self-Reliance, with the goal of helping people in disadvantaged countries to independently fulfill their own basic needs.

To make his ideas accessible, Friedman wrote easy-to-follow manuals dealing with issues in architecture and urban planning, and including instructions how to build simple buildings (*Manuals for the Self-Planner,* 1973). Yona Friedman also used his specific concepts of space in his designs for representative buildings such as museums (Centre Pompidou, Paris, 1970), sacred architecture (Hill of the Faiths, 1990), parliamentary houses (Dar-es-Salaam, Tanzania, 1967), or for urban buildings (Opera House, Paris, 1982).

Early on in his career, Friedman addressed the issue of how new space is appropriated in his project *Seven Bridge Towns to Link Four Continents* (1963). This kind of link has already been realized, according to Friedman's view of Europe as a *Continent City* (1994), a work composed of a dense transportation network. "The Continent City is neither a project nor a futuristic projection. It is reality, today. Is it transitory or definitive? We do not know yet." A. N.

La ville spatiale I *The Spatial City* I *Die Raumstadt,* 1958–1962
Photomontage of an interwoven city I Photomontage einer verwobenen Stadt

MESCHAC GABA

***1961 in Cotonou, Benin. Lebt/Lives in Amsterdam.**

Meschac Gaba begann Anfang der neunziger Jahre kritisch das Phänomen „Geld" zu reflektieren. Er integrierte Banknoten in eine Serie zweidimensionaler Arbeiten. Dabei war ihm die Materialität des Geldes an sich ebenso wichtig wie seine implizite Bedeutung. In einem Interview sagt Gaba zur Verwendung von Geld in seinem Werk: „Vielleicht benutze ich Geld, weil ich das Wort Kolonialisierung nicht benutzen möchte." Das Spannungsverhältnis zwischen wirtschaftlicher Macht und Kolonialisierung bestimmt seit 1997 seine Arbeit, deren einzelne Phasen als aufeinander folgende Abteilungen eines imaginären Museums für zeitgenössische afrikanische Kunst strukturiert sind. Das „Gaba Museum" formuliert eine Kritik an museologischen Institutionen nach westlichen Vorstellungen und ist gleichzeitig die Utopie eines möglichen Modells für eine nicht existente Institution. Diese Doppelnatur, zugleich kritisch und utopisch zu sein, entspricht Gabas existenziellem und künstlerischem Ansatz: eine Struktur aufzubauen, wo keine existiert, ohne den Blick für die Begrenzungen bestehender Modelle zu verlieren, die zu einer bestimmten sozialen und ökonomischen – real dominierenden – Ordnung gehören.

In den verschiedenen Abteilungen seines Museums untersucht Gaba die Beziehungen zwischen Kunst und Populärkultur, vorgefasste Meinungen über die angebliche gesellschaftliche Funktion des Museums, aber auch die Art und Weise, wie museologische Institutionen den kulturellen und ökonomischen Wert ihrer Exponate vermerken. In seinen scharfsinnigen, präzisen Arbeiten verliert er weder die historische noch die heutige institutionelle Rolle aus den Augen, die das Museum für Herrschafts- und Machtstrategien spielt.

Bei verschiedenen Gelegenheiten hat Gaba einzelne Räume seines Museums gezeigt: die Bibliothek, das Spielzimmer, die Sommer-Sammlung und das Restaurant. Zur Documenta11 wird er Restaurant, Bibliothek und Museumsladen präsentieren. Als Fragmente, die zusammen nicht das Ganze ergeben, belegen die Abteilungen des „Gaba Museums" die Zersplitterung eben jener Realität, auf die sie Bezug nehmen.

During the early 1990s, Meschac Gaba started reflecting on the devaluation of currency by incorporating bills in a series of two-dimensional works. The very materiality of money is as important to Gaba as its implicit significance. In an interview, Gaba refers explicitly to his use of money in his work: "Maybe that's why I use money, because I refuse to use the word colonization." The tension between economic power and colonization informed all of Gaba's work in various stages from 1997 onward, organized as successive sections of an imaginary Contemporary African Art Museum. The "Gaba Museum" is at once a criticism of the museological institution as conceived in developed countries, as well as the utopian formulation of a possible model for a nonexistent institution. This dual nature, critical and utopian, is related to the artist's existential and artistic point of departure. It is about founding a structure where there isn't one, without losing sight of the limitations of existing models that belong to a certain social and economic order based in the harsher realities of domination.

The various departments of the "Gaba Museum" explore the relationship between art and popular culture, the preconceptions about the supposedly social purpose of the museum, and the ways in which museological institutions endorse the cultural and economic value of objects within them. In his sharp and precise works, Gaba never loses sight of the museum's institutional role, past and present, with regard to strategies of power and domination.

On variuos occasions, Gaba has shown various rooms from his museum: the library, the game room, the summer collection, and the restaurant. Gaba will show the museum's restaurant, library, and museum shop at Documenta11. Complementary fragments that do not add up to a whole, the sections of the "Gaba Museum" testify to the fragmentation of the very reality to which they allude. C.B.

Museum of Contemporary African Art: The Museum Shop |
Museum zeitgenössischer afrikanischer Kunst: Museumsshop
Installation view | Installationsansicht, Kunsthalle Bern, 1999

GIUSEPPE GABELLONE

*1973 in Brindisi, Italien/Italy. Lebt/Lives in Mailand/Milan, Italien/Italy.

Giuseppe Gabellones Fotoserie von künstlichen Blumen für die Documenta11 versinnbildlicht die Arbeitsverfahren des Künstlers nicht nur als Fotograf, sondern auch als Bildhauer. Seine Skulpturen, die er aus so unterschiedlichen Materialien wie Lehm, Aluminium, Leinwand, Holz, Metall, Bast, Stroh, Mörtel, Backstein und Styropor fertigt, lassen sich unterteilen in jene, denen ein zukünftiges physisches Dasein gewährt wird, und jene, die der Zerstörung preisgegeben sind und nur im fotografischen Bild weiterleben. Die bleibenden Skulpturen bezeichnet Gabellone als „Doppelskulpturen", weil sie in verschiedenen Dimensionen funktionieren. Eine Arbeit von 1997 lässt sich wie ein Akkordeon zusammenschieben und auseinander ziehen und erscheint je nachdem wie ein Schutz bietendes Refugium oder wie ein langer weißer, von einem Aluminiumgerüst gestützter Leinwandtunnel. Eine andere Arbeit aus dem Jahr 1996 erinnert an eine post-minimalistische Soft Sculpture und hat die Form eines mehrere Meter langen ausgefransten Läufers aus Raffiabast, der zu einer weichen Kiste zusammengefaltet werden kann.

Gabellones Fotografien indes verhindern ein Betrachten der Skulptur aus verschiedenen Perspektiven. Der von Gabellone festgelegte Blickwinkel zeigt die zerstörte Skulptur auf einer nur einmal existierenden Fotografie, von der keine Editionen aufgelegt werden und deren Negativ vernichtet wurde. Die skulpturale Erfahrung ist durch die „bleibende", wenn auch „unvollständige" Fotografie ersetzt.

Gabellone geht es vor allem um die Frage von Dauerhaftigkeit. Ein mit Wasser gefülltes viereckiges Becken aus feuchtem Lehm, das von einer Backsteinwand gestützt wird (Vasca, 1996), hat von vornherein keine lange Lebensdauer. Eine gigantische architektonische Metallkonstruktion, die auf der einen Seite einen alten grünen Fiat und auf der anderen ein rotes Fass einschließt (1997), wurde demontiert und durch eine Fotografie unvergesslich gemacht.

Ein exemplarisches Beispiel für die billigen, kitschigen Poster, die in den achtziger Jahren an Jugendzimmerwänden hingen, zeigt die Fotografie eines solchen aus dem Jahre 2000: Flamingos stehen in einer romantischen, exotischen Landschaft, um sie herum Palmen und im Hintergrund Berge, in ein leicht violettes Braun getaucht. Nur ist das Poster an einer Holztafel angebracht, die durch einen Betonsockel erhöht und durch Metallstangen gestützt wird. Technik, Farbe und Brillanz der Aufnahme lassen Sentimentalität gar nicht erst aufkommen.

Gabellones frostige Bilder von blauen Styroporblumenskulpturen, die auf der Documenta11 zu sehen sind, streben ebenfalls danach, kühl, distanziert und gleichgültig zu wirken, um jegliche allegorische Deutung zu vermeiden.

Giuseppe Gabellone's photographic series of artificial flowers for Documenta11 emblematize the artist's working procedures, both as a photographer and as a sculptor. His sculptures, made from media as diverse as clay, aluminum, canvas, wood, metal, raffia, straw, plaster, bricks, or polystyrene, can be divided into those that are allowed to keep a physical presence, and those that are destroyed and only live on in the photographic image. Gabellone calls his surviving sculptures "Double Sculptures" because they can be assimilated and function in different dimensions. One sculpture (1997) can be folded and unfolded like an accordion, to appear as a compressed shelter-like refuge or, alternatively, as a long white canvas tunnel supported by an aluminum structure. Reminiscent of a post-minimal Soft Sculpture, another work (1996) takes the form of a frayed raffia runner several meters in length, which, through folding, can be turned into a crate.

Gabellone's photographs, on the other hand, make it impossible to see the sculpture in multiple perspectives. The viewpoint offered by Gabellone shows the demolished sculpture in one unique photograph of which no editions are produced and the negative is destroyed. The sculptural experience is replaced by the photograph, which has become a permanent, yet incomplete duplicate of the sculpture.

Permanence and duration are key issues in all of Gabellone's works. A square basin made of wet clay filled with water and supported by a brick wall (Vasca, 1996) is not designed for a long life. A gigantic architectural metal structure, which encases an old green Fiat on one side and a red barrel on the other has been dismantled and is commemorated through the photograph (1997).

One photograph (2000) shows a poster depicting several flamingos in a romantic landscape of palms before a mountain background. Tinted in a purplish brown, it is an embodiment of kitsch and exemplary of the kind of cheap poster that hung in teenagers' bedrooms in the 1980s. In the photograph the poster is mounted on a wooden board, elevated by cement pedestals and supported by metal rods. Its meticulous technique, color, and brilliance force back any notion of sentimentality.

Gabellone's frozen images of blue polystyrene flower sculptures presented at Documenta11 also attempt to avoid any allegorical and emotional value, but seek to appear distant, aloof, and indifferent. S. M.

Senza Titolo (Fenicotteri) I *Untitled (Flamingos)* I *Ohne Titel (Flamingos),* 2000
C-print I C-Print, 63 x 80,5 cm

CARLOS GARAICOA

*1967 in Havanna/Havana, Kuba/Cuba. Lebt/Lives in Havanna/Havana.

Seit den frühen neunziger Jahren der urbanen Realität des alten Havanna in den Zeiten seines Niedergangs verpflichtet, verändern Carlos Garaicoas fotografische und architektonische Interventionen nicht nur physisch die Struktur des Städtischen, sondern bewahren auch die Erinnerung an das, was man unter Kubas sozialistischer Revolution dem Verfall überließ. Immer noch mit dem Ruch der kolonialen Vergangenheit und ihres eklektisch-bourgeoisen Lebensstils behaftet, wurden viele (Bau-)Stellen Havannas zur Metonymie für die Suche nach den Spuren der politischen Krise und des sozialen Wandels. Havannas Ruinen entfesseln Garaicoas Sehnsucht nach einer utopischen Architektur, die spielerisch an die amerikanische Architektur der Moderne angelehnt ist: panoptische Strukturen, Tempel, Wolkenkratzer, freistehende Blöcke und eingeschossige Häuser. Die Zeichnungen und „archiscapes", diffizile Gerüste aus Holz, an Gebäude gelehnte Pfähle oder wuchernde pyramidenartige Türme verlängern das Tatsächliche in das Reich des Fantastischen – beispielsweise in Arbeiten wie *Frank Lloyd Wright y la casa del agua* (Frank Lloyd Wright und das Falling Water House, 1999), *Abraham Lincoln y san Juan Bosco, o los mapas del deseo* (Abraham Lincoln und Saint Juan Bosco, oder Karten der Sehnsucht, 1996), *Torre de Babel* (Turm zu Babel, 1991), *Primer sembrado de hongos alucinógenos en La Habana* (Erstes Pflanzen halluzinogener Pilze in Havanna, 1997), *Acera de esos incansables atlantes que sostienen día por día nuestro presente* (Über diese nicht müde werdenden Atlanten, die unsere Gegenwart Tag für Tag tragen, 1994/ 95) und *Ilustración para el libro „Anatomía de la Ciudad"* (Illustration für das Buch „Anatomie der Stadt", 1994).

Die Stadt als Raum für Wahrnehmung, Vorstellung und mentale Projektion erkundet Garaicoa fotografisch in *Cuando del deseo se parece a nada* (Wenn Wünsche dem Nichts gleichen, 1996); Ausgangspunkt ist die primitive Tätowierung der beiden Türme des World Trade Centers auf dem Arm eines eingewanderten Arbeiters. In einer Zeit, in der zunehmend alles Warencharakter annimmt – ein Prozess, der Erinnerung leugnet, weil neue Waren an die Stelle der vorangegangenen treten müssen –, wandeln sich Garaicoas Projekte zu einer urbanen Archäologie, die sich aktiv mit der durch einen hegemonialen politischen Diskurs kollektiv unterdrückten und vernachlässigten Vergangenheit auseinander setzt.

Garaicoas Projekt für die Documenta11 lenkt die Aufmerksamkeit der Gegenwart auf alles, was in der Vergangenheit unvollendet geblieben ist. *Continuidad de una Arquitectura Ajena* (Kontinuität einer freistehende Architektur, 2002) legt fotografisch unvollendete architektonische Projekte in Kuba frei, rekonstruiert sie digital und transformiert sie in reale Modelle visionärer Architekturlandschaften. Indem Garaicoa die Projekte zum Abschluss bringt, lässt er die Wunden der Geschichte verheilen.

Wie der Benjamin'sche Engel der Geschichte, der auf den Berg von Schutt, Ruinen und Niederlagen der Vergangenheit zurückschaut, im Bemühen, ihn abzutragen, kann sich Garaicoa nicht aus den Kraftfeldern der Sehnsucht, der Körperlandschaft, der Landkarte und der urbaner Stofflichkeit befreien, welche Realität und Fiktion miteinander verweben. Denn zugleich wird er von den Kräften des Fortschritts und der Modernisierung nach vorn getrieben.

Since the early 1990s Carlos Garaicoa has been investigating the urban reality of old Havana in times of its obsolescence. His photographic and architectural interventions physically change an urban fabric, and also preserve the remembrance of what was left to decay under Cuba's socialist revolution. Still bearing the odor of a colonial past and the old eclectic bourgeois lifestyle, many locations in Havana have become focal points for tracing political crisis and social change. Havana's ruins unleash Garaicoa's desire for a utopian architecture that alludes playfully to American modernist architecture: panoptic structures, temples, skyscrapers, freestanding blocks, and one-story buildings. Making drawings and creating archiscapes from elaborate wooden scaffoldings, supporting poles placed against buildings, or rank pyramidal towers, Garaicoa extends the actual into the realm of the imaginary in works such as *Frank Lloyd Wright y la casa del agua* (Frank Lloyd Wright and the Falling Water House, 1999), *Abraham Lincoln y san Juan Bosco, o los mapas del deseo* (Abraham Lincoln and Saint Juan Bosco, or The Maps of Desire, 1996), *Torre de Babel* (Tower of Babel, 1991), *Primer sembrado de hongos alucinógenos en La Habana* (First Planting of Hallucinogenic Mushrooms in Havana, 1997), *Acera de esos incansables atlantes que sostienen día por día nuestro presente* (About These Untiring Atlantes that Sustain Our Present Day by Day, 1994/95), and *Ilustración para el libro "Anatomía de la Ciudad"* (Illustration for the Book "Anatomy of the City," 1994).

The city as a space of perception, imagination, and mental projection is photographically explored in *Cuando del deseo se parece a nada* (When Desire Resembles Nothing, 1996), taking the primitive tattoo of the World Trade Center Towers on an immigrant worker's arm as a starting point. In times of growing commodification—a process that always negates memory as new commodities must replace previous ones—Garaicoa's projects turn into an urban archaeology, actively coming to terms with a collectively repressed and neglected past as promoted by a hegemonic political discourse.

Garaicoa's project for Documenta11 draws the attention of the present to everything that was left unaccomplished in the past. *Continuidad de una Arquitectura Ajena* (Continuity of a Detached Architecture, 2002) photographically excavates unfinished architectural projects in Cuba, digitally reconstructs and transforms them into actual models of visionary archiscapes, thus bringing them to conclusion by healing the wounds of history.

Like the Benjaminian angel of history looking back at the pile of debris, ruins, and defeats of the past in an effort to redeem them, Garaicoa continues to be caught up in the force fields of desire, the landscape of the body, the map, and the urban fabric interweaving reality and fiction, while at the same time being pushed forward by the forces of progress and modernization. N. R.

Edificio Público como Ágora Griega | Apartment Building like Greek Agora | Apartment-Haus wie die Griechische Agora, 2002
CAD drawings for model (cardboard, wood and plastic) |
CAD-Zeichnung für Modell (Karton, Holz und Kunststoff),
101,5 x 76 cm; black-and-white photograph | Schwarz-Weiß-Fotografie, 122 x 183 cm

KENDELL GEERS

***Mai/May 1968 in Johannesburg, Südafrika/South Africa.
Lebt/Lives in London und/and Brüssel/Brussels.**

Kendell Geers hat seit den späten achtziger Jahren an einer Verbindung von konzeptueller und politischer Kunstpraxis gearbeitet. Knappe Eingriffe in institutionelle Rahmenbedingungen, prozessuale Performances, die oft Jahre dauern, groß angelegte öffentliche Aktionen und raumfüllende Installationen können sowohl als Gesten direkten politischen Widerstands als auch als Aneignungsversuche konzeptueller Traditionen der Moderne verstanden werden.

Symptomatisch für seine Vorgehensweise ist die Arbeit *ANC, AVF, AWB, CP, DP, IFP, NP, PAC, SACP* (1993/94). Am 19. Juli 1993, als während der Unruhen vor den ersten freien und demokratischen Wahlen Südafrikas ein Mitglied der Inkathas Freedom Party (IFP) getötet wurde, entschloss sich Geers zur Mitgliedschaft in allen südafrikanischen Parteien. Die Aktion – die auch ein persönliches Risiko darstellte, da die Parteien einander feindlich gesinnt waren – endete offiziell am 7. Februar 1994, als ihm die ultrarechte Afrikaner Weerstandsbeweging (AWB) einen Mitgliedsausweis ausstellte. Für den dezidierten Antiapartheidaktivisten Geers ist die Arbeit – in der lapidaren Ansammlung der verschiedenen Mitgliedsausweise dokumentiert – vor allem eine Auseinandersetzung mit der eigenen Herkunft als Nachfahr der Kolonialherren und damit auch mit der in seine Biografie eingeschriebenen Rolle als „Unterdrücker".

In anderen Arbeiten überträgt Geers die direkte Beteiligung auf die Betrachter, indem er potenziell gefährliche oder physisch anstrengende Situationen entwickelt. *Title Withheld (Brick)* (1994–1996) – eine Performance, bei der Geers einen Ziegelstein durch die Schaufensterscheibe einer Galerie warf – ist sowohl ein Akt des Vandalismus, der oft mit politischen Protestkundgebungen, Krawallen und gewalttätigem Widerstand in Verbindung gebracht wird, als auch ein transformativer Akt, der als kurzzeitige Handlung einen dauerhaften, körperlich erfahrbaren Eingriff in die Architektur des Ausstellungsraumes erzeugt. Für *Title Withheld (Deported)* (1993–1997) errichtete Geers einen mit 6.000 Volt geladenen elektrischen Zaun quer durch den Ausstellungsraum, der die Besucher daran hinderte, einen Teil der Ausstellung zur betreten. Seine jüngsten Videoinstallationen verwenden oft Filmsequenzen schreiender oder schießender Protagonisten in kurzen Loops und dröhnender Lautstärke (*Title Withheld (Shoot)*, 1998/99; *Between the Devil and the Deep Blue Sea*, 1999; *Title Withheld (Scream)*, 1999).

Suburbia (1999), Geers Arbeit für die Documenta11, zeigt eine Serie von Fotografien mit Absperrungen und Sicherheitsvorkehrungen an privaten Wohnhäusern in Johannesburg – Orte, an denen „sich Menschen dadurch schützen, dass sie sie zu Gefängnisse ausbauen und sich damit zu einer lebenslänglichen Haftstrafe verurteilen, die sie Freiheit nennen" (Geers).

Since the late 1980s, Kendell Geers has worked constantly, often in controversial ways, on a connection between Conceptual and political art. In brief interventions, performances that frequently last for years, full-scale public actions, and large installations, Geers has created a broad spectrum of symbolic and concrete actions, which can be understood not only as gestures of direct political resistance, but also as attempts to appropriate conceptual traditions of modern art.

A typical work is *ANC, AVF, AWB, CP, DP, IFP, NP, PAC, SACP* (1993/94). On July 19, 1993, the day on which a member of the Inkathas Freedom Party (IFP) was killed during the unrest before the first free, democratic elections in South Africa, Geers decided to join all of the South African parties. The work officially ended on February 7, 1994, when the ultra-right Afrikaner Weerstandsbeweging (AWB) issued him a membership card. Documented in the terse collection of different membership cards, the work refers to Geers's personal involvement, which was not without personal risk, since the parties considered each other "enemies." It also illustrates the fundamental double bind of Geers's own cultural ancestry as a descendent of the colonial rulers, which, despite his anti-apartheid activism, reinscribes the role of the oppressor into his biography.

In other works, Geers conveys this direct involvement to the observer by developing potentially dangerous or strenuous situations. In *Title Withheld (Brick)* (1994–1996), in which Geers threw a brick through the window of an art gallery, the act of vandalism (often linked to political demonstrations, riots, and violent resistance) becomes a transformative act of performance. A brief action has lasting consequences for the architecture of the exhibition space, and these can be physically experienced. For *Title Withheld (Deported)* (1993–1997) Geers erected an electric fence charged with 6,000 volts across the showroom, which prevented visitors from entering part of the exhibit. His most recent video installations often employ film sequences of people screaming or shooting, repeated in short loops at booming volume (*Title Withheld (Shoot)*, 1998/99; *Between the Devil and the Deep Blue Sea*, 1999; *Title Withheld (Scream)*, 1999).

Geers's work for Documenta11, *Suburbia* (1999), features a series of photographs documenting the safety precautions taken in private houses in Johannesburg, "where people protect themselves by creating jails in which they willingly sentence themselves to a lifetime of imprisonment and call it freedom" (Geers). C.R.

Suburbia | Vorstadt, 1999
C-print | C-Print, 30,5 x 40,5 cm

ISA GENZKEN

***1948 in Bad Oldesloe, Deutschland/Germany.
Lebt/Lives in Berlin.**

Die künstlerische Praxis von Isa Genzken umfasst neben Skulpturen Fotografien, Collagenbücher und Filme. Ihre Themen sind die Struktur und Textur von Körpern sowie die Wechselbeziehungen zwischen einem Objekt und seinem Umraum. Dabei setzt sie sich bewusst auch mit dem Konstruktivismus oder der Minimal Art auseinander. Vielfach besitzen ihre Arbeiten autobiografische Bezüge.

Ihre *Ellipsoide* (1976–1982) und *Hyperboloide* (1979–1983) sind lange stereometrische Objekte aus lackiertem Holz. Die am Computer berechneten speerförmigen Gebilde liegen nur an ein oder zwei Punkten am Boden auf und definieren sich durch Einschnitte, die ihre geschlossene Form aufbrechen. Die Gipsplastiken von 1984 bis 1986 sind mit anderen Materialien kombiniert, so *Mein Gehirn* (1984), bei dem eine gekrümmte Antenne aus der Gipsmasse ragt. Seit 1986 entstehen die auf Stahlrohrgestellen präsentierten Betonskulpturen (*Doppelraum*, 1990). Die Verwendung von Beton stellt über das Material einen Bezug zur Architektur der Moderne her. Architekturzitate sind auch die Säulen, die Genzken in Innenräumen aufstellt. Hier stehen den schlanken, hohen und rotierenden Säulen aus Epoxidharz (1994) geschlossenere Versionen mit Flächen aus Press-Span, Marmor, Metall, Spiegeln oder solche, die mit Fotografien beklebt sind, gegenüber (seit 1998).

Neben den Innenraumobjekten entwickelt Genzken Skulpturen für den öffentlichen Raum. Hierzu zählen fensterartige Einfassungen aus Beton, Stahl und seit 1991 aus lichtdurchlässigem Epoxidharz, das die Trägerkonstruktion erkennen lässt. 1987 entstand die Skulptur *ABC* für die Ausstellung *Skulptur. Projekte in Münster,* die sich in Titel und Form auf Funktion und Architektur der benachbarten Bibliothek bezog und gleichzeitig den Blick auf die Stadt einrahmte.

Die Röntgenaufnahme ihres eigenen Kopfes (*X-Ray,* 1991) ist Selbstporträt und Aufnahme von Textur gleichermaßen. Die Abbildung des menschlichen Denk- und Kommunikationszentrums steht inhaltlich in Verbindung mit der fotografischen Serie von menschlichen Ohren (*Ohren,* 1980) und der Installation *Weltempfänger* (1982–1987), kleinen Betonskulpturen mit Radioantennen, aber nimmt auch ihre Arbeiten mit Licht und Reflexen in den Lampen- und Spiegelskulpturen vorweg.

Neben ihren architekturhaften Modellen aus Epoxidharz *New Buildings for Berlin* (2001) zeigt die Documenta11 Genzkens Arbeit *Spiegel* (1991), die aus 121 auf DIN-A4-Karton geklebten Bildausschnitten der gesellschaftspolitischen Wochenzeitschrift *Der Spiegel* besteht.

Isa Genzken's artistic practice comprises sculpture, photographs, collage albums, and films. Her subject matter is the object's structure and texture as well as the correlation between an object and the space surrounding it. She consciously deals with movements such as Constructivism or Minimal Art. In many of her works she refers to her own biography.

Her *Ellipsoide* (Ellipsoids, 1976–1982) and *Hyperboloide* (Hyperboloids, 1979–1983) are long stereometric, spear-shaped objects made of painted wood. Their forms and stability are calculated by computer, so that they can be supported through minimal contact with the ground, and are defined by the incisions that break into their closed form. The plaster sculptures of 1984–1986 make use of further materials, as in *Mein Gehirn* (My Brain, 1984), in which a bent antenna juts out of the plaster mass. Since 1986, Genzken has been working on concrete sculptures presented on steel tube frames (*Doppelraum,* Double Space, 1990), in which the material provides a reference to modernist architecture. Further quotations from architecture are found in Genzken's columns for interiors (1994). These slim, tall, and rotating columns made of epoxy resin are placed opposite static and more contained versions made of particle board, marble, metal, or with surfaces of mirror and photographs (since 1998).

In addition to objects presented indoors, Genzken also produces sculptures for public space. Most of these are window-like frames made of concrete, steel or, since 1991, translucent epoxy resin through which the supporting construction can be discerned. In 1987, Genzken created the sculpture *ABC* for the exhibition *Sculpture. Projects in Münster,* with both title and form referring to the function and architecture of the neighboring library while the work also framed the view of the city.

Genzken's x-ray of her own head (*X-Ray,* 1991) is both a self-portrait and a photograph of texture. The depiction of the locus of human thought and communication refers back to a photo series of human ears (*Ohren,* Ears, 1980) as well as to the series Weltempfänger (*World Receivers,* 1982–1987), small concrete sculptures with radio antennae. *X-Ray* also anticipated Genzken's illuminated lamp sculptures and the reflections of her mirror sculptures.

Alongside her architectural models in epoxy resin, *New Buildings for Berlin* (2001), Documenta11 presents Genzken's work *Spiegel* (1991), made up of 121 segments of pictures cut out from the political weekly magazine *Der Spiegel* stuck onto A4 cardboard. A. N.

New Buildings for Berlin I *Neue Gebäude für Berlin,* 2001
Glass, tape, mirror, foil, height 80 cm, width variable, pedestal
140 x 60 x 45 cm I Glas, Klebeband, Spiegel, Folie, Höhe 80 cm,
Breite variabel, Sockel 140 x 60 x 45 cm

JEF GEYS

*1935 in Léopoldsburg, Belgien/Belgium. Lebt/Lives in Balen, Belgien/Belgium.

Das künstlerische Schaffen von Jef Geys ist nicht von seiner Biografie zu trennen. Er begann ein Verzeichnis seiner Werke zu führen, als er 13 Jahre alt war. Ob sein Wirken als Kunst bezeichnet wird, ist für ihn nicht von Bedeutung. Er verwendet stets gestalterische Elemente aus Hoch- und Subkultur, arbeitet in allen Medien und behandelt Themen aus sozialen, politischen und ökonomischen Bereichen. Dreißig Jahre lang hat Geys Kunstunterricht erteilt, und viele seiner Arbeiten sind in diesem Kontext entstanden. In seinen Werken bezieht er sich sowohl auf Grundlagen wie Formen-, Farb- und Proportionslehre als auch auf Aspekte von Pop Art, Fluxus und Konzeptkunst.

Geys' Bilder, Fotografien, Skulpturen und Installationen sind vielfach als serielle und unabgeschlossene Arbeitsprozesse konzipiert: So entwickelte er 1966 den *Gevoelsspeeldoos* (Empfindungsspielkasten), dessen unterschiedliche Bausteine als Elemente für Bildhauerei dienten. Zeichnungen aus der Akademiezeit (1958) verarbeitete er erneut 1986 in der Arbeit *ABC-École de Paris*. Und für seine Bildserie *Grote Zaadzakjes* (Große Samentüten, ab 1963) malt Geys jedes Jahr eine Samentüte mit dem Motiv der jeweiligen Pflanze. Die konzeptionelle und enzyklopädische Entwicklung des Bildinhalts steht dabei im Kontrast zur Pop-Ästhetik der Lackgemälde.

Vielen Arbeiten des Künstlers liegt ein Mobilitätsprinzip zugrunde, so zum Beispiel der transportablen *Tent Sculptuur* (Zeltskulptur, 1966/67). Für die Ausstellung *Chambres d'amis* in Gent (1986) entwarf Geys Türen für Privatwohnungen, die er mit den Idealen der Französischen Revolution dreisprachig beschriftete. Geys beschäftige auch die Möglichkeit, den Außenraum für seine Arbeiten zu erschließen, und die Frage nach dem Wert von Prestigeobjekten. Beides charakterisiert sein Projekt für die Biennale von São-Paulo 1991: Geys sandte Modelle berühmter Architekturen an die Fußballvereine der Teilnehmerländer, um sie dort zusammen mit deren Trophäen ausstellen zu lassen. Seine Arbeit *Geloof net wat U ziet* (Glaub' nicht, was Du siehst) für die Ausstellung *Skulptur. Projekte in Münster 1997* bot den Besuchern die Möglichkeit, sich mit einem Hubwagen die Architektur der mittelalterlichen Kirchen Münsters genauer anzusehen.

Um die Frage von Identität ging es in Arbeiten wie *Jef Geys en Gijs Van Doorn* (Jef Geys und Gijs Van Doorn, 1987) – Geys stellte seine Werke zusammen mit denen eines Kindes aus, dessen Name genauso klingt wie der seine –, und *Kleurfoto met ster-groen hemd* (Farbfoto mit stern-grünem Hemd, 1991), einer Fotoserie von Selbstporträts mit Davidsstern.

Sein Beitrag für die Documenta11 ist der 36-stündige Schwarz-Weiß-Film *Dag en Nacht en Dag en ...* (Tag und Nacht und Dag en ..., 2002), der in langsamer Bewegung alle existierenden Fotografien des Künstlers der letzten vierzig Jahre zeigt. Der Film führt das Buchprojekt *Al de zwartwit Fotos tot 1998* (All die Schwarz-Weiß-Fotografien vor 1998) mit Abbildungen von Kontaktstreifen fort. Wie das Buch wird der Film zum Archiv von Geys' Lebens, betont aber in der bewegten Aneinanderreihung den monotonen Ablauf von Zeit.

Jef Geys's artistic works cannot be separated from his biography. He began keeping an index of his own work when he was 13 years old. It is not important to him if what he does is described as art. Geys constantly uses elements of both high and subcultures, works in all media, and deals with social, political, and economic themes. Geys has taught art for thirty years, and many of his works were created in this context. In his works, the artist refers to some fundamentals such as theories of form, color, and proportion, as well as to aspects of Pop, Fluxus, and Conceptual Art.

Geys's paintings, photographs, sculptures, and installations are often conceived as part of a serialized, unfinished process of work. In 1966 he developed the *Gevoelsspeeldoos* (Sensation Toy Box), containing various building blocks, which in turn served as sculptural elements. His drawings from the time at the Academy (1958) reappeared in the 1986 *ABC-Ecole de Paris*. For a series of paintings entitled *Grote Zaadzakjes* (Large Seed Packets, begun in 1963), Geys paints a seed packet every year with the motif of a different plant. Geys uses a Pop aesthetic as a contrast to the conceptual and encyclopedic development of the paintings' content.

Many of the artist's works are based on a principle of mobility, as in the transportable *Tent Sculptuur* (Tent Sculpture, 1966/67). For the exhibition *Chambres d'amis* in Ghent (1986), Geys inscribed the ideals of the French Revolution in three languages onto doors of private homes. Geys is also interested in opening up exterior spaces for his works and questioning the value of prestigious objects, as in his project for the 1991 Biennial in São Paulo. He sent models of famous buildings to the participating countries' soccer teams, so that they could display them along with their trophies. His work, *Geloof net wat U ziet* (Don't Believe What You See), for the *Sculpture. Projects in Münster 1997*, offered visitors an opportunity to look more closely at the architecture of Münster's medieval churches, while riding in a lift truck.

Identity was the theme of *Jef Geys en Gijs Van Doorn* (Jef Geys and Gijs Van Doorn, 1987), in which the artist showed his works alongside those of a child whose first name sounds similar to Geys's surname, and the same theme was addressed in *Kleurfoto met ster-groen hemd* (Color Photo with a Star-green Shirt, 1991), a photo-series of self-portraits featuring the Star of David.

Geys's contribution to Documenta11 is a thirty-six-hour long, black-and-white film entitled *Dag en Nacht en Dag en ...* (Day and Night and Day and ..., 2002). In this project, all the existing photographs of the artist from the past forty years pass slowly by. The film refers to *Al de zwart-wit Fotos tot 1998* (All the Black and White Photographs Before 1998), a book project consisting of photographic contact strips. Like the book, the film becomes an archive containing scenes of the artist's life, and the series of pictures reflects the monotonous passage of time. A. N.

Grote Zaadzakjes | *Large Seedbags* | *Große Samentüten*, since 1963 | seit 1963
Varnish on wood | Lackfarbe auf Holz, each | je | 140 x 90 cm
Installation view | Installationsansicht, Kunstverein München, Munich | München, 2001

DAVID GOLDBLATT

***1930 in Randfontein, Südafrika/South Africa. Lebt/Lives in Johannesburg, Südafrika/South Africa.**

Mit seiner Wiederbelebung der Dokumentarfotografie im Spannungsfeld der Apartheid hat David Goldblatt Pionierarbeit geleistet. Bestrebt, Stille aufzunehmen oder uneindeutige Darstellungen mehrdeutiger Strukturen, Räume und Menschen einzufangen, gelingt es ihm, die Aufmerksamkeit des Betrachters auf die polemischen Fundamente der Apartheid zu lenken: die Auswirkungen der niederländischen Siedlungskultur und der Zwangsumsiedlungen auf Südafrikas Landschaft. In seiner beeindruckenden Fotoreihe *The Structure of Things Then* zeichnet Goldblatt – ohne dabei auf die Präsenz menschlicher Körper zu setzen – den kulturellen Körper weißer Dominanz und schwarzer Enteignung nach. Die von Goldblatt veröffentlichten Fotoserien zeigen nach seinen eigenen Worten „gesellschaftliche Bedingungen" auf – zu ihnen gehören *On the Mines* (1973), *Some Afrikaners Photographed* (1975), *In Boksburg* (1982), *Lifetimes: Under Apartheid* (1986), *The Transported of Kwandebele: A South African Odyssey* (1989) und *The Structure of Things Then* (1998).

Sein immenses, seit 1948 entstandenes fotografisches Werk umfasst brisante historische und gesellschaftliche Dokumente, die die Hinterlassenschaften des Kolonialismus bis in die Zeit nach der Apartheid belegen. Goldblatts fotografische Bestandsaufnahme südafrikanischer Architektur und Landschaft reicht von den Aufnahmen der Johannesburger Township Soweto bis zu jenen der weißen Vorstadtviertel von Hillbrow. Sie offenbart die psychosoziale Überschneidung dieser Räume, um die Beziehungen zwischen Landschaft und Bürgerschaft aufzudecken. Das Vokabular der hochpolitisierten Bildersprache unter dem Vorzeichen eines „Kampfjournalismus" und einer politisch engagierten Fotografie wendet Goldblatt gegen dieses selbst, indem er sich auf die weiße Bevölkerung der Johannesburger Vorstädte und insbesondere auf das konzentriert, was er selbst als „Homogenisierung" der Stadt bezeichnet.

Goldblatt macht einen grundsätzlichen Unterschied zwischen seiner kommerziellen und seiner konzeptuellen Arbeit. In den fünfziger Jahren veröffentlichte er in *Life, Look* und *Picture Post* politische Fotografien – besonders von der Kampagne, die der Afrikanische Nationalkongress 1952 gegen die Passgesetze organisierte –, verlegte sich jedoch später darauf, „Situationen zu belichten" oder „Seinszustände, die zu Ereignissen führen", zu fokussieren. Goldblatts zur Documenta11 ausgestellte Arbeiten zeigen die Ablösung der dokumentarischen Tradition in früheren Beispielen von *In Boksburg*, die mit einem neuen, als Auftragsarbeit entstandenen Porträt von Johannesburg kombiniert wird. Unspektakulär und ambivalent verhandelt Goldblatt sowohl die persönlichen als auch die politischen Aspekte der südafrikanischen Landschaft – die dunklen Zwischenräume, welche die Erinnerung, das Land, die Geschichte, die Architektur der Apartheid prägen und reflektieren.

A progenitor of the reinvention of documentary photography in the charged territory of apartheid, David Goldblatt's work represents an effort at recording silences, or capturing obscure illustrations of ambiguous structures, spaces, and peoples. His practice subtly informs audiences of the polemical armature of apartheid, the agency of Dutch settlement culture and the repercussions of forced removals rooted in the South African landscape. In his prodigious series *The Structure of Things Then,* without relying on the presence of the figure, Goldblatt records the cultural body of white domination and black dispossession.

Goldblatt's publications of photographic series expose, in the words of the artist, "conditions of society," including *On The Mines* (1973), *Some Afrikaners Photographed* (1975), *In Boksburg* (1982), *Lifetimes: Under Apartheid* (1986), *The Transported of Kwandebele: A South African Odyssey* (1989), and *The Structure of Things Then* (1998).

His immense photographic corpus, dating from 1948, comprises critical historical and social documents representing the legacy of colonialism through the post-apartheid period. Goldblatt's approach to recording the architecture and landscape of South Africa ranged from photographing the township of Soweto to the white suburb of Hillbrow, revealing the psychosocial intersection of those spaces in order to interrogate affiliations between landscape and citizenship. Reversing the terms of the highly politicized imagery produced under the auspices of struggle reportage or activist photography, Goldblatt turned his attentions to the white populations of the suburbs of Johannesburg, centering on what the artist terms the "homogenization" of the city.

Goldblatt makes a distinctive break between his commercial and conceptual work. Having published political photographs in *Life, Look,* and *Picture Post,* primarily in the 1950s, centering on the Defiance Campaign mounted by the African National Congress against Pass Laws in 1952, he shifted from documenting political events to "exposing a situation" or focusing on the "states of being that lead to events." Goldblatt's work featured in Documenta11 shows his supplanting of the documentary tradition through examples of early work from *In Boksburg*, combined with a newly commissioned portrait of Johannesburg. In a quiet and ambivalent way, Goldblatt negotiates both personal and political aspects of the South African landscape, recording the obscure, in-between sites that register and reverberate the memory, territory, history, and architecture of apartheid. L.F.

In Boksburg (Hypermarket employee collecting trolleys) I *In Boksburg (Supermarkangestellter sammelt Einkaufswagen ein)*, 1979
Black-and-white photograph, c. 40 x 50 cm I Schwarz-Weiß-Fotografie, ca. 40 x 50 cm

LEON GOLUB

*1922 in Chicago, IL, USA. Lebt/Lives in New York.

Leon Golub entwickelte eine politisch engagierte ästhetische Praxis, weil er die seiner Meinung nach hermetischen Formalismen des abstrakten Expressionismus ablehnte, welche die amerikanische Nachkriegskunst dominierten. Mehr als fünf Jahrzehnte lang untersuchte Golub die gewaltgeprägte Peripherie einer Gesellschaft, die von Bildern dominiert wird. Das Ergebnis setzte er in Gemälde um, deren lädierte Oberflächen eine beunruhigende visuelle Faszination ausüben. Die beschädigten Leinwände, die er konventionell mit Lack- und Acrylfarben bemalt, anschließend jedoch mit Lösemitteln und Metzgerbeilen bearbeitet, sind Monumente der Konfrontation mit Ideologien, die das Individuum manipulieren und oft sogar auslöschen.

In seiner friesähnlichen Serie *Gigantomachies* (1964–1967) wandte Golub sich den klassisch inspirierten Darstellungen vom Körper als Ort ewiger Antagonismen zwischen universellen Kräften zu. Die Serien *Vietnam* (1972–1974), *Mercenaries* (1979–1987), *Interrogations* (1981–1986), *White Squads* (1982–1987), *Riots* (1983–1987) und *Prisoners* (1985–1990) dagegen sind aktuelle Beispiele der Auseinandersetzung mit körperlicher Gewalt und Vernichtung. Diese Arbeiten bestehen aus Fragmenten, die Massenmedien entnommen sind und deutlich Bilder von Folter, Verhören, Kämpfen, Attentaten, Schlachten und Morden zeigen. Die körperlichen Traumata finden ihren Ausdruck einerseits in einem fast dokumentarischen Realismus, der kaum mehr als nackte Fakten zeigt, spiegeln sich andererseits aber auch in sämtlichen Aspekten der Ausführung und Komposition der Bilder wider – in der Zerstörung der gemalten Oberfläche und der Vernichtung ganzer Leinwandbereiche oder im zermürbenden Zusammenfallen der Figuren mit dem Raum, den sie einnehmen. Damit gibt Golub zu verstehen, dass beide Dimensionen nur durch Bilder zugänglich sind – obwohl das moderne Verständnis von Macht an empirische Daten und an ein wenig greifbares sinnliches Zusammenspiel von Oberflächen und Texturen geknüpft ist. Um die Schlüsselrolle der Wahrnehmung wissend, differenziert und bricht Golub den Blickwinkel der Betrachter im Verhältnis zu den Vorgängen, denen sie beiwohnen. Er tut dies, indem er ihnen durchkomponierte, visuell faszinierende Bilder präsentiert, deren ästhetischer Genuss freilich beklemmend ist. Diese Dissonanz zwischen Mittel und Zweck, Vergnügen und Qual ist Hinweis auf die Strategie, mit der Machtstrukturen das Individuum kontrollieren.

Golubs neuere, kleinformatige Arbeiten zeichnen sich durch eine weniger ausgeprägte Kratztechnik, größere Flächen ungrundierter Leinwand, prekäre Körperlichkeit und die Einführung von Textspuren aus. Ergänzt werden sie durch großflächigere Bilder mit mythischen, oft kryptischen Archetypen und Allegorien. Golub präsentiert hybride Räume, in denen Katastrophen, Angst und Auflösung allgegenwärtig sind. Er kritisiert weiterhin die irrationalen sozialen Zustände, in denen wir leben – eine Realität, in der die körperliche Existenz durch öffentliche Strukturen und durch sie manipulierte öffentliche Formen der Kommunikation bedroht ist.

Rejecting what he regarded as the hermetic formalism of abstract expressionism, the dominant movement in the American postwar period, Leon Golub developed an aesthetic practice committed to political engagement. For more than five decades, Golub has been delving into the violent peripheries of a society mediated by images, in paintings whose maimed surfaces contain an unsettling visual allure. His ravaged canvases, painted in lacquers and acrylics before being eroded with solvents and scraped with a meat cleaver, are monumental sites of confrontation with ideologies that manipulate and often obliterate the individual.

In the frieze-like *Gigantomachies* series (1964–1967), Golub turns to the classically inspired body as a site of perpetual antagonism between universal forces and in the series *Vietnam* (1972–1974), *Mercenaries* (1979–1987), *Interrogations* (1981–1986), *White Squads* (1982–1987), *Riots* (1983–1987), and *Prisoners* (1985–1990) he represents contemporary instances of bodily aggression and annihilation. These works, often based on fragments taken from the mass media, contain explicit images of torture, interrogations, combat, assassinations, battles, and murder. While this corporeal trauma is expressed in an almost documentary realism that presents little more than the bare facts, it is also reflected in every aspect of a painting's execution and composition, from the destruction of the painterly surface and the removal of entire sections of the canvas, to an unnerving collapse of the figure with the space it occupies. In this way, Golub suggests that although the apprehension of power in modernity is linked to empirical data and to a more elusive sensorial interplay of surfaces and textures, both dimensions are made available only through images. Understanding the critical role of perception, Golub complicates the viewer's position in relation to the acts they are witnessing by offering carefully crafted, visually compelling paintings that provoke uneasy aesthetic pleasure. This dissonance between ends and means, anguish and enjoyment, reveals the strategy through which networks of power exert control over the individual.

Golub's recent small-format work is characterized by a lighter scraping technique, greater exposed areas of unprimed canvas, a precarious corporeality, and the introduction of textual traces. Larger canvases complement this output with mythic, often cryptic, archetypes and allegories. By presenting hybrid spaces in which catastrophe, anxiety, and dissolution are omnipresent, Golub continues to critique the irrational social sphere we inhabit, a reality in which bodily existence is perpetually threatened by public authorities and the public forms of communication they manipulate. N. B.

We Can Disappear you #10 I *Wir können Sie verschwinden lassen, Nr. 10,* 2001
Acrylic on linen I Acryl auf Leinen, 54,5 x 47 cm

DOMINIQUE
GONZALEZ-FOERSTER

*1965 in Straßburg/Strasbourg, Frankreich/France.
Lebt/Lives in Paris.

Dominique Gonzalez-Foersters Arbeiten sind oft von biografischen und literarischen Andeutungen geprägt. Es sind sich entwickelnde Erzählungen, die sich langsam aus unvollständigen Versatzstücken, aus Fotografien, besonders arrangierten Interieurs und persönlichen Details erschließen lassen. Diese Fragmente werden von Gonzalez-Foerster recherchiert und als „Indizien" für den Betrachter ausgelegt, der dann die „Reparage" (Gonzalez-Foerster) der Geschichte unternimmt.

Für die Werkgruppe *Rêves* (Träume, 1990) stellte Gonzalez-Foerster auf kleinen farbigen Plexiglasscheiben Ansammlungen von Fotografien – Schnappschüsse, Zeitungsausschnitte, Filmstills – zusammen, die als Hinweise für den Betrachter dienen, ihn „in einen Detektiv verwandeln, einen Geist der Recherche wecken, eine Neugier auf andere Geschichten als die eigene, um die Bedeutung aller Erzählungen als Sprache des Selbst und den Wert aller Schlussfolgerungen und Wortschätze zu betonen." (Gonzalez-Foerster)

In einer Serie von farblich strukturierten Interieurs entwickelt Gonzalez-Foerster Ambiente, die durch ihre Gestaltung bestimmte Stimmungen und Erinnerungsfragmente erzeugen. Für *R.W.F.* (1993) installierte Gonzalez-Foerster in einer Kölner Galerie eine Folge von Wohnräumen, die durch ihr Dekor und ihre vornehmlich braune Farbigkeit an eine glamouröse deutsche Wohnung der siebziger Jahre erinnerte. Der Titel verwies auf das Klingelschild Rainer Werner Fassbinders, der in den siebziger Jahren kurz in Köln wohnte, und das Interieur erinnerte an Filmsets einiger seiner Filme. Die zeittypische Einrichtung rief bei den Betrachtern eine generationsspezifische Erinnerung an die Zeit des Deutschen Herbstes hervor.

Mit ihren Filmen *Riyo* (1999) und *Central* (2001) verlagerte Gonzalez-Foerster ihre Suche nach bestimmten, assoziativen Ambientes erstmals in den Außenraum. In *Riyo* bestimmt der emotionale, flüchtige und offene Blick eines jungen Paares die Sicht auf den Kano-Fluss und die Stadt Kyoto. *Central*, gefilmt in der Bucht von Hongkong, verwandelt die Stadt in eine Kulisse individueller Veränderungen und Erwartungen.

Für die Documenta11 entwickelt Gonzalez-Foerster einen Park, in dem verschiedene geografisch und historisch codierte Elemente zusammengeführt werden: Eine Telefonzelle aus Brasilien, ein Rosenbusch aus Le Corbusiers Rosengarten im indischen Chandigarh und ein Lavastein aus Mexiko bilden gemeinsam mit anderen Elementen ein System von Referenzen, in dem sich reale und eingebildete Reisen, historische Details und kulturell geprägte Bedeutungen überlagern und das eine Fährte für die (Re-)Konstruktion verschiedenster Erzählungen bereithält.

Dominique Gonzalez-Foerster's works are often marked by biographical and literary allusions. They are developing narratives, which can slowly be deduced from incomplete set pieces, photographs, specially arranged interiors, and personal details. These function as fragmentary "indices," researched and displayed by Gonzalez-Foerster. The viewer undertakes a kind of "reparage" (Gonzalez-Foerster) of the individual stories.

For the series of works *Rêves* (Dreams, 1990) Gonzalez-Foerster put together a collection of photographs—snapshots, newspaper clips, film stills—on small, colorful Plexiglass sheets, which might refer to fragmentary memories and personal narratives, serving "to transform the viewer into a detective, generate a seeking spirit for a research, a curiosity for other stories to stress the importance of all kinds of narratives as self-language and the value of all clues or vocabularies" (Gonzalez-Foerster).

In a series of interiors structured by colors, Gonzalez-Foerster develops different atmospheres; the room designs create certain moods and store fragments of memories. For *R.W.F.* (1993), Gonzalez-Foerster installed a succession of living rooms in a Cologne gallery, whose decor and mostly brown color recalled a glamorous German apartment of the 1970s. The title of this work referred to the nameplate next to Rainer Werner Fassbinder's doorbell (the filmmaker lived for a short while in Cologne in the 1970s). The interior recalls film sets of some of his films, while the interior decoration, typical for the times, evokes the mood of fall 1977 ("Deutscher Herbst"), which a particular generation would remember.

With her films *Riyo* (1999) and *Central* (2001), Gonzalez-Foerster took her search for particular, associative atmospheres outdoors for the first time. In *Riyo,* the Kano river and the city of Kyoto are seen through the eyes of a young couple, whose viewpoint is emotional, fleeting, and open. In *Central,* filmed in Hong Kong Bay, the city is transformed into a setting for personal changes and expectations.

For Documenta11, Gonzalez-Foerster developed a park that links various geographical and historically coded elements with each other. A telephone booth from Brazil, a rose bush from Le Corbusier's rose garden in Chandigarh, India, and a lava stone from Mexico, along with other elements, form a system of references, in which real and imaginary travels, historical details, and culturally marked meanings overlap, storing traces for the (re)construction of multiple narratives. C.R.

Brasilia Hall | *Brasilia-Halle*, 2000
Installation view | Installationsansicht, Moderna Museet,
Stockholm, 2000

RENÉE GREEN

*1959 in Cleveland, OH, USA. Lebt/Lives in New York.

Die archivarische Fähigkeit von Film und Video, Zugang zu Erinnerung und Geschichte zu gewährleisten, untersucht Renée Green seit Anfang der neunziger Jahre, indem sie private Erinnerungen mit öffentlichen vermischt. Greens einladende, heimelige Videoinstallationen machen Geschichte greifbar, indem sie Ereignisse aus den Tiefen des kollektiven Gedächtnisses in den Bereich des Persönlichen und Familiären holen. Greens Rituale zu reisen führen Erinnerungsstränge zusammen und erkunden epochale Sujets wie den Koreakrieg, das US-Engagement in Kambodscha (*Partially Buried in Three Parts*, 1996–1999), die erste portugiesische Eroberung in Afrika 1415, (*Tracing Lusitania: Excerpts from an Imagined Prototype*, 1991–1999), die Diaspora der Molukken in den Niederlanden (*After the Ten Thousand Things: Scenes from the Hague*, 1994) und den Sklavenhandel im Frankreich des 19. Jahrhunderts (*Commemorative Toile*, 1992). Green diagnostiziert die Eigenschaft kulturell konditionierter Systeme der Wissensproduktion und -speicherung, nur eine Realität aufzunehmen, und analysiert die gegenwärtigen Bedingungen von Auflösung und Entwurzelung.

Eine zentrale Funktion in ihrem archäologischen Projekt kommt dem Geschichtenerzählen zu: Ihr in Neapel, Wien und New York gedrehtes Video *Some Chance Operations* (1999) legt Erinnerungen an die legendäre italienische Filmemacherin Elvira Notari (1875–1946) „räumlich" frei, indem es assoziativ auf die Architektur- und Lokalgeschichte ihrer Umgebung Bezug nimmt. In Interviews mit zufälligen Passanten werden der Ort Neapel und die Person von Notari systematisch miteinander verschmolzen. Statt der althergebrachten Vorstellung von einem beständigem Raum, dem „Zuhause", zieht sie die sich unablässig aktivierende Vorstellung von Raum als Knotenpunkt in der Zeit vor. Greens Videoprojekt *Partially Buried in Three Parts* (1996 – 1999) verwebt verschiedenste Erinnerungsstränge – z.B. die Spuren von Robert Smithsons *Partially Buried Woodshed* und die Erschießung von Studenten durch die Nationalgarde an der Kent State University im Jahr 1970 mit Erfahrungsberichten von Greens Mutter, die damals an der Universität arbeitete. Die Problematik von Übertragung wird in Greens Werk als Matrix von grenzüberschreitenden Ideen vor dem Hintergrund einer allgemeinen Idee von Entropie eingesetzt.

Zur Documenta11 präsentiert Green *Standardized Octagonal Units for Imagined and Existing Systems,* einen Freiluftpavillon mit fesselnden Klangwerken, Video- und Diamaterial in acht verschiedenen Räumen zu so disparaten Themen wie „Alphabet, Farbe, Afrika, Insel, Lebensmittel, Arbeit, Frau, Mann, Geschlecht, Intoxikation, Sinne, Synästhesie, Landschaft, Maschine und Musik" (Green) – eine evokative Ansammlung von Medien, die in einer Zeit des globalen Kapitals, der digitalen Welten und der Desillusionierung Träume von imaginären Ländern und Kulturen heraufbeschwört.

Intermingling private and public recollections, since the early 1990s Renée Green has been exploring the archival capacities of the media film and video to retain access to memory and history. Green's homely video installations reintroduce what is buried in popular memory into the realm of the personal and the domestic, making history tangible. Interweaving mnemonic traces, Green's rites of travel have explored subjects as far-reaching as the Korean war, U.S. involvement in Cambodia (*Partially Buried in Three Parts,* 1996–1999), Portugal's first conquest in Africa in 1415 (*Tracing Lusitania: Excerpts from an Imagined Prototype,* 1991–1999), the diaspora of the Moluccans in Holland (*After The Ten Thousand Things: Scenes from The Hague,* 1994), and 19th-century slave trade in France (*Commemorative Toile,* 1992). Investigating culturally conditioned systems of knowledge production and storage for their capacity to record a reality, Green probes the contemporary condition of dispersal and dislocation.

Central to Green's archaeological enterprise is the function of storytelling. In her seminal video *Some Chance Operations* (1999), shot in Naples, Vienna, and New York, the remembrance of Italian filmmaker legend Elvira Notari (1906–1930) is excavated "spatially" through associative links to a surrounding architectonic and localized history. In interviews with random passersby, the location of Naples and the figure of Notari are systematically conflated. Foregoing conventional notions of home in favor of active notions of place as knots in time, her video project *Partially Buried in Three Parts* (1996–1999) weaves together several strands of remembrance such as the ruins of Robert Smithson's *Partially Buried Woodshed* and the killing of students by National Guards at Kent State University, with Green's experiential accounts of her mother's teaching job there in 1970. Issues of translation are addressed in Green's work against the backdrop of an overall idea of entropy, as a matrix of ideas moving across boundaries.

For Documenta11, Green has produced *Standardized Octagonal Units for Imagined and Existing Systems,* an outdoor pavilion featuring arresting sound pieces, audio, video, and slide materials in eight enclosed chambers on subjects as disparate as "alphabet, color, Africa, island, food, work, woman, man, sex, intoxication, senses, synaesthesia, landscape, machine, and music" (Green); a sheltered array of media that induces states of reverie for imaginary lands and cultures in times of global capital, digital worlds, and disillusionment. N.R.

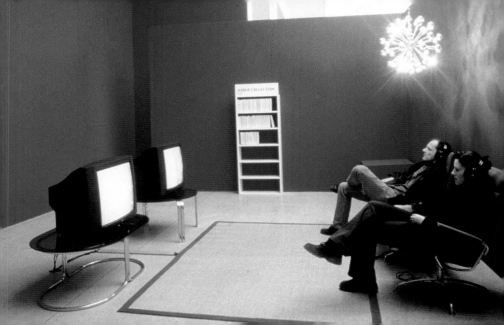

VICTOR GRIPPO

*1936 in Junín, Argentinien/Argentina. †2002 in
Buenos Aires.

Grippo studierte Chemie, bildende Kunst und Design an der renommierten Universität von Buenos Aires. Seine frühen Werke spiegeln diesen Einfluss wider, sie entwickelten sich nach und nach zu einer Untersuchung von „Arbeit" und ihren transformatorischen Kräften. Als metaphorisches Modell dient Grippo die Alchemie: Er sieht den heutigen Künstler, der das Individuum und die Gesellschaft umzugestalten sucht, als moderne Inkarnation des mittelalterlichen Alchemisten. Die paradigmatische Figur des Künstlers taucht in Verbindung mit der des Handwerkers – mit Bäckern oder Tischlern – in seinen Plastiken und Installationen immer wieder auf. Der bewusste Einsatz billiger, alltäglicher Materialien bestimmt als ethische Dimension das gesamte Werk: Grippo setzt diese Materialien ein, um soziale, ökonomische und politische Aspekte seiner Umwelt zu kommentieren.

Die Documenta11 zeigt Grippos Installation *Mesas de trabajo y reflexión* (Tische zum Arbeiten und Nachdenken), die zuerst auf der Biennale von Havanna 1994 zu sehen war. Die Arbeit besteht aus sieben in Havanna gekauften Tischen, von denen mehrere während der ersten kubanischen Alphabetisierungskampagne von 1959 als Schulpulte gedient haben. Auf die Tische hat Grippo ausgewählte Texte argentinischer Autoren geschrieben. Die Installation beruft sich auf die Arbeit *Tabla* (Tisch, 1978) – ein Tisch mit einem Text von Grippo über die profane Heiligkeit von Räumen, die von mehreren Generationen benutzt werden, um darin zu essen, zu lernen, zu denken, zu arbeiten und zu feiern. Alltagsobjekte erhalten hier, wie auch in anderen Werken Grippos, eine mehrdeutige, mystische Dimension, die mit dem transformativen Potenzial von Arbeit in Beziehung steht – ein Potenzial, das sowohl das bearbeitete Objekt als auch das bearbeitende Subjekt beeinflusst. Wie die Verwandlung von Metall in Gold durch die Alchemie auch die spirituelle Transzendierung des Alchemisten durch die Arbeit versinnbildlicht, transformiert Kunst für Grippo zugleich den Künstler und die Gesellschaft, der er angehört.

Grippo studied chemistry and visual arts and design at the prestigious University of Buenos Aires. His early work reflects these influences, which gradually developed into a study of labor and its transformative powers. Transformation through alchemy is Grippo's metaphorical model for synthesizing and articulating his work; he sees the artist as a present-day incarnation of the medieval alchemist, trying to transform individuals and society. The paradigmatic figure of the artist, nearly always connected to artisans—bakers or carpenters—recurs in Grippo's sculpture and installations. The deliberate use of cheap, everyday materials has an ethical resonance in Grippo's work as a whole. He uses materials to comment on the social, economic, and political characteristics of his environment.

At Documenta11, Grippo exhibits an installation entitled *Mesas de trabajo y reflexión* (Tables for Work and Reflection), which was first shown at the 1994 Havana Biennial. The work consists of seven tables acquired in the city of Havana. Several of the tables had been used as elementary school desks during the first literacy campaign in Cuba in 1959. On the desks is a series of texts by Argentinian writers selected by Grippo. This installation is derived from an earlier work called *Tabla* (Board, 1978), a table on which a text by the author speaks of the profane sacredness of the space used by successive generations to feed and educate themselves, think, work, and celebrate. As in other works by Grippo, everyday elements take on an ambiguously mystical dimension correlative to the transformative potential of work—a potential that affects the object of the action as well as the subject that exerts it. If the transformation of metal into gold through alchemy is a parable of the alchemist's spiritual transcendence through work, art for Grippo simultaneously transforms the artist and the society to which he belongs. C.B.

Tabla I *Table* I *Tisch,* 1978
Wood, text I Holz, Text, 75 x 120 x 60 cm

Sobre esta tabla, hermana de infinitas otras construidas por el hombre, lugar de unión, de reflexión, de trabajo, se partió el pan cuando lo hubo; los niños hicieron sus deberes, se lloró, se leyeron libros, se compartieron alegrías.

Fue mesa de sastre, de planchadora, de carpintero...

Aquí se rompieron y arreglaron relojes.

Se derramó agua, y también vino. No faltaron manchas de tinta, que se limpiaron prolijamente para poder amasar la harina.

Esta mesa fue tal vez, testigo de algunos dibujos, de algunos poemas, de algún intento metafísico que acompañó a la realidad.

Esta tabla, igual que otras, y la transubstanciación de

Sobre esta tabla, hermana de infinitas otras construidas por el hombre, lugar de unión, de reflexión, de trabajo, se partió el pan cuando lo hubo; los niños hicieron sus deberes, se lloró, se leyeron libros, se compartieron alegrías.

Fue mesa de sastre, de planchadora, de carpintero...

Aquí se rompieron y arreglaron relojes.

Se derramó agua, y también vino. No faltaron manchas de tinta, que se limpiaron prolijamente para poder amasar la harina.

Esta mesa fue tal vez, testigo de algunos dibujos, de algunos poemas, de algún intento metafísico que acompañó a la realidad.

Esta tabla, igual que otras, y la transubstanciación de

LE GROUPE AMOS
FLORY KAYEMBE SHAMBA, JOSÉ MPUNDU,
THIERRY N'LANDU, JOS DAS

Gegründet/Founded 1989 in Kinshasa, Demokratische Republik Kongo/Democratic Republic of the Congo.

Le Groupe Amos nennt sich nach dem alttestamentarischen Propheten Amos, der der Legende nach für die soziale Gerechtigkeit kämpfte. Umgeben von einer gespaltenen, sich selbst ausrottenden Nation, versucht diese außergewöhnliche Gruppe von Aktivisten unterschiedlicher christlicher Glaubensrichtungen, soziale Veränderungen durch gewaltlose Aktionen zu bewirken.

Groupe Amos hat eine Fülle von didaktischem Material in Zusammenarbeit mit unterschiedlichen kongolesischen Bürgerinitiativen produziert, darunter Videodokumentationen, Theaterproduktionen, Malerei, Radiosendungen und Publikationen. Von und für überwiegend analphabetische Gemeinden sind diese Arbeiten sowohl auf Französisch als auch in lokalen Dialekten entstanden. Das Engagement der Groupe Amos für die Veränderung der kongolesischen Gesellschaft mit gewaltlosen Mitteln zeigt sich in ihren zahlreichen inspirierenden und informativen Projekten. Besonders die Notlage von Frauen ist das Thema kurzer Videodokumentationen wie *Congo aux deux visages. L'Espérance têtue d'un peuple* (Zwei Seiten des Kongo. Die sture Hoffnung eines Volkes, 1997), *Femme congolaise. Femme aux milles bras* (Frau des Kongo. Frau mit Tausend Armen, 1997) und *Au nom de ma foi* (Im Namen meines Glaubens, 1997). *Et ta violence ma scul ta femme* (Deine Gewalt macht mich zu Deiner Frau, 1997) ist ein Video in Lingala, einem Dialekt aus Kinshasa, über die Kraft der Frauen, die für ihre eigene Rechte in einem Umfeld kämpfen, in dem Traditionen, Gebräuche, Religion und bestehende Gesetze Gleichheit erschweren. Gewalt gegen Frauen ist auch das Thema des Bilder- und Gedichtzyklus' *Chemin de croix de la femme congolaise* (Kreuzweg der kongolesischen Frau), der als ein Rundgang präsentiert wird. Ein von der Groupe Amos live aufgezeichnetes Theaterprojekt wurde mit Hausangestellten verwirklicht, die in ihrer knappen Freizeit als Schauspieler agierten. So wurde es Frauen ermöglicht, didaktisches Material für weitere von ihnen organisierte Gesprächsrunden zu erstellen und sie wurden ermutigt, über Tabuthemen wie Sexualität und Gewalt zu sprechen.

Geleitet von Zuversicht und dem Glauben an die Versittlichung aller Menschen geleitet, produziert Amos auch Unterrichtsmaterial, Broschüren und Bilderbücher zu unterschiedlichen Themen, u.a. zu freien und demokratischen Wahlen, zu Lokalgeschichte und Kultur. Ein weiteres Mittel der Verbreitung ihres Diskussions- und Informationsmaterials zu diesen Themen ist die Produktion und Ausstrahlung von Radioprogrammen, die gemeinsam mit dem katholischen Radiosender Radio Elikya auf Französisch und in lokalen Dialekten produziert werden. Mitschnitte der Programme werden landesweit verteilt und gehört.

Auf der Documenta11 wird eine Auswahl dieser Radioprogramme gesendet, die über Kopfhörer in der Ausstellung zu hören sind. Die Spannbreite der Aktivitäten der Groupe Amos wird zudem an Beispielen gedruckten Materials und durch Videos veranschaulicht.

Le Groupe Amos took its name from the Old Testament prophet Amos, who is known to have struggled for social justice. While surrounded by a divided nation in decay, this outstanding group of activists of various Christian faiths promotes social change by means of creative nonviolent action.

Groupe Amos has produced a wealth of didactic materials with various grass-roots Congolese groups in the form of video documentaries, works of theater, paintings, radio broadcasts, and publications. Designed by and for predominantly illiterate communities, these works are produced in both French and vernacular languages. Groupe Amos's commitment to changing Congolese society through nonviolent strategies is evidenced by numerous inspirational and informative projects. In particular, Amos has focused on the plight of women with short video documentaries such as *Congo aux deux visages. L'Espérance têtue d'un peuple* (The Two Faces of the Congo, The Stubborn Hope of a People, 1997), *Femme congolaise. Femme aux milles bras* (Congolese Women. Women with a Thousand Arms, 1997), and *Au nom de ma foi* (In the Name of My Faith, 1997). *Et ta violence me scul ta femme* (And Your Violence Made Me Your Woman, 1997) is a video in Lingala, a vernacular language from Kinshasa, which celebrates the power of Congolese women who struggle for rights in a context where traditions, customs, religion, and even existing laws do not facilitate equality. Violence against women is also the topic of the cycle of paintings and poems *Chemin de croix de la femme congolaise* (The Stations of the Cross of the Congolese Woman), which is presented as a tour that the viewer can follow. One of Groupe Amos's original recorded theater projects invited housekeepers to be actors in their limited leisure time. This allowed women to record didactic materials for sessions that they organized, and encouraged women to talk candidly about taboo subjects such as sexuality and violence.

Committed to the increased optimism and enhancement of all people, Amos has also produced educational documentaries, booklets and picture books on various topics such as free and democratic elections, local history, and culture. A further means of distributing materials and information on these topics is the production and distribution of radio programs, produced under the auspices of the Catholic radio station Radio Elikya, and made both in French and vernacular. Often, tapes of these radio programs are further distributed and listened to all over the country.

For Documenta11, a selection of radio debates will be accessible through headphones available in the exhibition. The breadth of the activities of Groupe Amos will further be illustrated with printed matter and a video. T.N'L.

Campagne éducation à la démocratie I *Education for Democracy-Campaign* I *Kampagne für eine Schule der Demokratie,* n.d. I o.J. Performed by Mama OFEDICO (Women's Organisation for Development, Integration, and Community), video, script and production: Thierry N'Landu I Dargestellt von Mama OFEDICO (Frauenorganisation für eine gesamt-gemeinschaftliche Entwicklung), Videoaufzeichnung, Drehbuch und Umsetzung: Thierry N'Landu

JENS HAANING

*1965 in Hørsholm, Dänemark/Denmark. Lebt/Lives in Kopenhagen/Copenhagen.

Seit Anfang der neunziger Jahre konzentriert sich Jens Haaning in seinen Arbeiten auf die Grenzbereiche und Konfliktzonen, die die sozialen, ökonomischen und politischen Verhältnisse westlicher Gesellschaften bereithalten. Immigration, Wirtschaftsmigration sowie die Tricks und Schlupflöcher globalisierter Marktwirtschaft tauchen als Themen und Strategien in Haanings Werken immer wieder auf. Seine Arbeiten greifen dabei unterschiedliche, in der Geschichte der modernen Kunst erprobte Modelle der Kontextverschiebung und des Zitats auf, um Fragen nach der Wirksamkeit und der kritischen Substanz künstlerischer Interventionen zu stellen.

Grundmodell von Haanings Arbeiten ist die Zusammenführung und Konfrontation verschiedener Systeme, die einander räumlich nahe sind, aber kulturell oder ökonomisch unterschiedliche Strukturen aufweisen. 1994 installierte er in einem Osloer Stadtviertel mit hohem türkischen Bevölkerungsanteil einen Lautsprecher, über den Witze auf türkisch übertragen wurden (*Turkish Jokes*, 1994), und ließ dabei sowohl das Objekt als auch den Adressaten der Mitteilung im Unklaren. Für die Documenta11 wird die Arbeit in einer neuen Form wiederholt und in einem zentralen Innenstadtbereich installiert.

In einigen Fällen machte sich Haaning die unterschiedlichen Steuersätze für Kunstobjekte und Konsumgüter zunutze, indem er Reisen und Flugtickets (*Travel Agency*, 1997) oder Lebensmittel (*Trade Bartering*, 1996; *Super Discount*, 1998) als Kunstwerke deklarierte und so mit Rabatt verkaufen konnte. Haanings Projekt *Office for the Exchange of Citizenship* (1998) liegt eine ähnliche Lücke in der internationalen Gesetzgebung zugrunde, da der freiwillige Tausch von Staatsbürgerschaften, den Haanings Büro zu vermitteln versucht, von keinem Land ausdrücklich untersagt ist.

Für die Arbeit *Middelburg Summer 1996* (1996) verlegte er für die Dauer der Ausstellung die komplette Produktion einer nahe gelegenen Textilfabrik, inklusive Kantine und Büros, in eine Kunsthalle im niederländischen Middelburg. Die Arbeit stellte nicht nur die verschiedenen Ökonomien künstlerischer und industrieller Produktion ein weiteres Mal gegenüber, sondern exponierte zugleich die Billiglohnarbeiter türkischer, kroatischer und iranischer Herkunft als Teilnehmer an einem komplexen Wirtschaftsgefüge globalisierter Arbeitsmärkte, deren Anwesenheit in der Kunsthalle nur ein weiteres Beispiel von „Displacement" darstellte.

Indem Haaning auf bestimmte Problemfelder im gesellschaftlichen Gefüge reagiert, Grauzonen und Schlupflöcher im juristischen und ökonomischen Apparat der europäischen Staatengemeinschaft ausnutzt oder wirtschaftliche Produktionsmodelle unverändert für die Kunst übernimmt – und das meist ohne Folgen bleibt –, weist er der Kunst explizite Funktionsmöglichkeiten zu, die den Anspruch der Kunst als Agens gesellschaftlicher Veränderung in Frage stellen.

Since the early 1990s, Jens Haaning's works have concentrated upon the peripheries and zones of conflict within the social, economic, and political conditions of Western societies. Immigration, economic migration, and the tricks and loopholes of the global market economy are constant themes and strategies in Haaning's works. He applies various models of contextualization and citation, all of which have been tried and tested in modern art, in order to pose questions about the effectiveness and critical substance of artistic interventions.

Haaning's works are based on combining and confronting various structures and systems that are closely located to one another, yet culturally or economically different. In 1994, he installed an loudspeaker in a part of Oslo with a large Turkish population, and broadcast jokes in Turkish (*Turkish Jokes*, 1994)—a tactic that left the listeners in uncertainty, not only about the subject of what was being broadcast but also about who was being addressed. For Documenta11, the work will be repeated in a new form and installed in a central inner city neighborhood.

In some cases, Haaning exploited the different tax laws for art objects and consumer products, declaring trips and plane tickets (*Travel Agency*, 1997) or food (*Trade Bartering*, 1996; *Super Discount*, 1998) to be works of art and thus able to be sold at a discount. Haaning's project *Office for the Exchange of Citizenship* (1998) is also based on a similar loophole in international law, since a voluntary exchange of citizenship, as Haaning's office attempts to arrange, is not expressly forbidden by any country.

In his work *Middelburg Summer 1996* (1996) Haaning moved an entire textile factory, including the cafeteria and offices, to a nearby exhibition hall in Middelburg, the Netherlands, for the full length of the show. The work not only once again forced the different economies of artistic and industrial production to confront each other, but at the same time exposed the fact that poorly paid Turkish, Croatian, and Iranian workers are participants in a complex economic network of globalized labor markets. Their presence in the exhibition hall was not the first, but simply a further example of displacement.

In reacting to particular problem areas in social networks, exploiting gray zones and loopholes in the European Union's legal and economic apparatus, or adapting unaltered economic production models for art, Haaning emphasizes the explicit functional possibilities of art, whose very ineffectiveness questions the notion of art as an agent for social change. C.R.

Turkish Jokes | *Türkische Witze*, 1994
In the Turkish quarter of central Oslo, a tape recording of jokes told by Turks in their native language was broadcast through a loudspeaker attached to a streetlamp. | Im türkischen Viertel der Innenstadt von Oslo wurden Tonbandaufnahmen mit Witzen abgespielt, die von Türken in ihrer Muttersprache erzählt wurden. Die Aufnahme wurde mit einem Lautsprecher übertragen, der an einer Straßenlaterne befestigt war.
P.I.G., Public Art Project | Kunst im öffentlichen Raum-Projekt, Oslo

MONA HATOUM

*1952 in Beirut, Libanon/Lebanon. Lebt/Lives in London.

Der Blick, die Wahrnehmung des Körpers, die Erfahrung von Dislokation und, damit verbunden, von Anderssein sind die vornehmlichen Themen von Mona Hatoums Performances, Videos, Installationen und Objekten. Das Kunsterlebnis ist für Hatoum eine physische Erfahrung, die dem Erkennen von Bedeutung, Konnotationen und Assoziationen vorausgeht. Als die Künstlerin 1975 von Beirut, wo sie als Tochter palästinensischer Exilanten aufwuchs, nach London kam, richtete sie ihren Blick auf die kulturell geprägten Unterschiede in der Körperwahrnehmung. Der Dichotomie von Körper und Geist begegnete sie mit Provokation durch das Brechen von Tabus und Aufzeigen unterschiedlicher Körpergrenzen. So sind die Endoskopien ihres eigenen Körpers in der Videoinstallation Corps étranger (Fremder Körper, 1994) gleichsam eine Erweiterung der Performance Don't Smile You're on Camera (1980), für die sie Videoaufzeichnungen des Publikums mit denen eines sich selbst nackt filmenden Paares und Röntgenbildern überblendete.

Measures of Distance (1988) ist ein sehr intimes Video über das Verhältnis Hatoums zu ihrer in Beirut lebenden Mutter. Fotografien, die die Künstlerin 1981 während eines Besuchs aufnahm, zeigen die Mutter unter der Dusche. Darüber liegen wie Schleier die Briefe der Mutter an die Tochter, die Hatoum mit schwermütiger Stimme auf Englisch liest, während im Hintergrund alte Aufnahmen von Gesprächen der beiden zu hören sind. Die Mutter reagiert in den Briefen auf Fragen nach Erotik und Sex, schildert die Erinnerungen an das Leben vor dem Exil und beschreibt die aktuellen Lebensverhältnisse in Beirut. Measures of Distance zeichnet ein persönliches Porträt, das dem Stereotyp der arabischen Frau als geschlechtsloser und passiver Mutter entgegengehalten wird. Die Überblendung als metaphorisches Verfahren dieses Films erzeugt dabei eine produktive Ambivalenz.

Homebound (2000) trägt dieses Strukturmerkmal bereits im Titel. Hinter einer horizontalen Drahtseilabsperrung, die an Hochsicherheitsgrenzen erinnert, sind über einem kargen, in gedimmtes Licht getauchten Arrangement von Wohn- und Schlafraummobiliar der fünfziger Jahre einfache metallene Küchenutensilien wie Abtropfsieb, Reibeisen und Trichter verteilt, die untereinander verkabelt sind. In einigen dieser Haushaltsgegenstände glühen in unregelmäßigen Abständen kleine Glühbirnen auf. Hatoum experimentiert hier mit der Verfremdung von alltäglichen Gebrauchsgegenständen, um von ihrem ambivalenten Verhältnis zu Heimat, Haushalt und Familie zu sprechen.

The gaze and the perception of the body, a personal experience of dislocation and the accompanying experience of the Other are the main themes in Mona Hatoum's performances, videos, installations, and objects. For Hatoum, the experience of art is physical, and precedes the understanding of significance, connotations, and associations. In 1975, the artist left Beirut, where she had grown up as the daughter of Palestinians living in exile. Once in London, she began to investigate cultural differences in the perception of the body. She reacted to the dichotomy of body and spirit by breaking taboos and revealing various limitations and borders of the body. In this respect, the endoscopies of her own body shown in the video installation Corps étranger (Foreign Body, 1994) can be seen as a continuation of the performance Don't Smile You're on Camera (1980), for which she superimposed video takes of the audience with those of x-rays and a naked couple filming itself.

Measures of Distance (1988) is a very intimate video description of Hatoum's relationship to her mother, who lives in Beirut. Photographs taken when Hatoum visited Beirut in 1981 show her mother in the shower. Resting upon these like veils are the mother's letters to the daughter, which Hatoum reads out sadly in English, while old recordings of conversations between mother and daughter can be heard in the background. In the letters, the mother responds to questions about eroticism and sex, describes her memories of life before exile as well as her current life in Beirut. In Measures of Distance, Hatoum draws a personal portrait which she opposes to the stereotype of the Arab woman reduced to the role of the mother, passive, and without gender. As a metaphorical method, the use of superimposition in Measures of Distance creates a productive ambivalence.

Homebound (2000) has the same kind of ambivalence in its title. A sparse arrangement of living room and bedroom furniture from the 1950s is dimly lit and fenced off by cable reminiscent of high security borders. Simple metal kitchen utensils—colander, grater, funnel—are distributed across the furniture and wired with each other. Small light bulbs glow intermittently in some of these household objects, becoming brighter and fading as the electricity flows through the utensils. Mona Hatoum experiments with an alienation effect of everyday objects, in order to speak of her ambivalent relationship to home, household, and family. T. M.

Homebound | Ans Haus gebunden, 2000
Kitchen utensils, furniture, electric wire, light bulbs, computerized dimmer switch, amplifier, speakers, dimension variable |
Küchenutensilien, Möbel, elektrischer Draht, Glühbirnen, computergesteuerter Dimmer, Verstärker, Lautsprecher, Maße variabel

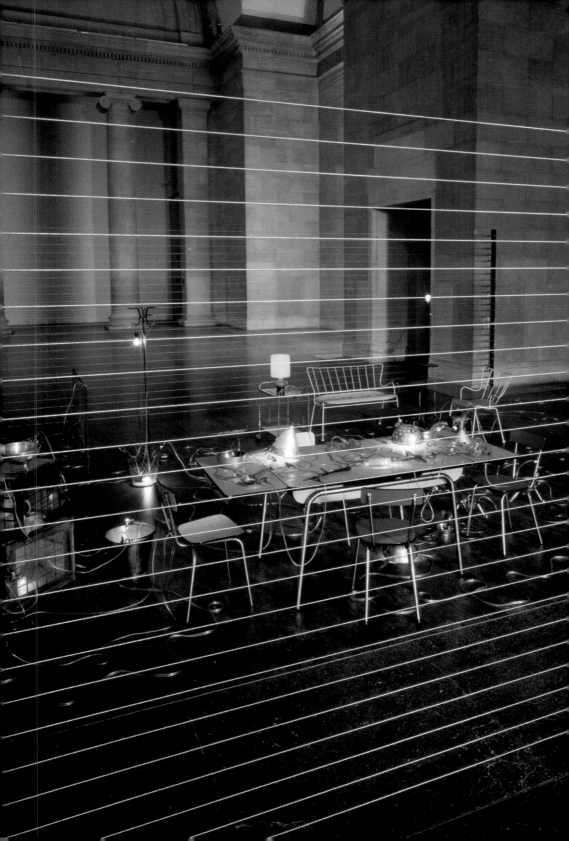

THOMAS HIRSCHHORN

*1957 in Bern/Berne, Schweiz/Switzerland. Lebt/Lives in Paris.

Thomas Hirschhorn ist ein Umgestalter der Conditio humana. Unzufrieden mit den aufgezwungenen Definitionen und Beschränkungen einer hyperkapitalistischen, multinationalen Globalisierungsrhetorik, macht er sich das kommunikative Potenzial des Denkens zunutze. Sein Werk, in dem der materielle Wert hintangestellt ist, umfasst skulpturale Modelle, die vornehmlich aus billigen Produktverpackungsmaterialien der Konsumgüterindustrie – Alufolie, Plastik, Karton und Sperrholz – gefertigt sind. Die Begierden des Kapitalismus werden damit in einen Zustand dauerhafter kreativer Anarchie überführt. Während die „direkten Skulpturen" im Museumsraum gezeigt werden, befinden sich Hirschhorns „Altäre", „Kioske" und „Denkmale" an vergänglichen, verwahrlosten öffentlichen Plätzen. Als temporäre Ausstellungscontainer akkumulieren sie einen Reichtum an visuellen Materialien aus Mode, Kunst, Politik und Philosophie und spiegeln so die duale Herrschaftsform der Waren- und Wissensproduktion. Sie verbinden, was keinen sichtbaren Zusammenhang aufweist – ein verschönerndes Werbeplakat für Chanel-Mode und eine schreckliche, doch zugleich vertraute Szene aus dem Zweiten Weltkrieg (Les plaintifs, les bêtes, les politiques; Die Ankläger, die Mitläufer, die Politischen, 1993/94) – und verfolgen damit das utopische Ideal der Gedankenfreiheit. Handgedrehte Aluminiumdrähte stellen „un-sinnige" (Deleuze) Verbindungen zwischen der Bildersprache der Massenmedien und alltäglichen Konsumgegenständen her. Die alles umfassende Weichheit und Fluidität zwischen ausgeschnittenen und auf Karton geklebten Bildern und handgefertigten Objekten wie beispielsweise den überdimensionalen Aluminiumnachbildungen von Schweizer Uhren (Time to Go, 1997) destillieren ein energetisches und kreatives Potenzial.

Verehrung und persönliche Verbundenheit sind zentrale Themen in Hirschhorns Hommage an Künstler und Schriftsteller des 20. Jahrhunderts, darunter Otto Freundlich (1998, Basel/Berlin), Ingeborg Bachmann (1999, Zürich), Robert Walser (1999, Zürich), Emmanuel Bove (2000, Zürich) und Fernand Léger (2001, Zürich). Als potenziell unfertige Altäre und Kioske sind sie in unbeachteten „Nicht-Orten" wie Fußgängerpassagen aufgestellt und laden die Passanten dazu ein, ihre eigenen Erinnerungsstücke hinzuzufügen.

Einer ähnlichen Logik von Kurzlebigkeit, Akkumulation und potenzieller „Offenheit" folgen auch Hirschhorns zeitlich begrenzte Denkmale für Benedict de Spinoza (1999, Amsterdam), Gilles Deleuze (2000, Avignon), Georges Bataille (2002, Kassel) und Antonio Gramsci (noch nicht realisiert), die sich mit kommunalem Engagement und „der Qualität innerer Schönheit" (Hirschhorn) auseinander setzen. Das Bataille Monument kartografiert die Stadt Kassel unter sozialen Gesichtspunkten und fügt sich für die Dauer der Ausstellung faktisch in das Leben einer marginalisierten lokalen Gemeinschaft ein. In einem begehbaren Container wird ein heterogenes Bild- und Textarchiv zu Bataille (1897–1962) aufgebaut, ergänzt durch Hirschhorns eigene Videodokumentation von Begegnungen mit Zeitgenossen wie Klossowski, Blanchot und Pauvert. Unter Verzicht auf traditionelle Kategorien der Wissensproduktion holt das Werk die zum Ritual formalisierte Sammel- und Ausstellungsfunktion des Museums in den öffentlichen Raum zurück und bereichert unprätentiös die soziale Landschaft.

Thomas Hirschhorn is a transformer of the human condition, plugging himself into the communicative potential of thought, discontent with the enforced definitions and limitations of a hypercapitalist, multinational rhetoric of globalization. Neglecting material value, his work comprises diverse sculptural models with an impoverished taste for the product wrappings of consumer industry—aluminum foil, plastic, cardboard, and plywood—suspending capitalist desires in a state of constant creative anarchy. "Direct sculptures" are located in the realm of the museum, whereas his "altars," "kiosks," and "monuments" are situated in neglected and transient public spaces. As impermanent exhibition containers they accumulate a wealth of visual materials from fashion, art, politics, and philosophy, mirroring the dual regimes of commodity and knowledge production. They connect what has no visible correlation—a beautifying Chanel fashion ad and a horrifying, yet familiar scene from World War II (Les plaintifs, les bêtes, les politiques, The Plaintive, the Dumb, the Politicals, 1993/94)—in pursuit of the utopian ideal of a freedom of thought from reason. Handrolled aluminum wires establish "nonsensical" (Deleuze) linkages between mass media imagery and common objects of consumption, distilling an energetic and creative potential by means of an all encompassing softness and fluidity between cutout images glued onto cardboard and handcrafted objects such as large blown-up aluminum Swiss watches (Time to Go, 1997).

Issues of commitment and personal attachment are central in Hirschhorn's commemorative homages to such 20th-century artists and writers as Otto Freundlich (1998, Basel, Berlin), Ingeborg Bachmann (1999, Zurich), Robert Walser (1999, Zurich), Emmanuel Bove (2000, Zurich), and Fernand Léger (2001, Zurich). Situated as potentially unfinished altars and kiosks in overlooked non-spaces such as public passageways, these invite pedestrians to add their own memorabilia.

Following a similar logic of ephemerality, accumulation, and a potential open-endedness, Hirschhorn's perishable monuments to Benedict de Spinoza (Amsterdam, 1999), Gilles Deleuze (Avignon, 2000), Georges Bataille (2002, Kassel), and Antonio Gramsci (not yet realized), reflect upon communal commitment and "the quality of internal beauty" (Hirschhorn). Socially mapping the city of Kassel, the Bataille Monument integrates itself actively into the lives of a marginalized local community for the duration of the exhibition. Hosted by an evanescent walk-in container, a heterogeneous textual and visual archive on Bataille (1897–1962) is diligently constructed with the help of young philosophers and accompanied by Hirschhorn's own video documentation of encounters with contemporaries such as Klossowski, Blanchot, and Pauvert. Forgoing traditional terms of knowledge production, the work returns the museum's ritualized function of displaying and collecting to the public realm, enriching a social landscape free of false pretenses. N.R.

Virus Ausstellung I Virus Exhibition, 1996
Installation view I Installationsansicht, Galerie Arndt & Partner, Berlin

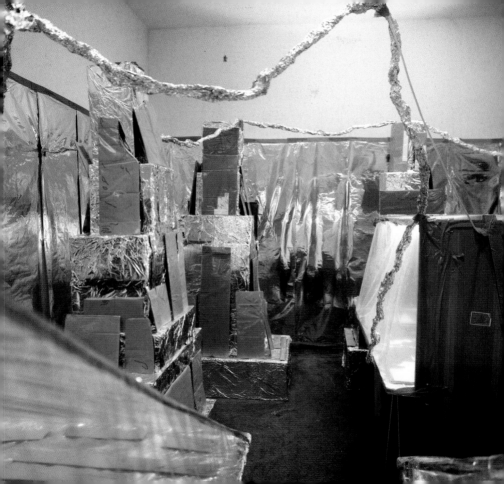

CANDIDA HÖFER

*1944 in Eberswalde, Deutschland/Germany. Lebt in Köln/Cologne, Deutschland/Germany.

Seit Ende der sechziger Jahre thematisiert Candida Höfer den sozialen und kulturellen Lebensraum des Menschen. In den siebziger Jahren entstand eine fotografische Dokumentation über das Leben türkischer Gastarbeiter in Deutschland. 1976 gehörte Höfer zu den ersten Studenten von Bernd Becher an der Düsseldorfer Kunstakademie. Menschenleere Innenräume kennzeichnen ihre Fotografien seit den achtziger Jahren. Es sind öffentlich zugängliche Architekturen wie Bibliotheken, Museen oder Universitäten, die Typologien von funktionalen und repräsentativen Versammlungsräumen bilden. Darüber hinaus finden sich Depots, Abstellkammern und Räume im Umbau als Motive. Die Ordnung in den Räumen und ihr Mobiliar weisen auf ihre Nutzung durch nur temporär abwesende Menschen. Häufig erscheint die Ordnung unvollkommen, wirken Einrichtungsgegenstände in der fotografischen Dokumentation unpassend oder absurd. Höfer macht die Widersprüchlichkeit dieser Räume sichtbar, indem sie immer auch die stilistisch-historischen Unstimmigkeiten der Orte – die Dialektik von Tradition und Moderne, Repräsentation und Gebrauch – abbildet.

Alle Motive werden gleich behandelt: Die Künstlerin fotografiert in den herrschenden Lichtverhältnissen aus Augenhöhe eine vorgefundene Situation, ohne die Orte zu verändern oder Dinge zu arrangieren. Der jeweils gewählte Blickwinkel ist unspezifisch. Oftmals erschließt sich der abgebildete Raumausschnitt mit seinen Details nur langsam und erfordert ein konzentriertes und intensives Sehen. Die Raumfotografien von Höfer sind fragmentarisch und dienen nicht als Dokumente für eine mögliche Identifikation oder Rekonstruktion. Die Systematik der Fotografien wird erst als Teil einer Serie und im Vergleich mit den anderen Raumbildern deutlich. Der Zusammenhang der Bildreihen ergibt sich aus dem abgebildeten normativen Einrichtungsstil, der die Funktion der Räume spiegelt.

Seit 1990 hat Höfer in ihren Fotografien von zoologischen Gärten Tiere zu Protagonisten ihrer jeweils für sie konstruierten Umgebung gemacht. Die Tiere sind das Äquivalent der Ausstattungsgegenstände in den Raumbildern.

Die Documenta11 zeigt eine Auswahl von Aufnahmen der von Auguste Rodin geschaffenen Bronzeskulptur Die Bürger von Calais (1884–1895). Höfer fotografierte die insgesamt zwölf Abgüsse an ihren Aufstellungsorten in Museen oder auf öffentlichen Plätzen weltweit. Mit der Dokumentation dieses Kunstwerks in seinen unterschiedlichen Umgebungen thematisiert Höfer Umgang und Rezeption einer Skulptur für den öffentlichen Raum. Dabei wird deutlich, welchen Einfluss die spezifischen Orte auf die Maßstäblichkeit und Wirkung der Skulpturengruppe besitzen.

From the end of the 1960s, Candida Höfer's photography has focused on human social and cultural environments. In the 1970s, she documented the lives of Turkish guest workers in Germany. In 1976, Höfer was one of Bernd Becher's first students at the Düsseldorf Academy of Art. Since the 1980s, she has been photographing interiors, mostly without people. Here, her topic is architecture that is accessible to the public—libraries, museums, universities, or lobbies. These are buildings that have always typified spaces where people meet, and they are both functional and representative. Höfer also photographs depots, storerooms and rooms undergoing reconstruction. In each case it is clear that the neat spaces and orderly furniture are used by people who are only temporarily absent. Often, however, this order appears to be incomplete, and the interior decoration in the photographs seems to be inappropriate or absurd. Höfer's photographs reveal the contradictions of these spaces because they always document the stylistic, historical incompatibility of the various sites—the dialectic between the traditional and the modern, between representation and practical use.

All the motifs are treated equally, as the artist photographs a found situation at eye level, without changing or arranging anything in the location, and using an unspecific point of view. Often, the room and its many details are only slowly revealed, demanding concentrated, intense viewing. Höfer's photographs are fragmentary, and thus cannot be used as documents for a possible identification or reconstruction. The system behind the photographs only becomes clear when the images are seen as part of a series and compared to the other photographs. It is not just their common theme that exposes the cohesion of the series, but also the normative style of interior decoration in the photographs, which mirrors the function of the rooms.

Since 1990, Höfer has been taking photographs in zoological gardens, making animals the protagonists of the surroundings constructed for them. The animals are the equivalent of the objects in the room pictures.

Documenta11 is showing a selection of photographs of Auguste Rodin's bronze sculpture The Burghers of Calais (1884–1895). Höfer photographed all twelve bronze casts in their different locations around the world, in museums or public squares. In making a record of this famous and symbolic artwork in its different surroundings, Höfer deals with the treatment and reception of a sculpture in the public realm, showing what kind of influence the specific sites have on the proportions and the effect of the statues. A. N.

CRAIGIE HORSFIELD

*1949 in Cambridge, England. Lebt/Lives in London.

Die Kunst hat für Craigie Horsfield ihren Ort im Dialog, innerhalb der „generativen Relation" des Miteinander-Denkens. Dieser produktive Zwischenraum verleiht ihr ein soziales Aktionspotenzial und bewahrt sie vor der idealisierten Isolierung, die dem Konzept des autonomen Kunstwerks zugrunde liegt.

Die Fotografien Horsfields entstehen in der Auseinandersetzung mit den Porträtierten, sie beziehen sich auf einen bestimmten Anlass oder einen konkreten Ort, den der Künstler schon lange kennt. 1988 präsentierte der Künstler seine Arbeiten zum ersten Mal. Fünf Jahre später stellte er sie in den Zusammenhang des Gemeinschaftsprojektes La Ciutat de la Gent (Die Stadt der Menschen, 1993–1995). Ausgangspunkt dieser Kollaboration, des so genannten „Barcelona-Projekts", bildeten Gespräche über die spezifischen Gegebenheiten von Orten und Gemeinschaften, insbesondere von Barcelona und Europa. Das Ziel war es, die Stadt durch ihre Bewohner beschreiben zu lassen. Mit Hilfe interaktiver Arbeitsgemeinschaften sollten Netzwerke in den Stadtbezirken ausgebildet und neue Methoden der Beschreibung entwickelt werden, die sich auf Erinnerung und Erfahrung gründen. Darüber hinaus wurden demokratische Prozesse vor dem Hintergrund urbaner Entwicklungskonzepte diskutiert. Das Ergebnis stellte das offiziell verbreitete Bild der Stadt Barcelona in Frage. Das Barcelona-Projekt, das auf den gemeinsam mit Manuel J. Borja-Villel und Jean-Francois Chévrier unternommenen Versuch zurückgeht, der Kunst eine Basis in der Gesellschaft zu erschließen, markiert für Horsfield den Beginn einer Serie von mehreren Projekten, die hinsichtlich des Nachdenkens über Gemeinschaft miteinander in Beziehung stehen.

Dazu gehört auch die im Rahmen der Documenta11 entstandene Arbeit The El Hierro Conversation. Ihr Gegenstand ist die Beschreibung der sozialen, kulturellen und ökonomischen Situation der Bevölkerung El Hierros, der westlichsten der Kanarischen Inseln, die eine lange Kolonial- und vielfältige Migrationsgeschichte hat. The El Hierro Conversation formiert sich um eine Kerngruppe von Beteiligten und stellt insofern nur einen Teil des Prozesses der Beschreibung dar. Dem Problem vieler sozial engagierter Kunstprojekte, die eigene Praxis in räumlicher oder zeitlicher Distanz adäquat zu zeigen, begegnet Horsfield, indem er die Installation seines „sozialen Archivs" mit Videomaterial von zehn Stunden Länge – der täglichen Öffnungsdauer der Ausstellung – speist. Horsfield vermeidet Wiederholungen und relativiert die Subjektivität der Montage durch ein Echtzeit-Verfahren, das die Zeitwahrnehmung und Aufmerksamkeit des Betrachters beeinflusst.

For Craigie Horsfield art has its place in dialogue, within the "generative relation" of communal thought. This productive interstitial space lends art a social potential for action and protects it from idealized isolation, which underlies the concept of the autonomous work of art.

Horsfield's photographs result from engagement with the portrayed, and refer to a certain occasion or a concrete place that the artist has known for a long time. In 1988, the artist presented his works for the first time. Five years later, he presented them within the context of the group project La Ciutat de la Gent (The City of People, 1993–1995). Discussions on the specific conditions in places and communities—in particular Barcelona and Europe—formed the basis for this collaboration, also called the "Barcelona Project." The goal was to have the city described by its inhabitants. With the help of interactive projects, networks were to be formed and new methods of description developed that are founded on memory and experience. The official image of the city of Barcelona was called into question, and democratic processes were discussed in the light of urban development concepts. The Barcelona Project goes back to Manuel J. Borja-Villel and Jean-Francois Chévrier's collective attempt to develop a basis for art in society, and for Horsfield it marked just the beginning of a number of projects that reflect on the concept of community.

The El Hierro Conversation, developed for Documenta11, is based on the experience of these earlier projects. The objective is to describe the social, cultural, and economic situation of the inhabitants of El Hierro, the westernmost Canary Island with a long colonial and diverse migration history. The El Hierro Conversation is made up of a nucleus of participants who have shaped the project since the beginning. In this respect, the installation in Kassel presents only a portion of the process of description and, like many socially engaged art projects, is confronted by the difficulty of adequately portraying its practice from a spatial or temporal distance. In order to respond to this problem, Horsfield's "social archive" puts special emphasis on time-based media (video/sound), which is fed material 10 hours in length—the daily length of the exhibition. He avoids repetitions and qualifies the montage's subjectivity by a procedure of real time with which he influences the observer's attention and perception of time. T.M.

Klub Pod Jaszczurami, Rynek Główny, Kraków February 1976 I
Klub Pod Jaszczurami, Rynek Główny, Krakau Februar 1976,
1991
Black-and-white photograph I Schwarz-Weiß-Fotografie,
270 x 278 cm

HUIT FACETTES
ABDOULAYE N'DOYE, EL HADJI SY, FODE CAMARA,
CHEIKH NIASS, JEAN MARIE BRUCE, MOR LISA BA,
AMADOU KANE SY (KAN-SI)

Gegründet/Founded 1996 in Dakar, Senegal.

Huit Facettes, ein Kollektiv bildender Künstler aus Senegal, hat den historischen Widerspruch der Moderne zwischen dem Anspruch der Kunst, ästhetisch autonom zu sein und zugleich soziale Relevanz zu besitzen, aufgelöst. Die 1996 gegründete Gruppe legt ihr Hauptaugenmerk auf prozesshafte soziale Aktionen in Form von Workshops. Statt sich vom institutionalisierten Kunstbetrieb abhängig zu machen, entzieht sie sich mit lokal konzipierten Aktionen den kanonischen Systemen der kommerzialisierten Kunstproduktion. Das Potenzial künstlerischer Kreativität setzt sie ein, um Fehlentwicklungen in den vorwiegend ländlichen soziopolitischen und ökonomischen Strukturen Senegals aufzuzeigen und zu beheben. Zu diesem einmaligen Ansatz gehört es auch, die Teilnehmer ihrer Kunstworkshops durch das Trauma ihrer sozialen Ausgrenzung zu begleiten. Indem sie sie sie bei der Wiederentdeckung ihrer kreativen Fähigkeiten und kulturellen Identität unterstützt, verankert sich Huit Facettes selbst in der eigenen kunsthandwerklichen Tradition. Mit Workshops in ländlichen Orten Senegals wie Joal, Ndem und Hamdallaye Samba M'Baye sucht Huit Facettes die Polarisierungen zwischen Urbanem und Suburbanem, zwischen Kunst und Unternehmertum, zwischen Kunsthandwerk und Handwerk (Batik, Glasmalerei, Keramik und Brandmalerei) aufzuheben.

Huit Facettes vermittelt zwischen den Gegensätzen der „Dritten" und der westlichen Welt, zwischen Globalisierungsprozessen und der Vielfalt individueller Zeitlichkeiten. 1999 errichtete sie in enger Zusammenarbeit mit Entwicklungshelfern vor Ort wie Maat Mbay (Landwirt und autodidaktischer Wandmaler aus Hamdallaye Samba M'Baye) ein „soziokulturelles Kreativitätszentrum" (Kan-Si) in dessen Heimatdorf. Die Hütten wurden mit einer neuartigen Form von Alphabet dekoriert. Dieses ergab ein individuelles grafisches Verzeichnis für die Dorfbewohner, das sich zu einer Art von kollektiver Corporate Identity entwickelte.

Die soziale Arbeit von Huit Facettes folgt einer nicht westlichen Logik von kapitalistischem Liberalismus, sie will durch die Einbindung künstlerischer Wahrnehmung in den Alltag jedem Einzelnen privilegierten Zugang zu Reichtum garantieren. Die Gruppe integriert nicht nur einfach Lokalität in Globalität, sondern potenziert die Kraft lokaler Ausdrucksformen und exportiert ihr Wissen, indem sie ihre Praxis mit den Mechanismen der globalen Moderne konfrontieren und sie sich zunutze machen. Für die Documenta11 präsentiert Huit Facettes zusammen mit belgischen regierungsunabhängigen Organisationen, die neue Technologien im suburbanen Raum fördern, eine Dokumentation ihrer sozialen Arbeit in Hamdallaye seit 1999.

Huit Facettes, a Senegalese collective of visual artists, has disentangled modernism's historical contradiction between art's claim to aesthetic autonomy and its ambitions for social relevance. Founded in 1996, Huit Facettes focus their attention towards processual social interventions in the form of workshops. Instead of depending on the institutional framework of art, their localized interventions debase canonical systems of commodified art production. Utilizing the capacities of creative energy, they aim to highlight and alter aberrations in the mostly rural Senegalese sociopolitical and economic systems. Huit Facettes' unique approach involves taking the participants of their artistic workshops through the trauma of being socially abject. Helping the participants to rediscover their creative abilities and cultural identities, they become anchored in their own tradition of arts and craft. Conducting workshops in rural Senegal, in villages such as Joal, Ndem, and Hamdallaye Samba M'Baye, Huit Facettes attempts to reconcile an ever increasing polarity between the urban and the suburban, between art and development, and between arts and craft (batik, painting on glass, ceramics, and pyroengraving).

Huit Facettes tries to mediate the disparities between the "Third" and the Western world, between processes of globalization and the multiplicity of individual temporalities. In 1999, in close contact with local developers such as Maat Mbay (a farmer from Hamdallaye Samba M'Baye and self-taught painter of frescoes), Huit Facettes set up a "sociocultural center of creativity" (Kan-Si) in his village. Establishing a personalized graphic register for the villagers by decorating huts with a new form of alphabet, a mode of corporate identity was collectively conceived.

Huit Facettes' social work follows a non-Western logic of capitalist liberalism where everybody should be granted privileged access to wealth by injecting artistic perception into everyday use. Their work does not simply incorporate the local into the global, but lends new strength to local idioms and exports their knowledge by confronting and profiting from the workings of global modernity. For Documenta11, Huit Facettes—in cooperation with Belgian NGOs devoted to the furthering of new technologies in suburban areas—presents a documentation of their social work from Hamdallaye since 1999. N.R.

Workshop in Hamdallaye Samba M'Baye, Senegal, 1999

PIERRE HUYGHE

***1962 in Paris. Lebt/Lives in Paris.**

Seit den frühen neunziger Jahren beschäftigt sich Pierre Huyghe mit den Bruchstellen zwischen dem Realen und dessen Abbildungen, vornehmlich in den Medien der modernen Unterhaltungsindustrie. In einer Reihe von Videoinstallationen setzt sich Huyghe mit der Frage auseinander, wie der Vereinnahmung des eigenen Bildes durch den Apparat der Unterhaltungsindustrie begegnet werden kann. Er entwickelte eine Strategie der Wiederinbesitznahme, die Verwertungsprinzipien und Techniken von Hollywood aufnimmt und unterläuft. So engagierte Huyghe für *Remake* (1994/95) drei Laienschauspieler, die an zwei Wochenenden Hitchcocks Klassiker *Fenster zum Hof* in einer im Bau befindlichen Vorstadtsiedlung nachdrehten. Die erstaunliche Nähe beider Versionen ermöglichte die Identifikation mit den nichtprofessionellen Schauspielern einerseits und die Aneignung der erinnerten Fassung des Originals andererseits.

Ein zentrales Motiv von Huyghes Arbeit ist es, durch die Übertragung von Inhalten auf die damit einhergehenden Bedeutungsverschiebungen aufmerksam zu machen. Zugleich nutzt Huyghe die Methode der Übersetzung als Möglichkeit, individuelle Ansprüche (auf Autorschaft, auf die Rolle des Vermittlers, aber auch auf die Hoheit über den eigenen Raum oder die eigene Zeit) zu erheben. Das Video *Blanche-Neige, Lucie* (Schneewittchen, Lucie, 1996) zeigt Lucie Dolène, die in dem Disney-Film *Schneewittchen* die französische Synchronfassung sprach und die den Konzern auf die Rückgabe der Autorenrechte an ihrer Stimme verklagte und gewann. Sie singt ein Lied aus dem Film, während die Geschichte ihres Prozesses in Untertiteln an den Betrachtern vorbeiläuft.

Anstelle eines „Displacement", also der Verschiebung eines Gegenstandes in einen neuen Kontext, wodurch neuartige Gegenüberstellungen erzeugt werden, unternimmt Huyghe eine Art „Re-placement": Er konfrontiert Bilder, die Gemeinbesitz zu sein scheinen, mit ihren Originalschauplätzen oder befragt sie auf ihre Ursprünge. In einer Reihe von früheren Arbeiten (*Chantier Barbès-Rochechouart*, 1994; *Rue Longvic*, 1994; *Géant Casino*, 1995; *Little Story*, 1995) ließ Huyghe inszenierte alltägliche Arbeiten auf öffentlichen Plätzen fotografieren. Danach plakatierte er die so entstandenen Bilder auf Werbetafeln an den jeweiligen Schauplätzen. Für *Light Conical Intersect* (1996) projizierte Huyghe einen Film des amerikanischen Künstlers Gordon Matta-Clark aus dem Jahr 1976, der dessen architektonische Intervention in ein Pariser Haus dokumentiert, an genau jener Stelle, an der der Film zwanzig Jahre zuvor gedreht und die in der Zwischenzeit zum Gegenstand baulicher Umstrukturierungen geworden war.

Dabei versucht Huyghe jedoch nicht, ein Medium oder Genre (etwa das Fiktive) durch ein anderes (z. B. das Dokumentarische) zu ersetzen. Vielmehr geht es ihm darum, die Räume und Zeiten hervorzuheben, die sich zwischen den Medien und Genres, zwischen Ton und Bild, zwischen zwei aufeinander folgenden Bildern oder zwischen einem Ort und dessen medialer Abbildung auftun. Es gilt, sie als Punkt kenntlich zu machen, an dem Kritik ansetzen und Wiederinbesitznahme beginnen kann.

Since the early 1990s, Pierre Huyghe has been interested in the discrepancies between the real and its representation, primarily in modern entertainment industry media. In a series of video installations, Huyghe explores the question of how to counteract the entertainment industry's appropriation of an individual's own image. To this end, he has developed a reappropriation strategy that employs and yet undermines Hollywood's techniques and principles of exploitation. For *Remake* (1994/95), Huyghe hired three amateur actors who spent two weekends filming a remake of Hitchcock's classic *Rear Window* in a suburban building. The remake's obvious technical limitations as well as its astonishing resemblance to the original give the viewer a chance to identify with the nonprofessional actors and, at the same time, with his own private, recollected version.

A central theme of Huyghe's work is translation, which can be used to present the appropriation and transference of content and to draw attention to the shifts in meaning accompanying these processes. Huyghe also sees the use of translation as an opportunity to activate individual claims (of authorship, the role of the mediator, but also of sovereignty over one's own space or time). *Blanche-Neige, Lucie* (Snow White, Lucie, 1996) features Lucie Dolène, a French actress who provided the voice for *Snow White* in the French version of the Disney film, and who sued the company to regain the rights to her voice and won. The video shows her once again singing a song from the film while the story of her trial is told in subtitles.

Instead of 'displacement'—transferring an object into a new context, thus creating new opposition, Huyghe undertakes a kind of 'replacement,' returning public images to their original showplace or questioning their origins, thus drawing attention to and reflecting the time that has gone by. In a number of earlier works (*Chantier Barbès-Rochechouart*, 1994; *Rue Longvic*, 1994; *Géant Casino*, 1995; *Little Story*, 1995), Huyghe reenacts scenes of daily life in public places. He photographs these events, turns the photographs into posters, and then places the posters on billboards at the various sites where the reenactments took place. For *Light Conical Intersect* (1996) Huyghe projected a film made in 1976 by American artist Gordon Matta-Clark (documenting his architectural intervention in a Parisian house) at the exact location where the film had been made twenty years before—and where, in the meantime, massive architectural changes had occurred.

Huyghe does not simply seek to replace one medium or genre (such as the fictional) with another (the documentary, for instance). Instead, he is more concerned with activating the spaces and times that appear between different media and genres, between sound and image, between two pictures in a series, or between a site and its media representation. He wants to show that these are particular sites where criticism and reappropriation can begin. C. R.

Les Grands Ensembles I *The Great Ensembles* I *Die großen Ensemble,* 1994–2001
Vistavision transferred onto digital hard disk, loop 7 min. 41 sec., music by Pan Sonic and Cedric Pigot (random program) I
Vistavision übertragen auf digital hard disk/Computer-Festplatte, Loop 7 Min. 41 Sek., Musik von Pan Sonic und Cedric Pigot (Zufallsprogramm)

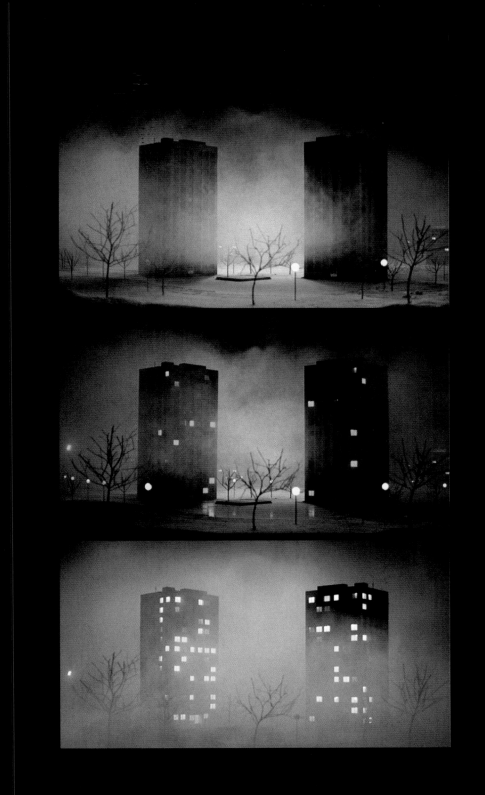

IGLOOLIK ISUMA PRODUCTIONS

ZACHARIAS KANUK, PAUL APAK, PAULOISSE QUALITALIK, NORMAN COHN

Gegründet/Founded 1988 in Igloolik, Kanada/Canada.

Igloolik Isuma Productions ist eine von Inuit geführte Produktionsfirma mit dem Ziel, die oralen Erzählungen der Inuit und die Gebräuche des Alltags vor der Modernisierungswelle, die sich seit 50 Jahren auf die Inuit-Gemeinden mit oft verheerenden Folgen (so ist zum Beispiel die Selbstmordrate unter Jugendlichen zehn Mal höher als im Landesdurchschnitt) ausgewirkt hat, aufzuzeichnen. „Die Erzählkultur der Inuit ist eine hoch entwickelte Mischung von Realität und Fiktion, Präsentation und Improvisation, Vergangenheit und Gegenwart und hat sich über 4000 Jahre lang ohne eine Schriftsprache bewahrt ... 4000 Jahre orale Geschichte, die von fünfzig Jahren Missionierung, Schule und Kabelfernsehen zum Schweigen gebracht wurde."

Igloolik, die Heimatgemeinde der Gruppe, ist Teil der östlichen Arktis. 1999 wurde sie zum weltgrößten von Ureinwohnern selbst verwalteten Hoheitsgebiet namens Nunavut (Unser Land) erklärt. Igloolik ist bekannt für seinen Widerstand gegen die Vormachtstellung des (amerikanischen und kanadischen) englischsprachigen Fernsehens und hatte bereits einige Stunden Sendezeit in Lokalsprache (Inuktitut), bevor Zacharias Kanuk 1981 mit den Einnahmen aus dem Verkauf einiger Schnitzereien eine Videokamera kaufte und begann, Videos zu drehen. *From Inuit Point of View* (1985) war das erste Projekt, an dem alle Mitglieder der Isuma-Gruppe beteiligt waren, und außerdem das erste, das Zuschüsse vom kanadischen Staat erhielt.

Igloolik Isuma Productions situiert ihre Arbeit in der kollektiven Tradition der Inuit-Kultur, ihre filmische Ästhetik in jener der südamerikanischen Guerilla-Dokumentarfilmer. Die Inuit-Völker wurden seit Flahertys *Nanook of the North* (1922) in ermüdender Art und Weise falsch dargestellt, indem ihre Lebensweisen mit westlichen ethnografischen und narrativen Konventionen erfasst wurden. Von beiden machen sich die Projekte von Igloolik sowohl politisch als auch kulturell unabhängig.

Nunavut (1994/95) ist eine aus 13 halbstündigen Teilen bestehende „Inuit-Seifenoper", die im Jahre 1945 spielt. Sie ist Dokumentation und Spielfilm zugleich und zeigt einer jüngeren Generation, wie Dinge getan wurden (und noch immer getan werden können) und bewahrt die Erinnerungen und Fertigkeiten einer älteren Generation, ob es sich dabei um die Errichtung eines Steinhauses gegen die Winterkälte oder um die Seehundjagd handelt. Für Kanuk ist der Dokumentarfilm eine Verlängerung von und eine Alternative zur oralen Geschichte und hilft der Gemeinschaft, neue Formen der Erzählung zu finden, mit deren Hilfe sie weitere tausend Jahre überleben kann. Jüngst führte Kanuk für den Film *Atanarjuat – The Fast Runner* (2001) Regie, den ersten Inuit-Spielfilm, der in Cannes und anderswo von der internationalen Kritik ausgezeichnet wurde. Beide Arbeiten, *Nunavut* und *Atanarjuat – The Fast Runner*, werden auf der Documenta11 gezeigt.

Igloolik Isuma Productions is an Inuit owned production company that aims to preserve the oral narratives of the Inuit past and to protect the realities of social life in the face of modernization, which has been affecting Inuit communities for the last 50 years—often with desperate results (the youth suicide rate is 10 times the national average). "Inuit storytelling is a sophisticated mix of fact, fiction, performance, improvisation, past and future which maintained Inuit culture for 4,000 years without a written language.... 4,000 years of oral history silenced by fifty years of priests, schools, and cable TV."

Igloolik, the community base, is part of the eastern Arctic. In 1999 it became the world's largest First Nations self-governing jurisdiction called Nunavut (Our Land). Igloolik has a history of resisting the hegemony of (US and Canadian) English language television and had already achieved a few hours of local language (Inuktitut) broadcasting, before Zacharias Kanuk bought a video camera with the proceeds of a sale of some carvings and began making videos in 1981. *From Inuit Point of View* (1985) was the first project to receive state funding from the Canada Council, and the first in which all the participants of the Isuma group collaborated.

Igloolik situate their work in the collective traditions of Inuit culture and their aesthetic in that of Southern community and guerilla documentary filmmakers. Inuit peoples have been tiresomely misrepresented since Flaherty's infamous *Nanook of the North* (1922), which imposed Western ethnographic and narrative conventions on Inuit realities and from which the Igloolik projects mark both a political and cultural independence.

Nunavut (Our Land, 1994/95) consists of 13 half-hour episodes of Igloolik family life, filmed like an Inuit soap opera set in 1945. It is as much documentary as fiction, since whether a stone hut against the winter cold is built or seal pups hunted, the emphasis is on both showing a younger generation how these things were done (and still can be done) and on preserving the memories and skills of the older generations. Kanuk sees the documentary form as an extension of and alternative to oral language, enabling the community to develop new forms of storytelling that will help them survive another thousand years. Recently, Kanuk directed *Atanarjuat-The Fast Runner* (2001), the first Inuit fiction film to receive critical acclaim in Cannes and elsewhere. Both works, *Nunavut* and *Atanarjuat-The Fast Runner*, will be presented at Documenta11. M. N.

Nunavut I Our Land I Unser Land, 1995
Still from episode 8: "Avamuktalik," "Fish Swimming Back and Forth" I Stills aus der Episode 8: „Avamuktalik", „Hin- und herschwimmender Fisch"
Video: color, sound, 28 min. 50 sec. I Video: Farbe, 28 Min. 50 Sek., director I Regie: Zacharias Kunuk

SANJA IVEKOVIĆ

*1949 in Zagreb, Kroatien/Croatia. Lebt/Lives in Zagreb.

Die seit Mitte der siebziger Jahre entstandenen konzeptuellen Fotografien, Videoarbeiten und Performances von Sanja Iveković sind von der Erkenntnis geprägt, dass das Ich ein Produkt seiner Darstellung in den Massenmedien ist. Sich selbst in den öffentlichen Diskurs einschreibend, untersucht Iveković, wie die Routinen des Alltags vom Diktat der Mode, der Werbung und des Starkults beeinflusst werden. Der Körper ist für die Künstlerin immer nur der Körper in der Darstellung, eine Bildfläche, die vom Blick dominiert wird. Iveković setzt sich bewusst dem männlichen Blick aus und stellt das weibliche Geschlecht und das Körperliche in den Kontext des politischen Klimas der kroatischen Kunstszene nach 1968, die der modernistischen, überwiegend abstrakt-geometrischen Tradition des sozialistischen Jugoslawiens den Rücken kehrte.

Double Life (1975) konfrontiert dialogisch Bilder von warenmäßiger weiblicher Schönheit aus der Werbung mit Porträts der Künstlerin aus ihrem privaten Fotoalbum (1953–1975) und zeigt, wie osmotisch die Grenze zwischen gelebter und medialer Realität verläuft. Der Blick und die Macht von Voyeurismus sind Thema in *Monument* (1976) – hier kreist das Auge der Kamera in extremer Nahaufnahme von unten nach oben um einen nackten Mann. In *Inaugurazzione* (Inauguration, 1977) begrüßt Iveković, den Mund mit einem Klebeband versiegelt, das Publikum zur Vernissage, während ihre Herztöne über Lautsprecher in den Galerieraum übertragen und sämtliche Interaktionen zwischen ihr und den Gästen fotografisch festgehalten werden. Mit ihrer 18-minütigen, auf Fotos dokumentierten Performance *Triangle* (1979), die sie bewusst an dem Tag aufführt, als der jugoslawische Präsident Tito Zagreb besucht, mischt sie sich in die Politik der Herrschaft des männlichen Blicks ein: Durch fingiertes Masturbieren auf ihrem Balkon provoziert die Künstlerin zwei Polizisten – einer steht vor ihrem Haus, der andere mit Walkie-Talkie und Fernglas auf dem Dach – und verführt sie dazu, im Namen des Gesetzes einzuschreiten.

In ihrer programmatischen Videoarbeit *Personal Cuts* (1982) schneidet Iveković runde Löcher in eine schwarze Strumpfmaske, während parallel dazu Archivmaterial eines staatlichen Fernsehsenders zur Geschichte Jugoslawiens eingeblendet wird. Wiederkehrendes Thema in ihren jüngsten Arbeiten ist das kollektive Gedächtnis, das sowohl die Konstruktion kollektiver Erinnerung als auch kollektiver Amnesie umfasst. Sie beschäftigen sich mit dem Krieg in Kroatien (*Fantasy of a Fresh Widow*, 1994; *Mind over Matter*, 1993), den Lebensbedingungen von Flüchtlingen (*Resnik*, 1994) und dem Widerstand von Frauen gegen die Nationalsozialisten (*GEN XX*, 1997; *Lady Rosa of Luxembourg*, 2001). Im Wechsel zwischen Blick und Berührung, indexikaler und metonymischer Darstellung des ausgebeuteten Körpers – in Arbeiten wie *Women's House* (1998), welche aus Gipsabgüssen der Gesichter von Frauen besteht, die häuslicher Gewalt ausgesetzt sind – verbindet Iveković in ihrem überaus reflektierten Werk die Themen Geschlecht, Identität und Erinnerung.

Sanja Iveković's conceptual photography, video work, and performances since the mid-1970s have been characterized by a keen awareness of how the self is a product of its representation in the mass media. Inscribing herself into the public discourse by examining the routines of daily life as they parallel and are inflicted upon by a world of fashion, advertisement, and star cult, the body for Iveković is always a body in representation, a pictorial field that is subjected to the mastering gaze. By exposing herself actively to the male look she juxtaposes female gender, the corporeal, and the political climate of a post-1968 art movement in Croatia that drifted away from the modernist, mostly abstract geometrical tradition of a socialist Yugoslavia.

Her work *Double Life* (1975) dialogically compares images of commodified female beauty from recent fashion ads with portraits of Iveković from her private photo album (1953–1975), restaging the osmotic barrier between lived and media reality. In *Monument* (1976), the camera eye spirals in extreme close-up around a naked man from the bottom to the top, evocatively addressing the look and the power of voyeurism. In *Inaugurazzione* (Inauguration, 1977), Iveković welcomes the audience to an exhibition opening, her mouth sealed with adhesive tape, transmitting her heartbeat into the gallery space through loudspeakers, and capturing photographically each contact between herself and the visitor. Interfering with the politics of the scopic regime, her 18-minute, photographically recorded performance *Triangle* (1979) is set on the day Yugoslavian president Tito visited Zagreb. By simulating masturbation she provokes a guard with a walkie-talkie and binoculars on the roof across the street and the policeman underneath her balcony to act in the name of the law.

In her seminal video *Personal Cuts* (1982) Iveković's act of cutting round holes into a head mask of black tights is intertwined with archival footage from a state TV program on the history of Yugoslavia. Ideas of collective remembrance that embrace the construction of both collective memory and collective amnesia are also a recurrent theme in her more recent works dealing with the war in Croatia (*Fantasy of a Fresh Widow*, 1994; *Mind over Matter*, 1993), the condition of refugees (*Resnik*, 1994), and female resistance against the Nazis (*GEN XX*, 1997; *Lady Rosa of Luxembourg*, 2001). Shifting from look to touch, from indexical and metonymical representations of the body in pain to works such as *Women's House* (1998), which consists of masks of women subjected to domestic violence, Iveković's highly reflective works seamlessly interlace issues of gender, identity, and memory. N.R.

Personal Cuts I *Persönliche Schnitte,* 1982
Video: color, sound, 3 min. 40 sec. I Video: Farbe, Ton, 3 Min. 40 Sek.

ALFREDO JAAR

***1956 in Santiago de Chile. Lebt/Lives in New York.**

Im Mittelpunkt von Alfredo Jaars Arbeit steht sein Anspruch, „Kunst aus Informationen zu machen, die die meisten von uns geflissentlich ignorieren". Die Überzeugung, dass die fotografische Bildsprache der Vorstellungskraft ihre ästhetische Transformation und ihr emotionales Engagement nimmt, veranlasst den Künstler, in seinen Bildern vor allem soziale, politische und humanitäre Fragen zu erörtern. In seinen Foto-, Text- und Lichtinstallationen übersetzt Jaar die Macht der Massenmedien und die globalen Gewaltverhältnisse durch die Fotografie – und impliziert immer auch die Frage nach den Möglichkeiten der Repräsentation. Seit den frühen achtziger Jahren bedient sich der Künstler neuer Strategien der Darstellung, die nicht mit der Geschwindigkeit von Info-Highways oder dem Auswurf von konsumierbaren Bildern konkurrieren wollen, sondern den Prozess des Wahrnehmens und Begreifens beim Betrachter zu kontextualisieren und zu verlangsamen suchen. Indem er die Grenzen der Darstellungsmöglichkeiten der Fotografie auslotet, richtet Jaar den Blick auf den einzigartigen und individuellen Index eines geschriebenen Satzes, die Nahaufnahme einer privaten Szene oder das zurechtgestutzte Bild eines menschlichen Ausdrucks, um uns direkt damit zu konfrontieren.

Lights in the City (1999), Jaars öffentliche, hunderttausend Watt starke Installation aus roten Lichtern, die in der Kuppel des Marché Bonsecours – Wahrzeichen im Zentrum von Montreal – angebracht waren, steht emblematisch für seinen Einsatz von Licht als Medium. Die roten Lämpchen leuchteten immer dann auf, wenn ein Obdachloser in einem der drei Obdachlosenheime der Stadt die Türklingel drückte. Das aufflackernde Licht signalisierte ein individuelles Bedürfnis eines obdachlosen Mitglieds der städtischen Gesellschaft. Das bekanntestes Langzeitprojekt Jaars, *The Rwanda Project* (1994–1998), befasst sich mit der von ihm immer wieder thematisierten Behauptung, die Fotografie sei ungeeignet, echte Anteilnahme zu wecken und das soziale Gewissen zu aktivieren. Im August 1994 reiste er nach Ruanda, nur wenige Wochen nach dem Ende des Genozids an fast einer Million Menschen. Das öffentliche Verdrängen der Krise – im Westen wusste man zwar von dieser humanitären Tragödie, hatte jedoch weder politisches noch ökonomisches Interesse an der Region – bestärkte Jaars Ansicht, dass die Fotografie ihre Grenzen hat, wenn es darum geht, politische Wirkung zu erzielen. Während seiner vierjährigen Arbeit mit Bildern, Licht, Kästen, Behältnissen und Texten beschrieb Jaar diese dramatischen Ereignisse und ermöglichte uns so einen kritischen Blick darauf.

Jaars Arbeit für die Documenta11, *Lament of the Images* (2002), ist eine Installation, die aus einem verdunkelten Raum mit drei in eine Wand eingelassenen Leuchttexten, zwei Gängen und einem zweiten Raum in gleißend hellem Licht besteht. Im Gegensatz zu den drei in der Dunkelheit glühenden Sätzen blendet die Wand aus Licht den Besucher zunächst – eine Metapher für unser vernebeltes Bewusstsein, das durch den täglichen Strom von Bildern in den Medien getrübt ist. Durch die Raumerfahrung erneuern wir physisch und geistig unsere Art, Informationen zu lesen und lernen die Sprache der Bilder verstehen.

The core of Alfredo Jaar's work lies in his aim "to make art out of information most of us would rather ignore." Jaar's belief that the imagery of photography robs the imagination of aesthetic transformation and emotional engagement is perpetuated in his continuous plight to represent social, political, and human issues. In his photo, text, and light installations, Jaar translates the power of mass media and global violence through the medium of photography and its emblematic question of representation. Since the early 1980s, Jaar has been employing new strategies of presentation that, rather than compete with the speed of the info-highway and consumer images, try to contextualize and slow down the viewer's process of reception and comprehension. Probing the limits of photography's representational possibilities, Jaar targets the singular and personal index of a written sentence, the close-up of a personal scene, or the cropped image of a human expression to confront us on a one-to-one basis.

His public installation *Lights in the City* (1999), consisting of a hundred thousand watts of red lights installed in the cupola of the Marché Bonsecours, a landmark monument in the center of Montreal, is emblematic for Jaar's use of light as medium. Sporadic flashes of red light appeared whenever a homeless person in one of three local shelters pushed a button, triggering the light to go on and off, thereby signaling the individual need of a local member of society without shelter. Jaar's most renowned long-term body of work, *The Rwanda Project* (1994–1998), is centered on his ongoing questioning of photography's capacity to evoke deeper feelings and reactions of social responsibility. In August 1994, a few weeks after the end of the genocide of nearly one million people, he traveled to Rwanda. Although aware of the humanitarian tragedy, the Western world had no political or economic interest in the region. The public evasion of the crisis reinforced Jaar's sense of the inadequacy of photography and its restricted means for political agency. Using images, light, objects of enclosure, and text over a four-year period, Jaar described and offered us a critical view of the dramatic events.

For his work at Documenta11, *Lament of the Images* (2002), Jaar creates an installation that consists of a darkened space with three light texts, inserted into a wall, two corridors, and a second space of blinding white light. In contrast to the three sentences glowing in the dark, the wall of light momentarily blinds the vision, a metaphor for our concealed awareness, dimmed by the daily flow of mediated images. Experiencing the space, we physically and mentally try to renew the way we read information and come to understand imagery. B.C.

Lumière de la ville | Lights of the City | Lichter der Stadt, 1999
Light installation with approx. a hundred thousand watts of red light in the Cupola of the Marché Bounsecours, Montréal, connected to three homeless shelters. Every time a homeless person enters any of these shelters, they are free to push a button and the red lights will flash in the Cupola. | Lichtinstallation aus über hunderttausend Watt roten Lichts in der Kuppel des Marché Bounsecours, Montréal, die mit drei Obdachlosenheimen verbunden ist. Betritt ein Obdachloser eines dieser Heime, so kann er einen Knopf drücken und rotes Licht erleuchtet die Kuppel von innen.

JOAN JONAS

*1936 in New York. Lebt/Lives in New York.

Joan Jonas untersucht in ihrer Arbeit die Themenbereiche Identität und Verlangen und verwischt dabei die Grenzen vielfältigster Materialien und Praktiken. Meist kombiniert sie ein Live-Performance-Element mit einer Film- und/oder Videoaufnahme oder -übertragung. Man könnte Jonas' Arbeit als eine Art „Bricolage"-Kunst bezeichnen: Sie bedient sich aus einem breit gefächerten Fundus literarischer Quellen, vom Märchen bis zum aktuellen Zeitungsbericht, und verknüpft diese mit einer ebenso eklektischen Auswahl musikalischer Referenzen und Requisiten, die sie auf Flohmärkten und Dachböden aufstöbert. Im Zentrum einer jeden Arbeit steht Jonas als Performerin, sie selbst als skulpturales Material. Die Auflösung von Subjektivität und ihre Neuformulierung in performativen Fragmenten ist eine zentrale Wendung in Jonas' Œuvre. Schon früh setzte die Künstlerin Spiegel ein, um diesen Prozess zu erleichtern – als Mythos und Metapher der Verdopplung und Wiederverdopplung einer fragmentierten Wahrnehmung –, und bot damit dem Betrachter noch einmal den Augenblick der Ichbildung, den Jacques Lacan als Spiegelstadium bezeichnet. Jonas beschäftigt sich in ihrem Werk stets mit feministischen Belangen: „In all meinen Arbeiten kommt eine Frau vor und immer steht ihre Rolle auf dem Prüfstand."

Zu einer Künstlergeneration gehörend, die sich systematisch mit den technischen Gegebenheiten des Mediums Video beschäftigte, hat sich Jonas schnell von Werken wie *Vertical Roll* (1972), das Einstellungsfehler des TV-Gerätes untersucht, entfernt. Seitdem unterstreichen ihre Arbeiten eher die Möglichkeiten von Film und Video sowohl als Werkzeuge für die Aufzeichnung von Performances als auch als Bildquelle für diese selbst. Film und Video fungieren als Feed-back-Schleife innerhalb der Performances und öffnen gleichzeitig einen Raum für fiktionale Erzählungen. So schlüpfte Jonas in ihren Arbeiten schon früh in die Rolle unterschiedlicher Personen. In *Organic Honey's Visual Telepathy* (1972) spielte sie neben der androgynen „working woman" aus New York City deren vor Fantasie sprühendes, verführerisches anderes Ich.

In ihren jüngeren Werken knüpft Jonas an Themen aus früheren Arbeiten an. Die Mobilität des Betrachters, die Jonas' Arbeit verlangt, sowie die zahlreichen Verweise auf das Kino – in ihrer Videoinstallation *My New Theater III: In the Shadows of a Shadow* (1999) setzt Jonas ein Miniaturkino ein – unterstreichen das Hauptanliegen der Künstlerin: die Untersuchung der Vorstellung des Visuellen im postkinematografischen Zeitalter. Durch die Verwendung von unveröffentlichtem Material aus alten Projekten erstellt sie einen metadiskursiven Kommentar zu ihrem Œuvre. Für ihre Installation bzw. Performance für die Documenta11, *Lines in the Sand,* greift Jonas auf die Schriftstellerin H.D. (Hilda Doolittle) und ihr Gedicht *Helen in Egypt* (1951–1955) zurück, in dem die Sage der schönen Helena neu aufgerollt wird: Indem sie die Griechin kurzerhand nach Ägypten umsiedelt, entlarvt H.D. ihre katalytische Rolle im Trojanischen Krieg als narrativen Mythos, dessen alleiniger Zweck es war, den Kampf zwischen Griechen und Trojanern um die Kontrolle über die Ost-West-Handelsstraßen zu verschleiern.

Joan Jonas's work explores issues of identity and desire across boundaries of very different materials and practices. Her work usually combines a live performance element and a film and/or video record or relay. Hers is an art of bricolage—combining the widest range of literary sources from folk tales to contemporary news reports with an equally eclectic range of references, music, drawings, stage props, and objects unearthed from flea markets and attics. At the core of each piece is Jonas as performer, using herself as sculptural material. The dissolution of subjectivity and its rearticulation in performative fragments is a major trope. Early on Jonas began to use mirrors to facilitate this process—as myth and metaphor doubling and redoubling a fragmented vision—returning the viewer to that moment of ego formation described by Jacques Lacan as the mirror stage. Her work has always involved a preoccupation with feminist concerns: "There is always a woman in my work, and her role is questioned."

Belonging to a generation of artists that systematically investigated the technical specificities of video, Jonas has quickly moved from works such as *Vertical Roll* (1972), which explores misalignment of the TV monitor, to works that stress the possibilities of video and film as devices for both recording performances and for contributing imagery to the performance itself. Film and video both function as feedback loops within the performance and at the same time open a space for fictional narratives. Thus, Jonas's appearance in her own work involved the creation of different personae from an early stage. In *Organic Honey's Visual Telepathy* (1972) she plays both an androgynous work-a-day New York City woman as well as a fantasy bejewelled, begowned masked other.

In recent years, Jonas has been developing work which extends the concerns of earlier pieces. The mobility of the spectatorial position her work creates and its many references to cinema—the recent work *My New Theater III: In the Shadows of a Shadow* (1999) includes a miniature cinema—serve to reinforce her preoccupation with notions of the visual in the post-cinematic age. Using previously unshown material from earlier projects, she engages in a metadiscursive commentary on her work as a whole. In her installation/performance for Documenta11, *Lines in the Sand,* Jonas returns to writer H. D. (Hilda Doolittle) and her poem *Helen in Egypt* (1951–1955), which reworks the myth of Helen of Troy. Relocating Helen from Troy to Egypt, H. D. renders her role as catalyst in the Trojan war a narrative myth, employed to obscure a conflict between Greeks and Trojans over control of East-West trade routes. M. N.

My New Theater I | Mein neues Theater I, 1997
Video Theater I Videotheater

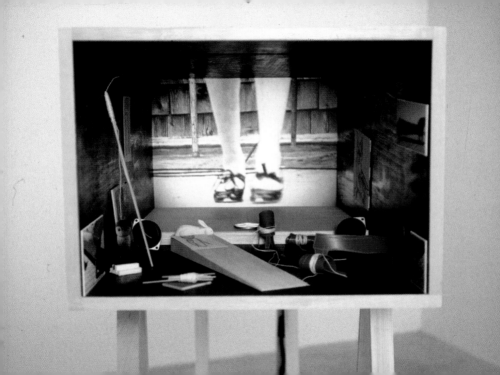

ISAAC JULIEN

*1960 in London. Lebt/Lives in London.

Isaac Julien war Gründungsmitglied des Sankofa Film/Video Collective, einer der zahlreichen Film- und Video-Workshops, die infolge der Proteste gegen Rassismus und für eine breitere kulturelle und politische Repräsentation der Schwarzen in den achtziger Jahren in Großbritannien entstanden sind. Gemeinsam mit Black Audio entwickelte Sankofa praktisch ein neues Genre, das am Realismus sowohl der britischen Dokumentarfilmbewegung als auch des Spielfilms Anstoß nahm. Sankofas erste Produktionen, *Territories* (Regie: Julien, 1984) und *The Passion of Remembrance* (Regie: Julien und Maureen Blackwood, 1986) hinterfragten die Konventionen des Dokumentarfilms, indem sie dokumentarisches Material mit fiktionalen Elementen kombinierten. Kernproblem der Filme war die Suche nach einer Sprache, mit der die Erfahrungswelt von Schwarzen reflektiert und umstrittene Muster afrobritischer Identität untersucht werden konnten.

Mit *Looking for Langston* (1989) begann Juliens andauernde persönliche und poetische Entwicklung dieser Themen in einem ausgereifteren ästhetischen Rahmen. *Looking for Langston* ist eine Bearbeitung der Biografie von Langston Hughes, einem der Autoren der so genannten Harlem Renaissance – eine poetische Meditation über die aktuelle Bedeutung seines Werks. Juliens besonderes Augenmerk liegt dabei auf dem unterdrückten homosexuellen Subtext in Hughes Schriften.

Julien hat mehrere Filme fürs Fernsehen gemacht, so zum Beispiel die Serie *Black and White in Colour* (1992) und den halbdokumentarischen Spielfilm *Frantz Fanon: Black Skin White Mask* (1996), Arbeiten, in denen er das Archiv „gegen sich selbst" interpretiert. Für die Serie recherchierte er die Fernsehgeschichte von schwarzen Künstlern und Entertainern der Nachkriegsgeneration in Großbritannien. Im Film verknüpfte er Bildmaterial aus französischen Kolonialarchiven mit der Biografie und den Gedanken von Frantz Fanon, einem der bedeutendsten schwarzen Psychiater, Philosophen und Revolutionäre unserer Zeit.

In seinen Mehrkanal-Installationen entwickelt Julien eine postkinematografische Praxis des bewegten Bildes. Sie steigert und intensiviert die voyeuristischen Freuden am Film, um den kinematischen Blick gleichermaßen zu rekonstruieren, bloßzustellen und zu brechen und die Betrachter somit für neue Fragestellungen zu sensibilisieren. Dabei entwickelt er die Komplexität der individuellen Schritte vielfache psychische Nuancen, die die geschlechtliche, ethnische und physische Differenz eher andeuten als sie klar verkörpern. Die Werkgruppe *The Attendant* (1993), *Three (The Conservators Dream)* (1996–1999) und *Vagabondia* (2000) steht als Trilogie in diesem Kontext und setzt sich mit der Institution Museum und der Position schwarzer Personen in ihm auseinander. In *The Long Road to Mazatlan* (2000) thematisiert Julien Grenzüberschreitungen sowohl sexueller Art als auch bezogen auf eine „rassische" Demarkationslinie, indem er die schwule Ikonografie im Western untersucht. Seine neue Arbeit für die Documenta11 *Paradise/ Omeros* erforscht die sinnbildliche Suche nach dem „neuen Leben", wie es vom Westen versprochen wurde, in der allegorischen Verarbeitung einer Vielzahl von kulturellen Referenzen.

Isaac Julien was a founding member of Sankofa Film/Video Collective, one of a number of film and video workshops set up in the UK in the 1980s in the aftermath of protests against British racism, with the aim of forming a new politics of representation. Together with Black Audio, Sankofa effectively created a new genre, contesting the realism of both the British documentary movement and of fiction feature films. Sankofa's first productions, *Territories* (director: Julien, 1984) and *The Passion of Remembrance* (directors: Julien and Maureen Blackwood, 1986), questioned the conventions of documentary by combining it with fictional dramatization. The films' main concern was the struggle to find a language to reflect the black experience and explore contested notions of black identities.

With *Looking for Langston* (1989), Julien begins an ongoing personal and poetic exploration of these issues within a highly worked aesthetic. *Looking for Langston* is a reworking of the biography of Harlem Renaissance poet Langston Hughes as a poetic meditation on the resonance of his work today, focusing particularly on the repressed gay subtext in Hughes's writing.

Julien has made a number of films for television, including the series *Black and White in Colour* (1992) and *Frantz Fanon: Black Skin White Mask* (1996), in which he reads the archive "against itself." In the former, he unearths the television archive's history of the first generation of postwar black performers and entertainers in Britain. The latter film uses images from the French colonial archives to visualize the ideas of one of the greatest contemporary black psychiatrists, philosophers and revolutionaries.

In his multichannel installation work, Julien develops a postcinematic practice of the moving image. Through its intense engagement of visual pleasure this work is also concerned to expose, deflect, and reconstruct the cinematic gaze and in so doing to open the audience to other concerns: complex subjective moves explore a wide range of psychological nuances where questions of gender, race, or sexual difference become a matter of indirect reference rather than embodiment. One group of works, *The Attendant* (1993), *Three (The Conservators Dream)* (1996–1999), and *Vagabondia* (2000), constitutes a trilogy reflecting on the institution of the museum and the position of black subjects within it. *The Long Road to Mazatlan* (2000) focuses on sexual and racial border crossings, unpacking gay Western iconography. Julien's new work for Documenta11, *Paradise/Omeros*, explores the emblematic search for the "new life" promised by the West through an allegorical reworking of a wide range of cultural references. M. N.

Trussed, 1996
Double-screen projection, 16mm film, black and white, sound, video transfer | Projektion auf zwei Leinwände, 16-mm-Film, schwarz-weiß, Ton, auf Video umkopiert

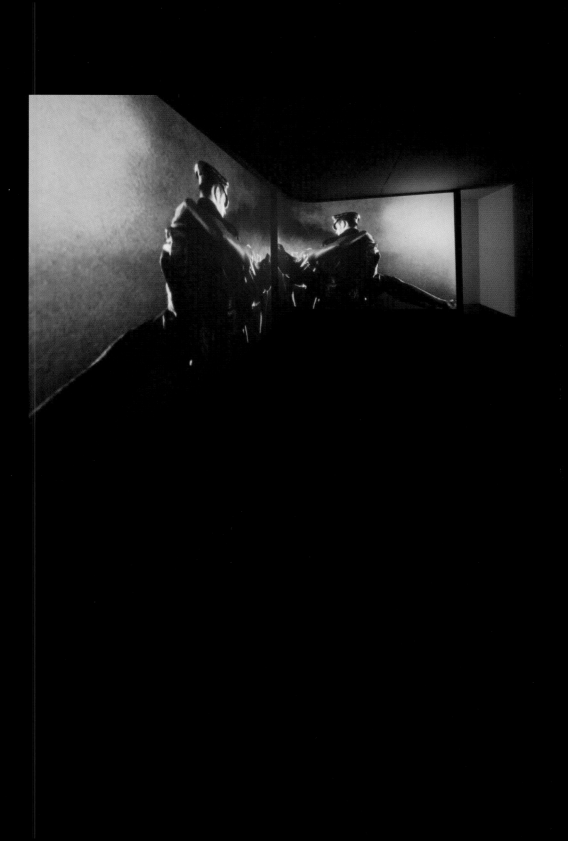

AMAR KANWAR

*1964 in Neu-Delhi/New Delhi. Lebt/Lives in Neu-Delhi/New Delhi.

Der unabhängige Dokumentarfilmemacher Amar Kanwar hat sich in vielen Filmen mit den Zuständen des heutigen Indien beschäftigt und so verschiedene Themen wie die Geschichte und Politik der Wasserförderung in der Wüste (*Murubhumi*, 1995), das Leben einer feudalen Familie in Madhya Pradesh bzw. die physischen und geistigen Räume für Frauen und Männer in der Familie (*Talash/In Search of a Future*, 1996) und die ökologischen Interpretationen des Buddhismus (*Earth as a Witness: a Dialogue with Buddhism*) verarbeitet. Andere Filme handeln von den Gegensätzen von Globalisierung und Stammesbewusstsein im ländlichen Indien: *Baphimali 173* (2000/01) zeigt die Schäden in einer Gemeinde bei Orissa, die durch den Bauxitabbau verursacht wurden. *Freedom ...!* (2001) porträtiert die Widerstandsbewegungen des Volkes der Chhattisgarh und der Küstengemeinden von Kutch in Gurjarat gegen die Bauvorhaben für große Häfen und Industrieparks. *The Many Faces of Madness* (2000) thematisiert die ökologische Zerstörung Indiens. Der Film konfrontiert uns mit dem Ausmaß und den Auswirkungen von Globalisierung und Industrialisierung, indem er verschiedenen Nachbarschaftsinitiativen, zum Beispiel für den Schutz des Waldes, die Folgen von Biopiraterie und chemische Verschmutzung gegenüberstellt.

Sein Film *A Season Outside* (1997) untersucht, wie die Nationalitäten am indisch-pakistanischen Grenzpunkt von Wagha gegeneinander ausgespielt werden. Jeden Tag kommen dort Menschen zu einer dünnen weißen Linie, an der die rituelle Öffnung und Schließung der Grenze stattfindet. Kanwar nimmt diese konfrontative Performance als Ausgangspunkt für eine Untersuchung der indischen Konstruktion von Männlichkeit – innerlich gespalten durch die Anforderungen des Nationalstaates, der Familie und der sehr anderen Tradition der tibetanischen Flüchtlinge. Dieses Thema wird weiter im Film *King of Dreams* (2001) verfolgt, der von Männern und Sexualität in Indien handelt. Er fragt, welchen Niederschlag Macht in Kultur und Kleidung, Arbeit, Fußball und Festen findet, und sucht zu ergründen, wo bei alledem „Liebe" ins Bild kommen könnte.

Kanwars Film *Of Poetry and Prophecies* (2002), der auf der Documenta11 gezeigt wird, handelt von Poesie und Liedern im heutigen Indien. Der Film entwirft Bilder von der Kraft der Dalit-Poesie in Maharastra, die aus der Schicht der arbeitenden, unberührbaren Armen stammt, denen bis heute der kulturelle Fluch der „Unreinheit" anhaftet. Walid zum Beispiel, ein alter Barde, der für einen Analphabeten gehalten wurde, hat über 6000 Gedichte verfasst, die viele Einwohner Bombays auswendig können. Kontrastierend dazu stellt der Film die ebenso kraftvolle Lyrik der extrem linken naxalitischen Dichter vor. In Nagaland rezitiert eine Lehrerin zwei Gedichte, zwischen deren Entstehung 25 Jahre liegen, das eine über einen Krieger, das andere über den Schmerz, der entsteht, wenn bewaffneter Widerstand nicht mehr von der Gemeinschaft kontrolliert werden kann.

Amar Kanwar, an independent documentary filmmaker, has engaged in many films on conditions in contemporary India, covering topics as diverse as the history and politics of harvesting water in the desert (*Murubhumi,* 1995), the life of a feudal family in Madhya Pradesh and the physical and mental spaces carved out for men and women within the family (*Talash/In Search of a Future,* 1996), and ecological interpretations of Buddhism (*Earth as Witness: a Dialogue with Buddhism*). Other films have dealt with the opposition between globalization and tribal consciousness in the heart of rural India. Kanwar's film *Baphimali 173* (2000/01) focuses on the damage caused to a tribal community in Orissa by bauxite mining, and *Freedom...!* (2001) portrays the mass movements of the Chhattisgarh people and the coastal communities in the region of Kutch, Gujarat, in their fight to resist development projects for large ports and industrial parks. *The Many Faces of Madness* (2000) addresses contemporary ecological destruction in India and confronts us with the intensity and impact of globalization and industrialization, contrasting various community-based initiatives such as forest protection with the effects of biopiracy or chemical pollution.

Kanwar's film *A Season Outside* (1997) inquires how national identities are enacted on an India-Pakistan border crossing at Wagha, where people are drawn every day to a thin white line around which a ritual opening and closing of the border is performed. Kanwar uses this confrontational performance as a starting point for the investigation of the construction of an Indian masculinity divided between the demands of the nation state, the family, and the very different tradition presented by Tibetan refugees. This theme is explored further in *King of Dreams* (2001), a film about men and sexuality in India that looks at power and its perpetuation through culture and clothes, jobs, trucks, football, and festivals, and which seeks to find out where love might fit into the picture.

Kanwar's film *Of Poetry and Prophecies* (2002), presented at Documenta11, is about poetry and song in contemporary India. The film presents images of the power of Dalit poetry in Maharastra, which rises from the working untouchable poor who can never be set free from the cultural curse of "impurity." Walid is an old illiterate bard who has authored more than 6,000 poems learnt by heart by the city folk of Bombay. His work is contrasted with the equally powerful poetry of the extreme left Naxalite poets. In Nagaland, a woman teacher recites two poems with a 25 year span between them, one about a warrior, the other about the pain when armed resistance begins to spiral out of control within the community. M.N./C.R.

A Season Outside | *Eine Saison draußen,* 1997
Video: color, sound, 30 min. | Video: Farbe, Ton, 30 Min.

ON KAWARA

*in Japan. Lebt/Lives in New York.
On Kawara wird am 8. Juni 2002 25.763 Tage alt.
On June 8, 2002, On Kawara will be 25,763 days old.

On Kawara markiert nicht nur das Verstreichen der Zeit. Er dokumentiert, wie in einer völlig von Informationen, Klassifizierungen und archivarischen Strategien besessenen Gesellschaft die Zeit gemessen und verstanden wird. Auf diese Weise erörtert er die Mittel, mit denen moderne Identität geformt und bewahrt wird. Denn Zeit mag eine Abstraktion sein, sie wird jedoch durch verschiedene Systeme in eine bestimmte Form gezwängt. Freilich kann es auch innerhalb von sich wiederholenden Mustern zu unvorhergesehenen Variationen kommen – darauf verweisen die verschiedenen Komponenten von Kawaras Arbeit.

Am 4. Januar 1966 begann Kawara, als Teil seiner Today-Serie, Date Paintings zu malen, die er seither in den unterschiedlichsten Teilen der Welt ständig wiederholt. Das Datum der Ausführung des Gemäldes wird sowohl zum Gegenstand der Arbeit als auch zur Arbeit selbst. In der Sprache und entsprechend den Konventionen des Landes, in dem das Gemälde entsteht, malt Kawara das Datum in Weiß von Hand auf einen monochromen Hintergrund. Dazu gehört ein Pappkarton, der mit einer Zeitung des jeweiligen Ortes ausgeschlagen ist. Die Date Paintings wirken zwar standardisiert, sind aber in der malerischen Ausführung der Oberflächen verschieden, und in ihren historischen Kontexten klingen große Umschwünge an.

Kawara registriert die Unterschiede in den sich wiederholenden Mustern der gemessenen Zeit peinlich genau, ebenso wie er die unterschiedlichen Handlungen, Orte und Menschen, an und in denen sich seine persönlichen Erfahrungen konkretisieren, beschreibt. Die Serie I READ (1966–1979) ist eine Sammlung von Ausschnitten aus Zeitungen, die Kawara an Tagen las, an denen er ein Date Painting schuf; I MET (1968–1979) verzeichnete sämtliche Leute, die Kawara an einem bestimmten Tag traf; I WENT (1968–1979) kartografierte Kawaras tägliche Bewegungen an verschiedenen geografischen Orten; I GOT UP (1968–1977) belegte durch täglich an zwei unterschiedliche Empfänger versandte Postkarten, dass und wann Kawara aufgestanden war; und I AM STILL ALIVE (seit 1970) bezeugt Kawaras Existenz durch immer wieder an bestimmte Empfänger verschickte Telegramme. Die Werke werden zum persönlichen Archiv in der Zeit, das sich von seiner künstlerischen Produktion nicht unterscheiden lässt.

Das episch angelegte Projekt One Million Years (Past and Future) (seit 1970) verdeutlicht, wie wichtig Daten als Maß unserer Existenz sind. The Past ist ein maschinegeschriebenes Verzeichnis aller Jahre von 998.031 v. Chr. bis 1969. The Future dagegen listet jedes einzelne Jahr von 1996 bis 1.001.995 n. Chr. auf. Unlängst wurden sogar Lesungen des Werks live veranstaltet und Tonaufnahmen produziert. Die variable Intonation, das Heben und Senken der Stimme, wodurch Vergangenheit und Zukunft in der Gegenwart erfahrbar werden sollen, deutet an, dass Zeitlichkeit Kommunikation und Selbstdefinition bestimmt.

On Kawara does more than mark the passage of time. By documenting the modes through which time is measured and understood in a society preoccupied with information, classification, and archival strategies, Kawara interrogates the means through which modern identity is formed and sustained. While time may be an abstraction, it is contained by diverse systems that try to give it shape. Yet, as the various components of Kawara's work suggest, even within patterns of repetition, never-ending and unforeseen variation can occur.

Kawara started making Date Paintings, part of his Today series, on January 4, 1966 and has been making them in various parts of the world ever since. The date of the painting's execution becomes both the object of the work and the work itself. Hand-painted in white onto a monochrome background, the date is written in the language and conventions of the country where the painting is made, accompanied by a cardboard box lined with a local newspaper. While the Date Paintings may seem like standardized objects, miniscule permutations appear in their painterly surfaces and monumental shifts resound in the historical contexts.

As Kawara meticulously registers the differences in the repetitive patterns of chronological time, he also records the infinitely diverse actions, places, and people that define his lived experience within them. The I READ series (1966–1979) is a collection of newspaper fragments that Kawara read on days he produced a Date Painting; I MET (1968–1979) registers the people Kawara encountered on any given day; I WENT (1968–1979) maps Kawara's daily movements in various geographic locations; I GOT UP (1968–1977) certifies Kawara's daily awakening through postcards sent to two recipients per day; and I AM STILL ALIVE (1970–present) verifies Kawara's existence via telegrams sent intermittently to selected addressees. As this body of work testifies, time is the arena in which Kawara constructs a personal archive indistinguishable from his artistic production.

The epic project One Million Years (Past and Future) (1970–present) is the most exhaustive documentation of the passing of time and daunting testament to the significance that dates possess as the measure of our existence. The Past is a typewritten record of every year from 998,031 BC to 1969 AD, while The Future accounts for every year from 1996 AD to 1,001,995 AD. Most recently, live readings of the work have been performed and sound recordings produced. The variable intonation and inflexion of the readers' voices as well as the direct experience of the past and future in lived time suggest, once again, that temporality is both a modern mode of communication and of self-definition. N. B.

March 5, 2000 I 5. März 2000, 2000
Liquitex on canvas I Liquitex auf Leinwand, 25,5 x 34,5 cm

WILLIAM KENTRIDGE

*1955 in Johannesburg, Südafrika/South Africa.
Lebt/Lives in Johannesburg.

Expressionistische Kohlezeichnungen, als Animationen projiziert, ephemere Schatten von Figuren aus Papier gerissen, Silhouetten einer Handvoll Schauspieler der Handspring Puppet Company mit ihren Requisiten, zeitgleich auf Bühne und Projektionsfläche agierend, das Ganze untermalt von einem Streichquartett – das sind die Elemente des „live cinematic image" von William Kentridges theatralischer Multimedia-Performance *Confessions of Zeno* für die Documenta11. In Italo Svevos 1923 erschienenem gleichnamigen Roman ist Zeno Gefangener seines eigenen Intellekts. Er analysiert seine Psyche in fiktiven Gesprächen mit seinem Analytiker selbst und sinniert in einem endlosen Bewusstseinsstrom über die dauernde Notwendigkeit, in der politisch zerrissenen Gesellschaft nach dem Ersten Weltkrieg Stellung zu beziehen. Kentridge versetzt Zenos Triest in Johannesburgs Vororte der achtziger Jahre, um einmal mehr das komplizierte Aufwachsen und Leben eines weißen Südafrikaners unter der Apartheid zu untersuchen. Auf selbstreflexiven Streifzügen erkundet der Künstler zeichnerisch die Landschaften des menschlichen Geistes sowie Räume und Orte, die weder neutral noch natürlich sind.

Kentridge zeichnet kraftvoll mit Kohle sowie roter und meerblauer Pastellkreide, seine Arbeiten entstehen in einem Prozess simultanen Schaffens und Auslöschens – die Spur grauer Verwischungen, die das Radieren hinterlässt, hat immer etwas Melancholisches. Zeichnen ist für den Künstler nicht Illustrieren, sondern ein Mittel der Wissensproduktion. Diesen einzigartigen Ansatz des Zeichnens, bei dem die Weitergabe von Gedanken im Ausdrucksmittel darstellt, entwickelte Kentridge seit den späten siebziger Jahren, dem Beginn seiner Arbeit als Schauspieler, Regisseur, Bühnenbildner und Filmemacher. In seinen zeichnerischen 16- und 35-mm-Kurzfilmen (*Medicine Chest,* 2001; *Stereoscope,* 1999; *Felix in Exile: Geography of Memory,* 1994; *Mine,* 1991) verschmelzen unbelebte Objekte, wiederkehrende menschliche Charaktere wie Soho Eckstein und die politische Landschaft Südafrikas in einen fließenden Zustand der (Alb-)Träumerei. Kentridge modifiziert traditionelle Animationstechniken, indem er aus einer einzigen Zeichnung durch wiederholtes Bearbeiten mehrere aufeinander folgende Erzählungen entwickelt. Aus nur zwanzig Zeichnungen entsteht so ein ganzer Film.

Kentridges Animationsfilme, Zeichnungen und Theaterstücke (*Ubu and the Truth Commission,* 1997; *Faustus in Africa,* 1995; *Woyzeck on the Highveld,* 1992) nutzen die Strukturen des Brecht'schen Theaters und die Idee des Verfremdungseffekts – seine Schauspieler und ihre Charaktere halten Distanz zueinander. Diese Verfremdungen bedeuten für Kentridge die Möglichkeit, die immanente Fähigkeit des Menschen zur Selbsterkenntnis als fundamentale Verantwortung zu vermitteln, Geschichte und Geschichten kritisch zu beurteilen.

Evocative, expressionistic charcoal drawings on paper projected as animations, ephemeral shadows of torn-paper figures, the silhouettes of a handful of actors from the Handspring Puppet Company with their requisites performing simultaneously on stage and on screen and accompanied by a string quartet—these are the diverse elements that create the "live cinematic image" of William Kentridge's theatrical multimedia performance *Confessions of Zeno* for Documenta11. In Italo Svevo's 1923 novel of the same name, Zeno is a prisoner of his own intelligence, who psychoanalyzes himself in a fictive dialogue with his analyst, fretting in a stream-of-consciousness narrative about the constant need to take a stance in the politically troubled society that exists after World War I. By resituating Zeno's Trieste in the suburbs of 1980's Johannesburg, Kentridge explores once again the intricacies of growing up and living as a white South African under apartheid. In self-reflecting ventures, the artist experiences the landscapes of the human mind and the spaces and places that are neither neutral nor natural through the medium of drawing.

Drawing forcefully with charcoal, red and maritime blue pastel, his is a process of simultaneous creation and erasure, always melancholically leaving in its path a trace of gray smudge. For Kentridge, drawing does not illustrate, but exists as a mode of knowledge production. It is from this starting point that his unique approach to drawing—traversing his work as actor, director, stage designer, and filmmaker since the late 1970s—evokes the proliferation of thought as a means of expression. His graphic 16 or 35mm short films (*Medicine Chest,* 2001; *Stereoscope,* 1999; *Felix in Exile: Geography of Memory,* 1994; *Mine,* 1991) fuse inanimate objects, cues from the political landscape of South Africa, and recurring human subjects like Soho Eckstein, into a fluid state of reverie. By modifying traditional techniques of animation, sequential narratives grow out of a single drawing in a process of constant reworking (not more than 20 sheets comprise one film).

Kentridge's animated films, his drawings, and his works for theatre (*Ubu and the Truth Commission,* 1997; *Faustus in Africa,* 1995; *Woyzeck on the Highveld,* 1992) utilize the structures of Brechtian epic theatre and the idea of the *Verfremdungseffekt,* where actor and character preserve their distances from each other. Kentridge embarks on this kind of alienation to actuate man's intrinsic ability to self-knowledge as a fundamental responsibility to evaluate stories and histories critically. N.R.

Zeno at 4 a.m. | Zeno um 4 Uhr früh, 2001
Theater performance in collaboration with | Theater-Performance in Zusammenarbeit mit Kevin Volans, Handspring Puppet Company, The Duke Quartet, actor | Darsteller: Dawid Minnaar

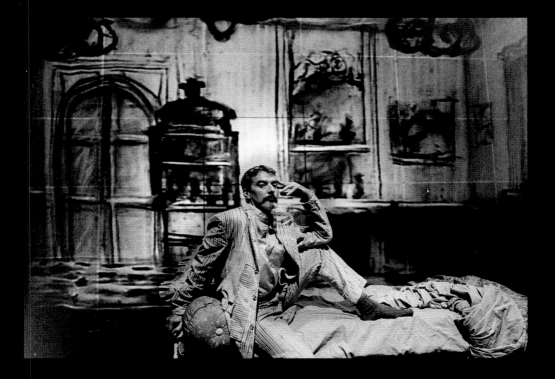

JOHAN VAN DER KEUKEN

***1938 in Amsterdam. †2001 in Amsterdam.**

Die Lust und die Neugier des Schauens hat Johan van der Keukens Werk von Beginn an geprägt. 1955, ein Jahr bevor er in Paris Film zu studieren begann, veröffentlichte er sein erstes Buch mit Fotografien *Wij zijn 17* (Wir sind 17), in dem er ein zärtliches Porträt der eigenen Generation zeichnete. Bereits die frühen Fotografien deuten auf die Vorläufigkeit, mit der van der Keuken sich an die „Bestandsaufnahme von der Flüchtigkeit einer aufgeregten Wahrnehmung der Welt und seiner eigenen Position in dieser" (Alain Bergala) wagt. Dieser Blick auf die Welt, der sich in immer wieder neuen Annäherungen an seine Protagonisten zeigt, bestimmt auch die über fünfzig Filme van der Keukens, die seit Ende der fünfziger Jahre entstanden sind.

Nach einer Reihe von frühen filmischen Personenporträts wurden seine Themen in den siebziger Jahren politischer. *Het Witte Kasteel* (Das weiße Schloss, 1973) beschäftigt sich mit den Lebensbedingungen von Bewohnern der Insel Formentera, Arbeitern in zwei niederländischen Fabriken und einer Gruppe sozialer Außenseiter in einem Gemeindezentrum in Columbus, Ohio. Die Erzählstruktur des Films folgt formal einer Form des Kreisens und der offenen Anschlüsse. Am deutlichsten wird dieses Prinzip in van der Keukens erfolgreichstem Film *Amsterdam Global Village* (1996). Er geht – im wörtlichen Sinne – den Geschichten einiger Bewohner Amsterdams nach, die manchmal an einer Straßenecke beginnen können und manchmal am anderen Ende der Welt. Van der Keuken begleitet die Menschen an ihre Heimatorte in Bolivien, Thailand und Tschetschenien oder besucht das Haus, in dem eine seiner Hauptpersonen während der Zeit der Naziokkupation unterkam.

Mit dem Film *Het Oog Boven de Put* (Das Auge über dem Brunnen, 1988) begann eine Reihe lyrischer Reiseberichte, zu der auch der letzte Film van der Keukens zählt. In seinem „filmischen Abschiedsbrief" *De Grote Vakantie* (Der Große Urlaub, 2000) bereist der Autor, von seinem Krebsleiden wissend, ein letztes Mal die Welt. *Het Oog Boven de Put,* der auf der Documenta11 zu sehen ist, porträtiert die indische Kerala-Region, die zu den spirituellen und kulturellen Zentren des Landes gehört. Der Film vermittelt das Bild von einer Welt, in der die Moderne – gespiegelt im städtischen Leben, das die Möglichkeiten ins Kino zu gehen, Mofa zu fahren oder fernzusehen bietet – mit alten Kulturformen wie traditionellen Tänzen und Gesängen, rituellen Kampfsportarten, Musik und religiösen Gebräuchen harmonisch versöhnt ist. Dem Wissen, dass Film immer nur ein unvollständiges Bild des Realen ist, entspricht van der Keukens offenes „framing" im Film, welches das Geschehen oftmals außerhalb des Bildes situiert.

The pleasure and the curiosity of seeing have always been central to Johan van der Keuken's work. In 1955, one year before he began studying film in Paris, he published his first book of photographs, *Wij zijn 17* (We Are 17), in which he tenderly portrays his own generation. The early photographs already point to the tentativeness with which van der Keuken again and again ventures "to take account of the impermanence of an anxious perception of the world and of his place in it" (Alain Bergala). This view of the world, evident in the many new approaches to his protagonists, also characterizes the more than fifty films van der Keuken has made since the end of the 1950s.

In the 1970s, following a series of early cinematic portraits of people, van der Keuken's subject matter became more political. *Het Witte Kasteel* (The White Castle, 1973) deals with the living conditions of the inhabitants of the island of Formentera, of workers in two Dutch factories, and of a group of social outsiders in a community center in Columbus, Ohio. The film's narrative structure follows a cyclical and open-ended form. This principle becomes most apparent in van der Keuken's most successful film, *Amsterdam Global Village* (1996). It follows several Amsterdam residents on their movements through the city, filming their stories, sometimes beginning on a street corner and sometimes at the far reaches of the world. Van der Keuken accompanies these people to their places of origin in Bolivia, Thailand, and Chechnya, or visits the house in which one of his main characters lived in hiding during the Nazi occupation.

A series of lyrical travelogues begins with the film *Het Oog Boven de Put* (The Eye Above the Well, 1988) and ends with van der Keuken's last film, *De Grote Vakantie* (The Long Holiday, 2000). Aware that he is suffering from cancer, van der Keuken travels the world one last time to make his "cinematic letter of farewell." The film shown at Documenta11, *Het Oog Boven de Put,* portrays India's Kerala region, one of the country's spiritual and cultural centers. The film shows a world in which modernism—reflected in an urban life that offers the opportunity to go to the movies, ride mopeds or watch television—is harmoniously reconciled with traditional forms of culture such as dance and song, ritual martial arts, music, and religious customs. Van der Keuken's open framing, which frequently situates events outside the picture, corresponds to his view that film can never offer a complete image of the real world. C.R.

Het Oog Boven de Put | *The Eye above the Well* | *Das Auge über dem Brunnen,* 1988
Film: 16mm, color, sound, 94 min. | 16-mm-Film, Farbe, Ton, 94 Min.

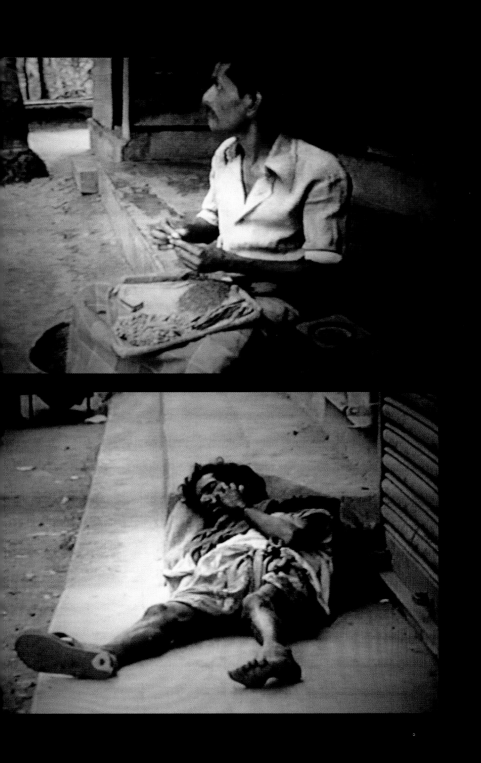

BODYS ISEK KINGELEZ

*1948 in Kimbembele Ihunga/Kimbeville, Demokratische Republik Kongo/Democratic Republic of the Congo. Lebt/Lives in Kinshasa, Demokratische Republik Kongo/Democratic Republic of the Congo.

Seit den späten siebziger Jahren findet der Autodidakt Bodys Isek Kingelez breite Anerkennung für seine vibrierenden und aufwändig ornamentierten fiktiven Stadtlandschaften, die er aus Klebstoff, Papier, Karton, Sperrholz und verschiedenen anderen Materialien der Verpackungsindustrie fertigt. Kingelez' visionäre, mehrere Meter große Modellwelten bestehen aus privatwirtschaftlichen und öffentlichen Gebäuden wie Hotels, Stadien, Parlamentsgebäuden und anderen beweglichen Komponenten des urbanen Raums, kombiniert in einer hyperrealen Simulation des zukünftigen Lebens in einem reichen und demokratischen Afrika. Hier weichen die modernistisch starren Straßenraster und die funktionalistische Architektur der Städteplanung in den Industrieländern einer organischen, hellen und dynamischen Stadtstruktur, in die autobiografische Bezüge des Künstlers einfließen – so in *Bodystate* (1999) und *Mundial Isek Sport* (1989) oder auch, durch ein Kingelez-Stadion und einen Club namens *Dear Bodys* kenntlich gemacht, in *Ville Fantôme* (Phantomstadt, 1995/96), in der sämtliche Freunde, Bewunderer und Mitarbeiter Kingelez' von überall auf der Welt zu Gast sind. *Kimbembele Ihunga (Kimbeville)* (1994) ist Kingelez' archetypische Stadt. Sie geht von der Allegorie einer Tradition – der Namensgebung von Stämmen – aus und wird gleichzeitig in die Hinterlassenschaft einer modernen Metropole überführt. Kingelez verarbeitet so das Trauma der Kolonialzeit und zeigt uns die verborgene Unterseite – die historischen Bedingungen eines Projekts, bei dem die Architektur zum Träger sozialer Bedeutung und Hierarchien wird. Er spielt mit den realen Bedingungen des afrikanischen Stadtlebens und bezieht dabei seine Erfahrungen der sozialen Verhältnisse in Kinshasa und in seiner Heimatstadt Kimbembele Ihunga als Simulation und Spektakel mit ein.

Kinshasa in the 3rd Millennium (1997) wird zum Ort, an dem es keine rassischen, sozialen oder ethischen Vorurteile, kein Verbrechen, keine Polizei und keine Gefängnisse gibt. Es ist die luxuriöse Vision einer Stadt ohne einen nationalen Status, eines wahrhaft transnationalen Stadtgebiets, in dem materieller Reichtum ein soziales, politisches und ökonomisches Gleichgewicht garantiert.

Seit er 1989 die internationale Kunstszene betrat, hat Kingelez seine architektonischen Utopien fortgesetzt und mit der Sehnsucht nach Exotik angereichert. *Aéromode* (1991), *Palais Hiroshima* (1991), *Mongolique Soviétique* (1989) und *Orient* (1989) sind die Namen zumeist touristischer Hotelkomplexe – hier werden Luftverkehrsmittel zum integralen Bestandteil einer urbanen Architektur, welche die alltägliche Realität von Reisen und Konsumieren widerspiegelt.

Kingelez' Phantasmagorie platziert die Beziehungen von Zeichen und Repräsentationssystemen innerhalb der Befehlsgewalt einer totalitären Ordnung anderer Art: Aus der Perspektive eines postkolonialen Afrika und seines in einer visionären Architektur synthetisierten Bildes legt sich der visionäre Plan von einem besseren Leben über die Welt.

Since the late 1970s, self-taught Bodys Isek Kingelez has gained recognition for his vibrant and meticulously ornate phantom cityscapes made out of glue, paper, carton, plywood, and miscellaneous other materials from the packaging industry. Visionary in character, Kingelez's aggregate model worlds of various meters in size comprise, through relations of semblance, corporate and public buildings such as hotels, stadiums, parliaments, and other moveable pieces of urban scenery. Combined into hyperreal simulacra of a future African way of life that is wealthy and democratic, the modernism of rigid grids and the functionalist architecture of Western city planning is broken in favor of an organic, bright, and dynamic urban fabric interwoven with autobiographical references. Kingelez inscribes his persona into works such as *Bodystate* (1999), *Mundial Isek Sport* (1989), or through a Kingelez stadium and a club building named *Dear Bodys* in the *Ville Fantôme* (1995/96), hosting all of Kingelez's friends, admirers, and co-workers from around the world. *Kimbembele Ihunga (Kimbeville)* (1994) is Kingelez's archetypal city; it is built upon an allegory of tradition—the naming of clans—and transported into the legacy of a modern metropolis. By reworking the trauma of colonialism, the artist shows us the hidden underside, the historical conditions of a project where architecture becomes the carrier of social meaning and hierarchies. Toying with the real conditions of African urbanism, Kingelez brackets the social relations he experienced in Kinshasa and his hometown Kimbembele Ihunga as simulation and spectacle.

Kinshasa in the 3rd Millennium (1997) becomes a place with no racial, social or ethical prejudice, no crime, no police, and no prisons. It is a luxury vision of a city without a nation state, a truly transnational urban area in which material wealth can guarantee a social, political, and economic equilibrium.

Since being introduced to the international art scene in 1989, Kingelez has continued to enrich his architectural utopia with a desire for the exotic. *Aéromode* (1991), *Palais Hiroshima* (1991), *Mongolique Sovietique* (1989), and *Orient* (1989) are the names of mostly touristic hotel complexes, where the means of aerial transportation become an integral part of an urban architecture of the everyday reality of travel and consumption. Kingelez's phantasmagoria places relationships of signs and representational systems into the command of a totalizing order of a different sort. A vision of a better life is mapped onto the world from the viewpoint of a postcolonial Africa and its synthesized image of a visionary architecture. N. R.

Kimbembele Ihunga (Kimbeville), 1994
Plywood, paper, cardboards, various materials I Sperrholz, Papier, Karton, verschiedene Materialien, 130 x 183 x 300 cm

BEN KINMONT

*1963 in Burlington, VT, USA. Lebt/Lives in New York.

Einer der Schlüssel zu Ben Kinmonts Arbeit liegt womöglich im Beuys'schen Konzept der sozialen Plastik. Kinmont hat systematisch an den Randbereichen traditioneller Kunstinstitutionen gearbeitet, um die Bedeutung des Kunstbegriffs zu hinterfragen. Als Teil seiner Arbeit hat er unter anderem Teller in Museumscafés gewaschen, Unbekannte in seine Wohnung eingeladen und Passanten befragt, ob man eine beiläufige Unterhaltung als Kunstform betrachten könne. Jüngst organisierte er ungewöhnliche Ausstellungen über die vertraglichen Beziehungen von Künstlern, die einerseits an ökonomischen Mechanismen teilhaben, diese andererseits aber auch mit ihren Werken gewollt oder ungewollt in Gang setzen. Kinmont entdeckt und re-interpretiert konzeptuelle Traditionen der Nachkriegszeit; in seiner Praxis stützt er sich auf das ethische und ästhetische Potenzial zwischenmenschlicher Beziehungen.

Ähnlich wie Ian Wilson, der das Gespräch als eine Kunstform definierte, strukturiert Kinmont seine Projekte stets um den Dialog mit dem Betrachter. Für das eigens zur Documenta11 entwickelte Werk *Movable Type* lässt Kinmont eine Publikationsserie drucken, die auf eine Reihe von Gesprächen zwischen ihm und einer repräsentativen Auswahl von Kasseler Bürgern zurückgeht. Er wird Menschen zu Hause, in öffentlichen Einrichtungen und in Unternehmen befragen, ob sie sich vorstellen können, ihre Tätigkeit als Kunstform zu betrachten. Die Gespräche sollen veröffentlicht und den Besuchern der Documenta11 zugänglich gemacht werden.

Kinmonts Dokumentationen des Alltags kartografieren das Alltagsleben in verschiedenen Kasseler Stadtvierteln, sie verweisen durch ihren Titel *Movable Type* auf die Erfindung der Druckpresse und ihr transformatives Potenzial. Gleichzeitig sind sie eine versteckte Referenz an die amerikanische Konzeptkunst, vor allem an die Arbeit der Künstler- und Kuratorengruppe um Mel Bochner und Seth Siegelaub, deren Ausstellungen gegen Ende der sechziger Jahre die Form von Printmedien annahmen. Kinmonts künstlerische Praxis greift gleichermaßen auf Kunstgeschichte und auf Alltagserfahrungen zurück, sie will jedoch vor allem dem Betrachter eine aktive, bestimmende Rolle ermöglichen.

Perhaps one of the keys to Ben Kinmont's work is to be found in Joseph Beuys's concept of Social Sculpture. Kinmont has been working systematically on the fringes of traditional art institutions to question the meaning of the very category of art. He has washed dishes in a museum cafeteria, received strangers at his home, asked passers-by on the street about the possibility of considering a casual conversation a form of art, all as part of his work. Recently, he has organized unconventional exhibitions about the contractual relationships artists submit themselves to and about the various parallel economies their works set in motion, voluntarily or not. Thus, Kinmont recovers and reinterprets the postwar conceptual tradition, basing his practice in the ethical and aesthetic potential of interpersonal relationships.

Following the example of Ian Wilson, who defined conversation as an art form, Kinmont always structures his projects around dialogue with the viewer. For *Moveable Type*, the work developed specifically for Documenta11, a series of publications are printed, originating in several conversations between the artist and a broad sample of Kassel citizens. Kinmont intends to visit homes, community organizations, and a number of businesses to ask people about the possibility of thinking about their activities as an art form. The resulting conversations will be published and made available to visitors to Documenta11.

These records of the everyday, produced by Kinmont like a chance map of everyday life in various neighborhoods of Kassel, allude to the discovery of the printing press and its transformative potential. They also constitute a veiled reference to the history of Conceptual Art in the United States, especially the work of a group of artists and curators like Mel Bochner and Seth Siegelaub, whose exhibitions in the late 1960s took the form of printed publications. Kinmont's practice appeals simultaneously to the history of art and to daily experience and tries to place the viewer in an active, leading role. C.B.

Moveable Type No Documenta | Bewegliche Lettern keine Documenta, 2002
Community based work; from a conversation with a participant in his church. Friedenskirche, Kassel, April 8, 2002 |
Gemeinschaftsarbeit: Aus einem Gespräch mit einem Teilnehmer in seiner Kirche, Friedenskirche, Kassel, 8. April 2002

It is most important to me that there is something greater than myself, something which we know through trust. Some look for this deeper meaning in the church whereas others (probably more) now go to the museum. However, you cannot say that one *should* understand this trust as art; but you can understand this trust and this way of life as art. From a conversation with a participant in his church.

Am wichtigsten für mich ist, dass es etwas gibt, das grösser ist als ich selbst, etwas, worauf wir vertrauen. Einige suchen nach diesem tieferen Sinn in der Kirche, wohingegen andere (wahrscheinlich mehr) mittlerweile ins Museum gehen. Man *muss* dieses Vertrauen jedoch nicht als Kunst verstehen, aber man kann dieses Vertrauen und die entsprechende Lebensart als Kunst verstehen. Aus dem Gespräch mit einem Teilnehmer in seiner Kirche.

Moveable type no documenta. Printed by the Antinomian Press. Friedenskirche. Kassel. 8 April 2002.

IGOR & SVETLANA KOPYSTIANSKY

Igor Kopystiansky: *Lwow/Lviv, Ukraine.
Svetlana Kopystiansky: *Woronesch/Voronezh, Russland/
Russia. Leben/Live in Berlin und/and New York.

Igor und Svetlana Kopystiansky verfolgen individuelle Karrieren, arbeiten aber auch regelmäßig zusammen. Seit den späten siebziger Jahren entstanden literarische und fotografische Arbeiten, die dem Geist von Fluxus und des absurden Theaters verpflichtet waren. Immer darum bemüht, die Vorgänge des Alltags, die Bewegungen der Menschen auf den Straßen und die unbeachteten Dinge des Lebens in ein Bild oder einen Satz zu bringen, sind die frühen Arbeiten der Kopystianskys von knapper konzeptueller Ökonomie geprägt. Theaterstücke, die oft aus wenig mehr als ein paar Sätzen bestehen, unprätentiöse Schwarz-Weiss-Fotografien oder sparsam arrangierte gefundene Gegenstände sind durch das Prinzip vereint, als Erzählung zu erfassen, was als Realität der Aufmerksamkeit entgeht. Dieses Prinzip findet sich auch in den poetischen Zeichnungen und Papierobjekten, den analytischen Untersuchungen wie der Fotoserie *Namen und Dinge* (1979), bei der Alltagsgegenstände mit nicht korrelierenden Namen versehen wurden, oder subtil verstörenden Objekten wie in der Arbeit *Geräte* (1981), einer Sammlung von Werkzeugen (Hammer, Zange, Feile, etc.) mit Untertiteln wie „Gerät zur Verbesserung der Denkweise" oder „Gerät zur Verbesserung des Gehörs", die unweigerlich an eine gewaltsame Verwendung denken lassen.

In den achtziger Jahren wurden die Arbeiten beider Künstler zunehmend skulptural, obwohl sie sich thematisch vor allem den Medien des klassischen Geschichtserzählungen, der Malerei und dem Buch, zuwandten. In einer Serie von Installationen wurden aufgeschlagene Bücher in Taschen verstaut (*I love neither Roads nor Mountains nor Forests*, 1995), in architektonische Raumelemente wie Wände, Säulen oder Pyramiden eingebaut (*Library*, 1990; *Universal Space*, 1994), oder in Lesesälen als Intervention präsentiert (*Reading Room I*, 1990). Landschafts- und Historienmalerei wird zum Gegenstand in *The Golden Age of Painting* (1992) – die Künstler platzierten dafür kleine bemalte und aufgerollte Leinwände in den Schauräumen klassischer Gemäldegalerien – oder in *Construction* (1988– 1990) und *The Museum* (1994) – hier bauten sie ganze Kabinette aus Leinwänden zusammen.

In jüngerer Zeit findet die unmittelbare und alltägliche Umgebung wieder Eingang in die Arbeiten der Kopystianskys. In dem Video *Incidents* (1997) folgt die Kamera achtlos weggeworfenem Abfall in den Straßen von Großstädten – Plastiktüten, kaputten Regenschirmen oder Essensverpackungen – und *Anthology or Things That Might Have Been* (1997) zeigt die Werkzeuge und Materialien, die von anderen Künstlern zur Produktion ihrer Werke benutzt wurden, aber nicht Eingang in sie fanden, als Fotografien auf städtischen Reklametafeln.

Die Videoinstallation *Flow* (2002), die auf der Documenta11 präsentiert wird, besteht aus sechs Projektionen unterschiedlicher, im Wasser schwimmender Objekte. Wieder entsteht aus Lapidarem eine Erzählung, indem den ambivalenten Objekten Beachtung geschenkt wird – sie sind beides: verunreinigender Müll und vom Wasser in ungewisse Gebiete getragene Symbole unbekannter Geschichten.

Igor and Svetlana Kopystiansky follow separate careers, yet regularly work together. Since the late seventies they have created literary and photographic works committed to the spirit of Fluxus and the theater of the absurd. The Kopystianskys' early works are marked by a concise, conceptual economy, reflecting their constant endeavors to reduce everyday occurrences, people's movements on the street, and things that go unnoticed in life to one image or one sentence. Plays, often consisting of little more than a few sentences, unpretentious black-and-white photography, or sparsely arranged, found objects are combined to capture in narrative form what has been ignored in reality. This principle is also found in the poetic drawings and paper objects, the analytical studies such as the photo series *Names and Things* (1979), in which everyday objects were given non-correlative names, or subtly disturbing objects as in the work *Devices* (1981), a collection of tools (hammer, pliers, file, etc.) with captions like "Device for Improving Thought," or "Device for Improving Hearing," which are peremptorily reminiscent of violent use.

During the 1980s, the works of both artists became increasingly sculptural. Thematically, however, they turned to the media of classical storytelling, painting and the book. In a series of installations, opened books are stowed in bags (*I Love Neither Roads nor Mountains nor Forests*, 1995), built into architectonic elements such as walls, columns, or pyramids (*Library*, 1990; *Universal Space*, 1994), or presented in reading rooms as an intervention (*Reading Room I*, 1990). Landscapes and paintings with historical subjects are the theme of works such as *The Golden Age of Painting* (1992)—the artists placed small, painted, and rolled up canvases in the exhibition rooms of classical picture galleries—and of *Construction* (1988–1990) and *The Museum* (1994), for which they assembled entire cabinets out of canvas.

Immediate and everyday environments have recently reentered the Kopystianskys' works. In the video *Incidents* (1997), the camera follows litter—plastic bags, broken umbrellas, or food containers—through the city streets, and in *Anthology or Things That Might Have Been* (1997) the city's billboards are postered with photographs of the tools and materials used by other artists in the production of their works, but that do not find entry into them.

The video installation *Flow* (2002) presented at Documenta11 consists of six projections of assorted objects swimming in water. Once again, a narrative develops from something peripheral by taking notice of these ambivalent objects—they are both polluting trash and symbols of obscure stories carried by water into uncertain territories. C.R.

Flow I *Fließen*, 2002
Video and sound installation for six screens I Video- und Sound-
Installation für sechs Projektionsflächen

IVAN KOŽARIĆ

*1921 in Petrinja, Kroatien/Croatia. Lebt/Lives in Zagreb, Kroatien/Croatia.

In den frühen siebziger Jahren gründete Ivan Kožarić die einflussreiche Künstlergruppe Gorgona, aus der einige der wichtigsten Impulsgeber in der jugoslawischen Kunstwelt kamen. Schon in den Anfängen seiner künstlerischen Arbeit hinterfragte Kožarić die Traditionen der modernen Plastik aktiv und unvoreingenommen. Mit den Fluxus-Künstlern teilt er eine anti-transzendentale, zutiefst kritische Einstellung, die seinem Werk ungewöhnliche Dynamik und Innovationsfähigkeit verleiht. Stets bestrebt, die Distanz zwischen Kunstobjekt und Publikum zu beseitigen und die sakralisierte „hohe Kunst" zu entsublimieren, vertritt Kožarić fraglos eine der konsequentesten und radikalsten künstlerischen Positionen der Nachkriegsplastik.

Im Haus des Kroatischen Künstlers, einem städtischen Ausstellungsraum in Zagreb, zeigte Kožarić vor zwei Jahren mit einer *Sculpture 1954–2000* betitelten Installation seine ikonoklastische Interpretation einer Retrospektive: Beim Eintreten in den kreisrunden Ausstellungssaal stießen die Besucher auf einen endlos langen Wurm aus Aluminiumfolie. Praktisch gezwungen, der skurrilen Skulpturform zu folgen, gelangten sie über die Treppe ins Obergeschoss, um dort zu entdecken, dass die Folie der verlängerte Arm einer Bronzeplastik war. Die Plastik – einen meditierenden sitzenden Mann – hatte Kožarić in dem im Ausstellungstitel zitierten Jahr 1954 geschaffen. Die Spannung zwischen dem Bronzearm und seiner grotesken Verlängerung, die bis zum Ende des Ausstellungsraums reichte (und damit sicher über den 1954 vom Ursprungswerk definierten semantischen Bereich hinaus), bringt Kožarićs Vertrauen in das transformative Potenzial von Kunst und sein Desinteresse an linearen Chronologien und abstrakten Kategorisierungen auf den Punkt. Am Ende der Ausstellung zerstückelte Kožarić seine Aluminiumfolienskulptur und verteilte die unterschiedlich großen Teile feierlich unter freudig überraschten Besuchern.

Kožarićs Arbeit für die Documenta11 geht auf ein Gespräch mit der kroatischen Kritikerin Evelina Turcovic zurück, das 1996 stattfand – auch damals ging es um die Vorbereitung einer Kožarić-Retrospektive. Auf Turcovics Anregung hin beschloss Kožarić, sein ganzes Atelier in den Ausstellungsraum zu verlegen und für die Dauer der Ausstellung dort zu arbeiten. Die Installation *Atelier Kožarić* kritisiert nicht nur eloquent das Konzept retrospektiver Ausstellungen allgemein, sondern auch die statische Natur von Kunstwerken. In Kožarićs Welt ist ein Objekt nichts weiter als ein Vorwand für noch ein weiteres, dies wiederum für das nächste, und so fort … *Atelier Kožarić* ist Performance, Installation und Labor in einem und verkörpert anschaulich die Arbeit eines Künstlers, dessen Werk in kontinuierlichem Experimentieren besteht.

In the early 1970s, Ivan Kožarić formed Gorgona, an influential group of artists that included some of the most important animators in the Yugoslav art world. From the start, Kožarić's artistic work has consisted of an unbiased and active reformulation of the foundations of modern sculptural tradition. Kožarić shares an anti-transcendental and profoundly questioning attitude with the Fluxus artists, giving his work an unusual dynamism and a surprising capacity for innovation. Always keen to eliminate the distance between the artistic object and its audience and to desublimate the supposed sacredness of art, there is no doubt that Kožarić's is one of the most consistent and radical positions in postwar sculpture.

Two years ago, Kožarić showed the suggestively titled *Sculpture 1954–2000,* his own iconoclastic version of a retrospective in an installation at the "House of the Croatian Artist," a city-run exhibition space in Zagreb. Upon entering the circular gallery space, the viewer comes upon a kind of enormous, endless worm made of aluminum foil. Compelled to follow the curious sculptural form, the viewer climbs the stairs to the second floor to discover that the shape is actually the modified extension of the long arm of a bronze of a seated meditative male figure that Kožarić made the year of the show's title, 1954. The tension between the bronze arm and its deformed extension stretching to the end of the exhibition space (and certainly beyond the semantic ambit defined by the work from the 1950s) synthesizes Kožarić's confidence in the transforming potential of art and his disregard for linear chronologies and abstract categorizations. After the exhibition Kožarić divided his aluminum foil sculpture into pieces of various sizes and distributed them ceremoniously among the surprised and happy viewers.

The work Kožarić is presenting at Documenta11 sprang originally from a dialogue between the artist and the Croatian critic Evelina Turcovic. The occasion for the meeting in 1996 was once again the opportunity to organize a retrospective of the artist's work. In response to Turcovic's invitation, Kožarić decided to move his studio in its entirety into the exhibition space and work there for the duration of the show. The *Atelier Kožarić* installation is an eloquent criticism not only of the notion of a retrospective exhibition, but also of the static nature of the work of art. In Kožarić's world, one object is nothing but an excuse for another, and so on successively. Performance, installation, laboratory: *Atelier Kožarić* is the dynamic new incarnation of the work of an artist whose oeuvre is a continual process of experimentation. C.B.

Atelier Kožarić , 1930–2002
Studio installed within gallery, with more than 500 sculptures
(various materials), more than 50 paintings (acrylic on canvas),
over 300 prints (various techniques), about 20 photographs, over
5000 drawings and other objects on display I Aufbau des Atelier
am Ausstellungsort: über 500 Skulpturen (verschiedene
Materialien), über 50 Gemälde (Acryl auf Leinwand), über 300
Drucke (verschiedenen Techniken), um die 20 Fotografien, über
5000 Zeichnungen sowie andere Objekte
Installation view I Installationsansicht, Galerija Zvonimir, Zagreb,
1993/94

ANDREJA KULUNČIĆ

***1968 in Subotica, Jugoslawien/Yugoslavia. Lebt/Lives in Zagreb, Kroatien/Croatia.**

1996 sollte ein fünfwöchiger Aufenthalt als ArtsLink-Stipendiatin die Entwicklungsrichtung von Andreja Kulunčićs Arbeit radikal verändern – fortan setzte sie sich mit den Möglichkeiten auseinander, das Internet für sie zu nutzen und gesellschaftliche und politische Fragen zu thematisieren. Statt jedoch sich selbst oder ihre Meinung in den Mittelpunkt stellen, bezog Kulunčić nach und nach immer mehr Menschen in die Entstehung ihrer Arbeiten ein.

Ihr erstes Web-Projekt *Thinking through Moving and Moving through Thinking* (1997) war zwar benutzerfreundlich, ähnelte aber noch den Raumsimulationen aus der Zeit vor ihrer internetbasierten Arbeit. In *State-Citizen Communication* (1998) arbeitete sie erstmals mit dem interaktiven Potenzial des Web, indem sie die Betrachter bzw. Benutzer ihrer Arbeit zu Wort kommen und über die Frage abstimmen ließ, ob ein echter Dialog zwischen Zivilgesellschaft und Staat bestehe. In ihrem Projekt *Letter* (1998) bot sie den kroatischen Bürgern eine Meinungsumfrage an, in der sie sich zu bestimmten aktuellen politischen Themen äußern konnten.

Ihre Arbeit *22%* (1998) macht auf andere Weise von diesem Medium Gebrauch: Eine Aktion von Künstlern gegen eine neue Steuer auf Bücher konfrontiert sie anhand konkreter Beispiele mit der Unmöglichkeit, Literatur in kroatischen Buchläden zu erhalten. Kulunčić zeigt sich in diesen Projekten vor allem an politischem, insbesondere gesellschaftlichem Engagement interessiert. Sie sucht auf tagespolitische und existenzielle Fragen und Themen einzugehen, die das Individuelle ebenso wie das Gesellschaftliche und Globale einschließen.

Kulunčićs bekanntestes Werk *Closed Reality – Embryo* (1999/2000) ist Kroatiens meistpräsentiertes web-basiertes Kunstwerk. Indem sie Wissenschaftler aus relevanten Bereichen – der Philosophie, Theologie, Biologie, Genetik, Medizin und Physik – mit einbezog, hat Kulunčić eine Diskussion über mögliche Optionen zur Schöpfung zukünftiger Generationen angestoßen. Die Arbeit ist als ein Spiel für zwei Nutzer angelegt, die online einen Embryo ihrer Wahl erschaffen müssen, indem sie jeweils aus mehreren von Kulunčić vorgegeben Optionen auswählen. Auf die statistische Auswertung der Ergebnisse folgten zahlreiche Forumsdiskussionen von Experten.

Distributive Justice (seit 2001), Kulunčićs Projekt zur Documenta11, beschäftigt sich mit der gesellschaftlichen Güterverteilung. Entwickelt von dem Team, das auch *Embryo* konzipiert hat, besteht es im Wesentlichen aus zwei Bereichen, zum einen aus einem Spiel für die Besucher der Webseite und zum anderen aus einem mit theoretischen und praktischen Materialien gefüllten offenen Raum, der je nach Präsentationsort verändert wird und so lokale Signifikanzen hervorhebt.

When Andreja Kulunčić received the ArtsLink fellowship in 1996, this five-week residency radically changed the direction of her work, which subsequently went through forms of exploring the use of the Internet and addressing social and political issues. Instead of getting involved herself or showing personal statements, Kulunčić gradually included more and more other people in the creation of her works.

Her first web-based project *Thinking through Moving and Moving through Thinking* (1997), although user-friendly, was still a simulation of space similar to those installations she worked on before her entry to the web. She first explored the interactivity of the web in *State-Citizen Communication* (1998), when she gave spectators/users of her work the possibility to voice their own opinions, by voting in answer to her question whether genuine dialogue between civil society and the state exists. Her project *Letter* (1998) offered a similar poll to the citizens of Croatia, asking about concrete current political issues.

In her work *22%* (1998), Kulunčić made a new use of the possibilities of the medium by juxtaposing a manifesto by artists with the newly introduced tax on books and a comment on the impossibility of buying literature in local bookstores. These projects illustrate Kulunčić's main interests in political and, above all, social commitment, her need to respond to issues of daily politics and life, and comment on topics ranging from the individual and intimate to the social and global.

Kulunčić's best-known work is *Closed Reality – Embryo* (1999/2000), which is the most exposed web-based artwork in Croatia today. By involving groups of people from fields such as biology, philosophy, theology, genetics, medicine, and physics, Kulunčić has initiated a discussion about possible choices for the creation of the future generation. The work was set up as a game for two online users, who are asked to create an embryo according to their choices from a number of options defined by the artist. The publication of the results was followed by numerous discussions among professionals in an open forum.

Distributive Justice (since 2001), Kulunčić's project for Documenta11, deals with the distribution of goods in society. It has been developed by the same team of collaborators as *Embryo* and consists of two basic sections, a game for site visitors, and an open space filled with theories and practical materials, which can be redesigned according to where it is presented, thus tracing local signifiers. J.V.

Distributive Justice | *Ausgleichende Gerechtigkeit,* since | seit 2001
Multidisciplinary project | Multidisziplinäres Projekt,
http://www.distributive-justice.com

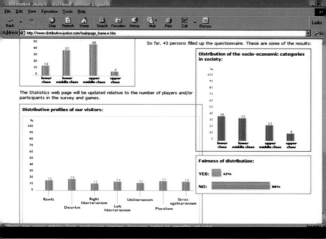

So far, 43 persons filled up the questionnaire. These are some of the results:

Distribution of the socio-economic categories in society:

The Statistics web page will be updated relative to the number of players and/or participants in the survey and games.

Distributive profiles of our visitors:

| Rawls | Dworkin | Right libertarianism | Left libertarianism | Utilitarianism | Pluralism | Strict egalitarianism |

Fairness of distribution:

YES: 12%

NO: 88%

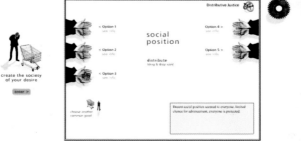

Distributive Justice

< Option 1
see info

< Option 2
see info

< Option 3
see info

social position

distribute
bring & drop icons

Option 4 >
see info

Option 5 >
see info

create the society of your desire

enter >

choose another common good

Decent social positions warranted to everyone; limited chances for advancement; everyone is protected.

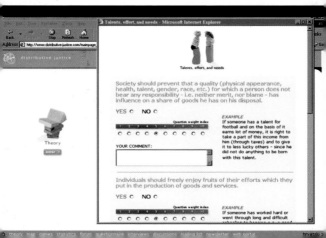

Theory

enter >

Talents, effort, and needs - Microsoft Internet Explorer

Talents, efforts, and needs

Society should prevent that a quality (physical appearance, health, talent, gender, race, etc.) for which a person does not bear any responsibility - i.e. neither merit, nor blame - has influence on a share of goods he has on his disposal.

YES ○ NO ○

Question weight index

| 1 | 2 | 3 | 4 | 5 | 6 | 7 | 8 | 9 | 10 |

○ ○ ○ ○ ○ ● ○ ○ ○ ○

YOUR COMMENT:

EXAMPLE
If someone has a talent for football and on the basis of it earns lot of money, it is right to take a part of this income from him (through taxes) and to give it to less lucky others - since he did not do anything to be born with this talent.

Individuals should freely enjoy fruits of their efforts which they put in the production of goods and services.

YES ○ NO ○

Question weight index

| 1 | 2 | 3 | 4 | 5 | 6 | 7 | 8 | 9 | 10 |

○ ○ ○ ○ ○ ● ○ ○ ○ ○

EXAMPLE
If someone has worked hard or went through long and difficult

theory map games statistics forum questionnaire interviews discussions mailing list newsletter web portal

GLENN LIGON

***1960 in New York. Lebt/Lives in New York.**

In seiner 1998 begonnenen Serie von 200 x 335 cm großen Kohlegrusbildern *A Stranger in the Village* überträgt Glenn Ligon Textabschnitte mit sozialen Belangen aus James Baldwins 1935 erschienenem gleichnamigen Essay auf horizontal angeordnete schriftrollenartige Leinwände und eröffnet damit eine ungeahnt kommunikative Dimension der Malerei. Ligon macht ein „nicht künstlerisches" Element zum Gegenstand seiner Arbeit: Die von ihm unvollkommen schablonierten Lettern lassen die monochrome, malerische Oberfläche der Leinwand durchscheinen. Wiederkehrendes Thema in Ligons Arbeit ist die manifeste Ambivalenz, die dem Traum von Bürgerrechten in Amerika inhärent ist. Durch das gleichzeitige Hervorheben und Unkenntlichmachen der Artikulationsfunktion von Baldwins Textfragmenten, die Ligon auf der Leinwand immer unleserlicher werden lässt, spiegelt er selbstreflexiv die Zwänge, die sein afroamerikanisches Erbe mit sich bringt. Im Prozess der Auseinandersetzung mit verschiedensten Fragen homosexueller schwarzer Identität macht sich Ligon den Raum des Literarischen zu Eigen und greift dabei auf poetische und künstlerische Untersuchungen der konkreten Eigenschaften von Sprache zurück.

Ligon zitiert aus einem breiten Spektrum an Quellenmaterial, er bevorzugt Darstellungsformen, die sich zwischen geschriebenem, gemaltem und gesprochenem Wort bewegen. Die Zitate reichen von typografisch adaptierten Titelseiten amerikanischer Sklavenerzählungen aus dem späten 19. Jahrhundert, in die sich der Künstler selbst einfügt (*Narratives – Black Like Me or the Authentic Narrative of Glenn Ligon*, 1993), zu Siebdrucken von Pressefotos des Million Man March von 1995, die auf die Abwesenheit schwarzer Frauen und schwuler Männer von diesem Ereignis hinweisen (*Days of Absence*, 1996), von Schriften Zora Neale Hurstons (*Untitled – I Feel Most Colored When I am Thrown Against A Sharp White Background*, 1990/91) und Ralph Ellisons (*Untitled – I Am An Invisible Man*, 1991) bis hin zu Witzen von Richard Pryor (*Cocaine – Pimps*, 1993). Zuletzt verwendete Ligon alte Malbücher aus den siebziger Jahren mit Abbildungen „schwarzer" Themen und prominenter Schwarzer, so zum Beispiel Malcolm X (*Coloring*, 2000).

In *Notes of the Margin of the „Black Book"* (1991–1993) stellt der Künstler Robert Mapplethorpes Aktfotografien von schwarzen Männern neben Textzitate von Künstlern, Politikern, Theoretikern aus der Homosexuellenszene und christlichen Kommentatoren, um die kulturelle Ausgrenzung und Marginalisierung von Afroamerikanern innerhalb der US-amerikanischen Gesellschaft zu offenbaren. Vorbild ist ihm die identitätsbewusste amerikanische Künstlergeneration der siebziger und achtziger Jahre, wie sie Adrian Piper und Lorna Simpson verkörpern, die sich mit Fragen der Darstellung von Geschlecht, Rasse und Sexualität beschäftigt haben. Ligon lenkt die Aufmerksamkeit auf die bildliche Darstellung des homosexuellen Schwarzen, sie wird zur Messlatte für den Gesamtzustand der Gesellschaft.

In *A Stranger in the Village,* Glenn Ligon—in what has been an ongoing series of large, 78 x 132 inch, coal dust paintings since 1998—introduces a "non-art" element into the role of subject matter, emphasizing the aesthetically extraneous quality of the imperfectly stenciled letter, and allowing the monochrome, painterly surface of the canvas to shine through. Inscribing socially charged paragraphs of James Baldwin's 1935 essay *A Stranger in the Village* onto horizontally oriented scroll-like canvases, Ligon opens an unforeseen communicative dimension. His recurrent theme is the manifested ambivalence inherent in the dream of civil rights in America. Heightening and obscuring the enunciative function of Baldwin's textual fragments by verging on illegibility, he self-reflexively mirrors the constraints that accompany, and are enforced by, his African American heritage. In a process of working through issues of gay black identity by making the space of the literary his own, Ligon takes recourse to poetic and artistic explorations of the concrete qualities of language.

Preferably situating his quotational procedures in niches of representation—between the written, the painted, and the spoken word—Ligon uses a broad variety of sources. These range from typographically appropriated title pages from late 19th-century American slave narratives, into which the artist inserts himself through doubling (*Narratives— Black Like Me or the Authentic Narrative of Glenn Ligon,* 1993), to silk-screen news photographs of the 1995 Million Man March, which point to the exclusion of black women and gay men (*Days of Absence,* 1996), from writings of Zora Neale Hurston (*Untitled—I Feel Most Colored When I Am Thrown Against A Sharp White Background,* 1990/91) and Ralph Ellison (*Untitled—I Am An Invisible Man,* 1991), to jokes by Richard Pryor (*Cocaine—Pimps,* 1993). Most recently, Ligon employed old coloring books with black themes from the 1970s, prominently featuring figures such as Malcolm X (*Coloring,* 2000).

In *Notes on the Margin of the "Black Book"* (1991– 1993), the artist juxtaposes photographs of Robert Mapplethorpe's male nudes with textual quotations from artists, politicians, queer theorists, and Christian commentators, bringing the contemporary cultural dislocation and the marginality of African Americans within US society to the surface. Coming out of an identity conscious generation of American artists from the 1970s and 1980s such as Adrian Piper and Lorna Simpson, concerned with issues of the representation of gender, race, and sexuality, Ligon directs attention to the imagery of the gay, black male as an indicator of the conditions of society at large. N. R.

Stranger in the Village #11 | Fremder im Dorf, Nr. 11, 1998
Enamel, oil, synthetic polymer, gesso, coal dust, and glitter on canvas | Emaillack, Öl, synthetisches Polymer, Gesso, Kohlegrus und Glitter auf Leinwand, 244 x 183 cm

The rage of the downtrodden is generally beneficent but it is a force neither intelligent nor sensible. This rage is generally discounted, as those who store it, even though the people whose daily bread it is, is one of the forces that makes history. Rage can only with difficulty and never entirely be brought under the domination of the intelligence and is therefore not appropriate to any application whatsoever. This is a fact which many representatives of the Hierarcavolle having never felt outrage and being unable to imagine it quite fail to understand. Also, rage cannot be hidden, it can only be dissembled. This dissembling deludes the... and strengthens radiant... contempt. There are... of many ways of meeting... and ... reading compulsion. There are workingmen in the world that will

KEN LUM

*1956 in Vancouver, Kanada/Canada. Lebt/Lives in Vancouver.

Seit den achtziger Jahren ist Ken Lum hauptsächlich für seine großformatigen Foto-Text-Arbeiten, seine Möbelskulpturen und seine Sprachgemälde bekannt. Die Foto-Text-Arbeiten drehen sich um Personen, deren „Sprache" die Fähigkeit reflektiert, Bewusstsein zu erlangen und zu handeln. Diese in gewisser Weise Brecht'schen „Essays" gegen rassen-, gender- oder klassenbezogene Stereotypen kombinieren Pathos mit Ironie in der Fragestellung, wie wir als Betrachter Bilder von Menschen konstruieren, die anders sind als wir selbst.

Die Möbelskulpturen verhandeln das Erbe der minimalistischen Skulptur. Lum benutzt Wohnungsmobiliar, um die „Theatralität" von Donald Judd und Zeitgenossen zu parodieren und die Betrachter gleichzeitig als soziale Subjekte und in ihrer physischen Erscheinung zu positionieren. Lums Sprachgemälde leiten sich von der polyglotten „Sprache" der Werbeschilder ab, die die Geschäfte in Vancouvers ausgedehnten Arbeiter- und Einwanderervierteln zieren. Indem er die Übertreibungen der Billigwerbung visuell überzeichnet und „Nonsens" zum Imperativ erhebt, bezieht sich Lum auf die utopisch-revolutionäre Glossolalie von Chlebnikow und Schwitters.

In den letzten Jahren arbeitete Lum mit Spiegeln. Seine ersten Arbeiten bestanden aus mannshohen Exemplaren, in deren Rahmen zufällig gefundene Schnappschüsse geklemmt waren. Der Besucher, der diesen Arbeiten gegenüberstand, wurde sich – im Zwiespalt zwischen seinen eigenen Reflexionen und den Schnappschüssen mit ihren Einblicken in das Leben anderer – seiner selbst bewusst. Aus einer ganzen Galerie von derartigen Spiegeln entstand der sich im Endlosen verlierende Raum eines Spiegelsaals.

Die Arbeit für die Documenta11, *Mirror Maze with 12 Signs of Depression* (2002), ist eine Weiterentwicklung solcher Spiegelstücke. Lums Spiegellabyrinth bezieht sich auf die im 19. Jahrhundert beliebten Spiegelkabinette. Es spielt auf kristalline Formen expressionistischer Architektur an, auf bestimmte Orte wie Einkaufszentren und Jahrmarktbuden, aber auch auf den berühmten Showdown im Spiegelsaal am Ende des Film-noir-Klassikers *The Lady from Shanghai* (1948). *Mirror Maze* soll bei den Betrachtern eine Selbstversenkung bis hin zu Selbstmitleid und Depression bewirken. In zwölf Innenspiegel sind Texte mit jeweils einer Nummer eingraviert; sie beschreiben zwölf häufig in Selbsttests von Lifestylemagazinen oder auf Gesundheitsseiten aufgezählte Depressionsanzeichen. Hier sind sie in der ersten Person formuliert: „Ich fühle mich, als sei ich allein auf der Welt.", oder „Ich weine ohne ersichtlichen Grund." Diese authentischen Zitate aus der Populärpsychologie bedeuten allerdings nicht, dass der Künstler wirklich am klinischen Erscheinungsbild der Depression interessiert wäre. Vielmehr geht es ihm darum, dass die meisten Besucher ein oder mehrere Zeichen bei sich selbst identifizieren dürften. Sein *Mirror Maze* ist eine Architektur der Identifikation und Entfremdung: Während das Bild des Selbst sich endlos wiederholt und der Raum sich in reflektierende Oberflächen auflöst, verliert der Betrachter seine Orientierung, so als sähe er sich durch das Komplexauge eines Insekts.

Since the 1980s, Ken Lum has mainly been known for his large photo/text works, his furniture sculptures, and his language paintings. The photo/text works feature subjects whose "speech" reflects on the ability to gain consciousness and to act. These somewhat Brechtian essays directed against the stereotypes of race, gender, and class combine pathos and irony, questioning how we as viewers construct pictures of people different from ourselves.

The furniture sculptures continue to negotiate the legacy of minimalist sculpture. Using domestic furniture, Lum parodies the "theatricality" of Donald Judd et al., so as to position the viewer as a social subject as well as a somatic presence. Lum's language paintings are derived from the polyglot "language" of retail signs in Vancouver's large working class immigrant neighborhoods. By exaggerating the look of low-level advertising hype and giving "nonsense" an imperative mood, Lum reaches back to the utopian, revolutionary glossalalia of Velimir Khlebnikov and Kurt Schwitters.

In recent years Lum has been working with mirrors. His first mirror works were full-length mirrors with found snapshots tucked into the frame. Before these works, viewers become subjects, caught between their own reflections and the curious intimations of other lives presented by the snapshots. A gallery full of them is transformed into the infinitely regressing space of a mirror room.

The work for Documenta11, *Mirror Maze with 12 Signs of Depression* (2002), is a further development of the mirror works. Based on 19th-century entertainments and alluding to crystalline expressionist architecture, the shopping mall, the fun house, and the famous climactic shoot-out in a mirrored room in the classic film noir *The Lady from Shanghai* (1948), Lum's mirror maze is meant to provoke self-absorption to the point of self-pitying depression. Twelve of the interior mirror panes bear etched inscriptions accompanied by a number. These are the twelve signs of depression frequently published for self-testing by the readers of lifestyle magazines or the "health" sections of newspapers. They have been turned into first person affirmations such as: "I cry for no reason," or "I feel alone in the world." Although the texts come from popularized psychology it would be a mistake to assume that the artist is really interested in the clinical condition of depression. Rather, it is the idea that most visitors to the maze will identify with one or more of the 12 "signs." *The Mirror Maze with 12 Signs of Depression* is an architecture of identification and alienation. As the image of the self endlessly replicates and space dissolves in reflective surfaces, the viewer loses his coordinates as he sees himself as if in the multifaceted eye of an insect. S.W.

Photo-Mirror: Japanese lovers I *Foto-Spiegel: Japanische Liebespaare*, 1997
Maple wood, mirror, photographs I Ahornholz, Spiegel, Fotografien, 137 x 99 cm

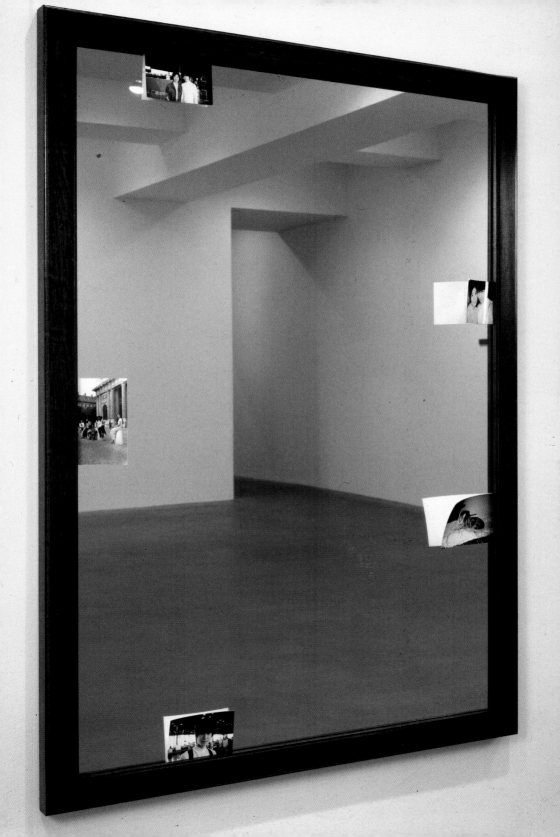

MARK MANDERS

*1968 in Volkel, Niederlande/Netherlands. Lebt/Lives in Arnheim, Niederlande/Netherlands.

„Ich befand mich in einer Welt, die ich nicht selbst bestimmt hatte. Ich beschloss, ein Gebäude neben dieser Welt zu bauen, oder vielmehr in dieser Welt: Ein Selbstporträt, worin ein sich verändernder Stillstand herrscht, worin und wodurch ich ständig mit meiner Auswahl, der ausgedachten von Mark Manders, konfrontiert wäre." Seit 1986 arbeitet Manders an diesem *Self-Portrait as a Building,* von dem er regelmäßig Elemente, darunter Zeichnungen, Objekte, Skulpturen, Räume, aber auch Schriften in veränderten Kontexten ausstellt. „Wenn ich durch mein Gebäude gehe, sehe ich mich überall tiefem Stillstand gegenüber, es ist gewaltig, die Dinge hier übersteigen mein augenblickliches Denken und sind mir sehr vertraut, ich langweile mich nie."

Manders arbeitet assoziativ. Seine Arbeiten sind schwer zu fassen, sie wirken, als kämen sie aus einer anderen Welt, einer Welt des Unbewussten und der Stille, als wären sie Spuren einer fremden, arrangierten Ordnung. Man kann ihre Einzelteile beschreiben, ohne jedoch ihren Zusammenhang definieren zu können.

Still-Life, Isolated Landscape, Reduced Nightscene with Broken Moment und *Fragment of Forgetting* sind charakteristische Bezeichnungen von Manders Arbeiten. Sie erinnern an Maschinen, Apparaturen und Laborgeräten; ihre verschiedenen Elemente, darunter Gefäße und Skulpturen von liegenden Kleintiere sind häufig mit Schnüren, Drähten, Rohren oder Hölzern verbunden und in Balance gebracht, als ob sie nach einer nicht erkennbaren Regel zusammengehörten und Energieflüsse austauschten. Gleiche Objekte werden in unterschiedlichen Positionen wiederholt, als handele es sich um ein und dasselbe Objekt, das sich bewegt hätte. So erscheinen zwei seltsam proportionierte Figuren (*Two Fragments from Self-Portrait as a Building*) nicht als zwei Wesen, sondern als ein Wesen in zwei Zuständen. In einer anderen Arbeit reduziert Manders drei überdimensionierte Streichhölzer, über die ein Bindfaden gelegt ist, optisch zu flächigen Lineaturen (*Colored Room with Black and White Scene*).

Proportionen und Dimensionen sind für Manders von elementarer Bedeutung. Er verkleinert Fragmente seines *Self-Portrait as a Building* in einer gerade noch wahrnehmbaren Weise (*–/Chair (reduced to 88%),* 1997/98), oder transformiert sie in andere Ebenen (*Provisional Floor-Plan Self-Portrait as a Building 10–3–1997*). Der realen Welt steht so die Welt des Künstlers gegenüber.

Auch Zahlen, Worte und Sätze bilden bedeutsame Komponenten im Werk; Zeitungen und Bücher sind für ihn wichtige Medien geworden. So thematisiert der Künstler die Zahl 5 durch Buchstaben- und Zahlenkombination oder durch das fünffache Wiederholen von Objekten (Zeitung für *SONSBEEK 9,* Arnheim 2001) und formt Schriftzeichen durch Biegen von Drähten oder Kleben von Tesafilmstreifen (Zeitung für *Territory,* Tokio 2000).

Die Documenta11 wird eine Installation präsentieren, die aus verschiedenen „reduzierten Räumen" und Elementen seines *Self-Portrait as a Building* besteht.

"I would find myself in a world that I hadn't determined myself. I decided to build a building next to that world, or rather, in that world. A building which was dominated by a changing arrest, where and through which I would be confronted continuously with my choice, the choice of Mark Manders." Manders has been working since 1986 on this *Self-Portrait as a Building,* elements of which—drawings, objects, sculptures, rooms, and writing—he regularly exhibits in different contexts. "Walking through my building, I get confronted everywhere with deep arrest, it is terrific, the things over here surmount my momentaneous thinking and are familiar to me, I never get bored."

It is difficult to define Manders' works. The works are associative. They seem to be from another world, a world of the subconscious, of stillness; they seem to be traces of a strange order. The individual components can be described, although their connection to each other remains undefined.

Still-Life, Isolated Landscape, Reduced Nightscene with Broken Moment, and *Fragment of Forgetting* are characteristic work titles. They regularly recall machines, apparatuses, and laboratory equipment; their various elements, frequently including containers and lifeless small animals, are often connected with string, wire, pipes, or wood, and brought into balance, as if they belonged together and exchanged energy according to some unknown physical law. The same objects are repeated in different positions, as if they were one object, which has moved. For instance, two oddly proportioned figures (*Two Fragments from Self-Portrait as a Building*) do not appear to be two creatures, but one creature in two situations. In *Colored Room with Black and White Scene* three oversized matches laid across a piece of string are optically reduced to flat lines.

For Manders, dimensions and proportions are of elementary importance. Fragments of his *Self-Portrait as a Building* are reduced almost imperceptibly (*–/Chair (reduced to 88%),* 1997/98) or transformed to other levels (*Provisional Floor-Plan Self-Portrait as a Building 10–3– 1997*). The world of the artist stands in contrast to the real world.

Numbers, words, and sentences are significant components in the artist's work. Newspapers and books have become important media for Manders. For example, the artist takes the number five as a theme, using letters or combinations of numbers and objects (newspaper for *SONSBEEK 9,* Arnhem 2001). Writing is created with bent wire or scotch tape (newspaper for *Territory,* Tokyo 2000).

Documenta11 will present an installation consisting of various "reduced rooms" and elements of *Self-Portrait as a Building.* A.N.

Silent Factory I *Stille Fabrik,* 2000
Wood, iron and other materials I Holz, Eisen und andere Materialien

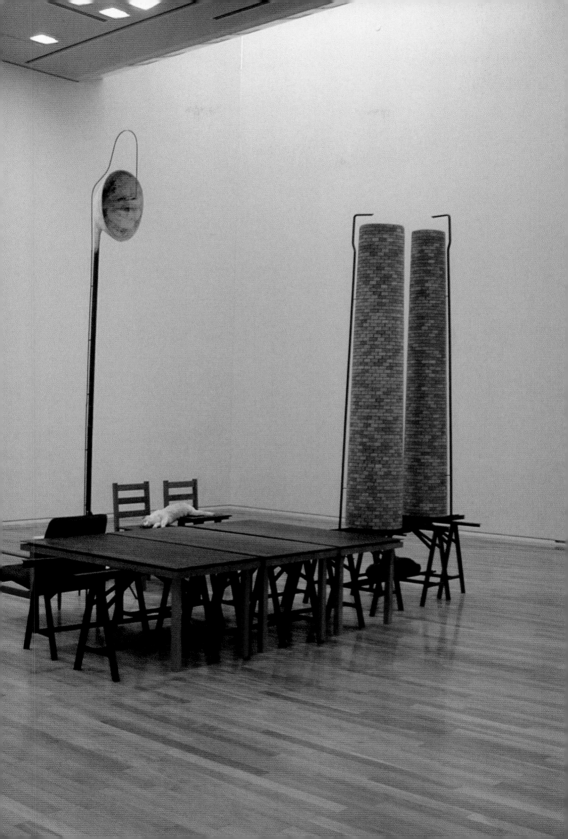

FABIAN MARCACCIO

*1963 in Rosario, Argentinien/Argentina. Lebt/Lives in New York.

Fabián Marcaccio studierte Philosophie an der Universität von Rosario und zugleich Malerei und Drucktechnik bei Jaime Rippa, Mitglied einer Künstlergruppe, die eines der wichtigsten politischen Konzeptkunstwerke im Argentinien der sechziger Jahre erschuf. Diese Umstände prägten seine künstlerische Produktion von Beginn an: Zum einen geht er die materiellen Aspekte der Malerei aus der unüblichen Perspektive der mechanischen Bildreproduktion an, zum anderen erweitert er diesen analytischen Ansatz um eine theoretische Dimension.

Marcaccio zog gegen Ende der achtziger Jahre nach New York; dort wurde seine Arbeit durch den Kontakt mit der nordamerikanischen Abstraktion bereichert, deren theoretische Grundlagen er mit bissiger Ironie demontierte. Seine ikonoklastische, radikal kritische Arbeit zielte auf die Dekonstruktion des angeblich „expressiven" Inhalts der Abstraktion. Es ging ihm darum, die Annahme eines autonomen Subjekts – fähig sich selbst durch einen geschlossenen Code von Pinselstrichen und Farbklecksen zu repräsentieren – ad absurdum zu führen. Ohne sich von den Fragen der Gegenständlichkeit zu entfernen, scheint diese Periode in Marcaccios Werk Abstraktion als getarntes ikonografisches System zu verstehen.

Gegen Mitte der neunziger Jahre begann Marcaccio mit neuen Druck- und Bildproduktionstechniken zu arbeiten. In einer architektonisch strukturierten Werkreihe hinterfragt er die Beziehung zwischen dem Bild als Kunstwerk und dem Bild als Werbeträger. In diese Reihe gehört das für die Documenta 11 geschaffene *Multiple/Site Paintants*. Mit dieser Arbeit, deren Elemente über ganz Kassel verteilt sind, untersucht Marcaccio mögliche Beziehungen zwischen Werbung im städtischen Raum und Malerei. Er schlägt vor, bei der behutsamen Analyse seiner Materialität eventuelle historische Dimensionen des Bildes wiederzuerlangen. Marcaccio malt unermüdlich und rastlos, um die historische Geltung und die zukünftigen Möglichkeiten der Malerei zu bekräftigen.

Fabián Marcaccio studied painting and printmaking in Rosario with Jaime Rippa—a member of the group of artists responsible for one of the most significant political and conceptual works in Argentina in the 1960s—and simultaneously studied philosophy at the National University of Rosario. This combination of circumstances shaped his artistic production from the outset. On the one hand, he engages the material aspects of painting from the unusual perspective of the mechanical reproduction of images. On the other hand, he invests this analytic dimension with theoretical resonance.

After moving to New York in the late 1980s, Marcaccio's work grew richer through exposure to the North American abstract tradition, the premises of which he attempted to dismantle with an acid irony. Marcaccio's iconoclastic, inherently critical work began to focus on an active dismantling of the supposedly "expressive" content of abstraction. His aim was to expose the fallacy of an autonomous subject capable of representing itself through a closed code made of brush strokes and drips. Far from moving away from the problems of representation, this period of the artist's work seems to understand abstraction as a disguised iconographic system.

Toward the mid-1990s, Marcaccio began experimenting actively with new techniques of printing and image reproduction. A series of works of architectural dimensions questions the relationship between the painterly image and the publicity image. *Multiple/Site Paintants*, created specifically for Documenta 11, clearly belongs to this category. On this occasion, Marcaccio investigates the possible relationship between painting and urban advertising through a work consisting of several sections in various locations throughout Kassel. Marcaccio proposes the recovery of a possible historical dimension of the image while carefully analyzing its materiality. In this, as in his other works, the artist paints continuously and tirelessly to attest to the historical validity and future possibilities of painting. C.B.

Paintant Stories, 2000
Installation view I Installationsansicht, Kölnischer Kunstverein, Cologne I Köln, 2000

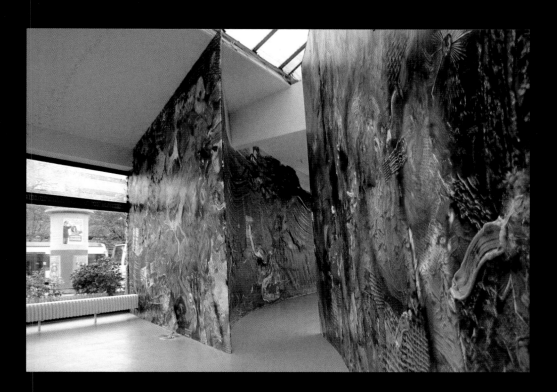

STEVE MCQUEEN

*1969 in London. Lebt/Lives in Amsterdam.

Steve McQueens Arbeit zielt sicher vor allem darauf ab, der Erfahrung von Bildern etwas Körperliches zurückzugeben. McQueen analysiert den Film nicht nur als Medium: Wichtig ist ihm auch die spezifische Bedeutung der Repräsentation, die bei ihm mit den nicht-narrativen Erfahrungen des Nouveau Roman und des Experimentalfilms der siebziger Jahre durchsetzt ist. Der aggressiven Oberflächlichkeit des Bildes, die in unserer Kultur offensichtlich zur dominierenden Form der Repräsentation geworden ist, setzt McQueen eine organische Narrationserfahrung entgegen, die nahezu physisch an die Kooperation des Betrachters appelliert.

Soweit man die zwei Arbeiten, die McQueen zur Documenta11 präsentiert, getrennt betrachten kann, stellen sie so etwas wie die gegenüberliegenden Momente eines Diptychons dar. In *Western Deep* (2002) entführt uns McQueen auf eine Höllenfahrt nach Südafrika in eine der tiefsten Goldminen der Welt. Die Bilder von der Abfahrt in die Mine sind beklemmend klaustrophobisch: aufblitzende Lichter, unvermittelt einsetzende Geräusche, eine endlose, vertikale Folge von Felswänden, Teile verschwitzter Körper der erschöpften Bergmänner. Der Abstieg wird zur Analogie forschenden Eindringens in einen Körper; die monotone, bedrückende Arbeit der Bergleute scheint einem rein mechanischen, verfremdeten Rhythmus zu folgen, und die moderne Vision des Arbeiters als Maschine steigert sich bis zum absurdesten Extrem. Die abrupten Dissonanzen des Soundtracks und das allgemeine Klima von Verzweifelung und bleierner Schwere verleihen der Arbeit einen Realismus, der über die reine Repräsentation des dargestellten Geschehens hinausgeht.

Der zweite Teil von McQueens Arbeit, der *Western Deep* begleitet und ergänzt, heißt *Carib's Leap* (2002) und geht von einem historischen Ereignis auf der Insel Grenada aus – dem Massenselbstmord der karibischen Indianer 1651 nach erfolglosem Widerstand gegen die Eroberung ihrer Insel durch die Franzosen. Die Kariben, die den Tod der Unterwerfung und Kolonisierung vorzogen, repräsentieren für McQueen eine Extremposition, in der Freiheit und Tod sich gleichen. In seiner Arbeit fallen Körper unterschiedlicher Gestalt und Altersgruppen endlos gegen einen leuchtenden Hintergrund. Die Körper, deren Gesichtszüge und ihr Ausdruck – manchmal nahe, manchmal fern und distanziert – undeutlich zu erkennen sind, scheinen aus der Zeit herausgefallen zu sein.

McQueen gelingt es, uns *Western Deep* und *Carib's Leap* hautnah statt nur rein visuell erleben zu lassen. Vom stummen, endlosen Leiden im Fegefeuer bis zur verlogenen, sinnentleerten Hoffnung auf ein Paradies kommentieren die Arbeiten ausdrucksvoll die extremsten Gewaltformen, denen ein Mensch unterworfen sein kann: Sklavenarbeit und Kolonialherrschaft als ultimativen Formen der Instrumentalisierung von Abhängigkeit.

Perhaps one could say that Steve McQueen's work is, above all, about returning the physical to the experience of the image. To the analysis of the filmic dispositive McQueen adds a concern for the contents of representation, shot through with the antinarrative experience of the nouveau roman and experimental films of the 1970s. Physically imploring the aid of the viewer, McQueen sets an organic experience of narration against the aggressive superficiality of the image that seems to have become the dominant form of representation in our culture.

If the two works McQueen presents at Documenta11 can be considered separately, they comprise something like opposing moments of a diptych. In *Western Deep* (2002) McQueen takes us on an infernal journey: the descent in South Africa into one of the deepest gold mines in the world. The images are oppressive and claustrophobic: intermittent lights and abrupt sounds, an endless and vertical succession of rocky walls, fragments of the sweaty bodies of an exhausted population of black miners. The descent into the mine becomes an analogy of the invasive exploration of a body, while the repetitive and oppressive work of the miners seems to heed a purely mechanical and alienated rhythm. The modernist image of the worker as machine is taken to its most condensed and absurd extreme. The soundtrack's abrupt dissonances and the general climate of despair and heaviness lend the work a realism that transcends pure representation of the events shown.

The second part of McQueen's work, or rather the second work that accompanies and complements *Western Deep,* is called *Carib's Leap* (2002) and uses an historical event as a starting point: the mass suicide of the Carib Indians on the island of Grenada in 1651 in resistance to French invasion of their territory. The Carib, who chose death over subjugation and colonization, represent an extreme position for the artist, in which liberty resembles death. In his work, bodies of different types and ages fall indefinitely against a luminous background. The bodies, whose faces and expressions are not clearly discernible, at times close to the screen, at times remote and distant, seem suspended in verticalized time without beginning or end.

McQueen allows us to experience *Western Deep* and *Carib's Leap* literally rather than merely visually. From the deaf, infinite suffering of purgatory to the hollow hope of a paradise devoid of meaning, these works constitute a powerful commentary on the most extreme forms of violence to which a human being can be subjected: slave work and colonial domination, ultimate forms of an instrumentalization of subjectivity. C.B.

Five Easy Pieces I *Fünf leichte Stücke,* 1995
Film: 16mm, black-and-white, color, 7 min. 34 sec. I 16-mm-Film, schwarz-weiß und Farbe, 7 Min. 34 Sek.

CILDO MEIRELES

***1948 in Rio de Janeiro. Lebt/Lives in Rio de Janeiro.**

Cildo Meireles gehört jener Generation brasilianischer Künstler an, zu der auch Artur Barrio, Tunga, Waltercio Caldas und José Resende zählen. Wie auch Barrio und Hélio Oiticica nahm er 1970 an der historischen Konzeptkunstausstellung *Information* am New Yorker Museum of Modern Art teil; 1992 stellte er im Rahmen der *documenta IX* aus.

Meireles' Arbeiten sind nicht nur visuell ansprechend, sondern hinterfragen kritisch – manchmal sogar auf irritierende Weise – das Wesen künstlerischer Arbeit. Ausgehend von der Untersuchung der Materialität des Werks, seinen internen Mechanismen und seiner Beziehung zur Geschichte moderner und zeitgenössischer Kunst stellt Meireles diese Aspekte in Beziehung zu ihrem sozialen und ökonomischen Kontext.

Zur Documenta11 zeigt Meireles die Arbeit *Disappearing Element/Disappeared Element (Imminent Past)* (2002), die auf unterschiedlichen Ebenen funktioniert: Auf der einen thematisiert sie die fortschreitende globale Wasserknappung, auf der anderen setzt sie die Untersuchung der Begriffe Nutz- und Tauschwert fort, die Meireles' gesamtes Werk durchzieht. Nicht zuletzt geht es hier aber auch um die Etablierung eines autonomen Produktionssystems in kleinem Maßstab. Nach Meireles' eigenen Worten „besteht diese Arbeit ganz einfach darin, Wasser-Speiseeis am Stiel zu produzieren und zu verkaufen. Die Idee ist, dass Leute mit bescheidenen Mitteln Eis herstellen und verkaufen. Die Verkäufer erhalten eine prozentuale Umsatzbeteiligung, und mit dem Rest werden die Maschinen bezahlt, die für die Eisherstellung, den Vertrieb und den Verkauf nötig sind."

Über ganz Kassel verteilt finden die Besucher an verschiedenen Stellen eine Reihe bunter Karren beladen mit Eis am Stiel. Meireles hat drei verschiedene Sorten hergestellt, alle drei an Plastikstielen mit der Aufschrift „Disappearing Element/Disappeared Element"; die eiskalten Erfrischungen kann man selbstverständlich kaufen.

Wie viele frühere Arbeiten von Meireles wirft auch diese eine Reihe von Fragen auf: Geht es hier um Eis oder um Kunst? In welcher Beziehung steht die behauptete Knappheit des Rohstoffs zu seinem Handelswert? Ist die Kunst Teil einer Ökonomie der Verknappung, die den Gesetzen von Angebot und Nachfrage gehorcht? Und während wir uns noch den Kopf über die Beziehung zwischen Kunst und Markt zerbrechen, macht uns die erstaunlich einfache und ressourcenschonende Arbeit erfolgreich auf einen gefährlichen und vernachlässigten Aspekt der Zerstörung unserer Umwelt aufmerksam – und unterstreicht so die unbestreitbare soziale Verantwortung aller künstlerisch-kreativen Arbeit.

Meireles belongs to a talented generation of Brazilian artists that includes Artur Barrio, Tunga, Waltercio Caldas and José Resende. Alongside Barrio and Hélio Oiticica, he took part in the historic exhibition of Conceptual Art, *Information*, at the Museum of Modern Art in New York in 1970. In 1992, Meireles participated in *documenta IX*.

Added to the immediate visual appeal of much of Cildo Meireles's work is an acute and at times disconcerting questioning of the nature of artistic work. Starting off with an investigation of the work's materiality, its internal mechanisms, and its relationship to the history of modern and contemporary art, Meireles makes these aspects of his work resonate with its social and economic context.

For Documenta11, Meireles is presenting *Disappearing Element/Disappeared Element (Imminent Past)* (2002) which works on various levels. On one level it alludes to the imminent and progressive scarcity of water on a global scale, on another it is a continuation of the questioning of the notions of the value of use and the value of change that recur in Meireles's work. Finally it is about establishing an autonomous production system on a small scale. In the artist's words, "this work simply consists of the production and sale of popsicles. The idea is that people of limited means produce and sell popsicles. The salespeople receive a percentage of the sales and the rest goes towards paying for the machinery needed for the manufacture, distribution, and sale of the popsicles."

At various points throughout Kassel the viewer will find a series of small colored carts containing popsicles. Meireles has made three different kinds, each provided with clear plastic sticks bearing the inscription "Disappearing Element/ Disappeared Element." The frozen snacks, obviously, will be for sale.

As in many of Meireles previous pieces, this work generates a battery of questions. Is this about ices or about works of art? What is the relationship between the advertised scarcity of the raw material and its commercial value? Is art part of an economy of scarcity organized in concordance with supply and demand? The work, which enjoys an admirable simplicity and economy of resources, manages to alert us to a dangerous and neglected aspect of the deterioration of our environment while puzzling over the relationship between art and the market, underscoring the undeniable social responsibility implicit in all artistic creativity. C.B.

Inserções em circuitos ideologicos: projecto Coca-Cola | Insertions into Ideological Circuits: Coc-Cola Project) | Einfügungen in ideologische Kreisläufe: Coca-Cola-Projekt, 1970
Coca-Cola bottles, 18 cm high, transferred text | Coca-Cola Flasche, Höhe: 18 cm, übertragener Text

JONAS MEKAS

*1922 in Semeniškiai, Litauen/Lithuania. Lebt/Lives in New York.

Das eigene Archiv und seine Biografie sind die zentralen Bezugspunkte innerhalb des filmischen Werks von Jonas Mekas. Seit mehr als fünf Jahrzehnten verfolgt der Filmemacher und Poet einen radikal subjektiven Ansatz. Tagebuchartig dokumentiert er Ausschnitte seines Lebens mit der handlichen 16-mm-Kamera, greift dabei „unmittelbar" auf die Wirklichkeit zu und betont seine Involviertheit in die Aufnahmesituation. Das über Jahre angesammelte Material unterzieht Mekas im nächsten Schritt einer Bearbeitung. Manchmal beiläufig, manchmal Bedeutung reklamierend, montiert er eine Vielzahl von Einzelsequenzen zu komplexen Erzählungen und Referenzsystemen. Aus den heterogenen Quellen entstehen so die Diary Films (Tagebuchfilme), in denen die traditionellen Strategien der filmischen Narration und die vom Mainstream-Kino etablierten Ökonomien der Produktion und Rezeption von Filmen keine Rolle spielen. Immer von der eigenen Person ausgehend, untersucht Mekas das Verhältnis zwischen der Dokumentation und (Re-) Konstruktion von Wirklichkeit.

Von den Nationalsozialisten verfolgt und interniert, emigrierte Mekas vier Jahre nach Ende des Zweiten Weltkrieges aus Litauen in die USA. Dort machte er sich als Filmautor und Publizist sowie als Kinobetreiber, Filmproduzent und -Verleger einen Namen und kann mit Recht als Protagonist des New Yorker Independent Cinema gelten. Als Autor von Filmkritiken und als Herausgeber des Magazins Film Culture (ab 1955) propagierte Jonas Mekas eine unabhängige US-amerikanische Filmkultur, die er explizit vom Kino Hollywoods, aber auch vom „Modernismus" des Avantgardefilms abzusetzen suchte. Neben seinen eigenen Filmen der sechziger und siebziger Jahre, etwa Walden (1964–1969), Lost, Lost, Lost (1949–1975) oder Reminiscences of a Journey to Lithuania (1971/72) entwickelte Mekas unter anderem mit der Film-Makers' Cooperative (ab 1962) und der Film-Makers' Cinematheque (ab 1964) neue Strukturen der Produktion, Distribution und Präsentation des unabhängigen Films. 1969/70 gründete er gemeinsam mit P. Adams Sitney und Jerome Hill die Anthology Film Archives, die heute zu den bedeutendsten Archiven des Avantgarde- und Underground-Films zählen.

Für As I Was Moving Ahead Occasionally I Saw Brief Glimpses Of Beauty (2000) unterzog der Filmautor Mekas sein persönliches Archivmaterial aus der Zeit zwischen 1970 und 1999 einer Revision. Entstanden ist ein knapp fünfstündiger Rückblick, in dessen der Filmemacher über die persönliche Erinnerung, die Freundschaft, die Schönheit und Flüchtigkeit des Moments reflektiert. Ausgesprochen „persönliche" Bilder von Familie und Freunden kommentiert er wiederholt mit der Aussage, es handele sich hier um einen politischen Film. Das Publikum verwickelt Mekas damit in ein Spiel mit Kategorien wie „öffentlich" und „privat", das sich auf seine untrennbar mit der eigenen Person verbundene Arbeit und auf seine Rolle innerhalb der New Yorker Kulturszene beziehen lässt.

The central points of reference in the film works of Jonas Mekas are his own biography and the archive. For the last five decades, the filmmaker and poet has followed a radically subjective approach. Diaristically, he documents excerpts of his life by recording fragments of reality with the handy 16mm camera, "directly" accessing reality, and emphasizing his involvement in the shooting process. Mekas then edits the material collected over many years. Like an amateur film, vacillating between triviality and significance, his montage of numerous individual sequences creates complex narratives and systems of reference. From heterogeneous sources emerge the Diary Films, with which Mekas negates the common strategies of cinematic narration and circumvents mainstream cinema's economies in the production and reception of film. Always starting from his own person, he examines the relationship between documentation and (re)construction of reality.

Persecuted and interned by the Nazis, he emigrated from Lithuania to the USA four years after the end of World War II. He made a name for himself as a film author, publicist, cinema owner, film producer, and publisher and can rightly be regarded as a protagonist of New York independent cinema. In film reviews and columns and as editor of the magazine Film Culture (est. 1955), Jonas Mekas propagated an independent American film culture that he distinguished from both Hollywood narrative cinema and from modernist avant-garde film. Alongside his own films of the 1960s and 1970s, such as Walden (1964–1969), Lost, Lost, Lost (1949–1975), or Reminiscences of a Journey to Lithuania (1971/72), Mekas developed new structures for the production, distribution, and presentation of independent film in collaboration with the Film-Makers' Cooperative (est. 1962), the Film-Makers' Cinematheque (est. 1964), and a variety of other projects. Together with P. Adams Sitney and Jerome Hill, he established Anthology Film Archives in 1969/70, still considered one of the most important archives of avant-garde and underground film.

For As I Was Moving Ahead Occasionally I Saw Brief Glimpses Of Beauty (2000) the film author Mekas put his personal archive material from 1970 to 1999 through a revision. The result is an almost five-hour retrospective whose mere length goes beyond the scope of any feature film. The filmmaker reflects on personal memory, friendship, beauty, and the fleeting nature of the moment. He repeatedly comments on extremely "personal" images of family and friends by stating: this is a political film. He thereby involves his audience in a game with categories such as "public" and "private," a game that refers to his work, inseparable from his own person, and his role within the New York cultural scene. K.R.

Jonas Mekas in As I was Moving Ahead Occasionally I Saw Brief Glimpses of Beauty | Während ich mich vorwärts bewegte, sah ich gelegentlich kurze Schimmer von Schönheit, 2000
Film: 16mm, color, sound, 288 min. | 16-mm-Film, Farbe, Ton, 288 Min.

ANNETTE MESSAGER

*1943 in Berck, Frankreich/France. Lebt/Lives in Malakoff, Frankreich/France.

Annette Messager setzt sich mit einschneidenden emotionalen Erfahrungen wie Schmerz, Grauen, Gewalt, Verlust, Verlangen, Ekstase und versagender Erinnerung auseinander, die, ebenso beunruhigend wie unkontrollierbar, die beherrschte Rationalität des isolierten Individuums erschüttern und mit einem Modus von Kommunikation verknüpft sind, der durch Exzess gekennzeichnet ist. Das Verständnis von Subjektivität als einem „Ganzen" wird faktisch und geistig durcheinander gebracht und auseinander genommen. In ihren Multimedia-Installationen arbeitet Messager seit den frühen siebziger Jahren mit Zeichnungen, Fotografien und Soft Sculptures – bevorzugt mit vertrauten Textilobjekten wie Kopfkissen, Nackenrollen, Wollgewebe und Moskitonetzen, mit präparierten und ausgestopften Tieren, Plüschpuppen und Marionetten. Mit deren Hilfe setzt sie entindividualisierte Körper im Raum dramatisch in Szene – als fragmentierte, durchlöcherte und zerstückelte Stellvertreter einer Menschheit, deren Dasein aus Unterdrücken und Unterdrücktwerden besteht.

Indem sie auf das Erbe des Symbolismus und den magischen, primitiven und erotischen Surrealismus von Künstlern und Autoren wie Hans Bellmer und Georges Bataille zurückgreift, vermählt Messager Skurrilität und Horror mit einer liebenswert-vertrauten Bildwelt des Alltags. Beim Betrachten der heterogenen Assemblagen wird man gewissermaßen vom „Lesen" zum „Erfühlen" der Arbeiten gezwungen. Sie erzeugen eine subjektive, manchmal körperliche Unruhe, vermittelt durch die ernste Intensität, mit der Messager privat wie öffentlich tabuisierte Themen anspricht – z. B. die dunkleren, gewalttätigeren Seiten des Menschseins (Péché, Sünde, 1990; Les piques, Die Spieße, 1991–1993), die Opfer, welche für Schönheit zu bringen sind (Les tortures volontaires, Gewollte Qualen, 1972), oder die Benachteiligung von Frauen. In einem frühen Werk (Ma collection de proverbes, Meine Kollektion von Sprichwörtern, 1974) stickt sie „Frauen lernen von der Natur, Männer aus Büchern" – eine frauenfeindliche französischen Redensarten, wie sie auch auf Kaffeetassen, Aschenbechern und Weinkaraffen zu finden sind – auf weiße Stofftaschentücher und hält damit kulturellen Klischees und Stereotypen einen Spiegel vor. Mit Selbstbezeichnungen wie „Annette Messager, Sammlerin, Künstlerin, Frau der Tat, Schwindlerin und Hausiererin" reflektiert sie ironisch den Drang zum „Schubladendenken" der (männlich dominierten) Gesellschaft. Von 1971 bis 1974 stellt die „Sammlerin Messager" in nummerierten Serien 55 Sammelalben mit Zeichnungen, Fotos und Presseauszügen zusammen, die tagebuchartig nicht nur ihre eigenen „Initiationsriten" dokumentieren (Mariage de Annette Messager, Die Hochzeit der Annette Messager), sondern auch pornografische Fantasien, Bilder von Schönheit und Glück sowie beklemmend manipulierend Fotografien (Enfants aux yeux rayés, Kinder mit ausgekratzten Augen) zeigen.

Messagers Versuche, durch Fantasien und Fiktionen von Geschlecht, Gewalt und Sex mit dem Dasein zu versöhnen, sind von der magischen Faszination des Sammelns motiviert – einer Leidenschaft, die ans Chaos grenzt, und doch nur als Damm gegen die Springflut der Erinnerungen fungiert (Walter Benjamin).

Profound inner experiences of pain, horror, violence, loss, desire, ecstasy, and the fallibility of memory are amongst the range of emotional states that concern Annette Messager. They disquiet precisely to the degree that they are uncontrollable, shattering the composed rationality of the isolated individual and breaking out into an excessive mode of communication. An understanding of subjectivity as "whole" is actually and mentally torn apart and dissected. Working since the early 1970s on multimedia installations, utilizing drawing, photography and soft sculpture—primarily physically intimate cloth materials such as pillows, bolster cushions, woolens, mosquito nets, taxidermized and stuffed animals, plush dolls and marionettes—Messager theatrically maps objectified bodies in space as fragmented, punctured, and dismembered substitutes, standing in for a larger human condition of suppression and oppression.

Taking recourse to a legacy of Symbolism and the magical, primitive, and erotic Surrealism of artists and writers such as Hans Bellmer and Georges Bataille, the fantastic and the horrific are fused with an affable imagery of daily life. Upon viewing the artist's heterogeneous assemblages one is forced to leap from reading to feeling in a disruptive movement manifesting subjective and corporeal disturbances that convey an intense seriousness about uncomfortable domestic and civil topics such as the dark and more violent sites of humanity (Péché, Sin, 1990; Les piques, The Pikes, 1991–1993), the sacrifices for beauty (Les tortures volontaires, Voluntary Tortures, 1972), and the disprivileging of the feminine. In an early work (Ma collection de proverbes, My Collection of Proverbs, 1974) the artist crudely embroiders derogatory French folk sayings about women on white handkerchiefs as they appear on coffee mugs, ash trays, and wine pots—"Women are taught by nature, men by books"—holding up a mirror to cultural clichés and stereotypes. With self-given job titles such as "Annette Messager Collector, Artist, Practical Woman, Trickster, and Peddler," the artist ironically reflects upon (a male dominated) society's urge to compartmentalize and separate. From about 1971 to 1974, Messager, the collector, assembled in numbered sequences fifty-five scrapbook-style albums of drawings, photographs, and media clippings diaristically recording her own rites of passage (Mariage de Annette Messager, The Marriage of Annette Messager), as well as pornographic fantasies, images of beauty, happiness, and agonizing hand-altered photographs (Enfants aux yeux rayés, Children with Their Eyes Scratched Out).

Messager's recurrent attempts to achieve a sense of reconciliation with the act of living through fantasies and fictions of gender, violence and sex is driven by the thrill and the magic of collecting, in a passion bordering on the chaotic—a mere dam against the spring tide of the chaos of memories (Walter Benjamin). N. R.

En Balance I In Balance I Im Gleichgewicht, 1998
Installation view I Installationsansicht, Guggenheim Museum Soho, New York, 1998/99

RYUJI MIYAMOTO

*1947 in Tokio/Tokyo. Lebt/Lives in Tokio/Tokyo.

Im Januar 1995 ereignete sich in Kobe ein schreckliches Erdbeben. Noch im gleichen Jahr dokumentierte der japanische Fotograf Ryuji Miyamoto die Zerstörungen der Stadt und schuf daraus eine Serie mittelformatiger Schwarz-Weiß-Fotografien. Die Intimität dieser Bilder veranlasst den Betrachter, nah an sie heranzutreten, und die Fülle an Information fordert ihn zu längerem Betrachten auf.

Die Fotografien zeigen eingestürzte Fassaden der teilweise ausgebrannten Wohn-, Geschäfts- und Bürohäuser, zerstörte Brücken, Gleisanlagen und Leitungsmasten sowie unpassierbare Straßen und Wege. Es sind Absperrungen, Einzäunungen und Warnschilder zu sehen, mitunter auch Räummaschinen und Kräne, die nicht in Funktion sind, und „temporäre Gebäude" für die vielen Obdachlosen. Die Fotografien bilden keine Menschen ab. Mitunter erscheinen schemenhaft Körper, die durch lange Belichtungszeiten nur als Andeutung wahrzunehmen sind. Die Bestandsaufnahme spiegelt die Stille dieser ehemals aktiven Metropole.

In den achtziger und neunziger Jahren fotografierte Miyamoto öffentliche und repräsentative Gebäude. Es handelte sich dabei um Ruinen, verfallene oder zerstörte Architekturen, um teilweise abgebrochene Gebäude oder Bauwerke, die renoviert werden sollten, und um neue Baustellen. Botschaften, Theater, Kinos, Gefängnisse, Fabriken, Flughäfen, Messehallen und Ausstellungsflächen sind die bevorzugten Motive, die als Großaufnahme in Schwarz-Weiß jedes Detail deutlich wiedergeben. Das Spektrum reicht von Aufnahmen wie *Großes Schauspielhaus Berlin* (1985) und *Dänische Botschaft Berlin* (1986), *Octagon Tower* und *Smallpox Hospital* (1991) auf Roosevelt Island, New York, bis hin zum *Kansai International Airport* (1993) in Osaka und dem *Tokyo International Forum* (1995). Vielfach gibt es von einigen Bildmotiven verschiedene, sich ergänzende Ansichten, die – wie jene von Kobe – eine Serie ergeben. Als eine solche Serie sind die Fotografien von *Kowloon Walled City* in Hongkong anzusehen. Die Aufnahmen der großen Wohnsiedlung aus dem Jahre 1987 belegen den schlechten Zustand der Häuser, die dort herrschende Armut und das gleichsam provisorische Leben der Bewohner. Aufnahmen von 1992/93 zeigen die unbewohnten Wohnblocks mit Brandschäden und Zerstörungen; ein Kran und ein neuer Vorplatz deuten den geplanten Abriss und die Neugestaltung des Viertels an.

Miyamotos Fotografien sind in ihrer Konzentration auf architektonische Gegebenheiten weder sozialkritisch noch politisch. Sie sind vielmehr Dokumente eines „Nicht-mehr" oder „Noch-nicht", eines Zwischenzustandes von Raum und Zeit, eines Vakuums zwischen Verlust und Erneuerung – Dokumente der Unwiederbringlichkeit eines Moments, der immer auch zukünftige Veränderungen in sich birgt.

In January of 1995, there was a terrible earthquake in Kobe. In the same year, Japanese photographer Ryuji Miyamoto documented the city's devastation, creating a series of medium-format, black-and-white photographs. The intimacy of these pictures engages the viewer, encouraging close inspection, and requiring time to take in the mass of information they contain.

The photographs show the collapsed façades of partially burned apartment and office buildings, destroyed bridges, railroads, and utility poles, obstructed streets and sidewalks. Blockades, fenced-off zones, and warning signs can be seen, along with idle heavy machinery and cranes for the clean-up work. One of the pictures shows temporary buildings for the many homeless. Though there are no people on most of the photographs, vestiges of human shapes are occasionally visible, and the pictures' long exposure time makes them seem like mere shadows. This photographic inventory of the aftermath of Kobe's destruction reflects the stillness of this once-active metropolis.

In the 1980s and 1990s, Miyamoto photographed public and representative buildings, again focusing on ruins, collapsed or destroyed buildings (already partially demolished or awaiting renovation), and also on new construction sites. Embassies, theaters, cinemas, prisons, factories, airports, convention centers, and exhibition halls are preferred themes, depicted in very detailed, large, black-and-white photographs. Photographs such as *Großes Schauspielhaus Berlin* (1985), *Danish Embassy, Berlin* (1986), *Octagon Tower, Smallpox Hospital* (Roosevelt Island in New York, 1991), *Kansai International Airport* (Osaka, 1993), and *Tokyo International Forum* (1995) show the international scope and variety of old and new damaged buildings. Frequently, there are also numerous views of particular motifs that complement each other and which, like the Kobe images, could be expanded to create a larger series. The photographs of *Kowloon Walled City* in Hong Kong are a good example. These pictures show the terrible housing conditions, the poverty, and the provisional lives of the inhabitants in 1987. Photographs from 1992/93 show uninhabited, burned, and destroyed apartment blocks, whilst a crane and a new courtyard hint at the planned demolition and renovation of the quarter.

Concentrating upon architectural conditions, Miyamoto's photographs criticize neither society nor politics. Rather, they are documents of "no more" or "not yet," a suspended condition of space and time, a standstill among loss, renewal, and the irretrievable moment that always bears the changes of the future. A.N.

Kobe 1995 After the Earthquake I Kobe 1995 nach dem Erdbeben, 1995–1998
Series of black-and-white photographs I Schwarz-Weiß-Fotografien, 61 x 51 cm

SANTU MOFOKENG

*1956, Johannesburg, Südafrika/South Africa. Lebt/Lives in Johannesburg.

Santu Mofokeng, der als Straßenfotograf begann, stellt mit seiner Arbeit das zwiespältige Genre der dokumentarischen Fotografie in Frage, insbesondere im Zusammenhang mit der fotojournalistischen Praxis im Südafrika der Apartheid.

Da Mofokeng nicht dem parteiischen „Kampfjournalismus" zuarbeiten wollte, ging er dazu über, als Widerstandsgeste den Alltag in den Townships zu dokumentieren. Seine Rekonfiguration des Dokumentarischen lässt sich an seiner ersten Ausstellung *Like Shifting Sand* (1990) erkennen, in der er seinen Landschaftsaufnahmen Fotos von Befreiungsbewegungen in den Townships gegenüberstellte. Diese dialogische Strategie findet sich auch in *Distorting Mirror/ Townships Imagined* (1995) fort. Mofokeng konfrontierte die öffentliche, politische Bildsprache der Printmedien mit privaten Aufnahmen aus Familienfotoalben – gleichsam als Antwort auf die lokale und internationale Übersättigung der Medien mit Bildern über die Apartheid in Südafrika.

Die Arbeit war der Anstoß zu seiner Serie *Black Photo Album/Look at Me* (1997), in der er Fotoalben städtischer südafrikanischer Familien aus der Zeit von 1890 bis 1950 zusammentrug. Die zeitweilig völlig vergessenen Aufnahmen setzen ins Bild, wie das „Ich" unter der Kolonialherrschaft bestimmt, imaginiert, geformt und fotografiert wurde. Mofokeng fand die einzelnen Identitäten, Namen und Biografien der zuvor anonymen Porträts in den Fotoalben wieder heraus. Diese Praxis des Wiederaufdeckens fordert nicht nur die Geschichte und die Erinnerung ein, sondern bestimmt auch die historische Beziehung zwischen Bild, Archiv und Staatszugehörigkeit neu. Der Künstler stellte damit der kollektivierenden und „entmenschlichenden" Funktionsweise von Archiven und den pauschalisierenden Identitätsvorstellungen, die durch Begriffe wie „Soweto" und „Townships" konstruiert werden, seine Praxis als eine Alternative entgegen.

In *Chasing Shadows* (1997) verlagerte Mofokeng sein Interesse auf die Landschaft. Er wandte sich gegen die simple Beschreibung von Zeichen der Apartheid und das typische Vokabular des Township-Lebens als Spektakel. Stattdessen fotografierte er einen ganz bestimmten geografischen Ort – den Eingang der Mouteleng-Höhle – während eines ostersonntäglichen Sangoma-Rituals und Pilger der Zion Apostolic Church, um die historisch gewachsene Beziehung zwischen Land, Repräsentation und kultureller Identität zu zeigen. Seit *Nightfall of the Spirit* (1992–1999) hat Mofokeng sich in Fotoserien mit internationalen Landschaften beschäftigt. Mit seiner Arbeit zur Documenta11 kehrt Mofokeng zu der auf die südafrikanische Landschaft bezogenen Untersuchung zurück. Er veranlasst Betrachter, Fragen von Ethnizität, Geschichte und Geografie zu reflektieren. Trotzdem bleiben die Bilder durch Brüche und Verlustmomente, Entkontextualisierungen und Überlappungen vor eindeutigen Festlegungen bewahrt.

Starting out as a street photographer, Santu Mofokeng negotiates the charged genre of documentary photography, particularly bound to the photojournalistic practice in the context of apartheid South Africa.

Driven by his desire not to serve as an agent of "struggle" reportage, Mofokeng recorded daily township life as a gesture of resistance. His reconfiguration of the documentary was manifest in his first exhibition *Like Shifting Sand* (1990), in which he installed photographs of liberation movements in townships juxtaposed to rural landscapes. This dialogic strategy resurfaced in the show *Distorting Mirror/Townships Imagined* (1995), in which he responded to the local and international hypersaturation of imagery of South Africa during the apartheid years, by contrasting the public political imagery in print media with private portraits from family albums.

This in turn fueled his series *Black Photo Album/Look at Me* (1997). Retrieving private archive photographs of urban South African families dating from 1890 to 1950, these once forgotten portraits signaled how the self is determined, imagined, fashioned, and photographed in an era of colonial domination. Through the "mining" of photo albums and by restoring the individual identities, names, and biographies of these once anonymous portraits, Mofokeng positions his practice as an alternative to the collectivizing and dehumanizing operations of the archive and the totalizing notions of identity constructed by the concepts of "Soweto" and "townships." Mofokeng's work signals a retrieval that represents both the reclaiming of history and memory and the rewriting of the historical relationship between image, archive, and citizenship.

In *Chasing Shadows* (1997), Mofokeng shifted his attention to landscape. This work sought to negate the literal recording of apartheid referents and the typical lexicon of township living as spectacle. Photographing the Mouteleng cave portal during a Sangoma ritual ceremony—a service on Easter Sunday—and Zion Apolostic Church pilgrims, Mofokeng turned to this specific geographical locale in order to engage with a historically rooted relationship between land, representation, and cultural identity. Having since worked on series of international landscapes (*Nightfall of the Spirit, 1992–1999*), Mofokeng's work featured in Documenta11 returns to this investigation particular to the landscape of South Africa. It engages the viewer to consider questions of ethnicity, history, and territory, and yet sustains the ambiguities of the images through rifts, moments of loss, extraction, and slippage. L.F.

Onverwacht/Botshabelo, Free State, 1997
Gelatin silver print, variable dimensions I Silbergelatine-Abzug, Maße variabel

MULTIPLICITY

STEFANO BOERI, MADDALENA BREGANI, FRANCISCA
INSULZA, FRANCESCO JODICE, GIOVANNI LA VARRA,
JOHN PALMENSINO

Gegründet/Founded 2000 in Mailand/Milan, Italien/Italy.

Am 26. Dezember 1996 wurde ein unter maltesischer Flagge segelndes Fischerboot mit 283 illegalen Flüchtlingen aus Pakistan, Indien und Sri Lanka an Bord beim Umladen von seinem libanesischen Mutterschiff gerammt und versank zwischen Malta und Sizilien im Mittelmeer. Dieser Platz ist das größte mediterrane Massengrab seit dem Zweiten Weltkrieg. Der Unfall, der lange Zeit von den lokalen Behörden dementiert wurde, bildet das Leitmotiv im jüngsten kollektiven Forschungsprojekt von Multiplicity, *ID: A Journey Through a Solid Sea* (2002). Nicht länger lebendiger Tummelplatz sich vermischender Kulturen und Traditionen, ist der Mittelmeerraum zu einem Ort des illegalen Handels mit bestimmten Identitäten geworden. Die Installation *ID: A Journey Through a Solid Sea* zeigt Forschungsergebnisse und Methodologien, die mit Hilfe eines 3D-Modells die Seewege im Mittelmeer visuell veranschaulichen. Unterschiedliche Bahnen von Identität, von Touristen, Immigranten, Fischern und Seeleuten kartografieren visuell ein sich ständig veränderndes Gebiet als Folge „einer zeitlichen Verdichtung lokaler Strukturen" (Boeri).

Architekten, Geografen, Künstler, Stadtplaner, Fotografen, Soziologen, Volkswirtschaftler und Filmemacher skizzieren ein gemeinsames Europa als ein kulturelles Gebilde, ein Dispositiv, innerhalb dessen Organisation und Wandel beobachtet und auf eine allgemeine Formel gebracht werden. Weder geht es Multiplicity darum, Beziehungen zwischen der physischen und der sozioökonomischen Morphologie des europäischen Raums zu etablieren, noch betrachtet die Gruppe diesen Raum als bloßen Entwicklungsrahmen. Vielmehr verfasst sie eine Grammatik des Raumes, indem sie eine radikal neue urbane Syntax formuliert.

An *USE – Uncertain States of Europe* (2000) – Teil von Rem Koolhaas' Mutations-Projekt – sind mehr als sechzig Experten aus fünfzig Städten beteiligt. Es beschäftigt sich mit der politischen und sozioökonomischen Unsicherheit auf europäischem Territorium, festgehalten im urbanen Raum von Priština bis Paris, von Helsinki bis Porto. Angesichts eines imaginär vereinten Europas, für das sich Brüssel einsetzt, in dem aber Begriffe wie Zentrum und Peripherie, urban und suburban, öffentlich und privat längst ihre Bedeutung verloren haben, wird die völlig neue, diffuse und vereinheitlichende Art und Weise des räumlichen Wandels in Europa mit disziplinübergreifenden Termini wie „Pulsschlag, Trägheit, Verbreitung, Ablenkung, Osmose, Umleitung und Expansion" beschrieben.

Multiplicity konfrontiert die traditionellen Formen des interdisziplinären Diskurses miteinander, dringt durch die Herrschaft des Blicks zum Bereich des Sozialen vor, bereichert Felder der Architektur und Stadtplanung. Kulturell gesehen reformuliert die territoriale, ökonomische und geopolitische Identität Europas ein neues Verständnis der europäischen Stadt und ihrer Repräsentationsformen als eine kollektive Form der räumlichen Reflexion, Wahrnehmung und Erinnerung.

On December 26, 1996, a fishing boat sailing under Maltese flag with 283 Pakistani, Indian, and Cingalese clandestine refugees was rammed by its Lebanese mother ship during trans-shipping and sank in the Mediterranean Sea between Malta and Sicily. The largest Mediterranean cemetery since World War II, an accident long denied by local authorities, is the guiding narrative in Multiplicity's most recent collective research project *ID: A Journey Through a Solid Sea* (2002). No longer a vivid place of the blending of cultures and traditions, the Mediterranean territory has become solid, a place for the trafficking of fixed identities. The installation *ID: A Journey Through a Solid Sea* displays research results and methodologies visualizing Mediterranean routes of passage with the help of a 3D model of the sea. Various trajectories of identity—of tourists, immigrants, fishermen, and seamen—visually map an ever changing territory of processes as a result of "a temporal thickening of local structures" (Boeri).

Architects, geographers, artists, urban planners, photographers, sociologists, economists, and filmmakers sketch a common Europe as a cultural entity, a dispositif within which organization and change are observed and generalized. Neither establishing correlations between the physical and the socio-economic morphology of European space, nor considering it as a mere context for development, Multiplicity is a grammarian of space, formulating a radically new urban syntax.

USE—Uncertain States of Europe (2000), part of Rem Koolhaas's Mutations project, is devoted to the political and socio-economical uncertainty of European territory anchored in urban space from Priština to Paris, from Helsinki to Porto, involving a team of over 60 people in 50 cities. Europe's radically new diffuse and homogenizing mode of spatial change in the face of an imaginary unified Europe as promoted by Brussels, onto which notions of center and periphery, urban and suburban, public and private, have long lost their connotational grip, is described along transdisciplinary termini such as "pulsation, inertia, dissemination, diversion, osmosis, detournement, and expansion."

Multiplicity confronts traditional forms of interdisciplinary discourse head on, cutting through the regime of the scopic to the domain of the social, enriching fields of architecture and urban planning. Europe's territorial, economic, and geopolitical identity, read through the cultural, fundamentally reformulates a new understanding of the European city and the forms of its representation as a collective mode of a spatial reflection, perception, and memory. N. R.

A Journey Through a Solid Sea I *Eine Reise über das feste Meer,*
2002
A research-project; detail: maps I Ein Recherche-Projekt, Detail:
Landkarten

JUAN MUÑOZ

*1953 in Madrid. †2001 auf/on Ibiza, Spanien/Spain.

In Juan Muñoz' Installationen herrscht Schweigen, und doch sind Geräusche, Musik und Gespräche wichtiger Bestandteil seiner Arbeiten. Obgleich Muñoz als einer der ersten Bildhauer seiner Generation Mitte der achtziger Jahre zur Figuration zurückkehrte, sind die Ideen des Minimalismus und der Konzeptkunst in seinen Werken nach wie vor präsent.

Muñoz erzeugt ein außerordentlich räumliches Spannungsverhältnis in seinen Arrangements von bis zu 100 Statuen (*Many Times*, 1999), die jeweils nicht mehr als ein halbes menschliches Maß haben. Einzeln werden die Figuren meist mit spärlichen Requisiten gezeigt oder auf begehbaren, den geometrisch-illusionistischen Bodenmosaiken der Renaissance nachempfundenen *Floorpieces* (ab 1987) inszeniert, die manchmal den gesamten Ausstellungsraum einnehmen. Intellektueller Ausgangspunkt ist dabei die Infragestellung des Sockels durch die Minimal Art. In Gruppen arrangiert, kommen die Statuen ohne diese Plattform aus, verlagern den Umgang mit dem Sockel aber ironisch auf die Einzelfiguren. Deren Körper scheinen oft einfach im Boden zu versinken, als stünden sie knöcheltief im Wasser, oder gehen vom Rumpf an abwärts in eine Kugelform über – wie in den *Conversation Pieces* (ab 1991), den ersten Gruppeninszenierungen. Die Figuren, die befremdlich anonym bleiben und sich von den anderen ihrer Gruppe nur durch Haltung und Gestik unterscheiden, verteilen sich im Raum – sie wenden sich einander zu, lachen, begrüßen sich, schließen sich zusammen oder bleiben von einer Menge ausgeschlossen. Einige horchen an der Wand oder schauen um sich, als hätten sie gerade etwas vernommen. Sie orientieren sich an Geräuschen, die der Betrachter nicht hören kann, oder richten ihre Blicke gemeinsam auf etwas, das nicht zu sehen ist. Solch explizite Verweise auf die Grenzen der Erschließbarkeit und die Tatsache, das nicht alles gesagt werden kann, erinnern an die absurden, architektonisch orientierten Metallskulpturen aus Muñoz' vorfigurativer Phase – Balkone, die niemand betreten kann, zerstörte Wendeltreppen oder das *Minarette for Otto Kurz* (1985).

Juan Muñoz hat mit Gavin Bryars und John Berger auch Hörspiele vertont. Sein letztes Hörspiel *A Registered Patent (A Drummer Inside A Rotating Box)* (2001) basiert auf seinem Text *Optical Illusion-Producing Rotating Box (A Drummer Inside A Rotating Box)*, eine in den USA patentierte Beschreibung für einen mechanischen Apparat, der die optische Illusion eines Schlagzeugers abwechselnd erzeugen und verschwinden lassen kann. Dieses Hörspiel vertonte der Komponist Alberto Iglesias, mit dem Muñoz schon in anderen Projekten zusammengearbeitet hatte, für die Documenta11 mit dem Schauspieler John Malkovich.

Juan Muñoz's installations are silent, and yet sounds, music, and conversations are important elements of his works. Although Muñoz was one of the first sculptors of his generation to return to figuration in the mid-1980s, the ideas of artistic and musical minimalism and Conceptual Art echo in his works.

In an installation of up to 100 statues (*Many Times*, 1999), each no more than half a human in size, Muñoz creates a remarkably tense spatial relationship. Exhibited individually, the figures are often set in theatrical arrangements, with a few props or on walkable *Floorpieces* (since 1987) modeled after the geometric-illusionistic floor mosaics of the Renaissance. The intellectual base of these works, which sometimes take up the entire exhibition room, lies in the Minimal Art's questioning of the plinth. Arranged in groups, the statues do without platforms, but the question of the plinth, however, is shifted ironically to the individual figures whose bodies often seem to sink into the floor, as if they were up to their ankles in water or, as in *Conversation Pieces* (since 1991), the first group arrangements, their torsos are spherical and bulky. The figures, which remain disconcertingly anonymous and differ from each other merely in pose and gesture, are distributed throughout the room, turning to each other, laughing, greeting each other, joining one another, or they remain isolated from the group. Some are listening at the wall or looking around as if they had just heard something that is no longer visible. They are either listening to conversations and sounds that the spectator cannot hear or together directing their gazes at something that cannot be seen. Such explicit references to the limits of conclusiveness and the fact that not everything can be spoken are reminiscent of the absurd, architectonic, metal sculptures of Muñoz's prefigurative phase—the balcony no one could enter, the wrecked spiral staircase, or the *Minarette for Otto Kurz* (1985).

With Gavin Bryars and John Berger, Muñoz set radio plays to music, dealing with his passion for sleights of hand and images that are more easily heard. Juan Muñoz's last radio play, *A Registered Patent (A Drummer Inside A Rotating Box)* (2001), is based on his text *Optical Illusion-Producing Rotating Box (A Drummer Inside A Rotating Box)*, US-patented instructions for a mechanical device with which the optical illusion of a drummer can alternately be produced and made to disappear. For Documenta11, the composer Alberto Iglesias, with whom Muñoz had worked on other projects, has set this radio play to music together with the actor John Malkovich. T. M.

Many Times | *Viele Male*, 1999
Juan Muñoz' Studio | Im Atelier von Juan Muñoz, Madrid 1999

SHIRIN NESHAT

*1957 in Kaswin/Qazvin, Iran. Lebt/Lives in New York.

Mit provokativer Ambivalenz verbindet Shirin Neshat Feminismus und zeitgenössischen Islam in beziehungsreichen bildlichen Diskursen. Ihre Auseinandersetzung insbesondere mit dem iranischen Islam bezieht sich auf die sozialen, kulturellen und religiösen Kodierungen vornehmlich des weiblichen Körpers und die geschlechtsspezifische Aufteilung öffentlicher und privater Räume. Die Synthese von Faktischem und Latentem in Neshats Darstellungen kritisiert dabei sowohl die fundamentalistisch orientierten muslimischen, als auch die westlich geprägten Vorstellungen. Die Künstlerin entwickelt poetische Metaphern für die gegenseitige Bedingtheit kultureller Identitäten, die auch ihren persönlichen Dialog zwischen den Kulturen beschreiben.

Als Shirin Neshat 1990 nach 16-jähriger Abwesenheit den Iran bereiste, erlebte sie die kulturellen Veränderungen in ihrem Heimatland als derart schockierend, dass sie beschloss, ihre künstlerische Produktion, die sie nach dem Kunststudium aufgegeben hatte, wieder aufzunehmen. Unter anderem war 1983 der Schleierzwang abermals eingeführt worden. Darauf Bezug nehmend entwickelte Neshat kontrastreiche Fotoserien, die sie und andere Frauen in den Tschador gehüllt zeigen (*Women of Allah*, 1993–1997). Ihre Gesichter, Hände und Füße sind mit rebellischer Poesie iranischer Dichterinnen kalligrafisch verziert.

Seit 1996 produziert Neshat vom post-revolutionären iranischen Kino (allen voran von Abbas Kiarostami) beeinflusste Videos und Filme. Die reduzierten allegorischen Handlungen kommen ganz ohne Sprache aus und entfalten sich über eine thematisch und formal dualistisch argumentierende Erzählstruktur. Dieses Verfahren bildet sich mit *Soliloquy* (1999) deutlich heraus. Zog Neshat in ihren vorangegangenen Videoinstallationen Parallelen zwischen sozial, kulturell und religiös kodierten und kontrollierten Räumen und dem weiblichen Körper, so entsteht hier anhand von Architekturen eine Polarisierung von Tradition und Moderne. Der emotionale Zustand einer Frau zwischen beiden Welten wird für den Betrachter erfahrbar, wenn er sich im Raum einer Doppelprojektion auf meist entgegengesetzte Flächen zwischen den zwei Filmbildern entscheiden muss.

Die Arbeit *Turbulent* (1998) eröffnet eine Trilogie, die die Dynamik zwischen Männern und Frauen in islamischen Gesellschaften zum Gegenstand hat. In stark ornamentalisierten Choreografien bewegen sich große, homogene Männer- und Frauengruppen durch beeindruckend karge Landschaften. Die allegorischen Inszenierungen erhalten durch Schnittrhythmus und Soundregie geradezu monumentalen Charakter. Einer ähnlichen Filmsprache bedienen sich auch jüngere Arbeiten wie etwa *Passage* (2001), die Konzepte islamischer Tradition und Philosophie thematisieren. Gegensätze werden hier als Kontinuum betrachtet. Shirin Neshats aktuelle Arbeit inszeniert eine mythologisch und motivisch inspirierte Auseinandersetzung mit dem Konzept des Gartens.

With provocative ambivalence, Shirin Neshat combines feminism and contemporary Islam in highly associative pictorial discourses. Her handling of Iranian Islam in particular refers to the social, cultural, and religious coding of female bodies and the gender-specific division of public and private space. The synthesis of the factual and the subliminal in Neshat's depictions confronts both fundamentalist Muslim and Western ideas. The artist presents the mutual contingency of cultural identities with metaphors that poetically describe a personal dialogue between cultures.

When Shirin Neshat returned to Iran in 1990, after a 16-year absence, she was so shocked by the cultural changes that she decided to take up her own artistic production again, which she had given up after her studies. Photographic series, rich in contrasts and inspired by the compulsion to wear the veil in post-revolutionary Iran since 1983, depict Neshat herself and other women in chador (*Women of Allah,* 1993–1997). Their faces, hands and feet are covered in Persian calligraphy, with rebellious poetry by Iranian female poets.

Since 1996, Neshat has produced videos and films influenced by post-revolutionary Iranian cinema (above all that of Abbas Kiarostami). The reduced allegorical plots are entirely without dialogue and develop from a thematically and formally dualistic narration. This process is clearly developed in *Soliloquy* (1999). In her previous video installations, Neshat had already drawn parallels between socially, culturally, and religiously coded and controlled spaces and the female body, and now it is the medium of architecture that is used to present a clear polarization of tradition and modernity. By being forced to decide between the two film images projected on opposing surfaces, the viewer of Shirin Neshat's double projections is able to experience the emotional condition of a woman caught between two worlds.

Turbulent (1998) opens a trilogy that brings to the forefront the dynamics between men and women in Islamic society. In intensely ornamental choreographies, large, homogeneous groups of men and women are moved through impressively stark landscapes. The editing rhythm and the film music give these allegorical productions an almost monumental character. More recent works use a similar film language, such as *Passage* (2001), which picks out concepts of Islamic tradition and philosophy as central themes. Here binary opposites are viewed as a continuum. Shirin Neshat's current work is inspired by the mythology and motifs associated with the concept of the garden. T.M.

Soliloquy Series (Figure in Front of Steps) | Monolog-Serie (Figur vor Stufen, 1999
Gelatin silver print, framed, 61 x 73,7 cm, from the film of the same name | Silbergelatine-Abzug, gerahmt, 61 x 73,7 cm, aus dem gleichnamigen Film

GABRIEL OROZCO

*1962 in Jalapa, Veracruz, Mexiko/Mexico. Lebt/Lives in New York.

Die Formung des Raumes als dematerialisierter Stoff führt Gabriel Orozco zu ephemeren Skulpturen, die permanent neue Gestalt annehmen. Statt den skulpturalen Körper in zwei gegensätzliche Hälften zu teilen – zurückgelassene, sinnlich erfahrbare Objekte und industriell gefertigte Waren und Zeichen –, verschmilzt Orozco verschiedene Traditionen abendländischer Skulptur miteinander, indem er mit einer Fülle von unterschiedlichen Materialien arbeitet. Unter anderem nimmt er Fundstücke (*Four Bicycles – There is Always One Direction,* 1994), alltägliche Dinge (*Cats and Watermelons,* 1992; *Crazy Tourist,* 1991) oder organische Substanzen wie menschliche Schädel (*Path of Thought,* 1997), aber auch Eisstiele (*My Hand is the Memory of Space,* 1991), Ton oder Knetmasse (*My Hands Are My Heart,* 1991). Die eingesetzten Körper hinterlassen wortwörtliche, metaphorische und indexikalische Spuren, durch Orozcos Praxis entstehen darüber hinaus fließende Zonen von Aktivität, die nicht nur die Schönheit des Schaffens und Daseins in sich bergen, sondern auch den inneren Bezug zu einer kulturell kodierten Umgebung aufzeigen. Weder beherrschen seine minimalen, ephemeren und recycelten Objekte ihre Umgebung, noch werden diese von ihr beherrscht, vielmehr koexistieren sie im Raum des Museums, im White Cube einer Galerie, in der freien Natur der Berge und Strände oder im Alltag der Straße und bewahren so ihre Bedeutung als disparate Objekte. In *Yielding Stone* (1992) wird ein weicher grauer Ball aus Knetmasse eine Straße entlanggerollt und nimmt dabei die schmutzige und grobe Beschaffenheit urbaner Stofflichkeit an.

Orozcos ist fasziniert von Bewegung, verstanden als virtuelle Linien im Raum, die als Erinnerungsspuren von der Aktion und Intervention zurückbleiben; diesbezüglich sind seine bildhauerischen Arbeiten eng mit seiner Fotografie verbunden. In *Extension of Reflection* (1992) fährt der Künstler immer wieder mit dem Fahrrad durch zwei Regenpfützen und lässt so einen ephemeren, kreisförmigen Abdruck von Realität zurück.

Cage'sche Zufallsspiele und das Wechselspiel absurder, zufälliger und geplanter Bewegungsmechanismen haben Orozco dazu gebracht, sich mit Gesellschaftsspielen wie Billard (*Oval with Pendulum,* 1996), Schach (*Horses Running Endlessly,* 1995), Pingpong (*Ping Pond Table,* 1998), Bowling (*Lost Line,* 1993) und Fußball (*Pinched Ball,* 1993) zu beschäftigen. Orozco verschiebt durch die Reflexion über die Beziehung zwischen Orts- und Objektwahl räumliche Grenzen – indem er einen französischen Citroën längs in drei Teile zerschneidet und die beiden Seitenteile wieder zusammenfügt (*La DS,* 1993), die Bewegungen von ostdeutschen „Schwalben", Hybriden zwischen Roller und Motorrad, verfolgt (*Until You Find Another Yellow Schwalbe,* 1995) oder eine italienische Vespa in Zement gießt (*Habemus Vespam,* 1995).

Orozcos formaler Minimalismus lässt sich weder in die Dichotomie kritisch versus affirmativ noch in die des Phänomenologischen versus des Konzeptionellen oder die des Kulturellen versus des Natürlichen einordnen, vielmehr fallen seine stillen Skulpturen in eine Kategorie, die sich jenseits der Grenzen von Denken und Interpretation befindet.

The molding of space as dematerialized matter leads Gabriel Orozco to a transient form of sculpture that assiduously transforms and shifts its weight in new directions. Refusing to split the sculptural body into opposing halves, into residual, perceptual objects and industrially produced commodities and signs, Orozco amalgamates disparate traditions of Western sculpture by operating on an exuberant array of matter, such as found commodities (*Four Bicycles – There is Always One Direction,* 1994), common goods (*Cats and Watermelons,* 1992; *Crazy Tourist,* 1991), and organic substances—human skulls (*Path of Thought,* 1997), ice sticks (*My Hand is the Memory of Space,* 1991), clay or Plasticine (*My Hands Are My Heart,* 1991). Imprinting the body literally, metaphorically, and indexically, Orozco's practice bestows fleeting zones of activity that bear within them not only the beauty of creation and existence, but an intrinsic correspondence to a culturally coded environment. His minimal, ephemeral, and recycled objects are never dominated by nor dominate their surroundings, but rather subtly coexist with the space of the museum, the white cube of a gallery, the landscape of mountains and beaches, or the everyday realm of the street, preserving their eminence as disparate objects. In *Yielding Stone* (1992) a soft, gray Plasticine ball is rolled down a street, absorbing the greasy and hard-edged texture of the urban fabric.

Orozco is fascinated by movement, seen as virtual lines through space that bequeath mnemonic traces as indices of action and intervention, and his sculptural work is thus intimately linked to his photographic practice. In *Extension of Reflection* (1992) the artist cycles repeatedly through two puddles of rain leaving behind a multilayered, circular imprint of reality.

Cagean games of chance and the interplay of absurd, random, and planned mechanisms of movement have led to Orozco's entanglement with parlor games such as billiards (*Oval with Pendulum,* 1996), chess (*Horses Running Endlessly,* 1995), ping-pong (*Ping Pond Table,* 1998), bowling (*Lost Line,* 1993), and soccer (*Pinched Ball,* 1993). Cutting a French Citroën longways into three pieces and reassembling the two sides (*La DS,* 1993), tracking the movements of East German "Schwalbe," bikes, a hybrid between a scooter and a motorcycle (*Until You Find Another Yellow Schwalbe,* 1995), and casting an Italian Vespa in cement (*Habemus Vespam,* 1995), he displaces spatial limits by reflecting on the relationship between site selection and object choice.

Orozco's formal economy neither falls prey to the dichotomies of the critical versus the affirmative, the phenomenological versus the conceptual, nor the cultural versus the natural, as his silent sculptures lapse into that which exists beyond the boundaries of thought and interpretation. N.R.

Yielding Stone (Piedra que cede) | *Ertragreicher Stein,* 1992
Plasticine and dust, 132.2 lb. | Knetmasse und Staub, 60 kg

OLUMUYIWA OLAMIDE OSIFUYE

*1960 in Lagos, Nigeria. Lebt/Lives in Lagos.

Zuerst war die Augenoptik Osifuyes Hauptberuf. Seit 1996 ist jedoch ein fotografisches Werk entstanden, das von den harten Lebensbedingungen, aber auch den Triumphen der Menschlichkeit im heutigen Nigeria erzählt. Osifuye ist Foto-Essayist, obwohl er zunächst eher dokumentarisch zu arbeiten schien. Seine Arbeit ist narrativ, wenn auch nicht unbedingt auf geradlinige Art. Die Bilder halten die bittere Realität einer Gesellschaft fest, die seit langem unter dem Joch einer Militärdiktatur steht und zu großen Teilen materielle Not leidet, und deuten zugleich eloquent und ohne in visuelle Klischees zu verfallen auf ein stolzes und unverwüstliches Volk (Faces of Poverty, 1999).

Für die Documenta11 produzierte Osifuye ein Foto-Essay über Lagos, Nigerias verwirrendste Stadt. Als er seine Heimatstadt für dieses, wie er selbst sagt, „leidenschaftliche Porträt mit Widersprüchen und ungeheurer Komplexität" durchstreifte, hatte Osifuye mit neugierigen und argwöhnischen Blicken zu rechnen. Durch seine Ortskenntnis und sein Auftreten als Einwohner, gleichzeitig aber durch die Kamera als „Außenseiter" zu erkennen, befand er sich in einer problematischen Situation. Besonders in der Innenstadt tarnte er sich, um misstrauischen Bewohnern nicht aufzufallen, für die das Kamera-Auge staatliche Überwachung bedeutet; immerhin könnte er als Vorbote von Bulldozern und Abbruchunternehmern das Stadtviertel kartografieren. Seine visuelle Biografie von Lagos ist jedoch eher eine gespenstische Romanze zwischen dem Künstler und der geliebten Stadt – einer Stadt, die er jedes Mal neu entdeckt, wenn er sich in die ständig wachsenden Suburbs oder in das laute, grelle, pulsierende Isaleko, das Zentrum der Stadt, begibt.

In dieser Fotoserie zeigt Osifuye mit unbestechlichem Blick die unglaubliche menschliche Aktivität, das Drama des Alltagslebens auf den geschäftigen Straßen und Marktplätzen. Oft steht eine einzelne Figur im unmittelbaren Vordergrund des Bildes und erzählt von den rauen Bedingungen des Alltagslebens in Lagos. Auf einem Foto sieht man beispielsweise einen Lebensmittelverkäufer unter einem riesigen Plakat hocken, das für die neuen „ultramodernen" Vorstadthäuser und -siedlungen wirbt. Ein anderes zeigt einen Schüler, der seine Hausaufgaben auf einer Fußgängerbrücke macht, unbeeindruckt von dem wahrscheinlich ohrenbetäubenden Lärm um ihn herum. Es ist eine gigantische Stadt, deren anonymisierende Macht von der Ausstrahlung und dem Zusammenhalt ihrer Bewohner bezwungen wird, eine Stadt, die zwischen den auseinander treibenden Kräften des strukturellen Zusammenbruchs und der strukturellen Regeneration steht – zwischen verfallenden Mietshäusern und verstopften Straßen, zwischen Umweltzerstörung, Verkehrschaos, zwischen weit verbreiteter Armut und einer aufregenden, schwelgerischen Farbenpracht.

Photography superseded optometry as Osifuye's primary professional concern in 1996. Since then he has created a body of work that speaks of the trials but also of the triumph of the human spirit in contemporary Nigeria. Although he comes off as a documentary photographer, he is more of a photo-essayist, and his work is narrative but not in a straightforward way. When he seeks to record the harsh realities of a society long tethered to the battering post of military dictatorship and widespread economic hardships, his images eloquently suggest, without falling into visual clichés, a proud and resilient people (Faces of Poverty, 1999).

For Documenta11, Osifuye creates a photo-essay of Lagos, Nigeria's most enigmatic city. Producing what he calls a passionate portrait of the city, with its paradoxes, its vast complexities, Osifuye traverses his native city and must contend with prying, suspicious eyes. Being at once a Lagosian with his street savvy manners, and an "outsider"— on account of his camera—places him in a zone of difficulty. Thus he adopts stealth techniques especially in the inner city, where he avoids suspicious residents to whom the camera lens signifies the government's gaze; he could be mapping the neighborhood prior to the coming of bulldozers and demolition men. Documenting the city's visual biography comes close to an uncanny romance between the artist and the city he loves, a city he discovers anew each time he sets out to its spreading suburbs, or to rowdy, intense Isaleko, the city center.

In this series, Osifuye keeps a keen eye on the incredible human activity, the drama of daily living, in busy streets and markets. Often he frames his images with a single figure in the immediate foreground, a figure that speaks to the harsh circumstances of ordinary life in Lagos. In one instance, a food vendor sits beneath a huge poster advertising new "ultramodern" suburban homes and estates. In another a schoolboy does his homework on a footbridge oblivious of what must be deafening noise around him. Osifuye presents a vast city where human presence and contact overwhelm its anonymizing potentials. He shows a city caught between the diametric pull of structural collapse and regeneration, between crumbling tenements and congested streets, between environmental devastation, traffic chaos, widespread poverty, and a thrilling, exuberant colorfulness. C.O.

Selected Feature Photographs of Lagos: The Marina Scene / Ausgewählte charakteristische Fotografien von Lagos: Szene auf der Marina, 2002
Color photograph, variable dimensions / Farbfotografie, Maße variabel
Marina Street as seen from the Eko Bridge that hitherto was sidelined by palm trees lining the lagoon. The area with its skyscrapers now serves as offices for the corporate world. / Marina Street, von der Ekobrücke aus gesehen, die bisher entlang der Lagune mit Palmen gesäumt war. Das Viertel mit seinen Wolkenkratzern bietet jetzt Büros für die globalisierte Welt.

ULRIKE OTTINGER

*1942 in Konstanz, Deutschland/Germany. Lebt/Lives in Berlin.

Ulrike Ottinger ist eine der konsequentesten Filmemacherinnen, die aus der Bewegung Neues deutsches Kino der sechziger und siebziger Jahre hervorgegangen sind. Ihre Spielfilmarbeiten waren stets von Realismusskepsis und einem starken Misstrauen gegenüber der impliziten Frauenfeindlichkeit ihrer männlichen Kollegen geprägt. Zentraler Aspekt ihres Werkes ist eine theatralische Meditation über Identität und Differenz, insbesondere in Bezug auf Geschlecht und sexuelle Orientierung, sowie die komplexe Psychodynamik der Macht. Ottingers Arbeit über die Mechanismen des Spektakels – samt einer breiten Palette sexuell aufgeladener Inhalte – hat sie sowohl bei feministischen als auch bei schwulen Kritikern und Filmemachern beliebt gemacht. Als Zeitgenossin von Derek Jarman war ihre Arbeit „queer" im ursprünglichen Sinn: politisch, ästhetisch und sexuell in Opposition.

Die frühen Werke wie *Madame X: Eine absolute Herrscherin* (1977) „bilden ein Hybrid aus Sciencefiction, Abenteuerfilm, Dokumentarfilm und Fantasy" und lassen komplexe, nicht lineare Erzählungen entstehen. Von Ottingers Filmen heißt es oft, sie befriedigten auf eine zügellose und verbotene Art unser Bedürfnis, das Ungewöhnliche zu betrachten, indem sie das Subjekt wie auch das Objekt des fotografischen Blicks von Scham befreien. (Sarah Valdez)

In ihrem späteren fiktionalen Schaffen bringt sie mit dem Spielfilm *Freak Orlando* (1981) das Lexikon des Andersseins aus Todd Brownings surrealistischem Meisterwerk *Freaks* (1931) auf den neuesten Stand, bevor sie mit *Johanna d'Arc of Mongolia* (1989), in dem eine Gruppe europäischer Frauen von einer Horde mongolischer Kriegerinnen verschleppt wird, einen kritischen ethnografischen Blick zu entwickeln beginnt.

Seit dem Fall der Berliner Mauer hat Ottinger außerdem experimentelle Dokumentarfilme gemacht, angefangen bei *Countdown* (1990), einem Film über die deutsche Wiedervereinigung, bis zu ihrem Werk *Taiga* (1991/92), einem achteinhalbstündigen Reisetagebuch, das allein durch die Aufzeichnung von Begegnungen und ohne das Bestreben, etwas erzählen zu wollen, ihre Reisen durch die Mongolei dokumentiert. Die gleiche kritisch ethnografische Praxis kennzeichnet ihr Projekt für die Documenta11, *Südostpassage* (2002). Auch hier hält der in drei Teile gegliederte Film kulturelle Begegnungen mit der Kamera fest: eine Reise von Berlin aus durch Osteuropa sowie zwei Stadtexpeditionen, eine durch Odessa und eine durch Istanbul. Mit ihrem beeindruckenden Blick fürs Detail und ihrem Respekt vor den Menschen, denen sie begegnet – wie sie arbeiten, sich kleiden, ihr Leben leben – präsentiert Ottinger ein Porträt der Völker am Rande Europas, denen es nicht gelungen ist, vom Ende des Kalten Kriegs zu profitieren.

Sowohl für ihre Dokumentar- als auch für ihre Spielfilme recherchiert Ottinger gründlich; gelegentlich stellt sie Fotos, Skizzen und Notizbücher aus dieser Arbeitsphase aus.

Ulrike Ottinger has been one of the most enduring of filmmakers to emerge from the New German Cinema movement in the 1960s and 1970s. Her fictional work always had a strong distrust of realism and the implicit gynophobia of the male filmmakers. Central to her work is a theatrical meditation on identity and difference particularly in terms of gender and sexual orientation, as well as of the complex psychodynamics of power. Ottinger's work on the mechanics of spectacle, together with a wide range of sexually flamboyant content, has endeared her both to feminist and queer critics and filmmakers. A contemporary of Derek Jarman, her work was Queer in the original sense of being politically, aesthetically, and sexually oppositional.

Her early films, such as *Madame X: An Absolute Ruler* (1977), "hybridize science fiction, adventure, documentary and fantasy" creating complex, nonlinear narratives. Ottinger's films have been described as extravagantly and transgressively indulging our desire to look at the unusual, liberating both subject and object of the camera's gaze from shame (Sarah Valdez).

Her later fiction work updates the lexicon of otherness found in Todd Browning's surrealist *Freaks* (1931), with her film *Freak Orlando* (1981), or begins to develop a critical ethnographic gaze, with *Johanna D'Arc of Mongolia* (1989), in which a band of European women are abducted by a band of Mongolian female warriors.

Since the fall of the Berlin Wall, Ottinger has also made experimental documentaries, from *Countdown* (1990), concerning German reunification, to her more recent *Taiga* (1991/92), an eight-and-a-half-hour journal of her travels in Mongolia, presented as a record of encounters without any attempt to narrate. The same critical ethnographic practice informs her project for Documenta11, *South East Passage* (2002). Structured in three parts, the film again records cultural encounters with the camera: a journey from Berlin through Eastern Europe, and two urban expeditions, one in Odessa and one in Istanbul. With her impressive eye for detail and respect for the individuals she meets—how they work, dress, and live their lives—Ottinger presents a portrait of the peoples on the edge of Europe who have failed to benefit from the end of the Cold War.

For both documentary and fiction films, Ottinger conducts a rigorous pre-production research process, and occasionally exhibits photographs, sketches, and notebooks from this process. M.N.

Südostpassage I *South East Passage,* 2001
Film: 35mm, color, sound, 360 min. I 35-mm-Film, Farbe, Ton, 360 Min.

OUATTARA WATTS

***1957 in Abidjan, Elfenbeinküste/Côte d'Ivoire.
Lebt/Lives in New York.**

Seit Mitte der achtziger Jahre beschäftigt sich Outtara Watts mit dem Platz des Künstlers als Akteur im kosmischen Plan der Dinge. Bezeichnenderweise wurde er darauf durch die Kindheitserfahrung vorbereitet, Eingeweihter der Geheimnisse seiner einheimischen Senufo-Religion zu sein. Die Auswanderung nach Paris und später nach New York erweiterte seine Perspektiven als Suchender nach okkultem und säkularem Wissen, aber auch als Maler in einer Weise, die im wahrsten Sinne global geworden war. So schöpft seine Arbeit ebenso aus seinem spezifisch afrikanischen Erbe wie aus der europäischen Renaissance und modernen Traditionen. Er ist in jeder Hinsicht ein Maler der Welt, denn seine gelegentliche Konzentration auf spezielle, lokal begrenzte Kunstformen und Vorstellungen, ob aus Afrika, Europa oder Asien, führt ihn zu Aussagen von kosmischen Dimensionen. Seine Arbeit bewegt sich folglich jenseits von geografischen, nationalen und kulturellen Zuschreibungen. Sie bezieht sich, wie er selbst sagt, auf den Kosmos.

Watts Bilder, oft großformatig und wuchtig, verbinden vielfältige formale Kriterien; sie kombinieren Zeichengebrauch, Malerei und Skulptur auf eine Art, die an Architektur denken lässt. Die Anmutung ist nicht nur indirekt festzumachen, da er sich auch existierender architektonischer Formen aus Dogon, Bambara und Senufo bedient – es sind zum Beispiel Pyramidenformen, die oft oben über seine Gemälden hinausragen (*Masada,* 1993), Fensteröffnungen (*Dance of the Spirits,* 1993) oder lehmziegelartige, aufgescheuerte Oberflächen (*Nok Culture,* 1993). Seine Multimedia-Konstruktionen aus okkulten Zeichen und rituellen Texten sowie religiösen Symbolen und Bildern wirken wie magische, sakrale Darstellungen und imponieren durch ihre physische Präsenz. Dabei sind sie höchst formal komponiert. Der visuelle Reichtum, die komplexe Mischung aus ikonenhaften, oft kultischen Formen und populärer Bildsprache, die Kombination von plakativen Farben und expressionistischer Pinselführung spiegelt gleichsam die multikulturellen Realitäten der Welt des späten 20. Jahrhunderts (*Hip-Hop, Jazz, Makoussa,* 1995).

In seiner Arbeit zur Documenta11 setzt Watts seine Vorstöße in die Zone zwischen dem Mystischem und dem Materiellem, die Verbindungsstelle zwischen dem Lokalen und dem Globalen, fort. Er verarbeitet nun europäische und afrikanische Stoffe, Seidensiebdrucke und fotografische Motive zu Collagen. Sein Interesse am französischen Mittelalter, an Shango, dem Yoruba-Gott des Donners und Blitzes, oder an Himmelskörpern (*Sirius,* 2002) reflektieren die formalen Elemente, mit denen er seine Oberflächen strukturiert. Wenn sein Werk als „magisch" bezeichnet wird, dann muss es die brillante Manipulation der gemalten Oberfläche, die Verwendung verschiedenster Bildtechniken in den monumentalen, architektonischen Gemälden sein, die dazu veranlasst.

Since the mid 1980s, Ouattara Watts has been concerned with the place of the artist as an actor in the cosmic scheme of things. Significantly, he had been prepared for this inquiry by his childhood experience as an initiate into the secrets of his native Senufo religion. But his migration to Paris and later to New York has expanded his perspectives, as a seeker of occult and secular knowledges and as a painter, in a way that has become truly global. As such his work draws from specifically African heritages as much as from European Renaissance and modern traditions. He is a painter of the world in every sense, for his occasional focus on particular, localized art forms and ideas, whether from Africa, Europe, or Asia, leads him to statements of cosmic dimensions. His work then is beyond the geographically specific, beyond national and cultural affiliations. It refers, as he says, to the cosmos.

Watts's paintings, often large-scaled and physically dominating, combine multiple formal registers; in them signage, painting, and sculpture combine in a way that suggests the architectural. But this quality is not always circumstantial, for he has drawn from Dogon, Bambara, and Senufo architectural forms, such as the pyramidal forms often projecting atop his paintings (*Masada,* 1993), fenestral apertures (*Dance of the Spirits,* 1993), or adobe-like, abraded surfaces (*Nok Culture,* 1993). His multimedia constructions, in their incorporation of occult signs, ritual texts, and iconic symbols and images, seem like magical, sacral enactments, but they are intensely formal, imposing and sheerly material. This visual plenitude, the complex mix of iconic, even cultic forms and popular imagery, and the combination of flat color and expressionistic brushwork speaks to the multicultural realities of late 20th-century world (*Hip-Hop, Jazz, Makoussa,* 1995).

In his work for Documenta11, Watts continues his inquiries into the interzones of the mystical and the material, and the juncture between the local and global. He now engages European and African fabrics, silk-screen and photographic images, as collage elements. His interest in French medieval history, in Shango, the Yoruba god of thunder and lightning, or in celestial bodies (*Sirius,* 2002) provides formal elements with which he builds his surfaces. If the word magical still describes the work it must be a consequence of the artist's brilliant manipulation of the painted surface, his use of multiple picture-making techniques to construct monumental, architectonic paintings. C.O.

Sirius – Sigui, 2002
Mixed media on canvas | Verschiedene Materialien auf Leinwand, 274 x 305 cm

PARK FICTION

MARGIT CZENKI, GÜNTHER GREIS, DIRK MESCHER,
THOMAS ORTMANN, KLAUS PETERSEN, CHRISTOPH
SCHÄFER, SABINE STOEVESAND, AXEL WIEST

Gegründet/Founded 1994 in Hamburg,
Deutschland/Germany.

„Eines Tages werden die Wünsche die Wohnung verlassen und auf die Straße gehen … Sie werden dem Reich der Langeweile, der Verwaltung des Elends ein Ende bereiten." Das wurde das Leitmotiv einer Gruppe von KünstlerInnen und MusikerInnen, die sich 1994 einer Bürgeriniative an St. Paulis Hafenrand anschlossen, dem Rotlichtbezirk in Hamburgs ärmstem Wohnquartier. Ziel der Bürgerinitiative war es, die Bebauung der letzten Freifläche zu verhindern und stattdessen einen kollektiv zu entwerfenden Park durchzusetzen. Die Kampagne und der folgende Planungsprozess verbündeten und bereicherten in einzigartiger Weise Kunst, Subkultur und Politik. Nicht nur um eine Grünfläche ging es, sondern um die Organisation eines kollektiven Prozesses, bestimmt von den individuellen Sehnsüchten und Wünschen der AnwohnerInnen. Die „Wunschproduktion" wurde wirtschaftspolitischen Interessen der „Imagecity" (Schäfer) entgegengestellt. „Infotainment" – Vorträge, die Entstehung des Parks vorwegnehmende Aktionen, Konzerte, Raves, Open-Air-Filmvorführungen und Ausstellungen – stellte die Basis für den Planungsprozess her, indem die sozialhistorische und politische Bedeutung von Gärten und Parks sowie die Konstruktion öffentlicher Räume reflektiert wurde. Die KünstlerInnen Christoph Schäfer und Cathy Skene entwickelten verschiedene „Tools", um die Formulierung von Wünschen zu ermöglichen: Ein Wunsch-Archiv, eine Garten-Bibliothek, ein Knet-Büro, eine Wunsch-Hotline, ein Planungscontainer und ein Action-Kit (mobiler Planungskoffer) wurden eingerichtet, Fragebögen und Pläne zum Ausfüllen verteilt.

Margit Czenki stieß 1997 zur Park Fiction-Gruppe, um in einem Film die emphatische Qualität des Planungsprozesses einzufangen. Der Film zeigt die Unterschiedlichkeit der Beteiligten und lässt die Vielstimmigkeit der Wünsche sichtbar werden. Der offene Entwurfsprozess beförderte ein gemeinsames Filtern und Verschmelzen der ästhetischen und praktischen Wünsche ebenso wie deren politische Durchsetzung. Immer wieder geäußerte Wünsche – z.B. einen Brunnen zu bauen – wurden mit Einzelentwürfen, etwa dem „SeeräuberInnen-Brunnen", in Verbindung gebracht. Die Frage, ob es „Erdbeerbaumhaus, in das Erwachsene nicht hinein dürfen", geben solle, wurde allgemein bejaht.

Die Bebauung der Freifläche konnte verhindert werden. Das Projekt von Park Fiction befindet sich nach acht Jahren radikal demokratischer Planung mitten in der Verwirklichung. Es ist damit ein einmaliges Beispiel konzeptueller Kunst, in dem die Trennung des privaten und des öffentlichen Raumes überwunden und die unterschiedlichen Interessen füreinander fruchtbar gemacht werden konnten. „Der Park ist ein utopischer Ort, sein Vorbild ist das Paradies … Der Park verspricht, was die Welt sein könnte." (Filmzitat)

"Someday, wishes will leave the house and hit the streets…. They'll put an end to the reign of boredom and bureaucratically managed misery." This was the leitmotif for a group of artists and musicians who joined a citizens' initiative in 1994 in the harbor area of St. Pauli, the red-light district in Hamburg and one of the city's poorest quarters. Their goal was to stop plans for construction on the last remaining open space and to have the city build a collectively designed park instead. The campaign and the planning process that followed brought together and enriched art, subculture, and politics in unique ways. It was not just about open space, but about organizing a collective process guided by the individual wishes and desires of the quarter's inhabitants. This "wish production" resisted the dominant interests of economic policy propagated by "the ImageCity" (Schäfer). "Infotainment" (lectures, actions, concerts, raves, open-air movie screenings, and exhibitions) formed the basis for the planning process, reflecting the social, historical, and political importance of gardens and parks and the construction of public spaces. In order to make it possible for people to articulate their wishes, artists Christoph Schäfer and Cathy Skene developed various tools for the initiative: a wish archive, a garden library, a clay modeling office, a wish hotline, a planning container, and an action kit (mobile planning briefcase). The artists also distributed questionnaires and plans for the public to fill out.

Margit Czenki joined the Park Fiction group in 1997 to capture on film the energetic spirit of the planning process. The film shows the wide variety of wishes as well as the project's different participants. The open planning process allowed participants to filter and combine aesthetic and practical desires with political achievement. Frequently mentioned wishes, such as a fountain, were matched with individual plans, resulting in the "Pirate Fountain," for example, while everyone agreed to the wish for a "strawberry tree house where grown-ups aren't allowed."

The planned construction was stopped. After eight years of radical democratic urban planning and negotiations, Park Fiction is now being realized. It is a unique example of a combination of Conceptual Art and collective subjectivity, navigating between private and public space and various cultural fields: a project in which differing interests were able to benefit each other. "The park is a utopian place; its model is paradise…. The park shows us what the world could be like" (film quote). C.M.

Park Fiction Planungscontainer | Park Fiction planning container, Hamburg, 1998

MANFRED PERNICE

*1963 in Hildesheim, Deutschland/Germany. Lebt/Lives in Berlin.

Seit Anfang der neunziger Jahre arbeitet Manfred Pernice an seinem offenen skulpturalen Vokabular, das sich auf die moderne Verpackungs- und Transportindustrie und ihre Architektur bezieht. Ein Hauptmodul Pernices ist die „Dose", die als Behälter unbestimmten Inhaltes das am weitesten verbreitete Grundelement der modernen Verpackungsindustrie darstellt. Pernice beschreibt die Prinzipien – die Segmentierung und Mobilisierung von Gütern und Räumen ebenso wie die zunehmende Diskrepanz zwischen Inhalt und Verpackung – metaphorisch als „Verdosung der Welt". Damit meint er auch die oft einfallslose Architektur moderner Bürogebäude, Shoppingmalls und Verwaltungszentren.

Anhand von Zeichnungen und kleinen Papp- und Holzmodellen, die als dreidimensionale Skizzen fungieren, aber auch eigenen Objektcharakter besitzen, entwickelt Pernice seine Skulpturen und Installationen, die in ihrer Formensprache oft an Litfaßsäulen oder Frachtcontainer erinnern und aus einfachen Materialien wie Press-Span, rohen Holzlatten und Pappe gefertigt sind. Oft nehmen einzelne Elemente und die Titel der Arbeiten Bezug auf spezifische Orte oder Situationen, ohne mit ihnen in einem unmittelbar referenziellen Verhältnis zu stehen. Sein monumentales Werk *Großdose* (1998), ein fast fünf Meter hoher Turm aus geschichtetem Press-Span, ist nicht nur ein Kommentar zu Vladimir Tatlins Entwurf des *Monuments für die 3. Internationale* aus den zwanziger Jahren, sondern korrespondiert in seiner Größe mit dem Ausstellungsort, an dem es zuerst gezeigt wurde: dem ehemaligen Atelier des Naziarchitekten Albert Speer. Die Arbeit *FIAT* (1997/98), die Pernice in unterschiedlichen Ausstellungszusammenhängen zeigte, wurde für jeden einzelnen Anlass umgearbeitet und erweitert und reflektierte so die jeweiligen Bedingungen der Ausstellungen. Die Arbeit *Sardinien* (1996) besteht aus einer Kombination von halb offenen, kubischen und abgerundeten Modulen aus rohem, nur vereinzelt bemaltem Sperrholz, die aussehen, als seien sie eine Mischung aus Wohnwagen und Fischbüchse. Ein Foto, das die Titel gebende italienische Insel zeigt, klebt an der Außenwand der Arbeit. In jüngerer Zeit verwendet Pernice häufiger solche zusätzlichen Hinweise: Für die Arbeit *Klagenfurt u.A.* (1999) hängte er Blätter mit Gedichten Ingeborg Bachmanns an die umliegenden Wände, oder er präsentiert Zeitungsausschnitte, Skizzen und Schnappschüsse als Material der Recherche und Planung einer Arbeit mit dieser gemeinsam und verwendet Fotos anderer Künstler.

Estrel: Quattro Stagioni (Estrel: Vier Jahreszeiten), Pernices Arbeit für die Documenta11, folgt dem Prinzip dieser offenen, assoziativen Referenz. Der Titel beruft sich auf ein Berliner Konferenzhotel. Pernice lässt aber bewusst im Unklaren, auf welche Weise die collagierte Konstruktion der vier ineinander gestellten Körper, aus denen die Skulptur besteht, mit dem Hotel in Verbindung steht.

Since the beginning of the 1990s, Manfred Pernice has been working on his open sculptural vocabulary, which is marked by modern packaging, transport tools, and architectural references. One of Pernice's primary modules is the "can," a container representing the undefined content of the most widespread basic element of the modern packaging industry. Pernice metaphorically describes the increasing segmentation, organization, packaging, and mobilization of goods and spaces as "canning the world," often including in his description the unimaginative modern mass architecture of office buildings, shopping malls, and government centers.

To develop his sculptures and installations, Pernice first makes drawings and small cardboard and wooden models, which function as three-dimensional sketches, yet also have their own objecthood. The sculptures themselves have shapes that often recall advertising pillars, shipping containers, and temporary buildings, and are made of simple materials such as particle board, raw wooden slats, and cardboard. Individual elements and titles of works often refer to specific places or situations, without, however, having any direct relationship to the reference. His monumental work, *Großdose* (Large Can, 1998), is a tower almost five meters high made of skeleton-like, layered particle board. It is not only a commentary on Vladimir Tatlin's 1920s design for the *Monument for the Third International,* but its size consciously placed it in a dialog with the site where it was first shown: Nazi architect Albert Speer's former studio. *FIAT* (1997/98) is a work that Pernice has shown several times in various contexts, reworking and expanding to reflect the new conditions each time it is shown. *Sardinien* (Sardinia, 1996) consists of a combination of half-open, cubic, and rounded modules made of raw, sporadically painted plywood, which seems to be part trailer, part sardine can. A photograph, showing the Italian island after which the work is named, is glued onto the outside wall. More recently, Pernice has used these kinds of hints—such as when he hung sheets of paper with poems by Ingeborg Bachmann on the walls of the work *Klagenfurt u.A.* (Klagenfurt et al., 1999), when newspaper clips, sketches, and snapshots, representing the research and planning of a work, are shown along with the work itself, or when Pernice presents photographs of other artists in his works.

Estrel: Quattro Stagioni (Estrel: Four Seasons), Pernice's work for Documenta11, follows the principle of the open, associative reference. The title of the work is taken from a conference hotel in Berlin. But Pernice deliberately fails to explain how the sculpture, consisting of four open, collage-like constructions placed inside of each other, is connected to the hotel. C.R.

Großdose I Large Can, 1998
Installation view I Installationsansicht, Kunsthalle Zürich, Zürich, 2000

RAYMOND PETTIBON

*1957 in Tucson, AZ, USA. Lebt/Lives in Hermosa Beach, CA, USA.

Seit den späten siebziger Jahren verfolgt Raymond Pettibon eine Strategie radikaler Umkehrungen: Er kombiniert und überlagert den Bereich visueller Repräsentation mit dem der Sprache. Vorwiegend mit Feder, Stift oder als Aquarell- und Kreidekombinationen entstehen Bilder, in die er als integralen Bestandteil Textzitate einarbeitet. Indem Pettibon gleichzeitig mit bildhafter Repräsentation und narrativen Formen arbeitet, destabilisiert er beides und schafft so ein neues Medium, einen flüchtigen und multiplen Kommunikationsmodus, in dem Produzent und Konsument, Autor und Leser sich ständig in einem Status der Rekonstitution befinden.

Den Gegensatz von Zeichnung und Text verstärkt Pettibon, wenn er Ikonografien und Formen der Massenkultur mit einer prämodernen Ästhetik kombiniert. Von seinen ersten politischen Cartoon-Serien in der Studentenzeitung der Universität von Los Angeles (1975–1977) über die mit *Captive Chains* (1978) einsetzende Serie von Zeitschriftenprojekten bis hin zu seinem jüngsten Buchprojekt (*Plots Laid Thick*, 2002) hat Pettibon stets eine Bildsprache kultiviert, die sich der Techniken und Strukturen von Cartoons, Comicstrips und dem Kino bedient und oft unverhohlen eine Abneigung gegen den Begriff der Kunstfertigkeit zeigt. Der Künstler benutzte den subkulturellen Wildwuchs der modernen Gesellschaft und entwickelte ein festes Repertoire politisch und sozioökonomisch marginalisierter, ausgefallener oder abnormaler Charaktere, welche die allgemeine Misere des Lebens in den fortgeschrittenen kapitalistischen Industriegesellschaften repräsentieren. Dass Pettibon seinen Schwerpunkt auf die Figuration legt, in populistischen Formen wie Karikatur und Illustration bemerkenswerte zeichnerische Virtuosität beweist und sich unter anderem auf Literatur von William Blake, John Ruskin, Henry James, Marcel Proust und James Joyce bezieht, verbindet sein Werk jedoch zugleich mit den Kommunikationsmodi, die der modernen Massenkultur vorangingen.

Seine chaotische Kombination von Vergangenem und Gegenwärtigem entsteht, indem Pettibon Alltagssprache mit literarischen Zitaten, Subkultur mit Hochkultur, Massenproduktion mit handwerklicher Arbeit und Dilettantismus mit Virtuosität kontrastiert. Darüber hinaus überhöht er die Arbeit durch ihre labyrinthische Präsentationsweise: Hunderte unterschiedlich große Zeichnungen werden über eine ganze Wand verteilt und fügen sich so zu einer Installation, deren Bedeutung über die jedes einzelnen Textes bzw. Einzelbildes hinausgeht. Die „lyrische Qualität" – wie er es gern formuliert – des aus diesem Mahlstrom neu entstehenden Mediums beinhaltet eine kritische Dimension: Pettibon konstruiert einen Ort des Widerstands gegen kapitalistische Macht- und Überwachungsstrukturen und ihre Tendenzen zur Vereinfachung, indem er eine Form schafft, die nie völlig stabil ist, sondern offen für grenzenlose Erfahrungen, Identitäten und Äußerungen bleibt.

Since the late 1970's, Raymond Pettibon has been pursuing a strategy of radical reversals by combining and collapsing the field of visual representation with that of language. Working primarily in pen and ink, graphite, or a combination of watercolor and crayon, Pettibon produces drawings that are inseparable from the textual citations inscribed within them. This engagement with both iconic representation and narrative form destabilizes both fields to create a new medium, a fugitive and multiple mode of communication in which the producer and consumer, author and reader are in a constant state of reconstitution and flux.

This juxtaposition of drawing and text is intensified by the combination of mass cultural forms and iconography with a premodernist aesthetic. From his earliest work as a political cartoonist for the UCLA student newspaper (1975–1977), through the series of zine projects begun with *Captive Chains* (1978), to his most recent book project (*Plots Laid Thick*, 2002) Pettibon has cultivated imagery that draws upon the techniques and structures of cartoons, comic strips, and cinema and often displays unabashed antipathy to notions of skill. By "mining" the subcultural wastelands of contemporary society, Pettibon has also developed a regular cast of politically and socio-economically disenfranchised, dysfunctional, and deviant characters that represent the shared malaise of life in conditions of advanced industrial capitalism. At the same time, however, Pettibon's emphasis on figuration, his demonstration of remarkable graphic virtuosity in populist forms such as caricature and illustration, and his reliance on the literary works of such authors as William Blake, John Ruskin, Henry James, Marcel Proust, and James Joyce links his work to communicative modes that precede mass cultural modernity.

The chaotic combination of past and present, achieved by juxtaposing everyday language with literary references, subculture and high culture, mass production and artisan fabrication, deskilling and virtuosity, is heightened by Pettibon's labyrinthine mode of display. Pettibon presents hundreds of variously sized drawings placed next to or on top of each other on an entire wall, constructing a single installation that exceeds the identity of any individual text or image. The newly constituted medium that emerges from this maelstrom is one whose "lyrical quality," a term he uses repeatedly, has a critical dimension. Pettibon constructs a site of resistance to capitalist systems of power and control and their homogenizing tendencies by producing a form that never becomes fully stable but remains open to infinite experiences, identities and utterances. N. B.

Installation view I Installationsansicht Regen Projects, Los Angeles, 2000

ADRIAN PIPER

*1948 in New York. Lebt auf/Lives in Cape Cod, MA, USA.

Seit den späten sechziger Jahren versucht die politisch und sozial engagierte Künstlerin Adrian Piper, tätlichem Rassismus, Sexismus und Xenophie mit einer Ästhetik der Erfahrung zu begegnen. Zu ihren performativen Strategien in der Öffentlichkeit zählen Mimikry, Maskerade und direkte Konfrontation. Mit eben jenen Erscheinungsformen von Rassismus und Sexismus konspirierend, die sie angreift, durchlebt Piper Vorurteile und Stereotypen, um auf der anderen Seite – oder auf der Seite der Anderen – anzukommen. In *My Calling (Card) Number One: A Reactive Guerilla Performance for Dinners and Cocktail Parties* (1986–1999) reagiert die Künstlerin – sich selbst als Schwarze identifizierend, ohne schwarz auszusehen – auf rassistische Bemerkungen in ihrer Gegenwart, indem sie an die Täter Visitenkarten verteilt, auf denen zu lesen ist: „Hallo, ich bin schwarz und Sie haben mich beleidigt." Pipers künstlerische Vision ist eine angstfreie Gesellschaft ohne unterschwelligen rassistischen Hass, in der die vorherrschende Einstellung zu anderen Kulturen oder Ethnien nicht Toleranz, sondern Akzeptanz ist.

Verwurzelt in der minimalistischen Phänomenologie der sechziger Jahre und der Konzeptkunst, vollzog Piper eine Wende weg von der Linguistik hin zu den Schriften von Immanuel Kant, zu Moraltheorie, indischer Philosophie und Yoga. Ihre Konzeption des Selbst vermag sie dabei mit großer Flexibilität und in verschiedenen Medien auszudrücken: Sie verwendet Tonaufnahmen, Videos, Zeichnungen, Foto-Text-Collagen, Installationen, Filme, Künstlerbücher, choreografiert Performances und benutzt öffentliche Verteilungssysteme wie Tageszeitungen.

Pipers Interesse gilt nicht den institutionellen, sondern den interpersonellen Manifestationen eines mehr instinktiven Rassismus. So wird das unmittelbare Hier und Jetzt – der soziale Raum der „indexikalen Gegenwart" (Piper) – in Arbeiten wie *Funk Lessons* (1982/83) aktiviert, in der Funk, kulturelles Idiom der schwarzen Arbeiterklasse, einem weißen Publikum nahegebracht wird. Rassen- und geschlechtsspezifische Stereotypen sind für die Künstlerin erst dann zerstört, wenn sie miteinander konfrontiert und neu besetzt werden – wie in den Straßenperformances und Zeichnungen der Serie *Mythic Being* (1973–1975). Für diese Arbeit begab sich die Künstlerin, mit Afro-Perücke, Schnurrbart und einer großen, dunklen Sonnenbrille als junger Schwarzer verkleidet, in das Kulturleben von New York und befreite auf diese Weise katalytisch ihr Geschlecht. Die Zeichnungen sind tagebuchartig, sie präsentieren Zeilen ihres persönlichen Tagebuchs als Mantras, die, endlos wiederholt und immer wieder neu erfahren, zu öffentlichem Gemeinbesitz werden können.

Eine ihrer jüngsten Arbeiten, die Serie *The Color Wheel* (2000–2002), erhellt die Dialektik zwischen dem Persönlichen und dem Politischen durch Selbsterkenntnis – zu der die Künstlerin durch die Meditation der Vedanta (der Philosophie des Hinduismus) gelangt –, indem sie das wahre Ich unter den Schichten der Illusion freizulegen sucht, welche die Sinnesorgane vermitteln.

Adrian Piper has been a political and social activist since the late 1960s, constantly in search of antidotes to ignorant actions of racism, sexism, and xenophobia through an aesthetics of experience. Her performative strategies are those of public mimicry, masquerade, and direct confrontation. Conspiring with the very manifestations of racism and sexism she aspires to rebuke, Piper goes through prejudice and stereotypes in order to come out at the other side, or, on the side of the other. In *My Calling (Card) Number One: A Reactive Guerilla Performance for Dinners and Cocktail Parties* (1986–1999), the artist, identifying herself as black without appearing black, reacts to racist remarks in her presence by handing out business cards to offenders stating: "You know, I am black and you are insulting me." Piper's artistic vision is a society without subliminal racist hatreds and fears in which the prevailing attitude to cultural and ethnic others is one not of tolerance but of acceptance.

Rooted in Minimalist phenomenology of the 1960s and in Conceptual Art, Piper took a turn away from the linguistic towards the writings of Immanuel Kant, moral theory, Indian philosophy and yoga, expressing her conception of the self with great flexibility and a wide range of available media including audio and video, drawing, performance, photo-text collages, installation, film, artist's books, choreography, and public distribution systems such as newspapers.

Looking for interpersonal manifestations of instinctive racism rather than institutional ones, the immediate here-and-now—the social space of the "indexical present" (Piper)—is activated in works such as *Funk Lessons* (1982/83), where Funk, the idiom of black working-class culture, is lectured on and taught to a white audience. For Piper racial and sexual stereotypes are not demolished until they have been confronted and re-inhabited, as in the street performances and drawings of the *Mythic Being* series (1973–1975). The artist cross-dresses as a young black male with an Afro wig, a moustache and large black sunglasses, invading New York cultural life and thereby catalytically liberating her gender. The drawings make a more diaristic use of the *Mythic Being* persona, featuring lines from her personal journal as mantras that, if repeated and re-experienced over and over again, might fuse into public space as common property.

One of her most recent works, *The Color Wheel* series (2000–2002), furthers the dialectic between the personal and the political by stripping away the layers of sensory illusion—under which the true self can be found—through self-knowledge grounded in meditation of the Vedanta, the foundational philosophy of Hinduism. N. R.

The Mythic Being: I Embody Everything You Most Hate and Fear I
Das mythische Wesen. Ich verkörpere all das, was Sie am meisten hassen und fürchten, 1995
Poster I Plakat, 61 x 91,5 cm

LISL PONGER

*1947 in Nürnberg/Nuremberg, Deutschland/Germany.
Lebt/lives in Wien/Vienna, Österreich/Austria.

Die Frage nach dem Zustand von Orten und deren territorialer Besetzung auch durch die Kamera, nach dem Erwerb von Bildern, der Funktion fotografischer und filmischer Repräsentation sowie nach der Darstellung kultureller Werte sind Themen, um die das fotografische und filmische Werk von Lisl Ponger kreist. Lässt man einige Titel ihrer Filme Revue passieren – Space Equals Time: Far Freaking Out (1979), Container-contained (1985), Sound of Space (1986), Substantial Shadow (1987), Train of Recollection (1988), Semiotic Ghost (1990), Passagen (1996) –, so wird deutlich, dass im Zentrum von Pongers Werk die Verortung von Flüchtigem im Raum, die Verknüpfungen zwischen Raum und Zeit sowie die Frage nach der Erinnerung und ihren Zeichen steht. Eigene und fremde Welten graben ihre Spuren in ein abendländisches Gedächtnis ein und bilden bei Ponger eine imaginäre Karte des zwanzigsten Jahrhunderts – von den dokumentarischen Fotoaufnahmen aus dem Umfeld des Wiener Aktionismus um 1970 in ihrem Buch Doppleranarchie – Wien 1967–1972 (1990), über die Bücher Fremdes Wien (1993) und Xenographische Ansichten (1995), die sich mit den Orten und der Darstellung des Anderen innerhalb einer europäischen Kultur auseinander setzen, bis hin zu ihrem jüngsten Film Déjà vu (1999), mit dem Ponger einen Beitrag zum postkolonialen, rassismuskritischen Diskurs formuliert.

Die Vorzeichen, die noch Filme wie Semiotic Ghosts prägen, oder das „Found footage"-Material wie zuletzt in Déjà-vu wandeln sich in Pongers jüngster Fotoarbeit, die auf der Documenta11 zu sehen ist, in aufgezeichnete Spuren von tatsächlichen Ereignissen. Im August 2001 reist Lisl Ponger nach Beendigung des G8 Gipfels nach Genua, um die VolxTheaterKarawane, eine AktivistInnen-Gruppe, die nach Ende des Gipfels an der Ausreise aus Italien gehindert und zeitweilig festgenommen wurde, zu unterstützen. Vor dem Hintergrund einer ganzen Anzahl an Dokumentarfilmen und (Theater-) Performances, die die Ereignisse während des Gipfels thematisierten und dokumentierten, zeichnet sich Pongers Fotoserie Sommer in Italien (Genua, August 2001) durch eine bemerkenswerte Zurückhaltung aus. Ponger zeigt nicht die offensichtliche Gewalt der Polizei, das Trauma der Globalisierungsgegner und die Verwüstungen in der Stadt durch beide Seiten im Moment ihres Geschehens, sondern spürt vielmehr das Danach auf, die latenten Spuren, die den Orten selbst lange nach den Ereignissen noch eingeschrieben sind. Diese Spuren sind unterschiedlicher Natur, wo sich deutlich artikulierendes Graffiti bis hin zu verplombten Kanaldeckeln. Die Aufnahmen von verlassenen Plätzen, dem unabhängigen Medienzentrum und zentralen Gebäuden wie dem Palazzo Ducale öffnen die Grenze zu privaten Schnappschüssen. Pongers Fotografien erzählen dennoch umso mehr von dem Abwesenden und zeitlich Verrückten. Für Ponger existiert „weder ein hermetisches Gedächtnis noch eine feststehende Unschuld der Bilder" (Buchschwenter). So zeichnen sich ihre Arbeiten gerade durch die Thematisierung des nicht mehr Vorhandenen aus, das auf ein schon Abwesendes verweist. Es ist latenter Bestandteil eines jeden ihrer Bilder, zugleich liegt darin die besondere politische Haltung ihrer Arbeiten.

Lisl Ponger's photographic and cinematic work investigates the circumstances of places and their territorial occupation by the camera, the acquisition of images, the function of photographic and cinematic representation, and the presentation of cultural values. Her film titles—Space Equals Time: Far Freaking Out (1979), Container-contained (1985), Sound of Space (1986), Substantial Shadow (1987), Train of Recollection (1988), Semiotic Ghost (1990), Passagen (Passages, 1996)—clearly indicate the heart of her work in locating the transient in space, making connections between space and time, and addressing the question of memory and its symbols. Familiar and exotic worlds engrave their traces into Western memory and create an imaginary map of the 20th century—from the documentary photographs of Vienna Actionism of 1970 in her book Doppleranarchie – Wien 1967–1972 (Double Anarchy – Vienna 1967–1972, 1990), to the books Fremdes Wien (Foreign Vienna, 1993) and Xenographische Ansichten (Xenographic Views, 1995), which examine the locations and the representation of the Other within European culture, up to her most recent film Déjà vu (1999), with which Ponger contributes to the postcolonial, antirascist discourse.

In Ponger's most recent photographic work on show at Documenta11, the portents that continued to shape films like Semiotic Ghosts, or the "found footage material," as in Déjà-vu, now become recorded traces of actual occurrences. After the G8 summit in August 2001, Lisl Ponger traveled to Genoa in support of the VolxTheaterKarawane, an activist group that was prevented from leaving Italy and was arrested for a short period of time. Compared to a number of other documentaries and (theater) performances that addressed and documented the events during the summit, Ponger's photo series Sommer in Italien (Summer in Italy, Genoa, August 2001) is remarkably restrained. Ponger does not depict the blatant violence of the police, the trauma of the globalization opponents, or the devastation of the city by both sides during the course of events. Rather, she seeks out the aftermath, the latent vestiges that remain registered in the locations, even long after the events. These vestiges are diverse in nature—from well-articulated graffiti to sealed drain covers. Ponger's pictures of deserted squares, the independent media center and central buildings, such as the Palazzo Ducale, begin to look like snapshots from a private vacation. And yet Ponger's photographs all the more strongly tell the stories of those who are absent, and they indicate temporal displacement. For Ponger there is "neither a hermetic memory nor a definite innocence of images" (Buchschwenter). Her works are characterized by that which is no longer present, which refers to that which is already absent. This is a latent component of each of her photographs and at the same time the particular political stance of her works. H.A.

Indymedia Center, August 2001
C-print I C-Print, 40 x 30 cm

PERE PORTABELLA

*1927 in Figueras, Spanien/Spain. Lebt/Lives in Barcelona, Spanien/Spain.

Um die historische Relevanz Pere Portabellas zu verstehen, muss sein Werk als Resultat der Verbindung von künstlerischer Avantgarde, filmischer Umsetzung und politischem Engagement begriffen werden. Er arbeitet „in synchrony" mit der internationalen Sprache der zeitgenössischen Avantgarde und ist doch, „in profundity", mit seinem eigenen kulturellen, politischen und historischen Kontext tief verwurzelt.

Die Filme von Carlos Saura und Marco Ferreri, die Portabella Ende der fünfziger Jahre produzierte, markierten den Einbruch einer neuen Art von kritischem Realismus in den spanischen Nachkriegsfilm, in dem europäische Neorealismen unter Bezug auf die Tradition des spanischen ästhetischen und literarischen Realismus verarbeitet wurden. Aus dem italienischen Exil zurückgekehrt – wohin er sich geflüchtet hatte, um dem Zorn des Francoregimes nach dem skandalträchtigen Erfolg von Buñuels *Viridiana* in Cannes (den er 1961 koproduzierte) zu entgehen – begann er wieder zu filmen. *No contéis con los dedos/No compteu amb el dits* (Zähl nicht mit den Fingern, 1967) und *Nocturno 29* (1968) standen unter dem Zeichen der Erneuerung des spanischen Kinos jener Zeit. Sie verbinden die Filmsprache, die in der ganzen Welt durch das Neue Kino eingeführt wurde, mit der Tradition des politischen Engagements in der spanischen Kunst, Literatur und dem Film der Avantgarde, die unter Franco ausgelöscht wurde.

Der Film *Caudecuc-Vampir* (1970) ist als unabhängiger, illegaler Film in der schwierigen Situation der letzten Jahre der Diktatur entstanden. Er steht am Beginn einer der produktivsten und wichtigsten Perioden des spanischen Films, aus der Portabella prominent herausragt. *Umbracle* (1971/72) ist ohne Zweifel ein Opus magnum: Durch die genaue Reflektion über die filmische Sprache entsteht eine Analyse der politischen Bedingungen der Diktatur. Zur selben Zeit schloss sich Portabella der Grup de Treball an, die in Katalonien auf einzigartige Weise die konzeptuelle Sprach- und Institutionskritik repräsentiert. Portabellas kreatives Engagement in verschiedenen Film- und Kunstinstitutionen ist untrennbar mit der Politik der radikalen Opposition gegen Franco verbunden. Sein Film *Informe General* (1975) ist eine Zusammenfassung dieser Jahre: Er zeichnet ein Bild des heterogenen Spektrums der Alternativen nach Francos Tod in seinen gesellschaftlichen Erwartungen und Widersprüchen.

„Mit dem aristotelischen Erzählkanon zu brechen, die Anekdote zu verschmähen, direkt auf den Punkt zu kommen" (Portabella), die Mechanismen des Sehens und des Naturalismus zu untergraben, der bürgerlichen Lebensweise und ihren entfremdeten Formen sozialer Identität etwas entgegenzusetzen, das sind einige der Aspekte, die dieses Kino charakterisieren, das in seinen Bildern so antiidealistisch und eigenartig materialistisch ist. Es bringt uns „zur Geschichte zurück" – über Portabellas *Puente de Varsovia* (Warschauer Brücke, 1989), der notwendige und kraftvolle Film eines unbeugsamen Filmemachers, der dem Vergessen und der Nostalgie widersteht.

To understand the historical relevance of Pere Portabella, his work must be conceived of as the result of a cross between artistic avant-garde, film practice, and political activity. It operates in synchrony with contemporary avant-garde languages and, in profundity, is deeply rooted in its own cultural, political, and historical context.

The films by Carlos Saura and Marco Ferreri which Portabella produced at the end of the 1950s, marked the irruption of a new kind of critical realism on the scene of Spanish post-civil war cinema, where European neo-realist trends were reworked through the tradition of Spanish aesthetics and literary realism. When he reappeared as a filmmaker after a brief exile in Italy to flee the ire of the Franco regime at the scandalous success of Buñuel's *Viridiana* (1961, which he co-produced) at Cannes, he did so as a protagonist of the modernization of the Spanish cinema of the period. *No contéis con los dedos/No compteu amb els dits* (Don't Count with your Fingers, 1967) and *Nocturno 29* (1968) take up with the cinematic languages that the New Cinemas introduced throughout the world, connecting them with the tradition of political commitment in Spanish avant-garde film, art, and literature that was wiped out by Franco's regime.

The hardship of the last years of the dictatorship places *Cuadecuc-Vampir* (1970) in the field of independent, clandestine cinema and marks the start, with Portabella as a prominent figure, of one of the tensest, most notable periods of Spanish cinema. *Umbracle* (1971/72) is indisputably an opus magnum: an analysis of the political conditions of the dictatorship articulated through a rigorous reflection on cinematographic language. At the same time, Portabella took part in the collective Grup de Treball, unique representative in Catalonia of the radical trends in conceptualism and institutional critique. Portabella's work within the fields of Spanish art and film is impossible to dissociate from the politics of radical oppositional anti-Franco movements. His film *Informe general* (1975) is the colophon to this period: a picture of the heterogeneous spectrum of alternatives after Franco's death, which incarnates its own contemporary social expectations and contradictions.

"Breaking with the Aristotelian narrative canon, rejecting the anecdote, going straight to the point," undermining the mechanisms of visuality and naturalism, and contradicting the bourgeois lifestyle and its alienated forms of social identity are a few of the aspects that characterize a strongly antiidealist and peculiarly materialist film practice, which finally takes us "back to history," via Portabella's return to cinema with *Puente de Varsovia* (Warsaw Bridge, 1989), a just and vigorous film by a perseverant filmmaker, which contradicts both amnesia and nostalgia. M.E.

Cuadecuc-Vampir, 1970
Film: 35mm, color, sound, 75 min. I 35mm-Film, Farbe, Ton, 75 Min.

RAQS MEDIA COLLECTIVE
MONICA NARULA, JEEBESH BAGCHI,
SHUDDHABRATA SENGUPTA

Gegründet/Founded 1991 in Neu-Delhi/New Delhi.

Ein Hauptanliegen der multimedialen Aktivitäten des experimentierfreudigen Medienkollektivs aus Delhi besteht darin, alternative Strategien des Produzierens und Verbreitens von Information mit Hilfe des World Wide Web und freier Software zu entwickeln. Das neueste Projekt des Raqs Media Collective, *28°28' N / 77°15' E :: 2001–2002 (An Installation on the Co-ordinates of Everyday Life in Delhi)* thematisiert gemeinschaftliche Formen des täglichen Lebens im städtischen Raum sowie das Entstehen und Niederreißen neuer wie alter Gebiete. *Co-ordinates Delhi* ist im Internet zugänglich und lädt ein, sowohl das Programm als auch die fotografische Bildsymbolik und öffentliche Zeichensetzung wie Slogans, Videos und Geräusche des kosmopolitischen Delhi – das ein urbanes, von ökologischem, sozialem und politischem Missbrauch charakterisiertes Gebilde repräsentiert – aktiv mitzugestalten. Mit freier Software ermöglicht Raqs den Usern, ganz nach Belieben Material von seiner Website herunter zu laden, zu benutzen, zu kopieren, zu verteilen, zu verändern und neues Material hinzuzufügen. Raqs fördert ein Modell von Produktion und (Re-)Kreation, das nach dem Prinzip des „copyleft" funktioniert – wer immer eine Software zur Verfügung stellt, muss mit ihr auch die Rechte zum weiteren Kopieren und Verändern freigeben. Da eines der Probleme so genannter alternativer Medien im unvermeidlichen Konflikt zwischen kommerziellem Erfolg und intellektueller Unabhängigkeit liegt, verlegt Raqs die Frage, wie Demokratie innerhalb dieser Beschränkungen zu praktizieren sei, in den Bereich eines „digital commons". Neue Eigentumsregeln im digitalen Raum bedingen auch andere Regulierungsnormen, die den Zugang zu Information und Kommunikation zu einem demokratischen, von der Konsumkultur unabhängigen Grundrecht machen.

Raqs zeigt auf, dass unregulierte Kommunikations- und Informationsmärkte letztlich die Informationsfreiheit einschränken, da durch sie Monopole und Marktzutrittsbarrieren entstehen und Wissen zu einem Konsumgut wird. Raqs umgeht die starre Dichotomie von Widerstand und Einverständnis, freiem Markt und staatlicher Lenkung, und postuliert stattdessen improvisierte, provisorische Lebensmuster, die sich an den Normen des Alltags in einer „gated city" wie New Delhi orientieren – einer Stadt, die von Imperativen der öffentlichen Ordnung, Verdächtigung, Instabilität und künstlicher Migration der Bevölkerung geprägt ist, zurückzuführen auf ein systematisches Regime der Überwachung und Identitätsüberprüfung.

Primäres Ziel von *Co-ordinates Delhi* ist es, eine Situation zu simulieren, die die Bedingungen der Angst und Furcht, aber auch die positiven Seiten des heutigen Stadtlebens aus subjektiver Sicht erfahrbar macht. *Co-ordinates Delhi* ermöglicht jedem Besucher, seine eigene „Besprechung" zu schaffen – eine Version der Realität, die weder Klon ist noch Kopie noch Original. Es ist der Versuch, eine andere Art von Gemeinschaft heraufzubeschwören, die sich auf Willens- und Entscheidungsfreiheit gründet.

A key feature of the inquisitive multimedia activities of Delhi-based Raqs Media Collective is to implement alternative strategies for the production and the distribution of information via free software and the World Wide Web. Interpreting the city and urban experience, their most recent project *28°28' N / 77°15' E :: 2001-2002 (An Installation on the Co-ordinates of Everyday Life in Delhi)* is devoted to common forms of inhabiting urban space, the making and unmaking of new and old territories. *Co-ordinates Delhi* is available on the Internet, inviting active modification of both the program and the public signage, slogans, videos, photographic imagery, and sounds of cosmopolitan Delhi that represent an urban fabric demarcated by forms of ecological, social and political abuse. By utilizing free software, Raqs gives the user complete freedom to study, run, copy, distribute, change, and add materials to their website free of charge. They further a model of production and (re)creation that follows the rule of "copyleft"—anyone who redistributes the software must also pass along the rights to further copy and change. Since one of the limitations of so-called alternative media in liberal democracies is the inescapable conflict between commercial success and intellectual independence, the question of how to practice democracy within these restraints is shifted into the realm of a "digital commons." New proprietorial rules in digital space set new regulatory standards by which access to information and communication becomes a fundamental democratic right disentangled from commodity culture.

Raqs exposes the fact that unregulated communication markets actually restrict freedom of communication by creating monopolies, setting up entry barriers, and turning knowledge into a commodity. They circumvent the stable binary of resistance and affirmation, of free market and state control, in favor of contingent and provisional patterns of living that now constitute daily life in a "gated city" such as New Delhi, a city controlled by imperatives of civic order, suspicion, instability, and affected migration caused by regimes of surveillance and identification.

The primary goal of *Co-ordinates Delhi* is to simulate an experiential situation of anxiety, fear, and the pleasures of a contemporary urban condition from a subjective point of view. Allowing each visitor to create his own "recension"—a version of reality that is neither clone, nor copy, nor original—it attempts to evoke a different type of community based on free will and choice. N.R.

Homestead interior transformed into public wall in the aftermath of demolition I Der Innenraum eines Eigenheims wird nach dem Abriss zu einer öffentlichen Wand

ALEJANDRA RIERA
WITH DOINA PETRESCU

Alejandra Riera: *1965 in Buenos Aires. Lebt/Lives in Paris. Doina Petrescu: *1960 in Ramnicu Valcea, Rumänien/Romania. Lebt/Lives in Sheffield, England and Paris.

Alejandra Riera untersucht in ihrer semiologisch orientierten Praxis Sprache als das Medium, das sich selbst verzwungenermaßen als Metamedium präsentiert, das alle vergangenen und zukünftigen Medien enthält. Sie widerlegt die Annahme, Schreiben könne für andere Medien sprechen oder Kunst als Text gelesen werden. *Un problème non résolu: Leyla Zana – Hiam Abbass – la photographe – ..., < 1995> – ...* (An Unresolved Problem: Leyla Zana – Hiam Abbass – the photographer – ..., < 1995> – ...), eine programmatisch unvollendete transkulturelle Foto-, Video- und Buchinstallation, beschäftigt sich mit Fragen von Freiheit und Demokratie innerhalb einer Politik der Repräsentation. Riera entwickelt stringent ein eigenes Archiv medialer Metaphorik, ebenso sorgfältig bearbeitet und eigenhändig produziert wie ihr Video, das in Interviews das Leben von Leyla Zana (*Turkey and Turkish Kurdistan: Leyla Zana – Leyla Umar*, 1992/93) und Hiam Abbass (*Speaking About Roles*, 2000) porträtiert. Zana wurde 1991 als erste Kurdin ins türkische Parlament gewählt und im März 1994 wegen angeblich subversiver und verräterischer Aktivitäten – z.B. einer Rede auf Kurdisch im türkischen Parlament – zu 15 Jahren Gefängnishaft verurteilt. Abbass ist eine in Paris lebende palästinensische Schauspielerin und verkörpert vor allem Rollen von Widerstandskämpferinnen wie Zana.

Auch *Un Unresolved Problem* verknüpft eine breit gespannte Palette fotografischer Bildsprache aus Politik, Philosophie, Kunst und Architektur mit umfassenden Untertiteln, um Ordnungen der Signifikation gleichzeitig zu konstruieren und zu dekonstruieren. Die dekontextualisierten Bilder unterlaufen den damit einhergehenden Prozess des Einfassens und des Ausschneidens in der Repräsentation durch die Künstlerin. Riera dosiert spielerisch den Entzug von und das Versorgen mit Information und insistiert dabei auf die stark dialogische Beziehung Bild und Text.

Auch *Un film non réalisable – (projet pour)* (Ein nicht machbarer Film – Projekt für, 2002), ein Film über die Bedingungen des kurdischen Alltagslebens, der in Zusammenarbeit mit der Architektin, Philosophin und Feministin Doina Petrescu entstand, versucht sich einmal mehr den Beschränkungen der Repräsentation zu entziehen, indem Riera ein Element von Zeit in die Form des Ausstellens selbst einbringt. Anstatt eine Ausstellung in einer Ausstellungen zu bauen, wird *Un film non réalisable* den eigenen Mechanismen von Konstruktion ausgesetzt. Riera untersucht darin Wissen als Mittel von Produktion gesellschaftlicher Kommunikation und Widerstand, das über Grenzen hinweg Unterschiede verdeutlichen kann. Die „Untersuchung" verlagert sich hier in Richtung einer Praxis des „cross over" der Politik der Repräsentation und der Politik von Territorien, verpackt in eine poetische Politik des Raumes. Sie wirft die Frage auf, inwiefern aktiv durch Repräsentation in soziopolitische Kontexte eingegriffen werden kann.

Language, as the medium always forced to present itself as a metamedium, containing all past and future media, is explored in Alejandra Riera's semiological practice, since this refutes the assumption that writing can speak for other media, or in other words, that art can be read as text. *An Unresolved Problem: Leyla Zana – Hiam Abbass – ... the photographer* (since 1995), a programmatically unfinished transcultural photo, video, and book installation, addresses essentially protracted questions of freedom and democracy as they are caught up in a politics of representation. Riera stringently constructs her own private archive of media imagery, diligently researched and self-made as in the case of her hand-held video interviews portraying the lives of Leyla Zana (*Turkey and Turkish Kurdistan: Leyla Zana - Leyla Umar*, 1992–1993) and Hiam Abbass (*Speaking About Roles*, 2000). Zana, the first Kurdish woman to be elected to the Turkish parliament in 1991, was sentenced to 15 years in an Ankara prison in March 1994 for "subversive and disloyal activities," such as making a speech in the Kurdish language. Abbass is a Palestinian actress living in Paris, who is preferably cast to play female resistance fighters such as Zana.

An *Unresolved Problem* ties together a wide range of photographic imagery from politics, philosophy, art, and architecture, with extended captions, attempting to simultaneously construct and deconstruct elaborate orders of signification. Those images, mostly taken from books, magazines, newspapers, from television and the movies—already once devalued through decontextualization—undergo additional processes of framing and cropping in their representation by the artist. Riera playfully doses the withdrawal and the making available of information, insisting on the powerful dialogical relationship between image and text.

Un film non réalisable – (projet pour) (A Unmakable Film—Project For, 2002), a film on the conditions of Kurdish everyday life made in association with architect, philosopher and feminist Doina Petrescu, is a collaborative effort to escape the confines of representation once again by introducing a processual element into the form of display itself. Here, knowledge as a mode of production, as a mode of social communication and resistance, is fully explored in its capacity of setting differences across boundaries. "Research" has shifted even more in the direction of an activist practice, as a crossover of the politics of representation and the politics of territories, wrapped into a poetical politics of space, raising the question of how to interfere actively into sociopolitical contexts by the means of representation. N.R.

Partial view from *travail-en-cours* (work in progress): "An unresolved problem, Leyla Zana – Hiam Abass - ... – the photographer, <1995 – ...>" | Teilansicht von *travail-en-cours* (in Arbeit): „Ein ungelöstes Problem, Leyla Zana – Hiam Abass – ... – die Fotografin, <1995 – ...>"
Installation view | Installationsansicht, Kunst-Werke, Berlin, 2000–2001

DIETER ROTH

*1930 in Hannover/Hanover, Deutschland/Germany.
†1998 Basel/Basle, Schweiz/Switzerland.

Dieter Roth war Maler, Grafiker, Aktionskünstler, Dichter, Objekte- und Filmemacher. Er lebte in der Schweiz, Dänemark, Island, Deutschland und Amerika, wo er vielfach mit Fluxuskünstlern zusammenarbeitete.

Seine *boks* (1956–1966) sind Musterbücher, in denen er vorhandene Zeichenvokabulare variiert und ephemere Massenmedien wie Zeitungen oder Comic-Hefte konserviert. Seine *Ideograme* (1959) weisen auf die Nähe zur konkreten Poesie. 1967 publizierte er das *Mundunculum. Ein tentatives Logico-Poeticum, dargestellt wie Plan und Programm oder Traum zu einem provisorischen Mytherbarium für Visionspflanzen*. Hier versucht Roth die Darstellung der Welt durch Stempelzeichnungen. Roth maß Büchern als Medium und als Objekt einen hohen Stellenwert bei – so gab er seit 1971 seine gesammelten Werke in zweimal zwanzig Bänden heraus.

Mit der Verarbeitung von Lebensmitteln in seinem Werk thematisierte Roth die organischen Prozesse von Wachstum und Zerstörung: Es entstanden die *Literaturwürste* (1967), Grafiken mit Schokolade (*Rakete*, 1968) und Mayonnaise (*Big Cloud*, 1971), *Selbstbildnisse aus Schokolade* (1969) und Schimmelobjekte (*Wurstbrunnen*, 1971). Der Prozess der Zersetzung und des Verfalls verweist auf die Vergänglichkeit und Nichtigkeit der Dinge, erhält jedoch immer auch eine grafische Ästhetik.

Seine *Große Tischruine* beschreibt Roth als 1970 zufällig begonnenes, bescheidenes Relikt seiner künstlerischen Arbeit. Da auf seinem Arbeitstisch in Stuttgart einige Werkzeuge durch Farbe fixiert worden waren, klebte er auch die anderen darauf befindlichen Gegenstände fest, darunter einige Kassettenrekorder. Sie dienten als Aufnahmegeräte für die Geräusche seiner Arbeit. Neue Möbel, Flaschen und Werkzeuge wurden nach und nach hinzugefügt, über die Jahre wurde die Arbeit immer größer und umfangreicher. Dieses Wachstum und Wuchern spiegelte den Schöpfungsprozess bei Roth und begleitete seinen gesamten Lebensweg bis zu seinem Tod.

Auf der Biennale in Venedig 1982 gestaltete Roth den Schweizer Pavillon mit seinem Filmwerk *Ein Tagebuch*, einer Installation aus dreißig Filmprojektoren mit Super-8-Filmen, die auf der Documenta11 in der erweiterten Form gezeigt wird. Die Filme, die alle zeitgleich vorgeführt werden, zeigen Szenen aus dem Leben des Künstlers. „Ich wollte mit den Filmen hier mein täglich stattfindendes Gelebe zeigen … Also gab es nichts Mutiges zu tun und dann (im Film) zu zeigen, sondern höchstens, die Umwege um mutig gelebte Ereignisse herum. Z. B. mutig wäre, schlecht aufgenommene Filme deutlich, vereinzelt, vorzuführen; aus Angst vor solcher Bloßstellung will ich 30 Filme dieser Sorte auf einmal zeigen – ein Flimmern vorführen, welches blendet und von der Armut des einzelnen Filmes ablenkt."

Dieter Roth was a painter, graphic and event artist, poet, object and filmmaker. He lived in Switzerland, Denmark, Iceland, Germany, and America, where he worked many times with Fluxus artists.

His *boks* (1956–1966) are scrapbooks, in which he varies a previously set vocabulary of forms or preserves ephemeral mass media such as newspapers or comic books. His *Ideograme* (Ideograms, 1959) display a closeness to concrete poetry. In 1967, he published the *Mundunculum. Ein tentatives Logico-Poeticum, dargestellt wie Plan und Programm oder Traum zu einem provisorischen Mytherbarium für Visionspflanzen* (Mundunculum. A tentative Logico-Poeticum, presented as a plan and program or dream of a provisional mytherbarium for vision plants). Here, Roth attempts to portray the world using rubber stamps to make drawings. The high value Roth placed on books as both medium and object is shown by the fact that he published his collected works, in two sets of twenty volumes each, beginning in 1971.

Working with food, Roth followed the organic processes of growth and decay in *Literaturwürste* (Literature Sausages, 1967), graphic prints made of chocolate (*Rakete*, Rocket, 1968) and mayonnaise (*Big Cloud*, 1971), self-portraits made of chocolate (1969), and moldy objects (*Wurstbrunnen*, Sausage Fountain, 1971). Deterioration always had a graphic aesthetic, and processes of waste and decay refer to the temporality and insignificance of things.

Roth describes his *Große Tischruine* (Large Table Ruin) as a modest relict of his œuvre, begun by chance in 1970. A few tools were stuck in paint on his worktable in Stuttgart, so he attached the other objects that were on the table, too, including some tape recorders, which were then used to record the noise of his work. New furniture, bottles, and tools were gradually added, and over the years the work became larger and more expansive. This wild growth of ordinary, used objects mirrored the artist's creative process throughout his life, and right up to his death..

Roth designed the Swiss pavilion for the 1982 Biennial in Venice, using his films from *Ein Tagebuch* (A Diary), an installation of what then consisted of thirty film projectors and super 8 films. This will be shown in expanded form at Documenta11. The films, all shown simultaneously, depict autobiographical scenes from the artist's life. "I wanted to show my daily life in the films here.... So I didn't have to do anything courageous, which would then be shown in (the film), but at the most, show the detours that lead around courageously lived events. For instance, it would be courageous to make a point of showing badly made films individually; but because I'm afraid of this kind of exposure, I will show 30 films of this kind at once—a flickering, which dazzles and distracts from the poverty of each individual film."
A.N.

Große Tischruine l *Large Table Ruin*, 1970–1998
Mixed media l Verschiedene Materialien, 12 x 6 m
Installation view l Installationsansicht, Sammlung Hauser & Wirth,
St. Gallen, 2001

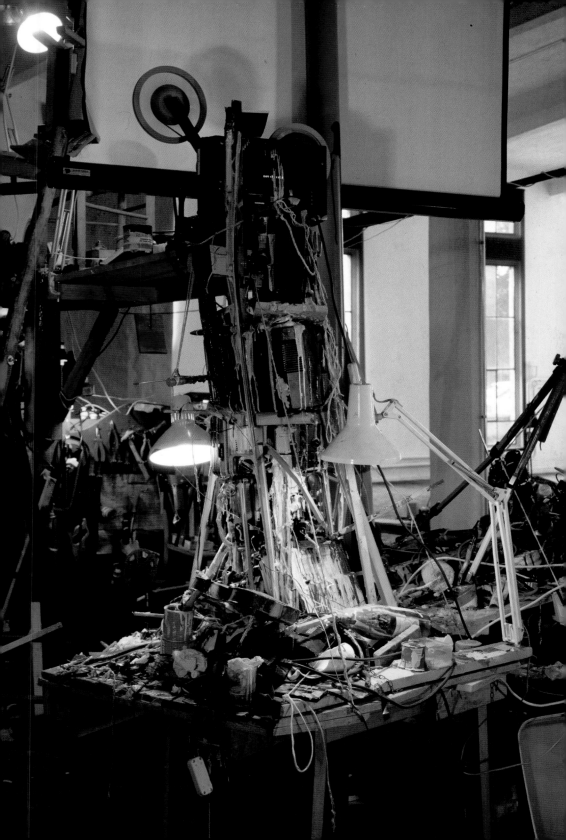

DORIS SALCEDO

***1958 in Bogotá. Lebt/Lives in Bogotá.**

Doris Salcedo untersucht in ihrer Arbeit die Veränderungen der Bildhauerei in der Nachkriegszeit und wendet dabei eine Reihe von bildhauerischen Verfahren an, die geeignet sind, die Aufhebung der Subjektivität durch Verlust- und Trauererfahrungen auszudrücken. Im Gesamtzusammenhang von Salcedos Werk dient der äußerst überlegte Umgang mit den verwendeten Materialien sowohl als rhetorisches wie als expressives Mittel. Teile von alten Möbeln, abgetragene Schuhe, Stoffreste und Knochenfragmente, die eine wuchtige Truhe überziehen oder in die Rückenlehne eines Stuhls eingearbeitet sind, sind was sie sind, und gleichzeitig mehr als das: Sie sind Zeichen einer schmerzvollen, dem Vergessen überantworteten Erinnerung.

Salcedo wurde in Kolumbien geboren, einem Land, das seit Jahrzehnten durch die nicht endenden Nachbeben des Bürgerkriegs zerrissen wird und unter der modernen Realität leidet, die vor allem durch die Produktion von Drogen und durch den Handel mit Drogen gekennzeichnet ist. Salcedo verliert nie den Kontext aus den Augen, aus dem ihre Arbeit hervorgeht. Deshalb behandelt sie den Ausstellungsraum auch nie als neutralen Boden. Für Salcedo ist die Kunst ein ethisch bestimmtes Territorium, auf dem die Erinnerungen einer Gesellschaft an Gewalt und die schrecklichsten Formen der Entfremdung ausgespielt werden können. Dennoch richtet sie in ihrer Arbeit das Augenmerk immer auch auf Material und Form, bemüht, deren expressiven Inhalt durch verschiedene bildhauerische Verfahren zu artikulieren. Sie gestaltet ihre Arbeiten um das, was aus der psychoanalytischen Theorie bekannt ist als die psychischen Mechanismen, die Träume organisieren: Verdichtung und Verschiebung.

Ausgangspunkt der Arbeiten, die Salcedo auf der Documenta11 zeigt, ist wie schon in einigen ihrer anderen Werke die jüngste Geschichte Kolumbiens. 1985 wurde der Justizpalast in Bogotá von einer Guerilla-Gruppe besetzt. Die Regierung behauptete, eine friedliche Lösung sei nicht möglich, und beschloss, das Gebäude und seine Insassen unter Beschuss zu nehmen. Die Aktion endete in einer schrecklichen Tragödie. Das Ereignis berührte eine ganze Nation in ihrem Innersten und machte deren Bürger zu unfreiwilligen Zeugen eines unvorstellbaren Verbrechens. Salcedos Arbeit für die Documenta11 beschwört das fragile, schwer zu definierende Wissen der Zeugenschaft herauf.

In Doris Salcedo's work, an investigation of the vicissitudes of postwar sculpture is combined with an attempt to set a series of sculptural procedures in motion capable of expressing the reversals of a subjectivity fundamentally defined by the experience of loss and mourning. Within the larger context of Salcedo's work, the extreme care taken with the work's materiality functions as both a rhetorical and an expressive tool. Bits of old furniture, pathetic used shoes, remnants of clothes and bone fragments encrusted in an imposing chest or buried in the backrest of a chair are both what they are and more than what they are: the mark of a memory so painful it is condemned to be forgotten.

Salcedo was born in Colombia, a country torn for decades by the never-ending afterschocks of a civil war, and disfigured by the more modern realities of the production and traffic of drugs. Right from the outset, the utter fidelity of Salcedo's work to the context from which it springs has kept her from considering the exhibition space as neutral ground. For Salcedo, the territory of art is a fundamentally ethical space where the social memory of violence and the most perverse forms of alienation are played out. Nevertheless, the work does not neglect material and form: Salcedo has always endeavored to articulate the expressive content of her work through a series of sculptural processes. She structures her work around what psychoanalysis sees as the mechanisms that organize dreams: condensation and displacement.

The point of departure for the works Salcedo is showing at Documenta11—as in several of her other works—is Colombia's recent history. In 1985, the Bogota Palace of Justice was occupied by a guerilla group. The government claimed that it was impossible to reach a peaceful agreement, and decided to bomb the building and its occupants. The action resulted in terrible tragedy. The event affected the imagination of an entire nation, turning its citizens into involuntary witnesses to an unimaginable crime. Salcedo's work for Documenta11 evokes the fragile and improbable knowledge of the witness. C.B.

Unland: The Orpahn's Tunic | *Unland: Die Tunika der Waise,* 1997
Detail: Wood, cloth, and hair | Detail: Holz, Stoff und Haar,
80 x 245 x 98 cm

SEIFOLLAH SAMADIAN

***1954 in Orumieh, Iran. Lebt/Lives in Teheran/Tehran.**

Seifollah Samadian ist ein international bekannter Fotojournalist und einer der aktivsten Dokumentarfotografen und Kameramänner im postrevolutionären Iran. Zuletzt arbeitete er mit Abbas Kiarostami an dessen Film *ABC Africa* (2001) über Hilfsnetzwerke für Menschen mit AIDS in Uganda, bei dem Samadian für Bildschnitt und Kamera verantwortlich war. Seine Fotografien haben viele Auszeichnungen erhalten, unter anderem den World Press Photo Preis 1991. Als Herausgeber des Magazins *Tasswir* (Bild) hat Samadian einen Großteil der sozialen und politischen Ereignisse in Iran seit der Revolution im Jahre 1979 begleitet. Die Revolution bekämpfte die Moderne, so dass viele Künstler und Filmemacher im Iran in Schwierigkeiten gerieten, sich mit den neuen Zuständen zu arrangieren. Dokumentarfotografen und -filmemacher hatten es hingegen leichter, über das veränderte politische und soziale Klima zu berichten.

Samadians jüngere Videoarbeiten sind intime, persönliche Filme. *Tehran, Sa'at-e 25* (Teheran in der 25. Stunde, 1999) beginnt in Samadians Wohnung, in der eine Gruppe junger Männer am Fernseher die Qualifizierung des Iran für die Fußballweltmeisterschaft 1998 verfolgt. Danach verlässt die Kamera die Wohnung und dokumentiert den Freudenausbruch im Stadion und in den Straßen Teherans, wo die siegreiche Mannschaft willkommen geheißen wird. Wie in seinen Dokumentarfotos ist Samadian auch hier daran interessiert, Gesten einzufangen, die gleichsam einen Gegendiskurs zur von der religiösen Ideologie erzwungenen öffentlichen Haltung konstituieren – in diesem Fall sind dies die Rufe und wilden Gesten der Frauen, die ihrer Mannschaft vor der Kamera zujubeln, während ganz Teheran stillsteht und jedes Auto zu einer feierlichen Bühne wird. Samadians sorgfältig entwickelter filmischer Blick befähigt ihn, im Stil des Cinema Verité zu improvisieren, während die Handlung vor seinen Augen abläuft.

Sein Film *The White Station* (1999), der auf der Documenta11 gezeigt wird, ist ebenfalls von seiner Wohnung in einem Teheraner Hochhaus aus aufgenommen. *The White Station* ist ein poetisches filmisches Haiku, in dessen Zentrum eine einzelne Frau in schwarzem Tschador in einem plötzlichen, unerwarteten Schneesturm in Teheran steht. Ihre dunkle Silhouette hebt sich ab vom weißen Hintergrund, während sie im Schneetreiben an einer Bushaltestelle wartend mit einem dunklen Regenschirm kämpft. Wie bei *Tehran, Sa'at-e 25* nutzt Samadian nur direkten Ton, und der Film kommt ohne Dialog aus. Die Schreie der Krähen und die Geräusche des Windes werden von dem durch den Schnee gedämpften Stadtlärm untermalt. Der Film ist vor allem ein stilles Zeugnis der postrevolutionären Veränderungen, die zu Lasten der Frauen gehen.

Seifollah Samadian is an internationally renowned photojournalist, and one of the most active documentary photographers and film cameramen in post-revolutionary Iran. He recently collaborated as cinematographer and editor on Abbas Kiarostami's *ABC Africa* (2001), about the Ugandan support network for people with AIDS, and has had many award exhibitions of his photographs including the 1991 World Press Photo prize. As the Editor of *Tasswir* (Image) magazine, Samadian has covered most of the social and political events in Iran since the 1979 revolution. The revolution confronted modernism head on, and many artists and filmmakers had difficulties adjusting. Documentary photographers and filmmakers were better placed to witness the new political and social climate.

Samadian's recent video works are intimate first person films. *Tehran, Sa'at-e 25* (Tehran, the 25th Hour, 1999) begins in his apartment where a group of men are watching Iran qualify for the 1998 soccer World Cup. The camera then exits the apartment to witness the eruption of joy in the streets and the stadium of Tehran, welcoming the victorious home team. As in his documentary photographs, Samadian is interested in capturing those gestures that constitute a counter discourse against that usually constrained by religious ideology—here women shout and gesture support for the team to the camera, as the whole of Tehran appears gridlocked and each car becomes its own stage of celebration. Samadian's experienced filmmaker's eye enables him to improvise a verité shooting style as the material develops in front of him.

His film *The White Station* (1999), which is featured in Documenta11, is shot from his high-rise apartment building in Tehran. *The White Station* is a more austere poetic statement, a filmic haiku which focuses on a lone woman in black chador in an unprecedented snowstorm that covers Tehran. Her dark silhouette stands out against the white background, as she wrestles with a dark umbrella in the driving snow while she is waiting for the bus. There is no dialogue and, as with *Tehran, Sa'at-e 25,* Samadian uses direct sound. Here sounds of crows and the wind are counterpointed by city noises muffled in the snow. The film is a silent witness to the post-revolutionary changes, of which women bore the brunt. M. N.

The White Station I *Die weiße Station,* 1999
Film: 35mm, color, sound (no dialog), 9 min. I 35-mm-Film, Farbe, Ton (ohne Dialog), 9 Min.

GILLES SAUSSIER

*1965 in Carrières sur Seine, Frankreich/France.
Lebt/Lives in Paris.

Nach seiner Tätigkeit als Fotograf für Gamma Press Images hat sich Gilles Saussier 1994 auf eine stärker konzeptuelle Form der Fotografie – zwischen Dokumentarfotografie und visuelle Anthropologie – konzentriert.

In den Jahren 1995 und 1996 lebte Saussier in Dhaka, Bangladesch, um an dem Projekt *Living in the Fringe* zu arbeiten – einem Werkkomplex von Landschaftsporträts Bangladeschs, der 1997 das erste Mal ausgestellt wurde. Saussiers Absicht war es, die Bewohner der Fluss- und Deltainseln zu zeigen und dabei die Traditionen der Fotoreportage zu problematisieren, indem er die traditionellen Genres der Fotografie überschritt; so wollte er den Fallen des ethnologisch-dokumentarischen Blicks entgehen. *Shakara Bazaar* (begonnen 1996) ist ein fortlaufendes Ausstellungsprojekt in den Straßen von Alt-Dhaka, bei dem die Fotografien Saussiers an die Bewohner verteilt werden; es stellt den Versuch dar, eine neue Form der Verbreitung und Ausstellung von Fotografien zu finden.

Saussier, dessen Arbeit durch die Porträtfotografie von Walker Evans, Dorothea Lange und August Sander, die Stadtaufnahmen von Brassaï, Boiffard und Doisneau und schließlich die Filme von Jean Renoir, Robert Bresson und Maurice Pialat beeinflusst ist, erklärt: „Ich verflechte verschiedene Dokumentarprojekte miteinander, halte sie für eine Neuinterpretation offen ... und versuche auf diese Weise, eine alternative und allegorische Geschichte zu erzählen, die um rhetorische Schlüsselfiguren organisiert ist: die Brücke als Symbol der Verbindung und gleichzeitig des Kolonialismus ...; die Insel als ein Ort der Besiedlung, an dem soziale Beziehungen neu erfunden werden können; die bevölkerte historische Straße (Shakari-Bazaar) als Gegensatz zu der entvölkerten historischen Prachtstraße (Champs-Elysées)."

In der Serie *Retour au Pays* (Zurück zur Landschaft, 1999) präsentiert Saussier eine poetische Meditation über die Landschaft des in der Nähe von Paris gelegenen Epte-Tales, die an die Tradition der Landschaftsmaler in Frankreich erinnert. Es werden mit dem Land verbundene Menschen porträtiert, wie Jäger, Bauern, Fischer und Gärtner. Diese Fotografien bezeichnet Saussier als „Panoramaporträts bei geschlossenen Augen". Er unterbricht die Porträtierten bei ihren gewöhnlichen Tätigkeiten, lässt „sie innehalten und ihre Augen schließen, um von der Landschaft, die sie umgibt, zu träumen", in der Absicht, ein Gesamtbild von den Menschen und ihrer Umgebung zu schaffen.

Zu seinem Umgang mit dem Erbe der Dokumentarfotografie erklärt Saussier: „Was mich vor allem an der Dokumentarfotografie interessiert, ist die Idee, soziale und kulturelle Formen einem (in gewissem Sinne demokratischen) gebräuchlichen Porträtverfahren zu unterziehen ... und eine topografische Gemeinsamkeit herzustellen. Von dort aus können ein Dialog und gesellschaftliche Veränderungen in Gang gesetzt werden."

Having worked as a news photographer for Gamma Press Images, Gilles Saussier shifted his practice in 1994 towards a more conceptual approach to photography, complicating and intersecting the genres of documentary photography and visual anthropology.

From 1995 to 1996, Saussier resided in Dhaka, Bangladesh, to focus on the project *Living in the Fringe*—a corpus of portrait landscapes of Bangladesh, exhibited first in 1997. With this project, Saussier intended to make visible the people of the riverine and delta islands while resignifying and rendering problematic the tradition of photographic reportage, intersecting and collapsing traditional genres of photography, thereby negating the trappings of the ethnographic-documentary lens. *Shakari Bazaar* (since 1996) is an ongoing project as a street exhibit in Old Dhaka, where Saussier's photographs are distributed to local inhabitants, in an effort to reconfigure the dissemination and exhibition of photographs.

Saussier is influenced by the portraiture of Walker Evans, Dorothea Lange, August Sander, the cityscapes of Brassaï, Boiffard, and Doisneau, and the cinematography of Jean Renoir, Robert Bresson, and Maurice Pialat. He says of his work: "By interweaving different documentary projects at the same time, by keeping them open to reinterpretation ... I try to build an alternative and allegorical history organized around key rhetorical figures: the bridge as a symbol of junction, but at the same time of colonialism ...; the island as a place of settlement where social relation might be reinvented; the popular historical street (Shakari bazaar) as opposed to the depopulated historical main road (Champs-Elysées)."

In the series *Retour au Pays* (Return to the Countryside, 1999), Saussier presents a poetic mediation on images of the suburban countryside of the Epte valley, outside of Paris. These works are reminiscent of the tradition of landscape painters in France, and they also recall people bound to the landscape—hunters, farmers, fishermen, gardeners. These subjects are photographed in what Saussier terms "closed eyes panoramic portraits." The artist interrupts the habitual activities of his sitters, asking them "to stop where they stand and to close their eyes to dream about the surrounding landscape," in order to provide an integral view of subjects in their surroundings.

In negotiating the charged legacy of documentary photography, Saussier maintains: "The main interest I see in documentary photography is the idea of submitting to a common portrait procedure (in a sense democratic), with social and cultural types ... providing a ... topographic common ground. That new ground can initiate dialogue and social change." L.F.

Vallée de l'Epte, Amenucourt, le Mauvérand, chasseur dans le marais | Epte valley, Amenucourt, Le Mauvérand, Hunter in the Swamp | Eptetal, Amenucourt, Le Mauvérand, Jäger im Sumpf, 1999
C-print mounted on aluminum | C-Print auf Aluminium, 242 x 90 cm

ALLAN SEKULA

***1951 in Erie, PA, USA. Lebt/Lives in Los Angeles, CA, USA.**

Allan Sekula beschäftigt sich mit dem historischen Konflikt, dem sich das Medium Fotografie seit seiner Entstehung ausgesetzt sieht: zwischen der Fotografie als Dokument sozialer Realitäten und als ästhetisch autonomes, künstlerisches Medium. Sekula geht es um die Erneuerung des „kritischen Realismus", er bedient sich der Aussage- und Wirkungsmacht sozial engagierter und kritischer Fotografie, ohne der naiven Vorstellung von der Dokumentarfotografie als „wahrem Bild" anheim zu fallen. Konzeptuelle Ordnungs- und Präsentationsmodelle begleiten seit Anfang der siebziger Jahre seine fotografische Produktion ebenso wie eine umfassende Textproduktion zu den historischen Problemen (dokumentarischer) Fotografie.

Die Arbeit *Untitled Slide Sequence* (1972) dokumentiert in einer Serie von 75 Dias den Heimweg der Arbeiter der General Dynamics Convair Division Fabrik am Ende der Morgenschicht. Aufgenommen vom oberen Ende einer langen Treppe, die zum Werktor führt, zeigen die Fotografien in kurzen Sequenzen zufällige Gruppen von Menschen, die auf den Betrachter zukommen. In *Aerospace Folktales* (1973) spürt Sekula den Auswirkungen makroökonomischer Entscheidungen (in der Luftfahrtindustrie) auf die Mikroökonomie einer Familie (in diesem Fall der seines arbeitslosen Vaters) nach.

Seit den achtziger Jahren verfolgt Sekulas fotografische Praxis in umfassenden Zyklen die Beantwortung der Frage, wie eine zeitgenössische „Ikonografie von Arbeit" aussehen kann. Die Prozesse des beschleunigten, globalisierten Kapitalismus sind das Thema, Häfen als Verladestationen der weltweiten Warenströme die Motive von Alan Sekulas groß angelegter Fotoserie *Fish Story* (1990–1995), die auf der Documenta11 gezeigt wird. Sie besteht aus 105 Farbfotografien, 26 Texttafeln und zwei Diaprojektionen und dokumentiert die Arbeitsbedingungen des maritimen Proletariats. Sekula findet in der differenzierten Hierarchie dieses Gewerbes, die von norwegischen Kapitänen bis zu philippinischen Besatzungen auf Schiffen unter der Flagge Maltas oder Panamas reicht, den Ausdruck für eine bis an die Grenzen der geografischen Peripherie wachsende Industrie und die Metapher für den globalisierten Kapitalismus, dessen Kartografie bereits die erste Reise des Kolumbus zu zeichnen begann.

Since the 1970s, Allan Sekula has been addressing the traditional conflict between photography as a document of social realities and as an aesthetically autonomous, artistic medium. In his attempt to renew a kind of "critical realism," Sekula uses the expressive and effective power of socially involved and critical photography, without falling prey to the naive illusion of documentary photography as "real depiction." He has always taken a conceptual approach to the arrangement and presentation of his work, and has also produced a considerable number of essays and texts on the history of (documentary) photography.

Untitled Slide Sequence (1972), a series of 75 slides, documents General Dynamics Convair Division workers on their way home at the end of the morning shift. Taken from the upper end of a long stairway leading to the factory gate, the photographs are shot at short intervals and show random groups of people walking toward the observer. In *Aerospace Folktales* (1973) Sekula further pursues the theme of the way home from work, examining the effects of macroeconomics (in the aviation industry) on the microeconomics of a family (in this case, that of his unemployed father).

Since the 1980s, Sekula has been using increasingly extensive cycles of photographic work to explore the potential for a contemporary "iconography of labor." These works investigate the processes of accelerated, global capitalism, as in Sekula's monumental photo series at Documenta11, *Fish Story* (1990–1995). The harbors and loading stations of a worldwide flow of goods are shown in 105 color photographs, 26 text panels, and two slide projections documenting the normally invisible and repressed working conditions of the maritime proletariat. In a sophisticated hierarchy of relations spanning from the Norwegian captain to the Philippine crew aboard ships sailing under the flags of Malta or Panama, Sekula finds the expression of an industry increasingly pushed to the geographical peripheries, and creates a metaphor for the present-day continuation of the old mythical trade routes that mapped modern capitalism from the days of Columbus. C.R.

"Coffin Factory, Tijuana" from *Dead Letter Office* I „Sargfabrik, Tijuana", aus der Serie *Dead Letter Office,* 1997
Cibachrome, 127 x 180 cm

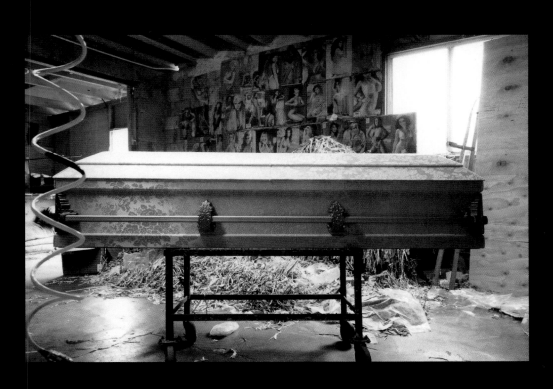

YINKA SHONIBARE

***1962 in London. Lebt/Lives in London.**

Yinka Shonibares Objekte und Installationen beinhalten ein komplexes Feld von historischen, kunsthistorischen, kulturellen und ökonomischen Bezügen und stellen dabei grundsätzlich Behauptungen kultureller Authentizität in Frage. Bevorzugt verwendet Shonibare afrikanische Stoffe, die mit ihren bunten, ornamentalen Mustern Vorstellungen von Authentizität und Exotik erwecken. Diese Stoffe werden in der Technik des sogenannten „Dutch wax" hergestellt, einem Wachsdruckverfahren, das in Indonesien seinen Ursprung hat und über die Niederlande und die Stoff-Fabriken Manchesters seit dem 19. Jahrhundert nach Afrika exportiert wurde. Seit den fünfziger Jahren des 20. Jahrhunderts symbolisierten sie freilich eine neue – postkoloniale – Identität, nationalen Stolz und kulturelle Differenz.

Die Geschichte der Herstellung und Verwendung dieser Stoffe verdeutlicht, dass deren vermeintliche Authentizität eine auf die Kolonialzeit zurückgehende Konstruktion ist, die sich Shonibare in einer Reihe von Arbeiten zunutze macht. Seine Arbeit *Double Dutch* (1994) präsentiert fünfzig kleinformatige Leinwände in einem streng geometrischen Raster auf einer Wand in grellem Pink. Bildträger sind verschiedene Stoffe mit afrikanischen Mustern, bei einigen jedoch wurden die Muster mit großer Geste in Impasto-Technik nachgemalt. Shonibare unterstreicht damit den gestischen Charakter der industriell hergestellten Stoffmuster und betont deren doppeltes Spannungsverhältnis zur Geschichte der westlichen abstrakten Malerei und zum westlichen Verständnis von afrikanischer Kunst als ornamental und exotisch.

In einigen jüngeren Arbeiten bildet Shonibare Interieurs, berühmte Porträts und Genreszenen der viktorianischen Epoche Englands nach und verwendet dafür afrikanische Stoffe. So setzte er für *Mr. And Mrs. Andrews without Their Heads* (1998) das berühmte Gemälde Thomas Gainsboroughs *Mr. And Mrs. Andrews* mit lebensgroßen, kopflosen Mannequins in Szene und rekonstruierte für die Arbeit *Victorian Philantropist's Parlour* (2000) detailgenau den Salon eines britischen Dandy im 19. Jahrhundert.

In seiner Arbeit *Gallantry and Criminal Conversation* (2002) für die Documenta11 verwendet Shonibare die Szene einer „Grand Tour" – im 18. Jahrhundert üblich als (auch sexueller) Initiationsritus für junge Aristokraten vornehmlich britischer Herkunft. Um eine im Zentrum befindliche Pferdekutsche platziert er verschiedene Figuren, eingekleidet in aus afrikanischen Stoffen gefertigte Kostüme der Zeit, die in unterschiedliche sexuelle Aktivitäten involviert sind. Shonibare konstruiert einen referenziellen Rahmen, in dem sich der exotische Charakter der Stoffe mit dem Begehren und dem „transgressiven Verhalten" (Yinka Shonibare) der Akteure verbindet. Er nimmt aber auch auf die ökonomischen Strukturen Bezug, die den verschiedenen Formen von Austausch während dieser luxuriösen Ausflüge zu Eigen sind.

Yinka Shonibare's objects and installations form a complex field made up of historical, art historical, cultural, and economic references, thus fundamentally bringing claims of cultural authenticity into question. One of his preferred materials is African fabric, whose colorful, ornamental patterns awaken immediate associations with authenticity and exoticism. This fabric is manufactured using the "Dutch wax" technique, a wax printing process originating in Indonesia, which was exported to Africa via the Netherlands and Manchester's cotton mills in the 19th century. Since the 1950s, the fabric has become a symbol of postcolonial identity, national pride, and cultural difference.

The fabric's complex history makes it clear that what is a supposedly authentic, symbolic quality is already a construction marked by the trading routes of the colonial powers, and Shonibare makes use of this idea in a number of works. His work *Double Dutch* (1994) presents fifty small-format paintings in a strict, geometric pattern on a bright pink wall. Instead of canvas, the artist uses various types of cloth featuring African patterns, and on some the pattern of the cloth has been painted over in impasto. Shonibare thus emphasizes the gestural character of the industrially manufactured pattern, doubling the tense relation between the history of Western abstract painting and the Western understanding of African art as ornamental and exotic.

In some of his more recent works, Shonibare deals with other culturally charged frames of reference, by reproducing interiors, famous portraits, and genre paintings from England's Victorian era and covering them in African fabrics. For instance, in *Mr. And Mrs. Andrews Without Their Heads* (1998), he took motifs from Thomas Gainsborough's famous painting, and placed the two human figures in the scene as life-size, headless mannequins. For *Victorian Philanthropist's Parlour* (2000), he reproduced every detail of a salon belonging to a 19th-century British dandy.

In *Gallantry and Criminal Conversation* (2002), his work for Documenta11, Shonibare uses a "grand tour" scene. In the 18th century, the grand tour was a common rite of initiation (including sexual) for young, elegant, British aristocrats. Surrounding a centrally placed, floating horse-drawn carriage, various figures wearing period dress made of African cloth are involved in sexual activities. Shonibare not only constructs a frame of reference in which the exotic material is linked to the desire and "transgressive behavior" (Yinka Shonibare) of the characters, but also refers to economic structures, which were the basis for the various forms of exchange that occurred during these luxurious journeys. C.R.

The Swing (after Fragonard) | *Die Schaukel (nach Fragonard,* 2001
Dutch wax printed cotton textile, life-size mannequin, swing, foliage | Wachsdruck auf Baumwollstoff, Schaufensterpuppe, Schaukel, Blätterwerk, 330 x 350 x 220 cm

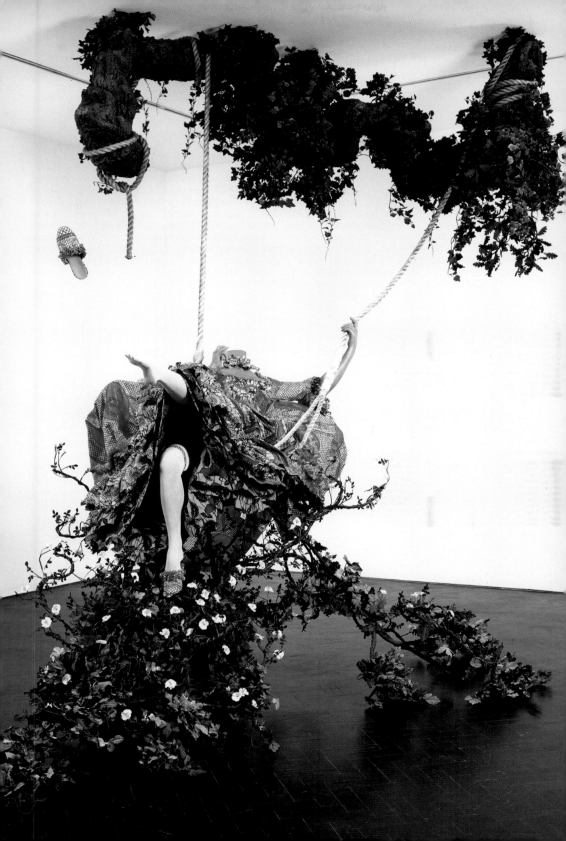

ANDREAS SIEKMANN

***1961 in Hamm, Deutschland/Germany. Lebt/Lives in Berlin.**

Andreas Siekmann arbeitet mit verschiedenen Medien wie Zeichnung, Malerei, Film, figürlichen und architektonischen Modellen. Seine Themen behandeln gesellschaftliche Fragen, so die Privatisierung und Ökonomisierung des öffentlichen Stadtraumes und – damit verbunden – sicherheitspolitische Maßnahmen.

„Wie die nun in den neunziger Jahren endgültig umstrukturierten und ideologisch konkurrenzlosen wirtschaftlichen Machtverhältnisse sich auf den öffentlichen Raum auswirken", wird in der Zeichnungsserie *Aus: Gesellschaft mit beschränkter Haftung* (seit 1996) dargestellt, die 1999 zum ersten Mal im Portikus Frankfurt ausgestellt wurde. Die Documenta11 präsentiert sie nun in leicht erweiterter Form mit über 200 DIN-A4-formatigen Zeichnungen in 16 thematisch spezifizierten Serien. Sie entwickeln – auf 16 langen Tischen angeordnet – ganze Argumentationsketten: Auf allen Zeichnungen findet sich das Motiv einer leeren Bluejeans, die zum Protagonisten der Bilder wird und in ihren unterschiedlichen Kontexten die gesellschaftlichen Verhältnisse diskutiert.

Siekmann hat in seinen Zeichnungen eine atmosphärisch dichte Bildemblematik entwickelt, die es ermöglicht, komplexe Sachverhalte „lesbar" darzustellen, um so seine politische Aussage verständlich zu machen. „Zeichnen ist für mich erst einmal eine Möglichkeit, sich auf andere Weise mit bestimmten Inhalten zu beschäftigen, als es mit Texten oder Diskussionen der Fall wäre. Es geht darum, wie in einem Storyboard, bestimmte Geschehnisse als Prozesse zu dokumentieren und darstellbar zu halten ... Zudem sind Zeichnungen für mich weniger ein Medium als eine Form der Aneignung."

Im Jahre 1992 entstand die Zeichnungsserie *Wir fahren für Bakunin,* eine Widmung an den russischen Revolutionär und Anarchisten Michail Bakunin. In den Zeichnungen schilderte Siekmann den idealtypischen Verlauf des Projektes, das in allen 260 Städten stattfinden sollte, die Bakunin bereist hatte. Personen, die Bakunin ähnlich sehen, wurden fotografiert und ihre Porträts in einem öffentlichen Gebäude jener Städte ausgestellt, in denen die Arbeit realisiert wurde.

1993 entwickelte Siekmann für die Ausstellung *Sonsbeek 93* das Projekt *Platz der permanenten Neugestaltung.* Er ließ einen zentralen Platz in der Stadt Arnheim durch einen Bauzaun absperren und mit Türspionen versehen. Durch diese konnten Besucher auf Zeichnungen schauen, die Möglichkeiten zeigten, wie der abgesperrte Platz für unterschiedliche Bevölkerungsgruppen und deren Bedürfnisse neu gestaltet werden könnte.

Das Projekt *Casino Totale* (2000) für den Kurpark in Bad Oeynhausen besteht aus einer Serie von Computerdrucken, die in Form von Zeichnungen die Geschichte einer Person erzählt, die nach einem Herzinfarkt in das Casino zum Stress-Simulationstraining eingeliefert wurde. Das *Casino Totale* ist Gegenmodell des Kurortes Bad Oeynhausen, der sein Krankenkassenimage gegen eine neue Exklusivität einzutauschen versucht.

Andreas Siekmann works with various media, such as drawing, painting, film, and figurative and architectural models. His themes deal with social issues, as well as the increasing use of public urban space for economic and private purposes, and the politically motivated security measures that accompany these developments.

"How economic power, which has finally been restructured and has no ideological competition, affects public space," is the subject of *Aus: Gesellschaft mit beschränkter Haftung* (From: Limited Liability Company), a series of drawings in progress since 1996 and first exhibited in 1999 at Portikus Frankfurt. Documenta11 now presents this series in a slightly expanded form, featuring over 200 A4 standard-size drawings, arranged according to 16 specific themes, displayed on 16 long tables. Directions for following the works in order and the developing chain of argument are provided. The motif of an empty pair of blue jeans appears on all of the drawings, becoming the protagonist of the pictures. The repetition of this motif in different contexts makes it possible to interpret and discuss social conditions.

Siekmann has developed an evocative system of emblems in his drawings, which makes it possible to present complex content in readable narrative structures, in order to make his political statements understandable. "For me drawing is primarily an opportunity to deal with certain topics in different ways, other than as texts or discussions. I'm concerned with documenting and presenting certain events as processes in a storyboard.... Also, for me, drawings are less a medium than a kind of appropriation."

Wir fahren für Bakunin (We Drive for Bakunin), a series of drawings dedicated to the Russian revolutionary and anarchist Mikhail Bakunin, was created in 1992. In the drawings for this traveling exhibit, Siekmann illustrated the ideal route for the project (meant to be shown in all 260 cities Bakunin visited). People resembling Bakunin were photographed and their portraits were exhibited in a public building in each city that was actually visited.

In 1993, Siekmann developed *Platz der permanenten Neugestaltung* (Square of Permanent Reorganization), a project for *Sonsbeek 93.* Using a construction fence equipped with peepholes, he blocked off a central square in the city of Arnhem. Through the peepholes, visitors could look at drawings that depicted various potential new designs for the square—each intended to meet the needs of different groups of citizens.

Casino Totale (2000), a project for the spa gardens in Bad Oeynhausen, consists of a series of computer prints, featuring drawings that tell the story of a person who was brought to the Casino for stress simulation training after a heart attack. The *Casino Totale* became the counterpart of the spa town, which was trying to rid itself of its dowdy, down-market image in favor of a new, exclusive one. A. N.

Aus: Gesellschaft mit beschränkter Haftung | From: Limited
Liability Company, 1999–2002
Billboards | Plakatwände, Frankfurt am Main, 1999

SIMPARCH
STEVE BADGETT, MATTHEW LYNCH

Gegründet/Founded 1996 in Las Cruces, NM, USA.

Bei ihren Erkundungen flüchtiger sozialer Orte der amerikanischen Sub- und Gegenkultur verankert das Künstlerduo Steve Badgett und Matthew Lynch seine Projekte in der profanen Architektur des Alltags. Simparchs „einfache Architektur", eine Anspielung an SciArch (Southern California Institute of Architecture) vertritt eine Design-Vorstellung, nach der die Form den Bedürfnissen nach besseren Lebensbedingungen folgt und sich nicht dem kapitalistischen Drängen nach Funktionalität, Effizienz und kosmetischer Erscheinung beugt.

Die kurzlebige Sinnlichkeit ihrer frühen Projekte speist sich aus der reichen, kulturell codierten Bevorzugung überholter und recycelter Altmaterialien. *Hell's Trailer* (1996), konstruiert wie ein Schaukelstuhl, ist aus handgemalten Plakatwänden und auf einem Autofriedhof neben der Route 66 gefundenen Schrott zusammengesetzt und vermittelt zwischen der Erfahrung und der Aufregung des auf der Straße-Unterwegs-Seins. Als melancholisches Simulakrum landestypischer Lebensweisen wird das Innere des Trailers zum Erinnerungsraum für Rast und Reisen in der Vorstellung. Die Untergrabung romantischer Vorstellungen vom Reisen und nomadischer Existenz durch klassifizierte Stereotypen wird in *Manufactured Home* (1996) sichtbar. Es ist die entmaterialisierte Version eines mobilen Heims, vergänglich und durchscheinend, da es vor allem aus Plastikfolie besteht, die von Speditionen verwendet wird. Im begehbaren Inneren wartet ein in Neumexiko gedrehtes Amateurvideo mit einem kitschigen, gefühligen Southwestern-Soundtrack, das die Ursprünge der Trailer-Kultur in den vom Militär entwickelten Behelfsunterkünften aufdeckt.

Deutsche Juggernaut (1998) verkörpert eine soziale Dimension bildhauerischer Produktion: Gekrönt von einem DJ-Pult, setzt sich die transparente, luftige, kathedralenartige Konstruktion auf Rädern aus dem gesammeltem Holz und orangefarbenem Plastiknetz eines früheren Potsdamer DDR-Gaswerks zusammen. *Spec* (2001), eine Gemeinschaftsarbeit von Simparch und dem Experimentalmusiker Kevin Drumm, besteht aus einem etwa 24 Meter langen Tonnengewölbetunnel mit folienüberzogenen Deckenplatten, in dem etwa 80 Menschen Platz haben, um sich gleichzeitig in die Raum schaffende Wirkung von Drumms Electro-Soundscapes versenken zu können.

Die Wahrnehmungserfahrung von Geräuschkulissen ist auch integraler Bestandteil von *Free Basin* (2000–2002), einer voll funktionsfähigen, nierenförmigen „skate bowl" aus Sperrholz, die im Inneren der Ausstellung präsentiert wird. Sie ist einem in der kalifornischen Surfkultur der siebziger Jahre sehr verbreiteten Modell von Garten-Swimmingpools nachempfunden und wird beispielhaft als um sich greifendes Element von Gegenkultur in eine Energie erzeugende, interaktive Vision urbaner Straßenkultur eingeführt.

Simparchs dynamische Architektur aktiviert Räume am Rande eines hegemonialen Kulturverständnisses, indem sie Gemeinschaftserfahrungen bewirkt, die die Grenzen zwischen Hierarchie, Institution und Generation aufweichen.

Investigating transient social spaces of American sub- and counterculture, artist duo Steve Badgett and Matthew Lynch anchor their projects in the vernacular architecture of everyday life. Simparch's "simple architecture," a pun on SciArch (Southern California Institute of Architecture), promotes a vision of design where form follows the need for better living as opposed to a capitalist urge for functionality, efficiency, and cosmetic appearances.

The ephemeral sensuality of their early projects draws upon a rich, culturally coded preferentiality of outdated and recycled waste materials. *Hell's Trailer* (1996), assembled from handpainted billboards and other roadside detritus found in a Route 66 graveyard and constructed like a rocking chair, mediates between the experience and the excitement of being on the road. A melancholic simulacrum of vernacular lifestyles, the interior space of the trailer becomes a mnemonic space for rest and imaginary journeys. The subversion of romantic notions of traveling and nomadic existence by classed stereotypes becomes apparent in *Manufactured Home* (1996), a dematerialized version of a mobile home, evanescent and translucent, primarily built from the sheet plastic used in the delivery industry. The walkable interior features an amateurish video shot in New Mexico with a kitschy, emotive Southwestern soundtrack that traces the origins of trailer culture back to the temporary accommodations developed by the military.

Moving into the communal dimension of sculptural production, *Deutsche Juggernaut* (1998), erected in a former East German gasworks in Potsdam out of salvaged wood and orange netting, is a transparent, airy, cathedral-like construction on wheels topped by a DJ's turntable station. *Spec* (2001), a collaboration between Simparch and experimental musician Kevin Drumm, consists of a 72-foot barrel-vaulted tunnel made from foil-backed ceiling tiles that holds up to 80 people, who tune into the space-stimulating capacities of Drumm's electrified soundscapes.

A heightened perceptual experience of noisescapes is also integral to *Free Basin* (2000–2002), a fully functional kidney-shaped plywood skate bowl presented inside the exhibition space. Modeled after a common type of backyard swimming pool from the Californian surf culture of the 1970s, a pervasive element of counterculture is introduced through an energizing and interactive vision of urban street culture with an exemplary function.

Simparch's dynamic architecture activates spaces on the verge of a hegemonic notion of culture by inducing communal experiences that soften the boundaries between the hierarchical, the institutional, and the generational. N.R.

Manufactured Home | Fertighaus, 1996
Plastic sheating, twigs, plastic twine, plywood, lights, video |
Plastikplane, Äste, Kunststoffkabel, Sperrholz, Beleuchtung,
Video, 3 x 11 x 2,40 m

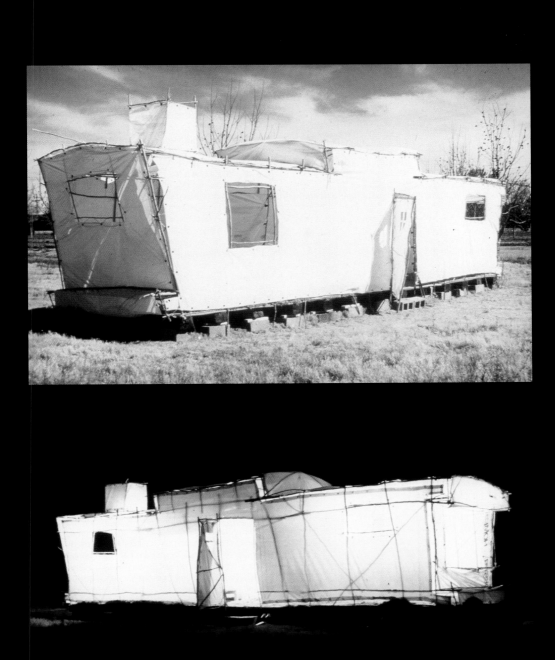

LORNA SIMPSON

***1960 in New York. Lebt/Lives in New York.**

Lorna Simpson versucht sich dem Medium Fotografie auf neuen Wegen anzunähern, zumeist durch Gegenüberstellungen von Bild und Text, die vorgefasste Meinungen über Geschlechterollen und Rasse unter die Lupe nehmen und gleichzeitig gängige Vorstellungen von Fotografie in Frage stellen. Simpson zeigt, dass das Ich in der Öffentlichkeit bloße Fiktion ist, die auf falsch gedeuteten Erwartungen auf Seiten des anderen und der Unfähigkeit beruht, den Wert des eigenen Ich zu erkennen. Aber Simpson präsentiert ihre These nicht als offensichtliche Moral einer erzählten Geschichte. In der frühen Arbeit *Screen 1* (1986) zum Beispiel sind drei Bilder von Waden einer sitzenden Frau auf einen Boudoir-Paravent aufgezogen. Darunter steht in roter Schrift: „Marie sagte, sie sei aus Montreal, obwohl", dann geht es auf der Rückseite des Paravents weiter, „sie aus Haiti ist." Auf allen drei Fotografien werden nur der Saum von „Maries" weißem Baumwollunterhemd und die unteren Körperpartien zusammen mit den angeschnittenen Details ihrer Hand und eines Spielzeugboots gezeigt. Sie stehen zum einen metonymisch für die ganze Person und zum anderen symbolisch für einen Menschen, der hinter einer Maske sein nicht eingestandenes Selbstbild versteckt. Die Arbeit ist gekennzeichnet von fehlenden Gesichtsausdrücken oder anderen Zeichen von Individualität, weil sie zuvorderst die soziale Konstruktion von Identität untersucht. Sie demonstriert nicht nur eine Herausforderung an die Geschichte schwarzer Frauen in der Gesellschaft, sondern auch eine über das Dokumentarische hinausgehende Verwendung des Mediums Fotografie.

Haare als Kennzeichen einer sozialen Identität sind ebenfalls ein zentraler Gegenstand von Simpsons Arbeit. Die 21 Bilder von unterschiedlichen Frisuren in *Wigs (portfolio)* (1994) ergeben eine Taxonomie, die Geschlechterrolle, Alter und Rasse bezeichnet. Die Serie ist auf cremeweißen Filz gedruckt, und das abgebildete Haar ist pechschwarz, bis auf das einer barbieblonden Perücke. Jede Frisur hat auf der taktilen Oberfläche der Bilder dieselbe Stofflichkeit. Sie ist ein Hinweis auf unsere Fixierung, die Haarbeschaffenheit rassenspezifisch konnotiert. Simpsons Arbeit *Interior/Exterior, Full/ Empty* (1997) besteht aus sieben ununterbrochen laufenden Schwarz-Weiß-Projektionen eines Videos. Im Laufe verschiedener dramatischer Entwicklungen wird der Betrachter sozusagen zum Voyeur bei diversen häuslichen Szenen. Er belauscht Telefongespräche und schaut durch ein Schlüsselloch, um zwei Frauen beim Baden zuzusehen, während die Projektion auf der hinteren Wand eine idyllische Szene im Park zeigt.

31 2002 (2002), Simpsons Installation für die Documenta11 besteht aus 31 Videobildschirmen, auf denen zwei Frauen zu sehen sind, die einen ganzen Tag lang von einer zudringlichen Kamera verfolgt werden. Obwohl sie ähnliche Tagesabläufe einzuhalten scheinen, treffen sich die beiden Frauen nicht. Es findet auch keine dramatische Auflösung statt. In der Art, wie sie Konventionen in einer bewusst nicht didaktischen Weise hinterfragen, regen die Arbeiten von Lorna Simpson eine Vielzahl von Deutungen an und bejahen das soziale Potenzial, das in der poetischen Präsentation liegt.

Lorna Simpson has explored innovative approaches to the medium of photography, most commonly through juxtapositions of image and text that scrutinize preconceptions about gender and race while undermining collective assumptions about photography. Simpson reveals that the self one presents to the public is a mere fiction based on misconceived expectations of the other and a failure to recognize the value of one's true self. But Simpson's thesis is not presented as an obvious moral to a narrated story. For example, in an early work titled *Screen 1* (1986), three images of a seated woman's calves are mounted on a boudoir screen, with red text below that reads "Marie said she was from Montreal although"—it continues around to the back of the screen—"she was from Haiti." In all three photographs, only the hem of "Marie's" white cotton shirt and lower body portions are presented with cropped details of her hands and a toy boat, standing metonymically for the whole person and symbolically for the person veiled by a screen or hiding the unacknowledged self-image. Questioning the social construction of identity, the work is marked by an absence of facial expressions or any other signs of individuality. This fact demonstrates not only a challenge to the history of black women in society but also a transgressive use of the documentary medium of photography.

Hair as a marker of social identity has occupied a central role in Simpson's work. The 21 images in *Wigs (portfolio)* (1994) provide a taxonomy of hairstyles signifying gender, age, and race. The series is printed on creamy-white felt and all the hair pictured is "Jet"-black except for one image of a "Barbie"-blond wig. The tactile surface of these images renders each hairstyle the same texture to emphasize our fixation on hair texture as a racial marker. Her work *Interior/ Exterior, Full/Empty* (1997) consists of seven continuously running black-and-white video projections. As various dramatic events unfold, the viewer becomes something of a voyeur of various interior scenes, eavesdropping on phone conversations and peeping through a keyhole to watch two women taking a bath, while one back wall projection shows a serene park setting.

31 2002 (2002), Simpson's installation created for Documenta11, consists of 31 video monitors showing two women who are followed by an invasive camera throughout the course of one day. While they seem to maintain similar routines, the women do not meet and there is no dramatic conclusion. Challenging conventions in a decidedly nondidactic manner, Simpson's works encourage a wide range of conclusions and celebrate the social potential inherent to poetic presentation. C.S.R.

31 2002, 2002
Video installation for 31 monitors I Video-Installation für 31 Monitore

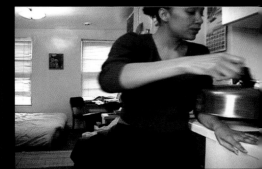

EYAL SIVAN

***1964 in Haifa, Israel. Lebt/Lives in Paris.**

Der Dokumentarfilmer und Dissident Eyal Sivan hat sich mit der politischen Manipulation von Erinnerung, dem Schicksal des palästinensischen Volkes und besonders mit zivilem Ungehorsam in Israel und der palästinensischen Intifada beschäftigt. Seit seinem ersten Film *Aqabat Jaber, Passing Through* (1987) über den Alltag in einem palästinensischen Flüchtlingslager, handeln Sivans Projekte von der Politik der Erinnerung sowie von der Instrumentalisierung und Darstellung des Genozids.

Sein Film *The Specialist* (1996–1999), den er gemeinsam mit Rony Braumann – inspiriert von Hannah Ahrendts Essay *Eichmann in Jerusalem* – schrieb, hat den Adolf-Eichmann-Prozess aus dem Jahr 1961 zum Thema. Sivan sichtete die gesamte Film- und Radioaufzeichnung des Prozesses, insgesamt mehr als 350 Stunden Material, das jahrzehntelang unbeachtet in israelischen Archiven lag, überarbeitete das Material digital, manipulierte es in einigen Fällen und stellte den gesamten Prozess in einem Dokumentarfilm zusammen. Eichmann, ein moderner Krimineller als „bloß" übereifriger deutscher Bürokrat, beschreibt sich als hilfloses Instrument in den Händen höherer Mächte, als Tropfen in einem Ozean. Im Gegensatz zur Ablehnung jeglicher Verantwortung durch Eichmann verdeutlicht Sivan das Problem, das jenseits der Person Eichmanns im Wesen und in der Rolle seiner Verbrechen und in der Ausformulierung seines Zuständigkeitsbereiches liegt.

Der Film *Itsembatsema – Rwanda, One Genocide Later* (1996), den Sivan gemeinsam mit Alex Cordesse erarbeitete und der auf der Documenta11 gezeigt wird, kombiniert Fotos und Nachrichtenmaterial über den Völkermord in Ruanda mit Radioübertragungen des Senders RTLM (Radio Télévision Mille Collines), die vom April bis zum Juni 1996 ausgestrahlt wurden und in denen zum Massaker an den Tutsi aufgerufen wurde. Die Fotografien aus dem Jahr 1996 geben einen bruchstückhaften Blick auf die Auswirkungen des Genozids und kontrastieren deutlich mit der schneidenden und eloquenten Rhetorik der christlich motivierten Radio-Aufrufe zum Völkermord.

Wie bei seinem Film *The Specialist* arbeitet Sivan auch in *Itsembatsema* mit den Möglichkeiten, durch die Präsentation von nur minimal bearbeitetem Archivmaterial auf die zutiefst zerstörerischen Potenziale in der menschlichen Psyche hinzuweisen. Indem er in die Vergangenheit zurückgeht, spricht Sivan zu uns von der Gegenwart und unserem Verhältnis zur Geschichte.

A documentary filmmaker and dissident, Israeli Eyal Sivan has focused on the political manipulation of memory and the fate of the Palestinian people, and particularly on civil disobedience in Israel and the Palestinian Intifada. Since his first film *Aqabat Jaber, Passing Through* (1987), about everyday life in a Palestinian refugee camp, Sivan's projects have concerned the politics of memory and the instrumentalization and representation of genocide.

His film *The Specialist* (1996–1999), which he co-wrote with Rony Braumann, is a representation of the 1961 Adolf Eichmann trial, inspired by Hannah Arendt's essay *Eichmann in Jerusalem*. Sivan resurrected the complete video and radio record of the trial, over 350 hours of material, which had been left ignored for many years in Israeli archives. By digitally remastering and in some cases manipulating the material, he condenses the trial into a documentary feature. Eichmann, a modern criminal, "merely" a zealous German bureaucrat, presents himself as a powerless instrument in the hands of superior forces, and describes himself as a drop in the ocean. Eichmann's position lends itself to the erasure of all notion of responsibility, but Sivan exposes the problem that lies beyond the person of Eichmann in the nature and status of his criminal activity and the demarcation of his tasks.

Itsembatsemba—Rwanda, One Genocide Later (1996), which Sivan made with Alexis Cordesse, and which is shown at Documenta11, combines contemporary footage and photographs after the massacres in Rwanda with recordings of radio broadcasts from RTLM (Radio Télévision Mille Collines) from April to June 1994, inciting people to massacre their fellow Tutsis. The photographs from 1996 give a fragmentary view of the aftermath of the genocide and contrast with the chillingly articulate rhetoric of Christian inspired calls for genocide on the radio.

As with *The Specialist*, in *Itsembatsemba* Sivan explores the possibility of presenting archival material with minimal intervention to reveal a deeply destructive level in the human psyche. By going back to the past, Sivan speaks to us of the present and our relationship to history. M. N.

Itsembatsemba, Rwanda One Genocide Later | *Itsembatsemba, Ruanda, einen Völkermord später,* 1996
Film: 35 mm, sound, 13 min., | 35-mm-Film, Ton, 13 Min.,
directors | Regie: Alexis Cordesse/Eyal Sivan

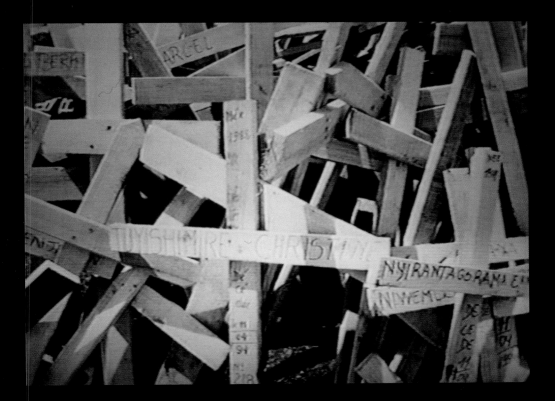

DAVID SMALL

***1965 in Manchester, CT, USA. Lebt/Lives in Cambridge, MA, USA.**

David Small erkundet die kommunikativen Möglichkeiten verräumlichter Sprache in den elektronischen Medien. In interaktiven Computerinstallationen, in denen mit Hilfe neuester Schnittstellentechnologie rein typografische Informationen in ein virtuelles Environment einfließen, erprobt er neue, am menschlichen Wahrnehmungsvermögen orientierte Arten des Lesens. Small beschränkt sich dabei nicht auf die Domäne des rein Visuellen, sondern dringt auch in taktile und interaktive Bereiche vor. Dazu zerlegt er die körperlichen Eigenschaften der Sprache in raum-zeitliche Anwendungen, wie sie im digitalen Zeitalter praktikabel sind. Herkömmliche Gewohnheiten des Lesens und Schreibens von Schriftrollen, Manuskripten oder Büchern nehmen in der virtuellen Realität eine völlig andersartige wahrnehmungs- und erkenntnistheoretische Qualität an. Im *Talmud Project* (2000) erlaubt eine dynamische, räumlich gestaffelte typografische Form auf der Grundlage von Emmanuel Levinas' Thora-Kommentar die simultane Ansicht dreier eng miteinander verbundener Texthierarchien: der Thora, des Talmuds und des Kommentars von Levinas.

Small konzentriert sich nicht auf Lesen und Schreiben als individuelle Akte der Wissensproduktion, sondern auf ihre potenziellen Implikationen im und für den öffentlichen Bereich. Durch sich ständig verlagernde und verändernde Informationsräume navigierend, prägt Small ein neues Verständnis vom Gebrauch und von der Funktion des Raums und modifiziert konventionelle Analogien zwischen narrativen und architektonischen Räumen oder Landschaften. In *Stream of Consciousness* (1998) kontrolliert der Betrachter einen „verflüssigten" Strom von Wörtern, während er in einem winzigen, beschaulichen Freiluftgarten im persischen Stil mit „wirklichen" Steinen, Pflanzen und einem Wasserbecken sitzt. Ein vom Betrachter haptisch per Touchpad zu bedienender Computer steuert dabei einen Videoprojektor, der die Illusion schafft, der Text flösse über Kaskaden von Wasser. Die Verzeitlichung und Verräumlichung von Typografie, bis heute Strategie der konkreten Poesie seit Anbruch der Moderne im späten 19. Jahrhundert, hat Sprache von ihren linguistischen Funktionen zugunsten der ästhetischen, kontemplativen Qualität von Buchstaben und Wörtern entbunden. In *Minksy Melodies* (1987), Teil seines umfassenderen *Brain Opera*-Projekts, wird mit Hilfe einer dynamischen, im Takt einer Melodie bewegten Typografie die komplexe Interaktion von Hören, Sehen und Lesen erprobt.

Smalls Projekt für die Documenta11, *The Illuminated Manuscript*, berührt Fragen des Speicherns und Wiederauffindens von Informationen, des architektonischen Potenzials von Büchern und der Evolution des geschriebenen Wortes. In einem dämmrigen, elektronisch mit einem Abecedarium der Schrifttypologie ausgefüllten Raum präsentiert er ein leeres, übergroßes Buch mit 26 Seiten, das von Hand hergestellt ist. Die Besucher können sich mit einem elektronischen Stift selbst in den virtuellen Raum des Buches eintragen, um die Geschichte des Wortes neu zu schreiben.

David Small explores the communicative possibilities of spatialized language in the electronic media. Combining physical interfaces with purely typographical information in a virtual environment, Small's interactive, computer-generated installations explore new types of reading in tune with human perceptual abilities. Moving away from the domain of sheer visuality into the realm of the tactile and the interactive, the corporeal capacity of language is dissected into workable spatial and temporal applications for the digital age. Traditional habits of reading and writing a scroll, a manuscript, or a book take on a substantially different perceptual and epistemological quality in virtual reality. In the *Talmud Project* (2000), a dynamic, spatialized form of typography based on Emmanuel Levinas's commentary on the Torah allows one to be engaged simultaneously with three deeply interconnected hierarchies of text: the Torah, the Talmud, and Levinas's commentary.

Small's focus is not on reading and writing as personal acts of knowledge production but on their potential social implications in and for a public sphere. Navigating through constantly shifting and mutating information spaces, Small imprints a new understanding of the use and the function of space and modifies conventional analogies between narrative and architectural space or landscape. In *Stream of Consciousness* (1998), the viewer controls a "liquidized" flow of words in a miniature, contemplative Persian outdoor garden with "real" rocks, plants, and a water pool. Navigated by the viewer through a haptic touchpad, the computer drives a video projector creating the illusion of text floating down cascades of water. The temporalization and spatialization of typography, an ongoing concern of concrete poetry since the onset of modernity in the late 19th century, has turned language away from its linguistic function towards the aesthetic, contemplative quality of letters and words. In *Minsky Melodies* (1987), part of Small's larger *Brain Opera* project, the complex interaction between hearing, seeing, and reading is optimized by introducing a dynamic typography that moves in sync with a musical tune.

Small's project for Documenta11, *The Illuminated Manuscript,* touches upon issues of the storing and retrieving of information, the architectonic capacity of books, and the evolution of the written word. An empty, oversized, handmade book of 26 pages is presented in a dim room filled electronically with an abecedarius devoted to the typology of writing. A sensing stylus allows the audience to inscribe itself into the virtual space of the book, re-writing the history of the word. N. R.

Talmud Project I *Talmud-Projekt,* 2000
Prototype for an interactive book I Prototyp für ein interaktives Buch

Torah

4. L'URBANISME DES VILLES-REFUGES
4. THE URBANISM OF THE CITIES OF REFUGE

Lisons maintenant notre texte. Le début dit la façon dont sont
Let us now read our text. The beginning tells of the way these cities of
aménagées ces villes-refuges pour que les hommes subjectivement
refuge are laid out so that the men who are subjectively innocent may
innocents» puissent échapper à la sanction illégale, mais compréhensible,
escape the illegal but understandable punishment of the avenger of
du vengeur du sang. Admirons d'abord - je ne vais pas tout lire - le niveau
blood. Let us admire first of all - I am not going to read it all - the
manifestement élevé de cet urbanisme, et reconnaissons-y le génie, ou la
evidently elevated level of this urbanism, and recognize in it the genius, or
source du génie, des bâtisseurs d'Israël, de ces Européens convertisseurs
the source of genius, of the builders of Israel, of these Europeans who
de déserts en jardins, et si ouverts sur ce point à tous les enseignements de
convert deserts into gardens, and are so open on this point to all the
l'Occident. Ils ont appris cela en Occident : ils ont eu des livres qui leur
teachings of the West. They have learnt this in the West: they have had
avaient ouvert l'esprit.
books which had opened their minds.

«Ces villes, on ne les choisit pas parmi les petits villages, ou
"These cities (of refuge) are to be made neither into small forts,

parce que, dans les petits villages, le vengeur du sang pourrait pénétrer et
because the avenger of blood might enter small forts and be tempted,
être tenté, sans rencontrer de résistance, de réussir; on ne les choisit pas.
without encountering any resistance, to succeed; nor are they to be

Genesis
Exodus
Numbers
Deuteronomy
Joshua
Ruth
I_Samuel
II_Samuel
I_Kings
II_Kings
I_Chronicles
II_Chronicles
Ezra
Nehemiah
Esther
Psalms

FIONA TAN

*1966 in Indonesien/Indonesia. Lebt/Lives in Amsterdam und/and Berlin.

Fiona Tan befasst sich in ihren Arbeiten mit der traditionellen Dialektik zwischen dem persönlichen Reisetagebuch als Suchwerkzeug des Subjektiven und dem ethnografischen Anspruch auf Wahrhaftigkeit, Objektivität und unvoreingenommene Beobachtung. Dabei benutzt sie Film- und Fotoaufnahmen aus verschiedenen Archiven und kombiniert sie zu umfangreichen Film- bzw. Videoinstallationen. Die traditionellen Missionars- und Reiseberichte – vor allem im frühen 20. Jahrhundert Manifestationen der kolonialen Machthierarchie, in der Afrikanern und Asiaten ihr „Platz" zugewiesen worden war – lässt Tan hinter sich, indem sie persönliche und gesellschaftliche Identitätsbildung miteinander verknüpft.

Smoke Screen (1997) ist eine Filminstallation mit einem Zehn-Sekunden-Loop, der einen Ausschnitt aus dem in den dreißiger Jahren im Staatsauftrag produzierten Schulfilm The Tropical Netherlands: A Journey with the Film Camera Through the East Indian Archipelago benutzt: Er zeigt drei dunkelhäutige balinesische Kleinkinder, die spärlich bekleidet und Zigaretten paffend vor der Kamera posieren. Im Außenraum projiziert, den Raum für die Werbung auf einer Plakatwand überblendend, wirft die Arbeit nicht nur aktuelle Fragen sozialer und ethischer Praxis auf, sondern entlarvt auch das ideologische Potenzial historischer Bildsprache. Das auf einer durchscheinenden Projektionsfläche gezeigte Video Tuareg (2000) porträtiert eine Gruppe nordafrikanischer Kinder vor und nach der Aufnahme eines Gruppenfotos und ersetzt dabei die statische Dimension des Fotografischen durch das zeitliche Element des Filmischen. In Facing Forward (1998/99) und Thin Cities (1999/2000) – Projektionen aus jeweils mehreren Filmen – konstruiert Tan eine Raumarchitektur, die den Besucher zwingt, den spektakulären Charakter dieser Filmsequenzen aus der Kolonialzeit physisch zu erfahren, indem er sich um die Projektionsflächen herum und zwischen ihnen hindurch bewegt.

May You Live in Interesting Times (1997), Tans erster abendfüllender Dokumentarfilm, geht dem australischen Erbe ihrer Mutter und dem Schicksal der Familie ihres Vaters als chinesische Immigranten in Indonesien nach und entwirft dabei eine persönliche Sicht auf Migration, die sozialen Rahmenbedingungen und den Verfall von Familienwerten. Saint Sebastian: Archers of the New Age (2000), eine in Musik und Umgebungsgeräusche gebettete 16-mm-Projektion auf die Vorder- und Rückseite einer Leinwand, zeigt die alljährliche Bogenschützenzeremonie beim Toshiya-Fest im buddhistischen Sanjûsangendô-Tempel in Kyôto. Der Initiationsritus für die 20-jährigen Frauen ist in anschaulichen Großaufnahmen dargestellt – die Vorbereitungsphase, dann die konzentrierte Sammlungsphase, in der die Bögen rituell die Wange berühren, und schließlich der Moment des Loslassens.

Sich auf August Sanders wegweisende physiognomische Archäologie der Arbeiterklasse aus den zwanziger Jahren beziehend, entwickelt Tan in Countenance, einem 16-mm-Film für die Documenta11, eine typologische Analyse des „West- und Ostdeutschen". In etwa 200 Filmporträts untersucht sie durch genaue Beobachtung und mit viel Gespür für Gesten, Details und Ausdruck Wertvorstellungen, Stereotypen und die Rolle von Erfahrung für die Bildung soziologischer Cluster.

Fiona Tan's works engage the traditional dialectic between the ethnographic claim to veritable objectivity of unprejudiced witness and the personal travelogue as the search for the subjective. She draws on photographic and filmic footage from various archives and combines the two into expanded film and video installations. Traversing the threshold of early 20th-century missionaries' and travelers' reportages, which served to reinforce the "place" of Africans and Asians in the colonial hierarchy of power, Tan interlinks personal and social formations of identity.

In Smoke Screen (1997), a film installation of a ten-second segment from the 1930s government educational film The Tropical Netherlands: A Journey with the Film Camera Through the East Indian Archipelago, three young, dark skinned, scarcely dressed Balinese children pose in front of the camera puffing cigarettes. Presented outdoors displacing the advertisement space of a billboard, simultaneously addressing current issues of social and ethical practice, the ideological potential of historical imagery is laid bare. Tuareg (2000), projected on a translucent screen, presents the moments before and after a group photograph of Northern African children was taken, thereby supplanting the static dimension of the photographic with the temporal element of the filmic. In the multiple film projections Facing Forward (1998/99) and Thin Cities (1999/2000), an architectonic environment is created that forces the viewer to physically experience the spectacular character of colonial footage by walking through and around the projection screens.

May You Live in Interesting Times (1997), Tan's first feature-length documentary, retraces her mother's Australian heritage and her father's family's fate as Chinese immigrants in Indonesia, establishing a personalized view on migration, social conditions, and the disruption of family values. Saint Sebastian: Archers of the New Age (2000), a recto-verso 16mm projection with a musical and an environmental noise-scape, features the annual, sacred Japanese archery ceremony of the Toshiya festival at the Sanjûsangen-dô temple in Kyoto. This coming-of-age ceremony for twenty-year old women is portrayed in revealing close-ups: the preparatory stage, the building up of concentration, when the bow ritually touches the cheek, and the moment of release.

In Countenance, Tan's 16mm film for Documenta11, she develops a typological inquiry of the contemporary "West and East German," based on August Sander's 1920s seminal physiognomic archeology of the working classes. Focusing on the details, on gestures, and changes of expression, around 200 filmic portraits give rise to observational scrutiny on issues of value judgment, stereotypes, and the role of empirical knowledge in the formation of sociological clusters. N. R.

Thin Cities, 1999–2000
Videoinstallation, Villa Arson, Nice I Nizza

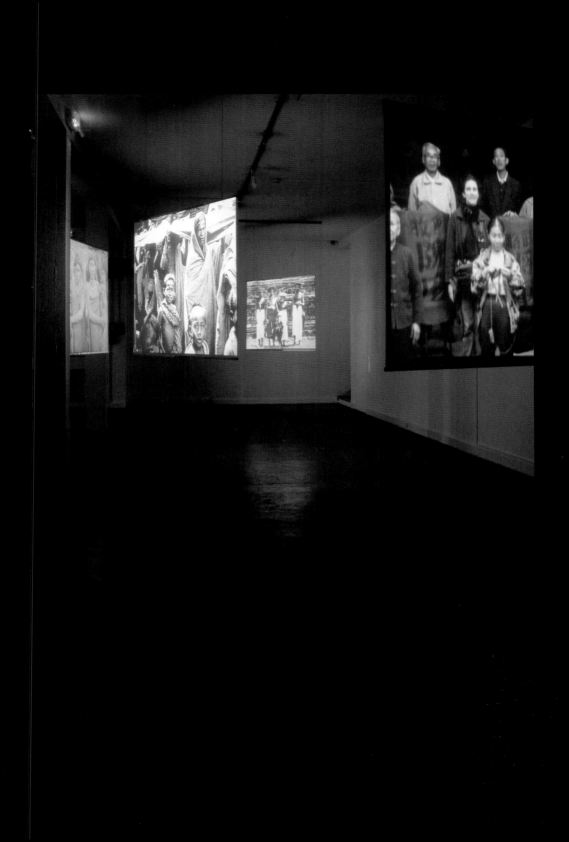

PASCALE MARTHINE TAYOU

*1967 in Jaunde/Yaoundé, Kamerun/Cameroon.
Lebt/Lives in Brüssel/Brussels und/and Jaunde/Yaoundé.

Zu den charakteristischerweise ortsgebundenen Installationen von Pascale Marthine Tayou zählen dichte Labyrinthe aus Müll, Graffiti und grafischen Zeichnungen, alles zu dynamischen und chaotischen, improvisierten Kompositionen geordnet, denen eine tagebuchartige und absurde Logik zugrunde liegt. Die Akkumulation, Ausdruck der Sammelleidenschaft Tayous, die sich auf persönliche Gegenstände, insbesondere Dokumente von seinen Reisen, bezieht, dient als eine Art Altar der Erinnerung und Migration. Das gilt für *Colorful Maze* (1997) ebenso wie für *Crazy Nomad* (1999), eine beispielhafte Arbeit, mit der er sein Pseudonym – verrückter Nomade – bekannt machte und seine nomadische und kosmopolitische Ästhetik konkretisierte. Für diese Installationen einer Stadtlandschaft verwendet Tayou Trümmer, um Kultur in ihrer Dichotomie als aufzubewahrendes und wegwerfbares Gut zu thematisieren.

Tayous Form der Aneignung und seine großflächigen Assemblage-Installationen haben ähnliche visuelle und konzeptuelle Eigenschaften wie jene Archive der Großstadt, die George Adeagbo oder Thomas Hirschhorn geschaffen haben. Seine lyrische, poetische Choreografie der Materialien ist jedoch nicht im selben Maße geplant und formal. Die großflächigen und beweglichen Rauminstallationen Tayous dienen als Bühne für Fundstücke – Notizen, Streichhölzer, Quittungen, Fahrscheine –, sie sind eine Art automatisches Schreiben der autobiografischen Natur. Tayou stellt die Spuren, die eine Großstadt hinterlässt – ihre Erinnerungen, ihre Fantasie, ihr Territorium und ihr Begehren –, in einen neuen Zusammenhang und erklärt dazu: „Das, was ich mache, … habe ich von der Stadt gelernt."

Für seine letzte Einzelausstellung hat Tayou *Le menu familial* (Familienmenü, 2002) geschaffen, ein labyrinthisches architektonisches Gebilde aus Gips, das Fotografien und Videos von seiner jüngsten Reise in seine Heimatstadt in Kamerun enthält. Die Arbeit mit ihrer Fülle von Ansichtskartenständern bringt Tayous Betrachtungen sowohl über seine persönliche Sicht auf diesen Ort als auch seine Kritik am touristischen Blick zur Ansicht. Für eine weitere Einzelausstellung *Qui perd gagne* (Wer verliert, gewinnt, 2002) hat Tayou, seiner Strategie folgend, Arbeiten aus seinem umfangreichen Werk immer wieder zu verwerten, eine Arbeit aus dem Jahr 1995 neu gestaltet und persönliche Erinnerungsstücke seiner Familie hinzugefügt. Diese autobiografische Installation vermittelt den unmittelbaren Dialog zwischen Objekten und Erfahrungen, verbunden mit Jaunde und Brüssel. Sie bildet eine Plattform für den Übergang zwischen Phantasie und Realität.

Game Station (2002), Tayous Beitrag für die Documenta11, besteht aus zehn Monitoren, die Bilder aus Jaunde zeigen. Zusätzlich zu den über den ganzen Raum verteilten Monitoren gibt es zahlreiche Kopfhörer, aus denen Geräusche von Radiosendern aus aller Welt dringen und so eine Kakofonie unverständlicher, sich gegenseitig störender Klänge und sprachlichen Durcheinanders erzeugen. Diese neue Arbeit ist das Forum für weltweiten Austausch und Dialog, für Übersetzung und Unübersetzbarkeit.

The site-specific installations of Pascale Marthine Tayou include dense labyrinths of city detritus, graffiti, and diagrammatic drawings, all arranged in dynamic and chaotic improvisational compositions of a diaristic and absurdist logic. The accumulation, a product of Tayou's obsessive gesture of collecting paraphernalia of his personal history, particularly tracing his history of travel, performs as a kind of altar to memory and migration. This is true of his *Colorful Maze* (1997) as well as his work *Crazy Nomad* (1999), a paramount work that proclaimed his pseudonym—crazy nomad—and concretized his nomadic and cosmopolitan aesthetic. In this body of urban-scape installations, Tayou employs debris to illustrate that culture is both collectible and dispensable.

Tayou's brand of appropriation and large-scale assemblage-installations share visual and conceptual traits with the kind of archives of the metropolis produced by George Adeagbo or Thomas Hirschhorn. Yet his lyrical, poetic choreography of matter has a less deliberate and formal dimension to it. His expansive and animated montaged environments are stages for found objects—notes, matches, receipts, tickets—a kind of automatic writing of an autobiographical nature. Recontextualizing traces of the metropolis— its memory, fantasy, territory, and desire—he contends: "What I am doing … I learned from the city."

For his most recent solo exhibition, Tayou mounted *Le menu familial* (The Family Menu, 2002), a labyrinthine architectural construction made of plaster, containing photographs and videos from his most recent trip to his home town in Cameroon. Replete with postcard stands, the work marks Tayou's mediation on both a personal vision of the site as well as a critique of the touristic gaze. In another solo exhibition, *Qui perd gagne* (Who Loses Wins, 2002), Tayou reconfigures work dated from 1995, part of his strategy of consistently recycling work from his larger repertoire, here sutured with personal familial relics. This autobiographical installation engages directly in a dialogue between objects and experiences relative to both Yaoundé and Brussels, a platform for the interface of both fantasy and reality.

For Documenta11, Tayou's *Game Station* (2002) is composed of 10 monitors screening images from Yaoundé. The monitors, proliferated throughout the space, are complemented by numerous headphones seeping sound from radio frequencies around the world, producing a cacophony of unintelligible competing sound and muddled language. This new work provides a forum for activating and literalizing global exchange, dialogue, translation, and untranslatability. L.F.

Crazy Nomad I Verrückter Nomade, 1999
Mixed media, dimensions variable I Verschiedene Materialien,
Maße variabel
Installation view I Installationsansicht, Lombard-Freid Fine Arts,
New York

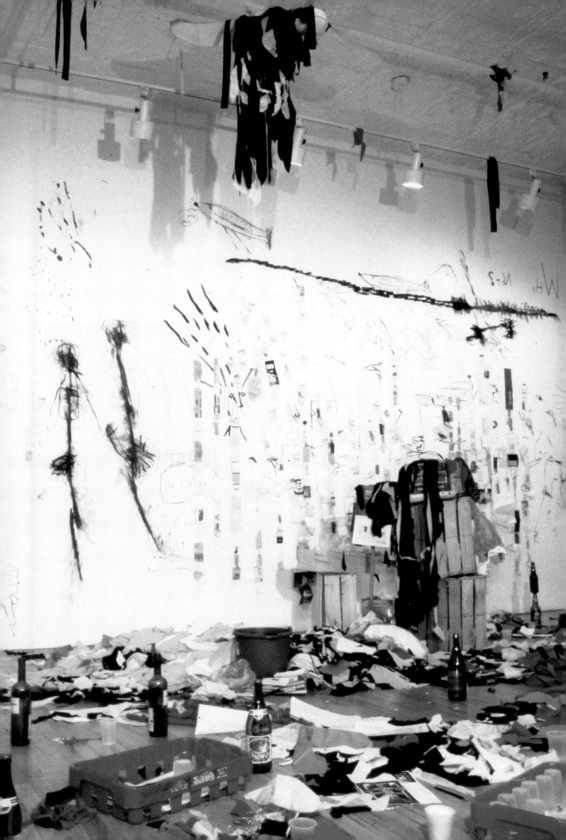

JEAN-MARIE TENO

*1954 in Famleng, Kamerun/Cameroon. Lebt/Lives in Issy les Moulineaux, Frankreich/France.

Im Mittelpunkt der Arbeit des Filmemachers Jean-Marie Teno stehen die Hinterlassenschaften des Postkolonialismus in den afrikanischen Gesellschaften, insbesondere in seinem Heimatland Kamerun. Sowohl in seinen Spielfilmen als auch in seinen Dokumentationen geht es ihm darum, die Probleme offen zu legen, die mit diesem Erbe in Afrika verbunden sind. Der Spielfilm *Clandestine* (1996) erzählt die Geschichte eines Mannes, der, nachdem er in Kamerun wegen Schwarzarbeit gefoltert und inhaftiert worden war, als illegaler Flüchtling nach Deutschland kommt. Von einer jungen deutschen Aktivistin ermutigt, kehrt er nach Kamerun zurück, um an der Veränderung der politischen Verhältnisse mitzuwirken. Seine Reise ist eine Metapher für die chaotischen Lebensbedingungen in den Städten Afrikas, den Wunsch nach selbst bestimmter Veränderung und für die abstrakten, vom freien Westen aufgezwungenen Vorstellungen von Gerechtigkeit.

Tenos Anliegen ist es, das Potenzial des Videofilms zu nutzen, um die Medienproduktion in Afrika zu stärken. Durch die geringen Herstellungskosten und einfachen Produktionsbedingungen ermöglichen Videos, persönliche Geschichten, die eindeutig auch politisch sind, zu entwickeln. Darüber hinaus können sie dem einheimischen Publikum durch privat organisierte Vorführungen zugänglich gemacht werden.

In einer Reihe neuerer Projekte untersucht Teno die Widersprüche der „tropischen Modernität", die die afrikanischen Gesellschaften angenommen haben. Nach den Worten eines Kritikers stellt Tenos Kino „die afrikanische Landschaft als Ort des Verlustes dar und das Subjekt als zerrissen zwischen dem, was ist, und dem, was niemals war". So erforscht *Afrique, je te plumerai* (Afrika, ich werde dich rupfen, 1992) den derzeit kritischen Zustand kultureller Produktion im Kamerun. Er führt ihn zurück auf die „zivilisierende Mission" der französischen Kolonialisten, die eine Klasse assimilierter Kameruner hervorgebracht haben, um die traditionelle Kultur und soziale Strukturen zu zerstören. *La tête dans les nuages* (Der Kopf in den Wolken, 1994) thematisiert den prosperierende Schattenwirtschaft, die in Afrika vielerorts zum Überleben notwendig ist, da ein parasitäres staatliches System die Wirtschaft ausblutet. Und *Chef* (1999) macht die Wurzeln autoritärer Herrschaft in der patriarchalischen Familie fest, in der unheilvollen Allianz von traditionellem Königtum und kolonialer Erfahrung.

In seinem neuesten Film *Vacances au pays* (Ferien auf dem Land, 2000) deckt Teno die falschen Versprechungen der postkolonialen Moderne auf. Die symbolische Verbindung zur großstädtischen Kultur des Westens, repräsentiert durch zwei einzeln stehende, moderne Betonhochhäuser in Kameruns Hauptstadt Jaunde, wird einer ständig abnehmenden Lebensqualität und einer nicht vorhandenen öffentlichen Versorgung gegenübergestellt. Diesen Konflikt symbolisieren für Teno die „Männer in Mänteln" – gut gekleidete Herren, die nicht einmal in der Lage sind, die Versorgung mit fließendem Wasser oder ein funktionierendes Verkehrswesen sicherzustellen.

The work of filmmaker Jean-Marie Teno focuses on the post-colonial heritage of African societies, particularly his native Cameroon. Teno's work shifts between feature film and documentary formats, but his ongoing concern remains to disclose the problems inherent to the colonial heritage in Africa. His feature film *Clandestine* (1996) traces the story of a man, who, after some clandestine work and brutal imprisonment, goes into illegal exile to Germany. He is inspired by a German activist to return to help change society in Cameroon, and his subsequent journey can be seen as a metaphor for the entanglement of the chaotic urban realities of Africa, the desire for self-governed change, and the abstract notions of justice yet again imposed by a disengaged West.

Teno has made a case for video's potential to reinvigorate media production in Africa. Benefiting from low production costs and easy operation, it makes it possible to develop personal stories which have an incisive political edge and can be accessible to local audiences through informal screening networks.

A recent series of projects has analyzed the paradoxes of the "tropical modernity" which African societies have embraced. As one reviewer put it, Teno's cinema "constructs the African landscape as a place of loss and the African subject as divided between what is and what never was." *Afrique, je te plumerai* (Africa I Will Fleece You, 1992) explores the current parlous state of cultural production in Cameroon and traces it to the civilizing mission of the French colonialists, who installed a class of assimilated Cameroonians as part of a strategy to destroy traditional culture and social structures. *La tête dans les nuages* (Head in the Clouds, 1994) investigates the burgeoning parallel economy essential for survival in many African economies impoverished by an essentially parasitic state sector. *Chef* (Chief, 1999) locates the roots of African authoritarian regimes based on the patriarchal family in a fatal alliance between traditional kingship and the colonial experience.

Teno's most recent film, *Vacances au pays* (A Trip to the Country, 2000), exposes the false promises of postcolonial modernism. The symbolic link to the metropolitan culture of the West, represented by two solitary modernist concrete tower blocks in Cameroon's capital Yaoundé, is contrasted with the ever-increasing degradation of the quality of life and the total lack of public services. For Teno, the dilemma is symbolized by the "men in overcoats"—sharp dressers who are unable even to ensure running water or a functioning transport system. M. N.

Vacances aux pays I *A Trip to the Country* I *Ferien auf dem Lande*, 2000
Film: 35mm and video, color, sound, 75 min. I 35-mm-Film und Video, Farbe, Ton, 75 Min.

TRINH T. MINH-HA

***1952 in Hanoi, Vietnam. Lebt/Lives in Berkeley, CA, USA.**

Als Schriftstellerin, Filmemacherin und Komponistin wurde Trinh T. Minh-ha durch ihre kreative Auseinandersetzung mit kulturellen Differenzen zu einer der führenden Stimmen im postkolonialen und postfeministischen Diskurs der achtziger und neunziger Jahre. In ihrem filmischen – so engagiert poetischen wie politischen – Werk untersucht sie anhand von Überschneidungen unterschiedlicher Kulturen, Genres und Disziplinen sowie visueller und musikalischer Bereiche die Grenzen zwischen Dokumentation und Fiktion, Realem und Inszeniertem, Innen und Außen. Die Erfahrungen der Heterogenität ihres eigenen kulturellen Hintergrundes als Vietnamesin zwischen American Way of Life (sie emigrierte 1970 in die USA), chinesischer Revolution, französischer Kolonialherrschaft und ihrer Tätigkeit als Musiklehrerin im Senegal von 1977 bis 1980 – anders gesagt, das „Aufpropfen" mehrerer Kulturen auf ein und denselben Körper – bewirken das bei Trinh immer wiederkehrende Motiv der Hybridität. Ihre frühen Filme sind ein eindrucksvoller Ansatz, die sinnlichen Erfahrungen der vietnamesischen und westafrikanischen Kultur zu veranschaulichen. Diese Arbeiten charakterisiert weniger die Transzendenz von Repräsentation zugunsten visionärer Präsenz und Spontaneität (wie Jean Rouchs Dokumentarfilme im Cinéma-Vérité-Stil) als vielmehr ein ethnografisches Interesse, genderspezifische Repräsentationspolitik zu entlarven.

Einer Poesie des Verweilens verpflichtet, experimentieren die 16-mm-Filme *Reassemblage* (1982) und *Naked Spaces – Living is Round* (1985) mit einem gesteigerten Bewusstsein für Klang, Musik, Umgebungsgeräusche und Momente der Stille à la John Cage, mit abrupten Kamerafahrten und plötzlichen Schnitten, um in den Genuss des Sehens und in die Wahrnehmung der für die jeweilige Kultur spezifischen Sinnlichkeit von Raum einzuführen. Trinh fängt ihre Filmgegenstände gleichzeitig aus unterschiedlichen Positionen und Blickwinkeln ein, um verschiedene Arten des Sehens und Betrachtens zu untersuchen. Die Präsenz der Kamera bleibt dabei freilich stets erkennbar. Ihre Kritik an der anthropologischen Ich-Perspektive ist zugleich als Kritik am männlichen Blick zu verstehen.

Surname Viet Given Name Nam (1989) kreist um Fragen von Identität, kollektivem Gedächtnis und Populärkultur und beleuchtet die Bedingungen des vietnamesischen Alltagslebens vornehmlich am Beispiel der Geschichte politischer Protestbewegungen von Frauen in Vietnam und in den USA. *A Tale of Love* (1995) befasst sich mit der Rolle des narrativen Raumes und dem Akt des Schauspielens im Film anhand einer Liebesgeschichte aus dem 19. Jahrhundert über das Mädchen Kieu, das mit Vietnam gleichgesetzt wurde. In einem ihrer neueren Filme, *The Fourth Dimension* (2001), erstellt die Autorin eine Art Reisebericht über Festivals, religiöse Zeremonien und Theaterereignisse, um die opake Realität Japans als Bild und visuelle Mechanismen wirksam in Ritualen des Reisens aufzulösen.

Dealing creatively with cultural differences, the writer, filmmaker, and composer Trinh T. Minh-ha is one of the major voices of postcolonial and postfeminist discourse of the 1980s and 1990s. In her film work, she poetically and politically explores the boundaries between documentary and fiction, the real and the staged, the inside and the outside at the interstitial spaces of several cultures, genres, disciplines, visual, and musical realms. Experiencing the heterogeneity of her own cultural background as a Vietnamese woman who triangulated between an American way of life (she emigrated 1970), the Chinese revolution, French colonialization and teaching music in Senegal from 1977–1980, the grafting of several cultures onto a single body is Trinh's recurrent motif of hybridity. Her early films represent a formidable attempt to materialize the sensual experiences that denote West African and Vietnamese cultures. Rather than transcending representation in favor of visionary presence and spontaneity (such as in Jean Rouch's cinema verité style documentaries) her early film work is characterized by an ethnographic interest that exposes a gendered politics of representation.

Engaged in a poetics of dwelling, her 16mm films *Reassemblage* (1982), and *Naked Spaces—Living is Round* (1985) experiment with a heightened awareness of sound, music, Cagean environmental noise and silence, abrupt camera movement and sudden cuts to inaugurate the pleasure of seeing and the perception of a sensuality of place that is specific to each culture. By portraying her subjects from different positions and angles simultaneously, Trinh explores various ways of seeing and looking, always acknowledging the presence of the camera. Her critique of the anthropological I/eye is also intended as a critique of the masculine gaze.

Surname Viet Given Name Nam (1989) evolves around questions of identity, popular memory, and culture, focusing on conditions of Vietnamese everyday life as seen through the lives and the history of women's resistance movements in Vietnam and in the US. *A Tale of Love* (1995) questions the role of narrative space, of acting, in filmmaking, taking recourse to a 19th-century love tale of Kieu, who has become identified with the nation of Vietnam. In one of her more recent films, *The Fourth Dimension* (2001), the filmmaker engages in a travelogue of festivals, religious ceremonies, and theatrical performances to unravel the opaque reality of Japan as an image and the visual machinery at stake in rites of traveling. N.R.

Naked Spaces: Living is Round | *Kahle Räume: Das Leben ist rund,* 1985
Film: 16mm, color, sound, 135 min. | 16-mm-Film, Farbe, Ton, 135 min.

TSUNAMII.NET

CHARLES LIM, TIEN WOON, TAY HAK PENG, CHARLES MOY,
MELVIN PHUA, TAN KOK YAM

Gegründet/Founded 2001 in Singapur/Singapore.

Technische Geräte wie Mobiltelefone und das Internet haben unsere Vorstellungen von Raum, Zeit, Distanz und die durch sie bedingten Beziehungen der Körper zueinander radikal verändert und erweitert. Wie Paul Virilio einmal bemerkte, hat die Geschwindigkeit unserer Kommunikation und Fortbewegung zu einem „weltweiten Phänomen geografischer und technologischer Schrumpfung geführt, die uns heute in ein künstliches topologisches Universum vordringen lässt". Diese „dromotechnologische Raumkontraktion" verdrängt freilich die Tatsache, dass geografische Standorte und die diesen Orten eigenen soziokulturellen, wirtschaftlichen und politischen Zusammenhänge unsere Erfahrungen weiterhin beeinflussen. Martin Dodge hat mit seinem Konzept der „Cybergeografie" aufgezeigt, wie der geografische Standort den Umgang mit dem Internet beeinflusst und damit kulturspezifische Eigenheiten hervorbringt. Der Vormarsch von den „location aware devices" genannten Ortungsgeräten, die ihre aktuelle geografische Position ermitteln und diese Information weiter übertragen können, hat in verschiedenen Technologiebereichen ein deutliches Umdenken in Bezug auf den Standort eingeleitet.

Die Arbeit von tsunamii.net ist darauf angelegt, die „geografisch neutrale" Konzeptualisierung des Internet zu unterwandern, indem der physische Standort zum Hauptbezugspunkt gemacht wird. Hierbei werden die Bewegungen eines Performers mit einem GPS-Satellitennavigationsgerät aufgezeichnet und per Mobiltelefon an eine Basisstation übermittelt, die diese Positionsangaben in Navigationsschritte im Internet umsetzt. Mit dem eigens von den Künstlern konzipierten Programm *Webwalker* wird das Gehen im realen Raum zur einzigen Möglichkeit, sich im Netz zu bewegen. So muss man sich, um beispielsweise zu einer bestimmten Internetseite zu „gehen", tatsächlich zum realen Standort des Servers bewegen, auf dem die Seite gespeichert ist. Auf diese Weise wird die physische Distanz, die beim Internet-Surfen normalerweise ausgeblendet wird, wieder in die räumliche Erfahrung integriert.

Die *Alpha 3.4* (2002) betitelte Arbeit für die Documenta11 besteht aus vier LCD-Bildschirmen, die auf dem Boden liegen und von denen jeder einzelne die räumlichen Bewegungen der Person des „webwalkers" auf andere Art abbildet. Der erste Bildschirm zeigt die IP-Adresse der Seiten an, die der Benutzer durch seine Schritte ansteuert, auf dem nächsten sieht man, wie ein Browser das Internet durchsucht und die der IP-Adresse entsprechende Website sichtbar macht. Am nächsten Schirm werden die geografische Position und die Route des Gehenden auf einer Satellitenkarte angezeigt, und auf dem letzten Schirm läuft ein „whois"-Programm, das den „second-level domain"-Namen der Webseiten (und damit die geografische Position der jeweiligen Seite) angibt und die Bewegungen im Web in Form von GPS-Koordinaten auf einer schematischen Weltkarte aktualisiert.

Technological devices like mobile phones and the net have come to mediate, conflate, and radically expand our notions of space, time, distance, and the bodily engagements implied by them. Paul Virilio noted that the speed of our communication and transportation technologies has resulted in "the worldwide phenomenon of terrestrial and technological contraction that today makes us penetrate into an artificially topological universe." However, this "dromotechnological contraction of space" tends to obscure the ways in which geographical location and the sociocultural, economic, and political complicities peculiar to these locations continue to affect our experiences. Martin Dodge's concept of cybergeography has shown how geographical location affects the operations and cultural specificities of the net. The increasing proliferation of location aware devices capable of identifying and transmitting information about their current geographical position has also initiated a serious rethinking of spatial location in various technologies.

The work of tsunamii.net seeks to unsettle the "geographically neutral" conceptualization of the net by making physical location the primary reference. It involves a performer whose physical movements are tracked by a GPS (Global Positioning System) device and sent via mobile phone to a remote base station that employs the positional data to initiate a series of web browsing movements. By way of a specially created program, *webwalker,* the artists have made walking in physical space the only means to browse the net. For example, if one wishes to "go to" a particular website one would have to move to the actual geographical location of the server that hosts the website to reach it. Thus, the notion of physical distance that is obscured when surfing the net is made integral to the spatial experience.

The work for Documenta11, *Alpha 3.4* (2002), comprises four LCD screens lying flat on the floor that each present a particular image of the spatial experiences of the walker. The first screen displays the IP address of the sites accessed by the walker's trajectory; the next screen shows the movements of a browser searching the net and bringing up for view the website corresponding to the IP address; on the following screen the geographical position and route of the walker are revealed on a satellite map; and the last screen features a "whois" program that identifies the second-level domain name of web sites (i.e. the geographical location of the particular website), and that updates the movements of the walker on the web as GPS coordinates on a schematic map of the world. G.N.

alpha 3.3, 2001
Webwalker walking from Singapore Art Museum to www.johore.my
(Johor Bharu, Malaysia) I Internet-Spaziergänger auf dem Weg
vom Singapore Art Museum zu www.johore.my (Johor Bharu,
Malaysia)

JOËLLE TUERLINCKX

*1958 in Brüssel/Brussels. Lebt/Lives in
Brüssel/Brussels.

Joëlle Tuerlinckx' intuitive, poetische Vermessung des Raums befasst sich eingehend mit Rahmenbedingungen von Wahrnehmung als Parameter künstlerischer Produktion. In ihren „film objects" und „exhibition objects" verwebt Tuerlinckx' transitive Praxis die phänomenologische Realität von Objekten und Subjekten als gleichwertige, sich gegenseitig definierende Körper in Augenblicke des sich in der Zeit Befindens. In Videoepisoden und fragilen Installationen, die aufs Wesentlichste reduziert die Inszenierung von Darstellung thematisieren, schafft Tuerlinckx ein „Nebeneinander" räumlicher Nähe, indem sie räumlichen Beziehungen zwischen Innen und Außen, zwischen Drei- und Zweidimensionalität ausweicht. Ihre *Stretch Films* (1999, 2000/01) erreichen einen Grad, der keine offensichtliche Bedeutung, Syntax oder Narration besitzt, und dekonstruieren so die Zweidimensionalität von Film und Malerei, indem sie auf die Wahrnehmungsdauer verweisen. Langsam rotierende, bunte Papierstreifen in Form von Fähnchen und geometrische Ausschneidefiguren an dünnen Stäbchen aus Holz, Papier oder Plastik erscheinen im Sucher der Videokamera, die den bedächtigen Bewegungen von Tuerlinckx' sich präzise durch den Raum bewegenden Fingern folgt.

In *FILMs D'ÉTUDE – série vues d'atelier + papier, barre, bâton* (2001) durchstreift die Kamera in neun am 21. Januar 2001 aufgenommenen Sequenzen von nur wenigen Minuten Länge scheinbar planlos Tuerlinckx' Atelier als einen möglichen Ort von Produktion. Tuerlinckx' „theory of walking" untersucht die Beweglichkeit des Raums und ist so ein philosophisches Mittel der Wissensproduktion, das auf Aktion, Bewegung und Ereignishaftigkeit beruht. Ihre Arbeiten gehen über die mechanisierte statische Beziehung von Hand, Kamera und Auge hinaus und nehmen die körperliche Dimension einer allumfassenden empirischen Realität der Wahrnehmung an.

In *Aqui Havia* (1998) erweitert ein langsamer Schwenk der Kamera um die Drehachse der Künstlerin den Blick auf das begrenzte, zweidimensionale Feld eines Graffiti an der Backsteinwand einer Lissaboner Kirche („Aqui havia historia – cultura agora 0", also „Hier haben wir Geschichte – Kultur hat 0") zu einem Landschaftspanorama. Auf der Documenta11 präsentiert Tuerlinckx ihr Video *Aqui Havia* neben anderen *Stretch Films* und reproduziert den gefundenen Satz als Wandbild. Mit einer geraden, zwischen Eingang und Ausgang gezogenen Linie legt sie den Weg durch ihre Installation von vornherein fest, um den Betrachter das Geschehen von Zerteilung und das daraus resultierende Bedürfnis nach Vervollständigung selbstreflexiv erfahren zu lassen.

Fragen der Beständigkeit (Konservierung und Archiv), der Namengebung (Identität) und Bedeutung (Symbolik), des Monumentalen und des Strebens nach Vollendung (als Objekt, Produkt) sind unentbehrliche Elemente von Tuerlinckx' unaufhörlichem Bestreben, die Rolle von Bewegung und Zeit in der Konstruktion von Raum auf subjektive Art zu erforschen.

Joëlle Tuerlinckx's intuitive and poetic taxonomy of space elaborates on the conditions of perception as parameters for art production. In "film objects" and "exhibition objects," Tuerlinckx's transitive practice entangles the phenomenological reality of object and subject as correlative bodies in moments of being in time. In episodic videos and frail installations that thematize the presentation of representation in its most reduced and fundamental form, the artist sidesteps, averts, or swerves around the spatial relations between inside and outside, three-dimensionality and two-dimensionality, in favor of an "alongside" of spatial proximity. Reaching a degree zero that has no apparent meaning, syntax, or narration, her *Stretch Films* (1999, 2000/01), deconstruct the flatness of film and painting by pointing towards the durational element of perception. Colored flag-shaped stripes of paper and geometric cutouts on thin wood, paper, and plastic sticks, slowly spinning and turning, appear in front of the video camera which follows the deliberate movement of the artist's fingers pinpointing through space.

In *FILMs D'ÉTUDE—série vues d'atelier + papier, barre, bâton* (2001), nine sequences of a few minutes length, shot on January 21, 2001, randomly assess the artist's studio as one possible locus of production. Tuerlinckx's "theory of walking" probes an elasticity of space that amounts to a philosophical mode of knowledge production based on action, movement, and the event. Extending the mechanized and static triangle of hand, camera, and eye, her works acquire a corporeal dimension of an all-encompassing empirical reality of perception.

In *Aqui Havia* (1998), the camera smoothly turns around the artist's pivotal axis and opens the limited two-dimensional field of graffiti on a brick wall of a church in Lisbon ("Aqui Havia Historia—Cultura Agora 0"; Here we have history—culture will have 0) into the surrounding landscape. For Documenta11, Tuerlinckx presents her video *Aqui Havia* as well as other *Stretch Films*, and recreates the found sentence as a wall drawing. Predetermining a pathway through her installation by drawing a straight line between entrance and exit, Tuerlinckx leads the viewer into a self-reflective experience of segmentation and the subsequent need for completion.

Questions of permanence (preservation and archive), designation (identity) and signification (symbol), of the monumental and of completion (as object, product) are integral to Tuerlinckx's ceaseless activities of subjectively exploring the role of movement and time in space. N.R.

AQUI HAVIA HISTORIA-CULTURA AGORA 0, a proposal for Documenta11 I ein Vorschlag für Documenta11
Video, color, 15 min. 7 sec., Lisbon, 1998 I Video, Farbe, 15 Min. 7 Sek., Lissabon, 1998

STRETCH VISION
FOUND SENTENCE
series

LUC TUYMANS

*1958 in Mortsel, Belgien/Belgium. Lebt/Lives in Antwerpen/Antwerp, Belgien/Belgium.

Luc Tuymans ist Maler. Seine Bilder zeichnen sich durch ein kleines Format aus, ihre Darstellungen sind figurativ und dennoch nicht leicht entschlüsselbar. Die Motive bleiben angedeutet, da Tuymans sie auf ihre Umrisse reduziert, vor leerem Hintergrund platziert oder ihnen Unschärfe verleiht. Der Titel verweist häufig nur interpretatorisch auf die Bildaussage.

Die wenigen Farben der Bilder sind fahl und stumpf, oft transparent aufgetragen und wirken ausgebleicht, manchmal fast immateriell. Obwohl die Gemälde formal den Charakter des Privaten tragen, bezieht sich Tuymans meist auf historische Inhalte, die zum kollektiven Gedächtnis gehören und bis heute nicht vollständig verarbeitet sind. Hierzu zählen die Gewaltherrschaft des Nationalsozialismus (*Signal*, 1978–2000), Flandern zur Zeit der Kollaboration (*Heimat*) oder die belgische Kolonialpolitik (Lumumba-Serie, 2000). Tuymans interpretiert Geschichte durch Kunstwerke, indem er die Ästhetik der Darstellung zur Befragung der Ethik des Dargestellten benutzt. Der ästhetische Charakter des Bildes eröffnet so die Möglichkeit der inhaltlichen Annäherung.

Für seine Ausstellungen bringt Tuymans Werke aus unterschiedlichen Jahren thematisch zusammen oder entwickelt ganze Bildserien. *Der diagnostische Blick* (1992) ist eine solche Werkgruppe, bei der das Bild der Diagnose einer Krankheit dient. Trotz naturalistischer Malweise wird erst bei genauer Betrachtung ein Krankheitsbild erkennbar. Dem Künstler geht es hier um die Darstellung eines Traumas, aber auch eines „absurden Interesses an menschlichem Leid, das … die Bedeutung eines Konsumgutes erreicht hat."

Mit ungewöhnlichen Fokussierungen und Perspektiven erreicht Tuymans in seinen Bildern eine Distanzierung und Verfremdung von kaum wahrgenommenen alltäglichen Dingen und verleiht ihnen so eine übergeordnete Bedeutung. Tuymans hatte Anfang der achtziger Jahre begonnen, Filme zu produzieren, weil er die Malerei als zeitgenössisches Medium in Frage stellte. Dann aber erkannte er die Malerei als Potenzial, ein Motiv gleichzeitig erscheinen und sich auflösen zu lassen: „Der kleine Raum zwischen der Erklärung des Bildes und dem Bild selbst gibt die einzig mögliche Perspektive auf die Malerei." Bis heute ist seine Malerei von der Auseinandersetzung mit dem bewegten Bild geprägt. Während beim Film eine Aussage aus zahlreichen Bildsequenzen heraus entwickelt wird, verweist das gemalte Bild als Konzentrat auf einen umfassenderen Inhalt: „Jedes Bild ist unvollständig, so wie auch jede Erinnerung unvollständig ist."

Luc Tuymans is a painter. A hallmark of his paintings is their small format; his subjects are figurative but nevertheless not easily deciphered. He appears only to allude to motifs, by either reducing them to their outlines, placing them before an empty background, or blurring them. Even though titles can identify what is portrayed, they often only hint at a possible interpretation of the picture.

Color is reduced, pale and dull, frequently transparent, appearing faded, almost incorporeal. Though most of the paintings have a private character, Tuymans refers to historical events and occurrences within collective memory, which still disturb us to this day. These include the violent regime of the National Socialists (*Signal*, 1978–2000), Flanders during the collaboration (*Heimat*), and Belgian colonial policy (Lumumba series, 2000). Tuymans is able to interpret history through an artwork, since the aesthetics of representation create a challenge to the ethics of what is represented. The aesthetic quality of the painting is what first allows the viewer to address its content.

Tuymans collects works from over several years for his exhibitions, and he also often creates groups of works. *The Diagnostic View* (1992) is such a group, in which a painting can serve as the diagnosis of an illness. Although the style of these works is naturalistic, the illness can only be seen after close observation. Here, paintings portray trauma, but also "the absurd interest in human suffering, which … has attained the status of a consumer good."

With unusual focus and perspective, Tuymans's pictures achieve distance and alienation from ordinary, barely perceptible things—something that lends them superior thematic importance. At the beginning of the 1980s, Luc Tuymans first began producing films, because he questioned painting as a contemporary medium. Then, however, he saw that painting was a chance to allow a theme to simultaneously appear and dissolve: "The small gap between the explanation of a painting and the painting itself creates the only possible way of looking at painting." To this day, Tuymans's painting is marked by his exploration of the moving picture. But unlike film, where countless sequences of images develop a statement, the painted image—a condensation—refers to a more comprehensive content. "Every image is incomplete, just as every memory is." A.N.

Reconstruction | *Wiederaufbau*, 2000
Oil on canvas | Öl auf Leinwand, 113 x 123 cm

NOMEDA & GEDIMINAS URBONAS

Nomeda Urbonas: *1968 in Kaunas, Litauen/Lithuania.
Gediminas Urbonas: *1966 in Vilnius, Litauen/Lithuania.
Leben/Live in Vilnius.

Nomeda und Gediminas Urbonas organisieren interdisziplinäre Kunstprogramme unter dem Titel *jutempus* mit dem Ziel, neue Rahmenbedingungen für die zeitgenössische Kunstpraxis zu entwickeln und kreative und kritische Diskurse zu ermöglichen. Das Projekt wirkt im physischen, medialen und sozialen Raum, funktioniert subversiv und vermittelt Bildungsimpulse an die Kunstwelt und die gesamte Gesellschaft, die gerade eine Zeit dramatischer Umbrüche durchlebt.

1998/99 starteten Nomeda und Gediminas Urbonas gemeinsam mit anderen Künstlern das Projekt *tvvv.plotas* (das litauische Wort „plotas" bedeutet Raum oder konspirative Vereinigung), das einige ganz zentrale Diskurse (Künstler/Kommunikation, Künstler/Bildung, Künstler/Institution, Künstler/Kooperation, Künstler/Körper, Künstler/Familie) anstieß und in der Form einer Fernsehreihe produziert wurde. Die im litauischen Staatsfernsehen ausgestrahlten und in Videokonferenzen diskutierten Sendungen fungierten nicht nur als Mittel der konspirativen Intervention zeitgenössischer Kunstpraxis im sozialen Raum, sondern auch als Labor zum Erproben der Sprache neuer Medien: Zur Systematisierung der gesammelten Informationen und zur Einrichtung des Interfaces wurden international gängige Werkzeuge des Webdesigns verwendet.

In dem jüngsten, im Jahr 2000 angelaufenen Projekt *Transaction* werden die schon angewandten Techniken der Kommunikation, wie mediale Zusammenarbeit, Diskussion, Informationspräsentation und -vermittlung eingesetzt, um Identitätspolitik zu untersuchen. Das Projekt erforscht die Repräsentation des Weiblichen in den Bildern der Medien und seine Auswirkungen auf das soziale Verhalten von Frauen; sein Schema basiert auf dem aus der psychologischen Transaktionsanalyse bekannten dramatischen Dreiecksverhältnis zwischen Opfer, Verfolger und Retter. Die Struktur ist gewissermaßen „trialogisch": Beteiligt sind zum einen feministische litauische Intellektuelle, die Frauenrollen in litauischen Filmen analysieren, dann ein Archiv von zwischen 1947 und 1997 entstandenen litauischen Filmen und litauische PsychiaterInnen, die die Lebensgeschichte eines bestimmten Opfers kommentieren. *Transaction* bietet theoretische Einblicke und eine Plattform für Kommunikation, an der vornehmlich die ZuschauerInnen teilnehmen, wenngleich sich das Projekt auch an einen weiteren Kreis von ExpertInnen vor Ort und weltweit wendet.

Das modulare Schema von *Transaction* ermöglicht es, das Projekt auf unterschiedliche Arten zu präsentieren und seine Raumerzählungen zu variieren. Zur Documenta11 werden hauptsächlich medienhistorische Einheiten gezeigt, welche die Aneignung neuer Produktionsmodi durch die Medien thematisieren – die Dekonstruktion von Bildern durch die Animation und das Nachzeichnen der weiblichen Stimme im audiomedialen Diskurs.

Nomeda and Gediminas Urbonas organize interdisciplinary art programs under the title *jutempus,* with the aim of developing new frameworks for contemporary art practices and facilitating creative and critical discourse. The project extends in various directions (physical, media space, and social environment), functions subversively, and educates both the art community and a society going through a dramatic period of changes.

In 1998/99, in collaboration with other artists, Nomeda and Gediminas Urbonas released the project *tvvv.plotas* (in Lithuanian "plotas" means space or conspiratorial party), where a few major discourses (artist/communication, artist/education, artist/institution, artist/collaboration, artist/body, artist/relatives, etc.), designed as a series of programs, were broadcast on Lithuanian national TV and discussed by videoconference. The *tvvv.plotas* was not only a means for the conspiratorial intervention of contemporary art practice into social space, but also a laboratory for testing the language of new media. Tools of global web design were used to order the information gathered and to create the interface.

In the latest project *Transaction,* launched in 2000, the previously applied techniques of collaboration, discussion, packaging of information, and disseminating it through media channels in the shape of communicative design are employed for the investigation of the politics of identity. The object of research is female representation in media images and its impact on the social behavior of women. The model of the project is based on the pattern of the dramatic triangle of victim, persecutor, and rescuer, taken from transactional analysis. The structure is a three-way dialogue between Lithuanian feminist intellectuals introducing female scripts in Lithuanian films, an archive of films made in 1947–1997, and Lithuanian psychiatrists commenting on the life script of a victim. *Transaction* provides theoretical insight and a platform for communication—the participants of which are above all spectators, though the project also addresses a wider circle of professionals locally and internationally.

The composite character of *Transaction* makes it possible to vary its presentation, arranging and rearranging its spatial narratives. For Documenta11, the project focuses on the history of media taking up other modes of production— the deconstruction of images through animation and the mapping of the female voice in the discourse of sound media. L.J.

Transakcija I *Transaction* I *Transaktion,* since I seit 2000
Collaborative project, including film archive, video projections, sign system I Gemeinschaftsprojekt mit Filmarchiv, Videoprojektionen, grafisches Zeichensystem

The ideal woman in
Lithuanian cinematography is
mother, which has the
function of giving birth,
educating children, etc.
And this is one of the main
images in Lithuanian
cinematography, in terms of
all images I remember.
So this principle is possible to
apply in reality, because we
used to recreate it for
ourselves and model the
environment where we lived
by laws of supposed reality
and when finally all obstacles
disappeared and everything
became available, the reality
turned out to be alien
image and fantasy. I think
that it is closely related to
cinematography, because
cinematography used to be
the main factor in the
development of esthetic and
moral criteria. This dual
interaction with the reality is
quite interesting.

JEFF WALL

***1946 in Vancouver, Kanada/Canada. Lebt/Lives in Vancouver.**

Nach einem Studium der Kunstgeschichte begann Jeff Wall in den siebziger Jahren mit der Entwicklung der eigenen künstlerischen Arbeit. Walls „konzeptuelle Fotografie" steht in enger Beziehung zur Konzeptkunst dieser Zeit, setzt sich jedoch über deren Tabuisierung des Bildes hinweg. Seit 1978 arbeitet er mit großformatigen Diapositiven in Leuchtkästen. Seine Bilder erzählen Geschichten, deren Darstellung – in der Mehrheit Alltagsszenen – zuerst wie eine beiläufige Beschreibung erscheinen (*Diatribe,* 1985; *The Crooked Path,* 1991), um dann als theatralische Inszenierung von geradezu krisenhafter Zuspitzung kenntlich zu werden (*Eviction Struggle,* 1988; *Outburst,* 1989). Als sei der Fotograf unvorhergesehen auf Szenen gestoßen, in der Handlungen im Moment des Auslösens der Kamera noch in der Entwicklung begriffen sind, wirken die aufwändig konstruierten Bilder wie zufällig geknipst. Wall etabliert in seinen Fotografien bewusst ein Moment der Entfremdung, das sie von einfacher Dokumentarfotografie unterscheidet. Die Auswahl von Orten und Personen folgt einer intuitiven und zugleich systematischen Suche nach einer Typologie der Gegenwart. Wall zeigt neben vereinzelten Menschen Vororte, industrialisierte Landschaften und nächtliche Straßen – Schattenseiten einer rationalisierten und sozial wie ethnisch fragmentierten Gesellschaft, in welcher Zukunft ungewiss ist. Er arbeitet mit Laienschauspielern, die in vorgegebene, typisierte Identitäten schlüpfen. Die urbanen oder häuslichen Szenarios sind gestellt, Details und handelnde Personen werden in aufwändigen Einzelaufnahmen festgehalten und dann zu einem Gesamtbild montiert. Wall bezieht sich dabei auf Traditionen des Films (Buñuel, Godard, Fassbinder) und vor allem der Malerei, die das Flüchtige und das Zufällige des modernen Alltags zu erfassen, zu deuten und mit einem Moment des „Ewigen" zu verbinden sucht – wie das bereits Baudelaire im 19. Jahrhundert gefordert hatte.

Walls Fotografien sind freilich auch Bilder des kulturellen Gedächtnisses, denn er verwendet zahlreiche Vorlagen aus der Kunstgeschichte und der Literatur. In seiner Arbeit für die Documenta11, *The Invisible Man* (1999), bezieht sich Wall auf den gleichnamigen Roman Ralph Ellisons. Sie zeigt den zentralen Rückzugsort des Protagonisten, seine Kellerwohnung in Harlem, in der dieser mit Hilfe von 1.369 Glühlampen jene Helligkeit erzeugt, die ihm die Gewissheit über die eigene Existenz verleiht. Im Bild des Ortes, an dem sich der Protagonist, unsichtbar für die Außenwelt, auf eine zukünftige Rolle in der Gesellschaft vorbereitet, verdichtet Wall das Potenzial der Selbst- und Welterkenntnis, von der der Roman handelt. Die kritische Rekonstruktion der durch den Kapitalismus als Erbe der Aufklärung geprägten Gegenwart zeigt sich hier gepaart mit Momenten der Hoffnung und der Überzeugung von der Heilkraft der Kunst.

After completing a degree in art history, Jeff Wall began working as an artist in the 1970s. His "conceptual photography" is closely related to Conceptual Art of the 1970s, yet disregards the intrinsic taboo of the image. In 1978, he began working with large-format transparencies in light boxes. His works tell stories by using images of everyday scenes that alternate from seemingly casual portrayal (*Diatribe,* 1985; *The Crooked Path,* 1991), to theatrical arrangements, moments of climactic crisis (*Eviction Struggle,* 1988; *Outburst,* 1989). The extravagantly produced photographs seem accidental, as if the photographer had come upon unexpected scenes whose plots were still under way at the moment the shutter released. Wall deliberately works with a moment of estrangement that distinguishes his work from mere documentary photography. His choice of people and places follows an intuitive yet systematic search for a contemporary typology. He depicts suburbs, industrialized landscapes, nocturnal streets, and isolated people; these are the dark sides of a rationalized, ethnically and socially fragmented society in which the future is uncertain. He works with lay actors who slip into predetermined, idealized identities. The urban or domestic scenarios are staged; details and characters are captured in laborious individual takes and only brought together as an entire image during the montage process. Wall draws upon traditions in film (Buñuel, Godard, Fassbinder) and painting that capture the fleeting and coincidental nature of modern life, interpreting it and connecting it with some "eternal" moment—the kind of art Baudelaire had called for in the 19th century.

Wall's photographs are also images of cultural memory, making use of models from the history of art and literature. In his work for Documenta11, *The Invisible Man* (1999), Wall alludes to the novel by Ralph Ellison. We see the protagonist's main place of retreat, his basement apartment in Harlem, in which 1,369 light bulbs produce the light that reassures him of his existence. By choosing this location where the protagonist, invisible to the outside world, is preparing himself for a future role in society, Wall heightens the potential for knowledge of the self and of the world, as dealt with in the novel. He critically reconstructs a present shaped by capitalism (as the heir to the Enlightenment), coupling this with moments of hope and a conviction in art's potential to heal. C.M.

Invisible Man | Der unsichtbare Mann, 2001
Cibachrome transparency, aluminum light box | Cibachrome-Diapositiv, Aluminium-Leuchtkasten, 240 x 320 cm

NARI WARD

***1963 in St. Andrews, Jamaika/Jamaica. Lebt/Lives in New York.**

Nari Ward verarbeitet im öffentlichen Raum aufgelesene Fundstücke zu Skulpturen und Installationen und stellt mit persönlichen Erfahrungen aufgeladene Szenen nach. Dabei greift er auf seine scheinbar unerschöpfliche Sammlung von überholten Haushaltsgegenständen – Waschmaschinen, Stereogeräte, Bügelbretter, Kinderwagen und Bettsprungfedern – zurück, um einen normalerweise sachlich-nüchternen Galerieraum in eine Spielwiese der Vorstellungskraft zu verwandeln. In der Installation *Happy Smilers: Duty Free Shopping* (1996) sind Teile der Autobiografie des Künstlers als Mikro-Erzählung in die Makro-Erzählung des postkolonialen Austauschs eingewoben. In einem sonnig-gelb gestrichenen und mit „Tropical Fantasy"-Getränkeflaschen geschmückten Raum läuft die Musik der Happy Smilers, einer jamaikanischen Band, in der Wards Onkel spielte. In einem anderen Raum bildet eine Wand aus mit Feuerwehrschläuchen gebündeltem Sperrmüll einen schmalen Korridor, durch den der Betrachter hindurchgehen muss, um in den mit Sand bedeckten Innenraum der Installation zu gelangen. Wäre nicht die Feuerleiter eines New Yorker Apartmenthauses in Originalgröße an die Decke montiert gewesen, hätte man sich vorübergehend in dem Labyrinth und der Musik irgendeines fernen Ortes verlieren können. Durch irreführende Details und absurde Proportionen erzeugt *Happy Smilers: Duty Free Shopping* eine Erfahrung voller Zwiespältigkeit und vielschichtiger Gefühle.

Wie die von den Straßen der Stadt aufgelesenen Gegenstände legt Wards Installation *Rites-of-Way* (2000) Teile der Geschichte und Lokalgeschichte(n) von St. Paul, Minnesota, offen. Die Arbeit folgt dem Grundriss eines Eispalasts in St. Paul, den der afroamerikanische Architekt Clarence Wigington in den vierziger Jahren entworfen hat, und zeigt Objekte, in denen sich persönliche Geschichten der ortsansässigen Gemeinden bewahrt haben. Sie erinnert damit an die Architektur und das Rondo-Viertel, das in den fünfziger Jahren durch den Bau des I-94-Highways in zwei Teile zerschnitten wurde. Ward verschickte von ansässigen Jugendlichen beigesteuerte Päckchen an nicht mehr existente Adressen in Rondo – Referenz an das Postamt, das ebenfalls zu Wigingtons Entwurf gehört hatte. Beiläufig auf Geschichten bauend geriet *Rites-of-Way* zur physisch beeindruckenden Skulptur aus leeren Häuschen auf Gänge bildenden Gerüsten, von denen wie Eis glitzernde Perlenvorhänge herunterhingen.

Landings, Wards Arbeit für die Documenta11, ist aus Sportkinderwagen, Sprungfedern und Kabeln konstruiert, Materialien, die auch schon in vielen früheren Arbeiten Verwendung fanden. Der hohe Baum wird durch eine Reihe von Kabeln aufrecht gehalten, die bei Einrasten eines Gelenks im unteren Bereich des Baumes nachgeben und den Baum kippen lassen. Das Versagen der Natur wie der Kultur transportierend steht *Landings* für das schwierige Kunststück, neues Leben in eine von dysfunktionalem Müll überschwemmte Welt zu bringen.

Nari Ward uses detritus collected from public environments to create sculptures, installations, and enactments replete with personal experience. Using his seemingly endless collection of dated household items such as washing machines, stereos, ironing boards, baby carriages, and bed springs, Ward transforms an otherwise dispassionate gallery setting into a playground for the imagination. In the installation *Happy Smilers: Duty-Free Shopping* (1996), bits of the artist's autobiography are woven as a micronarrative into the metanarrative of postcolonial exchange. A room painted sunny yellow and adorned with Tropical Fantasy drink bottles broadcasts island music by the Happy Smilers, a Jamaican band Ward's uncle played in. In another room a wall constructed of bundled junk home furnishings tied together with fire hose creates a small corridor, which viewers had to pass through to enter the space's interior with a floor of thick sand. Were it not for the full-scale New York apartment building fire escape that was attached to the ceiling, one might have become momentarily lost in the maze and music of some far away place. With disorienting details and preposterous proportions, *Happy Smilers: Duty-Free Shopping* produces an experience full of ambiguity and layered sentiment.

Like the physical materials recovered from city streets, Ward's installation *Rites-of-Way* (2000) uncovered pieces of history and community stories. Recreating the floor plan of a 1940's St. Paul, Minnesota, ice palace designed by African-American architect Clarence Wigington and displaying objects that contained personal stories of local community groups, the work recalls both the ice palace's architectural design and the city's Rondo neighborhood that was bisected in the 1950's by the I-94 highway. Ward sent packages donated by local youths to discontinued Rondo addresses, paying homage to the working post office that was part of Wigington's design. Though constructed of ephemeral stories and circuitous routes, Rites-of-Way was a physically impressive sculpture of small empty houses standing atop scaffolded passageways that were outlined by beaded curtains sparkling like ice.

Landings, Ward's work for Documenta11, is constructed of baby strollers, bed springs and cables, materials which have been included in numerous earlier works. This tall mechanical tree is held erect by a series of cables, which lose their tension when a hinge is engaged at the lower portion of the trunk to let the tree fall. Conveying the failure of both nature and culture, *Landings* embodies the oxymoronic task of breeding new life into a world overcrowded with dysfunctional refuse. C.S.R.

Rites-of-Way, 2000
Steel, plastic, beads, vinyl, coated stainless-steel cable, fiberglass I Stahl, Kunststoff, Perlen, Vinyl, beschichtetes, rostfreies Stahlseil, Fiberglas
Temporary installation through approx. 2002 I Temporäre Installation bis voraussichtl. Ende 2002, Walker Art Center, Minneapolis, Minnesota

YANG FUDONG

*1971 in Peking/Beijing. Lebt/Lives in Shanghai, China.

Yang Fudongs Arbeiten sind an der Schnittstelle des traditionellen China und der zunehmenden Internationalität urbanen Lebens situiert. Seit den späten neunziger Jahren untersucht Yang das imaginative Potenzial von Erzählungen über Freiheit, Freundschaft, Liebe, Krieg und Krankheit, indem er die Tatsache, dass heute selbst das Dasein zur Ware geworden ist, mit traditionellen chinesischen Glaubensvorstellungen von der harmonischen Einheit von Mensch und Natur synthetisiert.

Yangs erster 35-mm-Schwarz-Weiß-Film *An Estranged Paradise* (1997–2002), eine poetische und detailorientierte Meditation über Frieden, Langeweile, Liebe und Melancholie – unausweichlich mit dem Leben verbunden – erinnert an eine Zeit noch vor der Allgegenwart von Information und globalem Kapital. Zhuzi, ein junger Intellektueller, lebt mit seiner Verlobten Linshan in Hangzhou, einer malerischen Stadt, deren Name in der Umgangssprache „Paradies" bedeutet. Er leidet an einer eingebildeten Krankheit, die er nicht als bloße Ruhelosigkeit erkennt, und die mit dem Ende der Regenzeit in Hangzhou wieder verschwindet. Selbsterkenntnis mischt sich hier mit dem Respekt vor der natürlichen Umwelt, in der Raum, Zeit, Wandel, Empfindungen, Gefühle und Geschichten in wesenhafter Verbindung zur Natur stehen. Die Erzählungen in Yangs Mehrkanal-Videoinstallationen *Tonight's Moon* (2000) und *Su Xiao Xiao* (2001) sind um einen traditionellen chinesischen Gartenteich konstruiert, in dem – mittels digital eingefügter Videosequenzen – Menschen schwimmen und Boot fahren. In *Su Xiao Xiao* – betitelt nach einer legendären, literarisch talentierten Schönheit der Tang-Periode – inszeniert Yang seine romantischen Visionen auf einer zehn Meter breiten, von zahlreichen Monitoren flankierten Projektionsfläche: Er spinnt den Betrachter in einen Kokon verschiedener Fragmente von Erzählungen über die Liebe und das Leben ein, die vor einer künstlichen Landschaft mit Bergen und Pflanzen spielen. Ähnlich den berühmten, nach Stadtansichten und Landschaftsbildern angelegten chinesischen Lustgärten des 16. Jahrhunderts wird hier stellvertretend für die ganze Welt ein Mikrokosmos in der Zeit arrangiert, um den Rhythmus des Lebens als Wandel von Tag und Nacht und als Abfolge der Jahreszeiten zu reflektieren. Im Gegensatz zu westlichen Paradiesvorstellungen einer idealen Vision von Perfektion nach dem wirklichen Leben mutet Yangs Himmel auf Erden üppig, sinnlich – manchmal – erotisch an.

Backyard: Hey! Sun Is Rising (2000) ist ein Kurzfilm über Kameradschaft, Krieg und die Rituale des Tötens. Er verpflanzt das Leben von vier jungen Männern, gekleidet in Mao-Uniformen, mit seinen banalen, geruhsamen, aber auch gefährlichen Seiten in die urbane Landschaft heutiger Megastädte. In Yangs Fotoessay *The First Intellectual* (2000) verschmelzen die Unterscheidungen zwischen Gewalt und Revolution im Bild eines aufgebrachten chinesischen Geschäftmanns: Vor der Kulisse einer großstädtischen Skyline allein auf der Straßenmitte stehend, hält er in seiner erhobenen Hand einen Ziegelstein, während ihm Blut aus der Nase rinnt.

Yang Fudong's work is situated at the interstice of traditional China and the ever increasing cosmopolitanism of urban living. Since the late 1990s, the artist has been synthesizing traditional Chinese belief systems in the harmonious unity of nature and humankind with the commodification of being, with a view to exploring the imaginative capacities of narratives of freedom, friendship, love, war, and sickness.

Yang's first 35mm black-and-white feature film *An Estranged Paradise* (1997–2002), a poetic, detailed meditation upon life's inescapable moments of peace, boredom, love, and melancholia, recalls a time before ubiquitous information and global capital. Zhuzi, a young intellectual living with his fiancée Linshan in Hangzhou—a picturesque city called "paradise" in the vernacular—goes through an imaginary illness he fails to recognize as a form of restlessness, before it clears out as the rainy season in Hangzhou draws to its close. Self-knowledge is interwoven with a respect for the natural world where space, time, change, feelings, emotions, and stories connect with the essence of nature. In Yang's multiple channel video installations *Tonight's Moon* (2000) and *Su Xiao Xiao* (2001), both narratives are constructed around a traditional Chinese garden pond containing digitally inserted footage of people swimming and boating. In *Su Xiao Xiao*—the name of a legendary beauty of the Tang period blessed with literary talent—Yang stages his romantic visions on a projection screen 10 meters in width and surrounded by numerous monitors, and encapsulates the viewer in a cocoon of different fragmented narratives on love and life set in an artificial landscape of mountains and plants. Reminiscent of the famous 16th-century Chinese gardens for lingering modeled after urban sceneries and visions of landscape painting, a microcosm of the world is arranged to reflect, within the passage of time, the rhythm of life as the dissimilarity between morning and evening and the succession of the seasons. In contrast to Westernized images of paradise presenting an ideal vision of perfection beyond real life, Yang's heaven on earth is luscious, sensual, and at times erotic.

Backyard: Hey! Sun is Rising (2000) is a short film on comradeship, war, and the rituals of killing that places the banal and leisurely, and yet also dangerous sides of the lives of four young men in Mao uniforms in the urban scenery of today's megalopolis. In Yang's photo essay *The First Intellectual* (2000), the distinction between violence and revolution is revoked in the image of a highly agitated Chinese businessman who, holding a brick in his raised hand while blood runs from his nose, stands alone in the middle of a road against the backdrop of the city skyline. N. R.

Su Xiao Xiao, 2001
Video installation I Videoinstallation

DOCUMENTA11_FILMPROGRAMM
DOCUMENTA11_FILMPROGRAM

Bali Kino I Bali cinema, Kassel
10.Juni–15.September 2001 I
June 10–September 15, 2002

Das Documenta11_Filmprogramm würdigt das Medium Film in einem Präsentationsrahmen, der den speziellen technischen, räumlichen und zeitlichen Bedürfnissen des Mediums nachkommt. Es ist ein integraler Bestandteil der fünften Plattform der Documenta11 und wird im Bali Kino in Kassel parallel zur Laufzeit der Ausstellung gezeigt. Um die größtmögliche Zugänglichkeit der im Programm versammelten Filme auch für auswärtige Besucher und Gäste zu gewährleisten, wird ein wöchentliches Programm mit drei Vorführungen pro Tag während der gesamten 100 Tage kontinuierlich wiederholt.

Ein separates Programm mit Spielzeiten, ausführlichen Informationen zu den gezeigten Filmen und den Filmemachern ist erhältlich.

The Documenta11_Filmprogram allows for the appreciation of film appropriate to the specific technical, spatial, and temporal needs of the medium. As an integral part of Documenta11's fifth platform it is presented at the Bali cinema in Kassel, simultaneously with the exhibition. Allowing visitors the greatest opportunity to see all films, a weekly program of three screeinings per day is repeated throughout the 100 days of the exhibition.

A separate program with a screening schedule, extensive information on the films included and the filmmakers is available.

Auswahl der Filme, die wöchentlich im Documenta11_Film-
programm in Zusammenarbeit mit dem Bali Kino in Kassel
gezeigt werden

Shown in collaboration with the Bali cinema Kassel the
following is a selection of films included in the Documen-
ta11_Filmprogram:

D'Est (Von Osten I From the East)
Chantal Akerman, 1993, Belgien I Belgium, 35 mm, 107
min.

Sud (Süden I South)
Chantal Akerman, 1999, Belgien I Belgium, Video, 70 min.

Chile, I Don't Take Your Name in Vain
Colectivo Cine Ojo, 1983, Chile, 16 mm, 55 min.

Atanarjuat (The Fast Runner)*
Igloolik Isuma Productions, 1999, Kanada I Canada, 35
mm, 163 min.

Territories
Isaac Julien, 1984, GB, 16 mm, 25 min.

Looking for Langston
Isaac Julien, 1989, GB, 16 mm, 40 min.

The Attendant
Isaac Julien, 1993, GB, 35 mm, 10 min.

Of Poems and Prophecies (Arbeitstitel I working title)*
Amar Kanwar, 2002, Indien I India, Digi Beta DV Cam, ca.
60 min.

Amsterdam Global Village
Johan van der Keuken, 1996, NL I The Netherlands, 35
mm, 245 min.

Ticket to Jerusalem*
Rashid Masharawi, 2002, Palästina I Palestine, 35 mm, 85
min.

Reminiscences of a Journey to Lithuania
Jonas Mekas, 1971-72, USA, 16 mm, 82 min.

As I Was Mowing Ahead Occasionally I Saw Brief Glimpses
of Beauty
Jonas Mekas, 2000, USA, 16 mm, 288 min.

Taiga
Ulrike Ottinger, 1991-92, BRD I Germany, 16 mm, 501
min.

Umbracle
Pere Portabella, 1971-72, Spanien I Spain, 35 mm, 85
min.

Puente de Varsovia (Warschauer Brücke I Warsaw Bridge)
Pere Portabella, 1989, Spanien I Spain, 35 mm, 85 min.

Izkor, les esclaves de la mémoire (Sklaven der Erinnerung I
Slaves of Memory)
Eyal Sivan, 1990, Frankreich I France, 16 mm, 97 min.
Aqabat-Jaber, paix sans retour? (Frieden ohne Rückkehr? I
Peace with No Return?)
Eyal Sivan, 1995, Frankreich I France, 16 mm, 61 min.

Chef!
Jean-Marie Teno, 1999, Frankreich I France, 16 mm, 61
min.

Reassemblage
Trinh T. Minh-ha, 1982, Senegal, 16 mm, 40 min.

Surname Viet Given Name Nam
Trinh T. Minh-ha, 1989, USA, 16 mm, 108 min.

Shoot for the Contents
Trinh T. Minh-ha, 1991, China–USA, 16 mm, 102 min.

* Deutsche Erstaufführung I German Premiere

DOCUMENTA11_RADIO

In Zusammenarbeit mit ihrem Medienpartner, dem Hessischen Rundfunk/Hörfunk hr2, hat die Documenta11 eine Reihe von Künstlerprojekten realisiert, drei davon exklusiv für das Radio. Zusätzlich zu diesem gemeinsam produzierten Programmen strahlt hr2 während der Laufzeit der Ausstellung eine Reihe von weiteren Sendungen zur Documenta11 aus: Einzelbeiträge zu den vier Plattformen und zur Geschichte der documenta sowie diverse tägliche Berichterstattungenüber die Ausstellung. Genaue Sendezeiten sind dem Tagesprogramm zu entnehmen.

In collaboration with its media partner, the Hessischer Rundfunk/Hörfunk hr2, Documenta11 has co-produced three artists' projects for radio. In addition, Hessischer Rundfunk is creating a large number of special features on Documenta11 to be broadcast throughout the 100 days. These include individual features on the four platforms and the history of documenta, as well as several daily reports about the exhibition. For broadcast times, please refer to your local program listings.

Die folgenden Projekte wurden für Documenta11_Radio realisiert:

The following projects were realized for Documenta11_Radio:

Chantal Akerman
A Family in Brussels
Sendetermine I Broadcasts:
Teil 1: 6. Juli I Part 1: July 6, 2002
Teil 2: 13. Juli I Part 2: July 13, 2002
13.05–14.00 Uhr I 1:05–2:00 p.m.

On Kawara
One Million Years
Sendetermine I Broadcasts:
10. Juni–13. September I June 10–September 13, 2002
Montags bis Freitags, 12.00–12.30 Uhr I Monday to Friday, 12:00–12:30 p.m.
in der Sendung I during the program „Aus Politik und Kultur"

Juan Muñoz
A Registered Patent: A Drummer Inside a Rotating Box
Radioarbeit I Radio piece
Text von I by Juan Muñoz
Vorgetragen von I Performed by John Malkovich
Musik von I Music by Alberto Iglesias
Sendetermine I Broadcasts:
10., 17., 24. Juni I June 10, 17, 24, 2002
1., 8., 15., 22., 29. Juli I July 1, 8, 15, 22, 29, 2002
5., 12., 19., 26. August I August 5, 12, 19, 26, 2002
2., 9. September I September 2, 9, 2002
23.30 Uhr I 11:30 p.m.

hr2-Empfangsmöglichkeiten I Broadcast frequencies
UKW Südhessen: 96,7 / 95,3 / 97,4 MHz • Rhein-Main: 96,7 MHz • Mittelhessen: 96,7 / 99,6 / 95,0 MHz • Nordhessen: 95,5 / 99,6 / 95,0 MHz • Osthessen: 95,5 / 95,0 MHz
ADR (europaweit I throughout Europe)
Satellit Astra 1C, Transponder 40, Frequenz 11,0675 GHz / vertikal, Tonunterträger 6,30 MHz
www.hr2.de • hr2@hr-online.de • hr2-Hörertelefon: 069 155 4022

Medienpartner der | Media Partner of Documenta11

DOCUMENTA11_EDITIONEN

DOCUMENTA11_EDITIONS

Wie zum ersten Mal für die 4. documenta 1968 erscheint auch dieses Mal eine Reihe von Kunsteditionen, Objekte in verschiedenen Medien, die in Zusammenarbeit mit den Künstlerinnen und Künstlern eigens für die Documenta11 geschaffen wurden. Diese Editionen geben einen Einblick in den Geist und das künstlerische Programm der Documenta11.

Continuing a tradition begun with documenta 4 in 1968, a number of the participating artists have been invited to create a series of limited editions for Documenta11. These editions, comprised in different media, provide examples of the spirit and the artistic program of Documenta11.

Bernd und Hilla Becher
Fotografie s/w im Triplex-Druck I Photograph b/w printed in Triplex, c. 60 x 50 cm, Auflage I edition of 60

Zarina Bhimji
Farbfotografie in Leuchtkasten I Color photograph in light box, c. 60 x 50 cm, Auflage I edition of 40

William Eggleston
Farbfotografie in Leuchtkasten I Color photograph in light box, c. 50 x 60 cm, Auflage I edition of 15

David Goldblatt
Digitaldruck (Iris Giclée) auf Bütten I Digital print (Iris Giclée) on rag paper, c. 60 x 40 cm, Auflage I edition of 45

Dominique Gonzalez-Foerster
Dia in Leuchtkasten I Transparency in light box, c. 50 x 50 cm, Auflage I edition of 30

Mona Hatoum
Skulptur aus Marmor, Holz I Sculpture: marble, wood, c. 20 x 60 x 15 cm, Auflage I edition of 30

Thomas Hirschhorn
Objekt aus Pappe, Goldpapier, und Klebeband I Object: cardboard, gold paper, tape, c. 250 x 80 x 10 cm, Auflage I edition of 50

Candida Höfer
Farbfotografie, aufgezogen I Color photograph, mounted, c. 70 x 70 cm, Auflage I edition of 50

Pierre Huyghe
Filmstill I Film still, Technik, Maße und Auflage noch unbekannt I technique, measurements, and edition unknown to date

Alfredo Jaar
Farbfotografie in Leuchtkasten I Color photograph in light box, c. 36 x 96 x 9 cm, Auflage I edition of 30

William Kentridge
Papier-Collage auf Bütten I Paper collage on rag paper, c. 50 x 66 cm, Auflage I edition of 45

Mark Manders
Zeichnung im Digitaldruck I Drawing, digitally printed, c. 50 x 65 cm, Auflage I edition of 35

Shirin Neshat
Fotografie I Photograph, c. 41 x 51 cm, Auflage I edition of 35

Gabriel Orozco
Fotografie I Photograph, Maße und Auflage noch unbekannt I measurements and edition unknown to date

Manfred Pernice
Porzellanteller I China plate, c. 27 cm ø I in diameter , Auflage I edition of 50

Yinka Shonibare
Farbfotografie I Color photograph, c. 50 x 60 cm, Auflage I edition of 40

Fiona Tan
Filmstills I Film stills, Technik, Maße und Auflage noch unbekannt I technique, measurements, and edition unknown to date

Luc Tuymans
Kastenrahmen mit Collage hinter opak-Plexiglas I frame box with collage behind opaque plexi, c. 60 x 80 x 4 cm, Auflage I edition of 50

Editionen herausgegeben von I Editions published by
Edition Schellmann, München I Munich – New York, for Documenta11
Bestellungen an I Orders to Edition Schellmann, München I Munich
www.editionschellmann.com

Deutsche
Telekom **T** ▪ ▪

⑤ Finanzgruppe

**DIE FREIHEIT DER KUNST
IST EIN GRUNDRECHT.**

**UND WIR NEHMEN UNS
DIE FREIHEIT,
SIE ZU FÖRDERN.**

SEIT 1870

BINDING–BRAUEREI

AKTIENGESELLSCHAFT

Deutsche
Städte-Medien
GmbH

DOCUMENTA11_TEAM

Träger I Organizer
documenta und Museum Fridericianum Veranstaltungs-GmbH

Gesellschafter I Stockholders
Land Hessen
Stadt Kassel

Geschäftsführer I Chief Executive Officer
Bernd Leifeld

Prokurist I Authorized Signatory
Frank Petri

Aufsichtsrat I Supervisory Board
Georg Lewandowski, Oberbürgermeister, Kassel, Vorsitzender
Ruth Wagner, Staatsministerin, Wiesbaden, stellv. Vorsitzende
Bernd Abeln, Staatssekretär, Wiesbaden
Prof. Dr. Hans Brinckmann, Kassel
Dr. Michael Eissenhauer, Staatliche Museen, Kassel
Bärbel Hengst, Stadtverordnete, Kassel
Thomas-Erik Junge, Stadtrat, Kassel
Dr. Monika Junker-John, Stadtverordnete, Kassel
Jochen Riebel, Staatsminister, Wiesbaden
Christine Schmarsow, Stadtverordnetenvorsteherin, Kassel

KÜNSTLERISCHER LEITER I ARTISTIC DIRECTOR
Okwui Enwezor

Ko-KuratorInnen I Co-Curators
Carlos Basualdo
Ute Meta Bauer
Susanne Ghez
Sarat Maharaj
Mark Nash
Octavio Zaya

**AUSSTELLUNGSORGANISATION I
CURATORIAL DEPARTMENT**
Projektleitung I Project Manager
Angelika Nollert
Projektkoordination I Project Coordinator
Renée Padt
Ausstellungsassistenz I Curatorial Assistants
Luise Essen
Stephanie Mauch
Nadja Rottner
Executive Assistant
Andreas Seiler
Assistentin des Künstlerischen Leiters I Assistant to the Artistic Director
Christina Werner
Assistentin des Künstlerischen Leiters, Büro New York I Assistant to the Artistic Director, New York Office
Mavette Maton
Praktikantinnen I Interns
Dany Beier
Patricia Holder
Chantal Russo
Angelika von Tomaszewski

KOORDINATION I COORDINATION PLATFORM 1-2
Charity Scribner

KOMMUNIKATION I COMMUNICATION
Leiter der Kommunikation I Director of Communication
Markus Müller
Marketing
Antonia Simon
Redaktion I Editing
Christian Rattemeyer
Koordination Medienpartner I Coordination Media Partners
Barbara Clausen
Internet und Bildarchiv I Internet and Image Archive
Timo Kappeller

Assistenz I Assistants
Vera von Lehsten
Tanja Wunderlich
PraktikantInnen I Interns
Christina Carlberg
Cristina Peierl
Julia Schleipfer
Stefan Unterburger
Laura Wittgens

WEBSITE
candela2
Production/Video-Encoding
expanded cinema

NON-LOGO
Ecke Bonk

GESTALTUNG I GRAPHIC DESIGN
Bernhard Wollborn, atelier grotesk, Kassel

PUBLIKATIONEN I PUBLICATIONS
Redaktion und Koordination I Managing Editor
Gerti Fietzek
Redaktion I Coordinating Editors
Heike Ander
Nadja Rottner

EDUCATION
Projektleitung I Project Supervisors
Karin Rebbert
Oliver Marchart
Assistenz I Assistant
Sophie Goltz
StipendiatInnen I Scholarship Holders
Montserrat Albores Gleason
Elizabeth Gerber
Veronika Gerhard
Olga Kopenkina
Anna Kowalska
Arshiya Lokhandwala
Jorge Munguia
Francesca Recchia
Shuko Wada

ARCHITEKTUR I ARCHITECTURE
Kühn Malvezzi Architekten: Johannes Kühn, Wilfried Kühn,
Simona Malvezzi, Alexander Opper, Jan Ulmer

TECHNISCHE ABTEILUNG I TECHNICAL DEPARTMENT
Technischer Leiter I Technical Director
Winfried Waldeyer
Produktionsleiter I Production Manager
Martin Müller
Assistenz I Assistant
Ulrike Gast
Registrar
Barbara Heinrich
Projektleiterin I Project Manager
Ute Schimmelpfennig
Projektionen/Medientechnik I Projection/Media Technique
Tomski Binsert
Medien/Datenformate I Media/Data Formats
Kim Krier
DVD Authoring
Oliver Schulte
Maik Timm

Restauratoren I Conservation
Tilman Daiber
Ekkehard Kneer
Assistenz I Assistant
Heide Skowranek
Praktikantinnen I Interns
Simone Miller
Martina Pfenniger

Organisation der Ausstellungsgebäude I Coordination of the Exhibition Buildings
Peter Anders, Rob Feigel, Dieter Fuchs, Hans Peter Tewes
Aufbauteam I Installation Team
Volker Andresen, Tereza de Arruda, Sabine Balzer, Michael Blum,
Anna Buttler, Almas Corovic, Imke Dustmann, Martina Fischer,
Luis González Toussaint, Heino Goeb, Daniel Graffé, Ulrike Grötz,
Beatrix Grohmann, Marcel Hager, Anja Helbing, Jutta Hermann,
Sonja Hohenbild, Jesse Howell, Sven Ittermann, Andreas Johnen,
Anna Jakupovic, Horst Jonescu, Stephanie Jüngling,
Alexander Kahlert, Sonja Karle, Jörn Kathmann, Paul Kirschner,
Alfred Josef Klose, Kordula Klose, Jan Köchermann, Knut Kruppa,
Kristiane Krüger, Chantal Labinski, Dragan Lovrinovic, Ralf Mahr,
Jan Mennicke, Milen Miltchev, Ruth Münzner, Patrick Muise,
Fernando Nino-Sánchez, Uwe Pawlak, Mari Reijnders,
Kai Rometsch, Judith Rudolf, Eckardt Sauer, Oliver Scharfbier,
Benjamin Scherz, Christof Schmidt, Dierk Schmidt,
Astrid Schneider, Marcel Schörken, Henner Schröder, Knut Sippel,
Janek Sliwka, Lukas Stäbler, Mathias Steins, Philipp Striegeler,
Marcus Tragesser, Christian Uchtmann, Konrad Urban,
Franziska Vollborn, Dirk Waldeck, Mark Warnecke, Moritz Wiedemann

HAUSTECHNIK I MAINTENANCE
Klaus Dunckel, Andreas Osterbart, Wolfgang Schulze,
Hans Weiser

TECHNISCHE BERATUNG I TECHNICAL CONSULTANTS
Jens Lange
Otto Meyer

VERSICHERUNG I INSURANCE
Aon Jauch & Hübner Gmbh / Aon Artscope, Mülheim
Mundt & Fester, Hamburg

TRANSPORT
Hasenkamp Internationale Transporte, Köln

**INTERNET-/NETZWERKTECHNIK I INTERNET/NETWORK
TECHNOLOGY**
basis5: Lars Möller, Matthias Zipp

FOTOGRAF I PHOTOGRAPHER
Werner Maschmann
Assistenz I Assistants
Annette Koch
Martina Thierschmann

KÜCHE I CATERING
Dany Beier and Steffen Kilian

BESUCHERDIENST I VISITOR SERVICE
x:hibit GmbH: Johannes Krug, Katharina Schenk
Assistenz I Assistants
Anika Cordes
Beatrice Giulini
Ann-Cathrin Limmer
Brian Poole
Julia Wendt
Ausbildung I Education Guides
Karin Rebbert und Oliver Marchart
Führungen I Guides
Steffen Andreae, Gundula Avenarius, Zdravka Bajovic, Klaus Baum,
Elke Beilfuß, Annette Beisenherz, Gertrude Beisenherz,
Ana Bilankov, Holger Birkholz, Monica Lisa Blotevogel,
Martin Bober, Thomas Bornheim, Gregor Brodnicki, Sabine Buch-
holz, Sandra Bürgel, Dominique Busch, Pieter Coetzee, Sabine
Dahmen, Marita Damkröger, Cordula Daus, Winny Decroos, Henrike
Dustmann, Anna Ettel, Elke Falat, Helga Filte, Melanie Fröhlich,
Frauke Frötschl, Juliane Gallo, Gerald Geilert, Gabriele Gerlt,
Martina S. Gnadt, Rose Marie Gnausch, Bärbel Goldbeck-Löwe,
Tilo Grabach, Jennifer Greitschus, Kristina Grüb, Kerstin Hallmann,

Sylvia Hempelmann, Dagrun Hintze, Thorsten Hinz, Nataly Hocke,
Carola Hoffmeister, Nina Jansen, Irina Kaldrack, Gregor Kanitz,
Patricia Kende, Lutz Kirchner, Birgit Kloppenburg,
Karin Klussmann, Konstantin Knape, Susanne König, Yolande Korb,
Timo Kraft, Katrin Kramer, Doris Krininger, Christine Kunze,
Stephan Kurr, Claudia Kurzweg, Susanne Lagemann,
Karin Langsdorf, Evelyn Lehmann, Wolfgang Lenk, Vera Leuschner,
Antje-Kathrin Lielich, Pauline Liesen, Silvia Lorenz, Claudia Manns,
Ellen Markgraf, Natalija Martinovic, Takako Ma ruga, Bill Masuch,
Doreen Mende, Christiane Mennicke, Tabea Metzel,
Dana Meyer-Hinz, Iris Mickein, Frank-Thorsten Moll, Tanja Möller,
Constanze Musterer, Jehodit Orland, Julia Otto, Ute Pannen,
Vanessa Pudelko, Heike Radek, Theodor Rathgeber,
Stefanie Reimers, Katharina Reinhold, Barbara Richartz-Riedel,
Sanja Richtmann, Jeannette Rohrbacher, Klaus Röhring,
Mirja Rosenau, Rebecca Roth, Friedhelm Scharf, Sabine Maria
Schmidt, Heinz-Ulrich Schmidt-Ropertz, Tanja Schomaker,
Katharina Schönle, Ulrich Schötker, Marietta Johanna Schürholz,
Dagmar Seidel, Robert Sobotta, Tina Strippel, Christa Sturm,
Ursula Tax, Karin Thielecke, Julia Tieke, Dorothea Ullrich,
Eveline Valtink, Alexandra Ventura, Hilke Wagner, Anette Weisser,
Petra Werner, Judith Wiese, Ines Wiskemann, Ernst Wittekindt,
Elke Ziegler, Lena Ziese, Maxa Zoller

**ORGANISATION UND VERWALTUNG I ADMINISTRATION AND
COORDINATION**
Assistenz der Geschäftsführung I Executive Assistants
Matthias Sauer
Eberhard Weyel
Verwaltung I Administration
Karin Balzer-Meyer
Birgit Herzog
Brigitte Kraußer
Katharina Krzywon
Marli Moj
Barbara Toopeekoff
Annette Wolter-Jaußen
**Koordination Reisen und Unterbringung I Coordination Travel and
Accommodation**
Hendrik Wilhelm Kallisch
Organisation Aufsichtsdienst I Coordination Guards
Veronika Rost
Frauke Stehl
Organisation Kartenverkauf I Coordination Ticket Sales
Ullrich Franke

Pro Helvetia, Zürich

U.S. participation in Documenta11 is made possible by generous
support from The Fund for U.S. Artists at International Festivals and
Exhibitions, a public-private partnership of the National Endowment
for the Arts, the U.S. Department of State, The Pew Charitable
Trusts, and the Rockefeller Foundation. The Fund is administered
by Arts International.

arte

BILDNACHWEIS I PHOTOCREDITS

Seite I page

9: Thilo Härdtlein. Courtesy jointadventures.org.

11: Courtesy Ravi Agarwal.

13: © Crystal Eye Ltd., Helsinki.

15: © Chantal Akerman. Courtesy Corto Pacific, Paris.

17: Courtesy Gaston A. Ancelovici.

19: © Fareed Armaly.

21: Oren Slor. Courtesy Andrea Rosen Gallery, New York, N.Y.

23: © Asymptote Architecture.

25: Courtesy Kutlug Ataman + Lehmann Maupin Gallery, New York, N.Y.

27: Courtesy Walid Raad.

29: Courtesy Julie Bargmann + Stacy Levy.

31: César Carneiro. © Artur Barrio.

33: Courtesy Bernd + Hilla Becher.

35: © Zarina Bhimji.

37: Courtesy Black Audio Film Archive.

39: Knut Klaßen. Courtesy Galerie Klosterfelde, Berlin.

41: © Ecke Bonk.

43: Claude Postel. Courtesy C.A.A.C. – The Pigozzi Collection, Genf I Geneva.

45: Christopher Burke.

47: Courtesy Pavel Braila.

51: Courtesy Liebmann Magnan, New York, N.Y.

53: © Luis Camnitzer.

55: © James Coleman.

57: Victor E. Nieuwenhuijs. Courtesy Haags Gemeentemuseum, Den Haag I The Hague.

59: Courtesy Carnegie Museum of Art, Pittsburgh, Pa.

61: Courtesy Destiny Deacon + Roslyn Oxley9 Gallery, Sydney.

63: Courtesy Stan Douglas + David Zwirner Gallery, New York, N.Y.

65: Courtesy Cecilia Edefalk.

67: Courtesy Cheim & Read, New York, N.Y.

69: Hans-Georg Gaul © VG-Bild-Kunst.

71: Touhami Ennadre.

73: Cerith Wyn Evans.

75: Courtesy Feng Mengbo.

77: Jean-Luc Mabit. Courtesy Galerie Patricia Dorfmann, Paris.

79: Courtesy Yona Friedman.

81: Courtesy Carlier/Gebauer, Berlin.

83: Courtesy Studio Guenzani, Mailand I Milan; Raum aktueller Kunst, Wien I Vienna.

85: Courtesy Galeria Continua, San Giminiano, and Lombard-Fried Fine Arts, New York, N.Y.

87: Kendell Geers. Courtesy Stephen Friedman Gallery, London.

89: Courtesy Magnani, London.

91: Wilfried Petzi. Courtesy Kunstverein München, München I Munich.

93: David Goldblatt.

95: David Reynolds. Courtesy Ronald Feldman Fine Arts, New York.

97: Asa Lunden.

99: Courtesy Renée Green.

101: Courtesy Ruth Benzakar, Galerie de Arte, Buenos Aires.

103: © Arc en Ciel Multimedia.

105: Jens Haaning. Courtesy Galleri Nicolai Wallner, Kopenhagen I Copenhagen.

107: Edward Woodman. Courtesy of Jay Jopling/White Cube, London and Alexander and Bonin, New York, N.Y.

109: Courtesy Galerie Arndt & Partner, Berlin.

111: Courtesy Candida Höfer.

113: Larry Lame. Courtesy Craigie Horsfield + Frith Street Gallery, London.

115: Courtesy Huit Facettes.

117: © Marian Goodman Gallery, Paris/New York, N.Y.

119: Courtesy Igloolik Isuma Productions Inc. © Igloolik Isuma Productions.

121: Courtesy Sanja Ivecović.

123: Courtesy Alfredo Jaar.

125: Courtesy Joan Jonas.

127: Courtesy Isaac Julien + Victoria Miro Gallery, London.

129: Courtesy Amar Kanwar.

131: Courtesy David Zwirner, New York, N.Y.

133: Ruphin Coudyzer (FPPSA).

135: Courtesy Ideal Audience Int'l, Paris.

137: Claude Postel. © C.A.A.C. – The Pigozzi Collection, Genf I Geneva.

139: Ben Kinmont.

141: Courtesy Igor & Svetlana Kopystiansky.

143: Courtesy Ivan Kožarić.

145: Courtesy Andreja Kulunčić.

147: Courtesy Glenn Ligon + D'Amelio Terras, New York, N.Y.

149: Orcutt and Van Der Putten. Courtesy Andrea Rosen Gallery, New York. © Ken Lum.

151: Courtesy Mark Manders + Zeno X Gallery, Antwerpen I Antwerp.

153: Courtesy Fabian Marcaccio.

155: Peter Fleissig. Courtesy Anthony Reynolds Gallery, London © Steve McQueen.

157: Courtesy Cildo Meireles + Galerie Lelong, New York.

159: Courtesy Jonas Mekas.

161: Courtesy Marian Goodman Gallery, Paris/New York, N.Y.

163: Axel Schneider. Courtesy Museum für Moderne Kunst, Frankfurt am Main.

165: Courtesy Santu Mofokeng.

167: Courtesy Multiplicity.

169: Courtesy Estate Juan Muñoz.

171: Courtesy Barbara Gladstone, New York, N.Y.

HERAUSGEBER / EDITOR
documenta und Museum Fridericianum Veranstaltungs-GmbH

REDAKTION UND KOORDINATION I COORDINATING EDITOR
Gerti Fietzek
Redaktion I Editor
Christian Rattemeyer
Bildredaktion I Picture Research
Heike Ander

LEKTORAT I EDITING
Greg Bond, Uta Grundmann

ÜBERSETZUNG I TRANSLATIONS
Aus dem Deutschen I From the German
Rebeccah Blum, Allison Plath-Moseley
Aus dem Englischen I From the English
Alexandra Bootz und Andrea Honecker, Andrea Stumpf
Aus dem Spanischen I From the Spanish
Linda Phillips

TEXTE
Documenta 11 Team
Heike Ander (H.A.)
Carlos Basualdo (C.B.)
Barbara Clausen (B.C.)
Stephanie Mauch (S.M.)
Mark Nash (M.N.)
Angelika Nollert (A.N.)
Christian Rattemeyer (C.R.)
Karin Rebbert (K.R.)
Nadja Rottner (N.R.)
Octavio Zaya (O.Z.)
und I and
Noit Banai (N.B.)
Marcelo Expósito (M.E.)
Lauri Firstenberg (L.F.)
Lolita Jablonskiene (L.J.)
Christiane Mennicke (C.M.)
Tabea Metzel (T.M.)
Gunalan Nadarajan (G.N.)
Thierry N'Landu (T.N'L.)
Chika Okeke (C.O.)
Cay Sophie Rabinowitz (C.S.R.)
Edward Scheer (E.S.)
Janka Vukmir (J.V.)
Scott Watson (S.W.)

GESTALTUNG I GRAPHIC DESIGN
Angus Hyland, Pentagram Design, London
Assistenz I Assistance
Charlie Hanson, Sharon Hwang, Charlie Smith

SATZ I TYPESETTING
Uta Grundmann, Berlin

REPRODUKTION I REPRODUCTION
Weyhing digital, Ostfildern-Ruit

GESAMTHERSTELLUNG I PRINTED BY
Dr. Cantz'sche Druckerei, Ostfildern-Ruit

© 2002 documenta und Museum Fridericianum Veranstaltungs-
GmbH, Kassel, Hatje Cantz Verlag I Publishers, Ostfildern-Ruit, die
Autoren, Künstler, Fotografen und Übersetzer I authors, artists,
photographers and translators
© 2002 für die abgebildeten Werke von I for the reproduced works
by Georges Adéagbo, Eija-Liisa Ahtila, Louise Bourgeois, Constant,
Destiny Deacon, Maria Eichhorn, Jef Geys, Candida Höfer, Annette
Messager, Gediminas Urbonas bei I by VG Bild-Kunst, Bonn, für die
übrigen abgebildeten Werke bei den Künstlern oder ihren
Rechtsnachfolgern I for the other reproduced works by the artists
and their legal successors.

ERSCHIENEN IM I PUBLISHED BY
Hatje Cantz Verlag I Publishers
Senefelderstrasse 12
73760 Ostfildern-Ruit
Tel. 0711 44050
Fax 0711 4405220
www.hatjecantz.de

VERTRIEB IN DEN USA I DISTRIBUTION IN THE USA
D.A.P., Distributed Art Publishers, Inc.
155 Avenue of the Americas, Second Floor
New York, NY 10013-1507
USA
Tel. +1 212 627 1999
Fax +1 212 627 9484

ISBN 3-7757-9087-X

Printed in Germany
Die Deutsche Bibliothek – CIP-Einheitsaufnahme
Ein Titeldatensatz für diese Publikation ist bei Der Deutschen Biblio-
thek erhältlich